Illuminated Greek Manuscripts

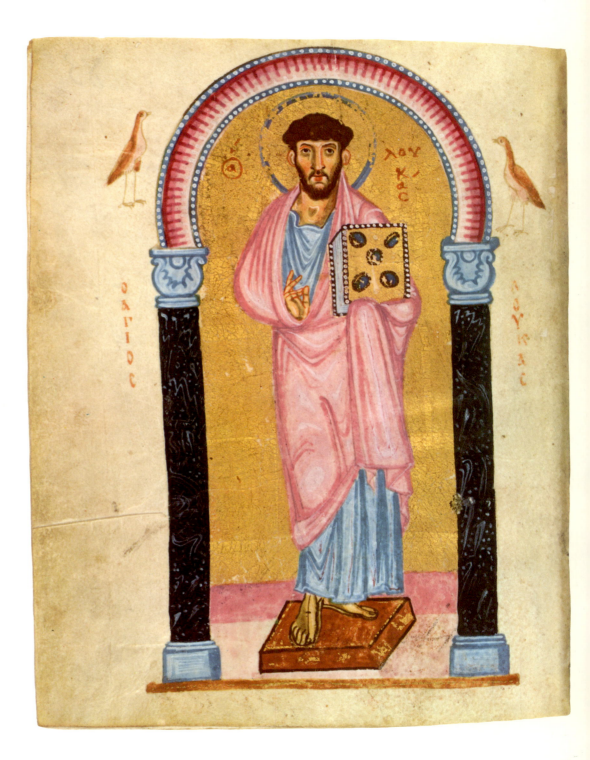

# Illuminated Greek Manuscripts from American Collections

*An Exhibition in Honor of Kurt Weitzmann*

EDITED BY GARY VIKAN

The Art Museum, Princeton University

DISTRIBUTED BY PRINCETON UNIVERSITY PRESS

Dates of the exhibition:
April 14–May 20, 1973

Library of Congress Catalogue Card Number
72-92151
ISBN cloth: 0-691-03889-9
ISBN paper: 0-691-03890-2

Designed by George Lenox
Composed by Princeton University Press
Printed by the Meriden Gravure Company

FRONTISPIECE Luke
Princeton, Univ. Lib. cod. Garrett 6, fol. 83v

# Contents

# Lenders to the Exhibition

Andover-Harvard Theological Library, Cambridge, Massachusetts

The Art Museum, Princeton University

Beinecke Rare Book and Manuscript Library, Yale University

Cleveland Museum of Art

Dumbarton Oaks Research Library and Collection, Washington, D.C.

Firestone Library, Princeton University

Free Library of Philadelphia

H. P. Kraus, New York

Houghton Library, Harvard University

Joseph Regenstein Library, University of Chicago

Montreal Museum of Fine Arts

Museum of Fine Arts, Boston

New York Public Library

The Pierpont Morgan Library, New York

Robert E. Speer Library, Princeton Theological Seminary

Saint Mark's Library, General Theological Seminary, New York

Scheide Library, Princeton

University of Toronto Library

Walters Art Gallery, Baltimore

# The Contributors

J.C.A.    Jeffery C. Anderson, Princeton University

L.D.A.    Leo D. Arons, Princeton

R.P.B.    Robert P. Bergman, Princeton University

C.L.B.    Claudia Lazzaro Bruno, Princeton University

A.VAN B.    Anne van Buren, Princeton

R.D.    Robert Deshman, University of Toronto

G.G.    George Galavaris, McGill University, Montreal

S.G.    Stephen Gardner, Princeton University

H.L.K.    Herbert L. Kessler, University of Chicago

D.M.    Doula Mouriki, Polytechneion, Athens

L.N.    Lawrence Nees, Harvard University

    Shigebumi Tsuji, Seisen Women's College, Tokyo

B.A.V.    Birute Anne Vileisis, Princeton University

G.V.    Gary Vikan, Princeton University

T.J.-W.    Thea Jirat-Wasiutyński, Kingston, Ontario

Kurt Weitzmann in his University office

# Foreword

Patrick Joseph Kelleher
Director, The Art Museum

Any colleague, friend, and former student of Kurt Weitzmann can only feel pangs of nostalgia in honoring his retirement from the Department of Art and Archaeology of Princeton University and the Institute for Advanced Study with this truly imperial exhibition of illuminated Greek Manuscripts from North American collections and its attendant scholarly catalogue prepared by some who hold this exceptional scholar precious indeed. The enumeration of specific years that any of us has been fortunate enough to work closely with Dr. Weitzmann is immaterial. Despite age or generation, all have shared a rich, common experience and a great heritage. Kurt Weitzmann is one of those rare scholars to whom the designation "maestro" can be properly applied.

The ultimate disciple of another master, Adolph Goldschmidt, Kurt today remains preeminent in his field, as was his mentor in an earlier period of the exploration and reconstruction of the late classic and other sources of Mediaeval art in both the Eastern and Western worlds. Pioneers in establishing a solid fabric for this discipline in pre-World War II Germany, Goldschmidt and Weitzmann, apart from their own brilliant collaboration, early became associated with (and Weitzmann joined) the comparable center for Mediaeval art established by Charles Rufus Morey in the late 1920s in Princeton, together with some brilliant colleagues he had assembled about him, among them E. Baldwin Smith, A. M. Friend, Jr., Ernest T. DeWald, W. Frederick Stohlman, Donald D. Egbert, Richard Stillwell, and George Forsyth. Professor Morey, as Chairman of the Department of Art and Archaeology, was an extraordinary scholar and administrator of exceptional influence and vision, and truly an augustan figure. As a student in Rome he had known Achille Ratti, Librarian of the Ambrosiana and subsequently elevated to the papacy as Pius XI, and two other young scholarly churchmen who later were to become significant princes of the church as the Cardinals Mercati and Tisserant. The tradition in Princeton was that Morey was the only Protestant "to have keys to the Vatican." And these he had, though he had to admit that he could never coerce the Patriarch of Venice, later Giovanni XXIII, into permitting his students to work in the Patriarchial collections through Vatican influence. This had to be done through personal contact. And this he had too.

Mr. Morey chose to think in terms of grand design. Trained initially as a student of classical languages, he had come to Princeton as one of Woodrow Wilson's original preceptors. Under the spell of Professor Allan Marquand, founder of the Department of Art and Archaeology, Morey turned to art history, and specifically to the art of the Middle Ages. As successor to Mr. Marquand as Chairman of the Department, Morey embarked on a series of projects designed to extend knowledge of Mediaeval art and its sources in the late antique world. His major achievements, as well as his special interests, were the creation of the Index of Christian Art, the cataloguing of treasures in the Museo Cristiano of the Vatican collections, and his monumental project for the excavation of the rich

Hellenistic-Roman-Early Christian city of Antioch-on-the-Orontes, founded in the wake of the conquests of Alexander. Here, he and his colleagues hoped to find some major sources of Early Christian Art. They succeeded with the discovery of the brilliant series of late classical mosaics that extended knowledge of ancient painting, its sources and eventual translation into Early Christian and Byzantine style.

But Morey also had other plans. Spurred on by the initiative of Professor Friend, Mr. Morey hoped to achieve a distinguished series of publications centering about Mediaeval manuscript illuminations and texts that again would reveal some ancient sources for the diverse styles of the Middle Ages in both the Eastern and Western worlds. To aid his project, he made a major coup in arranging for Kurt Weitzmann to join first the Institute for Advanced Study in 1935 and subsequently to be his successor in the field of Mediaeval art in the Department of Art and Archaeology at Princeton. This was a moment of consequence for more than a generation of students in Princeton.

Goldschmidt, Nestor of Kurt, though never officially canonized by his peers in Princeton, nonetheless was considered "Highly Venerable." It is interesting to note, in passing, that Goldschmidt was the first German citizen to receive an honorary degree in the United States after World War 1—and appropriately enough, it was awarded by Princeton. In the celebrated "manuscript seminary" in old McCormick Hall, a sensitive lithograph portrait of Goldschmidt occupied a prominent place, looking benignly out on his prize student Kurt, on his Princeton colleagues, on visiting scholars from America and abroad, and on those current graduate students privileged to be granted working space in that crowded room.

The old seminary room itself consisted of a semistage set with Sienese Gothic windows designed by the production studios of Ralph Adams Cram. Some fine Turkish tiles, for no apparent reason, were spotted in the walls between the lancets. Below, oblivious to this eclectic setting, was a warren of desks and tables littered with books and manuscripts in progress. Rare and essential publications lined an opposite wall, in two tiers, flanked by Professor Friend's minuscule office which displayed a fine fifteenth-century German pietà of exceptional quality. From a catwalk nearby, he appeared frequently to survey the domain and give encouraging words to his common friends in Mediaeval studies. Close at hand was the mysterious, locked cage which contained, among other wonders, much of Goldschmidt's unpublished studies and photographs and the archives collected by Weitzmann from his years on Mount Athos and elsewhere, as well as portions of Bert Friend's small but extremely choice collection of *Kleinkunst* and theater drawings of the seventeenth and eighteenth centuries.

In this room Weitzmann, Friend, DeWald, and visiting specialists from the Institute for Advanced Study and elsewhere conducted their seminars and pro-

duced the milestone publications in the series *Studies in Manuscript Illumination*, edited first by Friend and later by Weitzmann. Over half of the volumes in this series, a monument of twentieth-century scholarship, were written by Kurt Weitzmann.

Kurt of them all, however, was omnipresent at his desk in the manuscript room (as he continues to be in enlarged quarters in the new McCormick Hall), always available to consult, advise, and produce some unknown photograph or piece of supporting evidence from "the cage" for his students. He was truly at home in this atmosphere and normally worked late into the night. It was then that J. R. Martin and I, his first candidates for the Ph.D. degree in 1947, were able to discover and explore other facets of Kurt's rich and diverse interests that have made him such an exceptional teacher, scholar, and individual. His first interest had been in seventeenth-century Dutch painting and he was enthusiastic about German and Central European Baroque art and the twentieth-century Expressionists, subjects not so fashionable in 1947 as in 1973. His range of knowledge and exceptional eye have been invaluable to The Art Museum in making numerous acquisitions in diverse periods and cultures as he served as Honorary Curator of Mediaeval Art.

It is again indicative of the depth and quality of Kurt's instruction that, though Martin and I received our doctorates in Mediaeval studies under his aegis, Jack went on to become a specialist on Rubens and Baroque art and I entered the Museum world. Kurt approved of these choices, as he did also of those of his subsequent students. That he kept many, however, in his own fold is attested to by the essays and studies in this volume.

And so on this occasion we, your students and colleagues, hail and honor you, Kurt, and give you our pledge of lasting friendship.

# Preface

Wen C. Fong
Chairman,
Department of Art and Archaeology

This catalogue of an exhibition of illuminated Greek manuscripts from North American collections, dedicated to Kurt Weitzmann, Professor Emeritus of Art and Archaeology at Princeton, includes not only catalogue entries prepared by Professor Weitzmann's former and current students, but also essays by six of his former students now teaching the history of Byzantine art in various parts of the world. The foreword and preface writers of this catalogue, P. J. Kelleher and I, are also former Weitzmann pupils: Joe had written his Ph.D. thesis under Weitzmann before turning to a career in museum work and modern art, while I qualified for my doctoral candidacy by taking the General Examination in Early Christian art before choosing to write a thesis in the field of Chinese painting.

The Weitzmann legacy is an integral part of the Princeton tradition: as recently as the early 1950s, the study of Early Christian art not only dominated the Princeton Department, but as an established discipline also prepared Princeton scholars to adapt its methods and techniques to the different demands of many other fields, such as Renaissance, Baroque, Modern, and Far Eastern art.

One of the principal concerns of the Princeton school of Mediaeval studies has been, from the earliest days, the survival and revival of late-antique images in Early Christian art, and consequently, characterization of stylistic changes during this period. In 1924, Charles Rufus Morey published his famous essay, "Sources of Mediaeval Style" (*Art Bulletin*), in which he proposed an "Alexandrian Style" as the source of a vestigial late-antique illusionism in Early Christian art. In 1927 and 1929, Albert Mathias Friend, Jr., produced in two installments the seminal paper on "Portraits of the Evangelists in Greek and Latin Manuscripts" (*Art Studies*), in which he traced the portraits of the Evangelists to late-antique models.

Despite his well-known disagreement with Morey's views of the development of Byzantine art, Professor Weitzmann was brought to the Institute for Advanced Study at Princeton in 1935 at Professor Morey's instigation. Whereas Morey's hypothesis of an "Alexandrian Style" attempted to demonstrate the continuity of classicism in Early Christian art, Weitzmann saw a "Renaissance" of the arts in Mid-Byzantine Constantinople under the Macedonian emperors in the tenth century. Weitzmann's central scholarly concern is the problem of tradition and change in art history. Throughout his prodigious output, from his early pioneer work on Byzantine ivories and his systematic investigations of manuscript illustrations to his more recent studies of mosaics, frescoes, and icon paintings, he has shown a remarkable sensitivity to the subtle problems of different individual uses of the formal models. Thus, to him, the peculiar "Renaissance" character of the Paris Psalter—which Morey dates in the seventh or early eighth, but which he dates in the tenth century—lies in the artificial and not always successful combinations of typical Byzantine motifs with genuinely classical models. In his famous book, *Illustrations in Roll and Codex* (first published in 1947), he analyzes the migration of pictures from the "basic" texts (e.g., the Old and New Testa-

ments) into "secondary" texts (e.g., Psalters, Lectionaries, and patristic commentaries) with subtle modifications. And in his investigations of liturgical manuscripts, he demonstrates the differences between straightforward narrative cycles and those based on liturgical considerations. Weitzmann's iconographic studies, in short, are carefully tempered by his concern for stylistic and expressive problems. The titles of the papers in the recently compiled volume *Studies in Classical and Byzantine Manuscript Illumination* (edited by Herbert L. Kessler, 1971) clearly reflect these concerns: e.g., "Book Illustration of the Fourth Century: Tradition and Innovation," "The Classical in Byzantine Art as a Mode of Individual Expression," "The Narrative and Liturgical Gospel Illustrations," etc.

I remember vividly those years in the late 1940s and early 1950s in McCormick Hall when I was first an undergraduate and then a graduate student. The presence of the grand old man Morey, recently retired, was still very much felt in the great halls. Through their deep involvement in the Princeton illuminated manuscript project, Friend and Weitzmann had become the fastest of friends. This great project of publishing the Septuagint manuscripts involved the collaboration of many scholars guided by a common purpose. The methods developed by Friend and Weitzmann in their seminars were subjects of curiosity as well as objects of study: great monuments and lost styles were reconstructed in these seminars, and the history of Byzantine art seemed to take shape and unfold before our very eyes. Weitzmann's supreme moment came in 1956 when he joined the Michigan-Alexandria-Princeton expedition to Mount Sinai. The great apse mosaic and the pre-iconoclastic icons thoroughly investigated there for the first time fully vindicated his earlier theories of a classical heritage in Constantinopolitan art of the sixth and seventh centuries. Weitzmann's first volume on the Sinai icons is now ready for publication. As I write this preface, word has just been received that the volume has been accepted for publication by Princeton University Press.

It has been said of American art scholarship in general that "we have contributed little to the characterization of style process in major areas of Western art . . . [but] in less well-trodden periods, the absence of pre-existing style classifications impelled [us] into the arena of theory" (J. S. Ackerman and R. Carpenter, *Art and Archaeology*, 1963, p. 201). This seems to explain why scholars in this country have shown exceptional boldness in plotting out less-developed areas of art history, such as Byzantine, Modern, and Far Eastern art. The imposing edifice of scholarship that Weitzmann has erected during the past forty-odd years is characterized by a methodological consistency and rigorousness seldom equaled in the field. His ultimate contribution to art history, it seems to me, lies even beyond his special theories of Byzantine art; it has to do with the forging and refinement of a style of thought, a way of dealing successfully with the problems of visual images.

The present exhibition, organized and catalogued by his students, is a fitting tribute to Weitzmann's scholarship. The nature of any exhibition, which is a selective presentation of art objects as historical data, is perhaps best described by a Chinese phrase, *hsiao-chung hsien-ta*, "to see large within the small." Inasmuch as no one can make an intelligent catalogue of works of art without a theory of history and style, it is clear that the present exhibition could never have been done without Weitzmann's lifework.

The exhibition received extraordinary cooperation from the various lending institutions and collectors. Many rare and fragile items were made available explicitly for the purpose of honoring Kurt Weitzmann. We are grateful to all those who have participated in the exhibition. To Richard Randall, Jr., and Dorothy Miner of the Walters Art Gallery; William Tyler of Dumbarton Oaks; Charles Ryskamp and John Plummer of The Pierpont Morgan Library; Robert Rosenthal of the Joseph Regenstein Library, University of Chicago; William Wixom of the Cleveland Museum of Art; H. P. Kraus; William Scheide; and Alexander Clark of Firestone Library, Princeton University, we owe a special debt of gratitude and lasting friendship.

# Introduction and Survey of Style

Gary Vikan

This exhibition of sixty-seven illuminated Greek manuscripts and single leaves from twenty-one North American collections is the largest of its kind to be held in the United States, comparable only to the 1947 exhibition in Baltimore, *Early Christian and Byzantine Art*, which included among its almost nine hundred entries more than fifty Greek manuscripts. In size and diversity the Princeton exhibition approaches the sections allotted to illuminated Greek manuscripts in the Paris exhibition of 1958, *Byzance et la France médiévale*, and the huge Byzantine exhibition in Athens, *Byzantine Art: An European Art*, held in 1964. It affords the first opportunity in over twenty-five years to examine side by side most of the finest illuminated Greek manuscripts in the United States, representing the pioneering initiative of such American collectors as Robert Garrett, Henry Walters, and J. P. Morgan. Twenty of these items have never been included in any exhibition; fewer than a dozen have been recently displayed in their own institutions.

Although none of the few extant pre-iconoclastic illustrated Byzantine manuscripts belongs to an American collection, this exhibition provides a representative cross section of texts and styles from the ninth to the eighteenth century, as well as two codices with modern forged miniatures. Unfortunately, a presentation of this type is only partially suited to the demonstration of Professor Weitzmann's research procedures. In applying the philologist's methods of text criticism to pictures, he necessarily deals with comparisons of cycles of narrative illustration, most often of Old Testament or classical texts. About half the miniatures in this exhibition, however, are Evangelist portraits, by far the most common type of figural decoration in Greek manuscripts. And although three classical codices are included, there are, excluding the Psalter, no Old Testament texts, since these were rarely illustrated at any period in the Byzantine East. However, in addition to the more than half-dozen manuscripts with narrative text illustration, there appear in the exhibition seven Psalters and five Lectionaries—two liturgical texts to the study of which Weitzmann has contributed much fundamental research. The exhibition catalogue also clearly documents many of the contributions made by Professor Weitzmann to the history of miniature style as well as to the study of specific iconographic problems.

The introductory chapters, written by six of Dr. Weitzmann's former students, attempt to treat comprehensively a variety of subjects applicable to broad groups of illustrated manuscripts, and thus to supplement the individual catalogue entries. Chapter 6, for example, in its examination of the nature and origin of Evangelist portraits, relates directly to more than half the items in the exhibition.

The catalogue entries represent the cumulative efforts of two Princeton graduate students, ten present and former students of Professor Weitzmann, and three independent scholars. In each entry we attempt, after a brief codicological analysis, to describe the illumination, to estimate the date of its production through

comparisons with manuscripts of known date, and to examine its iconographic peculiarities. Almost every object was studied at first hand. Professor Weitzmann generously made available his own notes, as well as his list of dated manuscripts. In addition, we relied heavily on "the cage," the Princeton Manuscript Room's rich photographic collection. Many of the forty-eight manuscripts and nineteen fragments had never before been researched; illustrations of fifteen are published here for the first time.

For seventeen fragmentary manuscripts and single leaves we have illustrated either leaves from the parent manuscript or companion fragments; several of these provenances are published here for the first time. We are especially fortunate in being able to exhibit the parent manuscripts or associated fragments of four single leaves, thus reuniting parts of codices that in some cases have been separated for decades.

In addition to the contributors, who gave generously of their time to the writing of these essays and entries, I should like to thank Lynda Hunsucker for help in editing the essays; Miss Dorothy Miner, Robert W. Allison, and Professor Ihor Ševčenko for their contributions to our research; and Virginia Wageman and Jean MacLachlan for their patient assistance in preparing this manuscript for publication. Finally, we all owe a special debt to Professor Weitzmann, whose spirit and scholarship pervade the entire catalogue.

This exhibition provides the extraordinary opportunity to trace at first hand stylistic trends in Greek manuscript illumination from the end of Iconoclasm well into the Post-Byzantine period.

Two stylistic trends may be identified in those manuscripts illustrated soon after the final Restoration of Images in 843 A.D. The first, following more closely classical Greek traditions, is best exemplified in the luxurious Gregory codex (Paris, Bibl. Nat. cod. gr. 510) made for Basil I, founder of the Macedonian Dynasty. The second, just as highly sophisticated but showing stronger Eastern influences, may be seen in the portraits of a Gospel book from the Princeton University Library (cat. 1). Especially characteristic of this second style are light tonalities, bold linear draperies, and low-browed, sharply outlined faces.

The tenth century, often called the Macedonian Renaissance in recognition of the revival of classical taste evident in works of art produced under the court patronage of such scholarly emperors as Leo the Wise and Constantine Porphyrogennetos, saw the development of a unified, naturalistic style evolved in the process of copying antique models. Although the most brilliant and sumptuous Renaissance codices, including the Paris Psalter (Bibl. Nat. cod. gr. 139) and the Joshua Roll (Vatican Lib. cod. Palat. gr. 431), are in European libraries, excellent counterparts may be found in American collections. The illustrated *De Materia*

*Medica* of Dioscurides from The Pierpont Morgan Library (cat. 6), for example, is representative of those luxurious copies made directly from antique manuscripts as part of the encyclopedic revival of classical learning undertaken by the early Macedonian emperors. Contemporary Evangelist portraits, like that of Mark from the Walters Art Gallery (cat. 7), were copied from Early Christian models, which in turn were based on the portraits of classical poets and philosophers. These dignified, contemplative figures reveal a clear understanding of the mass and structure of the body as well as of the plastic rendering of classical garments. Such portraits often include complex architectural backgrounds modeled on the decorative stage facades of the Roman theater. A simplified version of such a background may be seen in the early tenth-century New Testament fragment from Baltimore (cat. 5).

Although dated 1084 A.D., the Dumbarton Oaks Psalter-New Testament (cat. 20) is a close copy of a now lost Psalter of the early tenth century. Especially indicative of the Renaissance tendency to combine classical and Christian elements is the seminude personification of Mount Sinai found in the miniature of Moses Receiving the Law.

By the end of the tenth century, the stylistic forms of the Macedonian Renaissance had become mannered. The Evangelist Mark on a single leaf from Baltimore (cat. 8) is exaggeratedly muscular and tense; the folds of his garments have multiplied and become hard. His head, jutting sharply forward, is marked by a protruding brow knit in a typical Mid-Byzantine frown.

Miniatures datable to the first half of the eleventh century show, in addition to the relaxation of this tension, lighter, more graceful figures and a more decorative linear articulation of the body (cat. 9, 11). Manuscript painting has become minute and delicate, approaching the quality of enamelwork. Colors are stronger, more localized and decorative. The basic stylistic and iconographic formulae of the next several centuries have been established and have spread to the Byzantine provinces. Naturalistic flower-petal ornament, a creation of the Macedonian Renaissance, is almost universal (cat. 38), having replaced more abstract motifs predominant until the mid-tenth century (cat. 2, 3, 5, 10); shimmering gold backgrounds abound.

Manuscript illumination in the second half of the eleventh century is unusually well documented in this exhibition, with twenty-one items dated between circa 1050 and circa 1100 (cat. 12–32). They are characterized by elongated, weightless figures, flat, schematically highlighted garments, and two-dimensional landscapes and backdrops (cat. 19, 21–23, 26, 32). Evangelists, when compared with those of the tenth century, are dematerialized and often disjointed; their garments are hard, flat, and linear (cat. 13–16). In abandoning the naturalistic, antique style of the Macedonian Renaissance, these miniatures have acquired a new, unified decorative quality and have evolved an ascetic ideal appropriate to the revived monastic

movements of the period led by the Studion monastery and Symeon, the New Theologian. From the third quarter of the century two stylistic extremes may be identified: one is monumental, drawing directly upon Macedonian Renaissance models and associated with the Imperial court (cat. 14); and the other, developed in the Studion monastery itself, is delicate with linear gold highlights (cat. 12, 29).

Succeeding periods are difficult to characterize because of the dearth of firmly dated and localized manuscripts as well as the lack of comprehensive, scholarly treatments of style. A major school of manuscript painting in the first half of the twelfth century, exemplified in a portrait of Matthew from the Walters Art Gallery (cat. 36), shows a return to plastically modeled drapery folds. Highly sculptural and patternized, these garments often obscure the structure of the body beneath, which is typically ill-proportioned and rubbery. Heads are characteristically large with low protruding brows and piercing eyes. Drapery highlights are more intense than those of the eleventh century, forming independent patterns; and colors, especially reds and blues, are unusually bold and vivid. The entire composition, comprising few straight lines or right angles, has a new sense of buoyant movement, anticipating the expressive qualities characteristic of much late Comnenian and Palaeologan illumination. At the same time, however, the broad monumental style of eleventh-century miniature painting has been continued (cat. 35).

Several manuscripts in this exhibition have been assigned to the second half of the twelfth century, a period still inadequately documented and researched (cat. 34, 38–42, 45). While some show rigid, stunted figures, the Virgin Enthroned in a Gospel book from the Princeton University Library (cat. 34) possesses an hieratic monumentality unsurpassed in any period. Highlights are increasingly broad and unrelated to garments, and while there is a growing awareness of body mass, organic structure is comparatively little understood. Colors tend to be murky, with occasional strong contrasts, and backgrounds are painted in dull gold.

During the same decades a classicizing, "dynamic" style appears, characterized by tall, elegant figures dressed in highly articulated garments marked by a mannered reduplication of drapery loops. These illuminations reveal a new concern for emotional realism. An excellent representative may be seen in the portrait of John from a manuscript owned by Mr. H. P. Kraus (cat. 42). By the early thirteenth century this classicizing trend has abandoned stylized drapery and expressive poses in favor of monumental, simplified forms. The miniatures in a Baltimore Gospel book assigned to this period (cat. 44) include serene, sculptural figures modeled in soft, painterly shadows. The subtle pathos of these compositions is enhanced not through line, but through color.

Thirteenth-century miniatures, often copied from tenth-century models, have an antique quality unknown in Byzantine illumination since the Macedonian Renaissance. The style of the second half of the century, although far from uni-

fied, is characterized by densely highlighted, bulky garments broken by energetic, angular drapery folds (cat. 50–53). Faces, typically painted in loose brushstrokes, are individualized to the point of caricature, and architectural backgrounds are stereometrically rendered and complex. Almost all compositional elements show elongation; and expressions, gestures, and proportions are exaggerated, imparting an emotional intensity to the miniature unknown in earlier periods.

Although well documented by dated manuscripts, fourteenth-century illumination has only one clear representative in this exhibition, a washdrawing portrait of Luke dated 1380 (cat. 57). Characteristically it shows a crystallization of thirteenth-century drapery styles into masses of nervous, brittle folds almost conveying the impression of sparkling brushstrokes. Background architecture is increasingly fanciful and traditional iconographic forms are treated with new freedom.

After the fall of Constantinople in 1453 A.D., Byzantine manuscript painting was continued in several Eastern centers, the foremost of which was Crete. Abandoning the emotional intensity and agitated movement of the last phases of Palaeologan art, these centers concentrated on the preservation of earlier traditions (cat. 61, 63).

# 1.

# Manuscripts and the Liturgy

George Galavaris

When the first Christians met they sang the Psalms and heard readings from the holy books, accounts of the Apostles or the Prophets, and a sermon delivered by the bishop. The sermon or homily was either a commentary on the Gospel readings or a panegyric on a special festival day. Prayers concluded this part of the service and the Kiss of Peace exchanged between members of the congregation opened the sacramental celebration in which the catechumens could not participate. The faithful presented their offerings of bread, wine, and water, over which prayers were recited by the bishop, and the Communion followed, with the communicants receiving the bread and the wine mixed with water. A hymn of thanks was chanted by the congregation and the dismissal took place.

In the course of time the Celebration of the Eucharist, or the Liturgy, underwent changes resulting in the formation of several liturgical "families." The Byzantine or "Divine Liturgy" goes back to the fourth century and belongs to a family deriving from Antioch. By the ninth century its structure and text had crystallized, although other changes took place later.

In the Liturgy, the Biblical story was seen not as a historical succession of single events, but rather as a unified whole made immediate by the sacramental reenactment of the Great Mysterium, the Incarnation of Christ, His teachings, His sacrifice, His glory. We know the principal prayers as they were recited in their alternate versions ascribed traditionally to different authors. The version used throughout the year in the Orthodox Church is attributed to John Chrysostom, the great Patriarch of Constantinople in the late fourth and early fifth century. It is divided into three parts: the *Prothesis* or *Proskomide*, that is the offertory, involving the preparation of the gifts; the Liturgy of the Catechumens; and the Liturgy of the Faithful, culminating in the eucharistic sacrifice.

Of primary importance to the service, second only to the bread, wine, and water, were manuscripts with the holy texts. Although the congregation knew by heart the Psalms and the Gospels, both texts nevertheless existed in book form in the church. The Gospels were recited from the *ambo* by a reader from the ranks of the *anagnostes*. At the beginning of and between the readings, singers in the same pulpit chanted Psalms antiphonally, using Psalter manuscripts containing a set of twelve canticles excerpted from the Holy Scriptures. In the course of time, festivals commemorating important events in the Life of Christ or special days of martyrs and saints were established in the church calendar, and relevant texts were added to supplement the daily lessons. Among these were the commentaries on the Gospels delivered as sermons by the early church fathers. These sermons were collected into books and found a special place in the Liturgy beside the Gospels.

The awe of the Holy Word felt by the faithful was manifested in the appearance of the books. Their vellum pages were bound in beautiful covers of leather or costly metals (cat. 31) and were frequently adorned with precious stones. They

were often decorated with scenes reflecting church dogma, such as the Crucifixion (cat. 61) or Anastasis, or simply with the portrait of the author (cat. 31). Their script was arranged in one, two, or three columns, or more rarely in cruciform (cat. 2, 25, 35). Lacking spacing and punctuation, they required special training of the readers. The wide margins and intercolumnar spaces surrounding the large and beautiful script were dotted with small signs indicating the various pericopes.

The role of liturgical manuscripts was not confined to their appearance and dignity. From the beginning the church had utilized all the arts to reveal to the eyes of the faithful ". . . the mystery of God, and of the Father, and of Christ; in whom are hidden all the treasures of wisdom and knowledge" (Colossians 2:2–3). In their illustration as well as their texts, these material vehicles of the Word and Sacraments manifested the impact of the ceremonies in which they were used. The most obvious example of this influence is the changes in iconography reflecting the actual performance of the Liturgy. Such changes had already occurred in the Early Byzantine period, when the Liturgy was still developing. In the sixth-century Rossano Gospels there is a narrative representation of the Last Supper, with Christ and the Apostles reclining around a sigma-shaped table. On the following pages is a liturgical representation of the Communion of the Apostles in a composition reflecting the actual Communion rite. The best literary parallel to this pictorial representation is a fourth-century description of the Communion of the Faithful in the *Catechetical Orations* of Cyril of Jerusalem: "Stepping forward, approach, not with outstretched palms, nor with fingers spread wide apart; but make your left hand a throne for your right in order to receive your king; and forming a hollow in the palm of your hand accept the body of Christ, saying: Amen. After you have sanctified your eyes by touching them carefully with the Holy Body, eat, taking care that no part of it is lost" (*PG*, xxxiii, 1124f.). The representation in the Rossano Gospels is no longer narrative but liturgical.

Extant manuscripts show a much greater impact of the Liturgy upon illustration beginning after the Iconoclastic Controversy and gaining in intensity in the eleventh century. It is in the Middle Byzantine period that the earliest illustrated manuscripts with the texts of the Byzantine Liturgies appear. They are in the form of rolls and are decorated with numerous miniatures, some relating directly to the text of the liturgical prayers, although more representing the actual Liturgy. Of course, not every manuscript with the text of the Liturgies adheres to this form or has illustrations. There are later manuscripts in codex form, with illustrations limited to small ornamental headpieces (cat. 65).

A more dramatic liturgical influence is seen in the service books, the most important of which is the Gospel Lectionary. During the Liturgy of the Catechumens, the Lectionary (as the Gospel Lectionary is usually called) is carried by the priest or deacon down the nave, through the royal doors of the iconostasis to the altar. This ceremony, called the Little Entrance, took in the course of

time the form of a litany symbolizing the coming of the Lord in His role as Teacher of Truth before becoming the Sacrificial Lamb. Hymns and prayers have already prepared the congregation to hear the Word of God; the believers have become "a people prepared for the Lord" (Luke 1:17). Shortly thereafter the deacon, receiving the Lectionary from the hands of the priest, emerges from behind the royal doors preceded by tapers, and ascends the *ambo* to read the lesson of the day.

The rearrangement of the Gospel book into the Lectionary, completed by the tenth century, caused a corresponding rearrangement of its picture cycles. In Lectionary manuscripts the scenes were arranged to follow the sequence of festivals, with a cycle of feast pictures of dogmatic and liturgical significance becoming fixed (cat. 28).

The church calendar is comprised not only of festivals commemorating the great events surrounding the Life of Christ; there are also feasts celebrating saints and martyrs. Already in the Early Byzantine period, written stories of their lives had become popular and were extensively illustrated. Gradually these texts came to be used as daily readings in the Divine Office, and after Iconoclasm they found a specific place in the Liturgy. In the canon at the end of the sixth Ode, sung in the *Orthros* shortly after the reading from the Gospel, a short text describing the life of a saint or containing reflections on his feast was read. These accounts were necessarily brief and, like the Gospel lessons, were organized to follow the church year. A collection of short biographies, deriving from the more extensive, mostly pre-iconoclastic saints's lives, was produced at the end of the tenth century and is generally attributed to Symeon Metaphrastes. This collection, a kind of biographical dictionary of saints called the Menologion, normally had one life for each day of the ecclesiastical year. Because of its considerable length it was divided into either twelve or twenty-four volumes, each corresponding to a month or half-month. The picture cycle was limited in most of the biographies to two miniatures—one at the beginning and one at the end; these were either portraits or scenes of martyrdom (cat. 11).

After the Lectionary, the Psalter is the most important liturgical book. Although verses from the Psalms are sung in many hymns throughout the service, they serve above all as antiphons where they symbolize the Old Testament and the Law that prepared the way for the Grace of Christ. Since antiphons are designated for certain days of the church year, a connection is suggested between specific Psalms and festivals. The first antiphon is Psalm 103 (104): "Bless the Lord, O my soul; and all that is within me, bless his holy name." It is chanted every Sunday of the year except Easter, the Sunday after Easter, Pentecost, and the Sunday of the Entry into Jerusalem.

The illustrated Psalter reveals the influence of the Liturgy as well, especially in manuscripts of the eleventh century. At the beginning of Washington, Dum-

barton Oaks cod. 3 (cat. 20), a late eleventh-century Psalter with full-page miniatures, there is an illustrated account of the life of David originally found in the Book of Kings. The illustrator, however, has included a scene of the Birth of David that has no basis in the Kings account. The miniature, invented for the Psalter, was probably inspired by the desire to complete a "life" for David analogous to those customarily found in illustrated saints's lives. Its immediate model may have been the Birth of the Virgin, which formed part of the festival cycle, heading the lesson for September 8.

Psalters with marginal illustrations also show an increase in the number of representations of saints in the eleventh century (cat. 29). Certain verses from the Psalms were incorporated into the *troparia* chanted at matins and vespers on the feast day of a particular saint. In some Psalters these verses are accompanied by the portrait of the appropriate saint. The same is true for a number of Psalms that came to be illustrated with episodes from the Life of Christ or the Virgin. Very frequently these Psalms were chanted in the course of the service commemorating the represented event.

Although many illustrious church fathers contributed to the beauty of Byzantine homiletic literature, John Chrysostom and Gregory Nazianzenus assume a special importance. Their sermons were very popular and illustrated copies were probably in circulation before Iconoclasm. Their simplest illustrations show either the bishop teaching or merely his portrait (cat. 4).

Manuscripts of the homilies of John Chrysostom are not as widely or as richly illustrated as those containing the sermons of the great Cappadocian Father, Gregory Nazianzenus, who wrote in a style of great popular appeal. A complete illustrated edition of Gregory's forty-five sermons was composed in the ninth century. An abridged edition, reflecting drastic accommodations to liturgical usage, was put into circulation probably in the tenth and certainly existed in the eleventh century. Sixteen of the original forty-five homilies were selected to supplement the readings on certain great festival or saints's days, their order being altered to follow that of the Lectionary (cat. 31).

Some illustrations were invented for this new edition, while others were borrowed from various sources including Old and New Testament books as well as a menologion. Those miniatures belonging to the New Testament group migrated to Gregory illustration from a Lectionary and accordingly place their emphasis on feast pictures. For example, an Anastasis miniature, which almost always begins a Lectionary, also opens the book of homilies. Other feast pictures—the Nativity, the Baptism, the Incredulity of Thomas, and the Pentecost—illustrate the relevant sermons. It is significant that such pictures cannot be explained through the texts of the homilies, but are instead derived directly from a Lectionary, where the illustrator had found them arranged conveniently in the required order.

The effect of the Liturgy on Gregory manuscripts goes beyond feast scenes. Apart from general liturgical influences on composition and setting, some illustrations represent rites as described in liturgical texts such as the *Euchologion*. These rites include Baptism and the ceremony performed for the consecration of a church, as well as various phases of the eucharistic Liturgy. It should be stressed that these liturgical scenes do not reproduce mechanically the ceremonies performed in the church, but reveal that their creators were aware of the meaning and significance of the rites.

The festival cycle and the portraits of saints and martyrs, as well as the representations of the actual Liturgy, ceremonies of the office books, and litanies for saints and relics are intended to remind the faithful of the life of the Church. The main aim of the Liturgy, however, is to make real the presence of God. The believer who participates in it desires to enjoy the "sweetness of the face of the Lord, the inaccessible light which no one can see and still live" (Exodus 33:20). In all its moving symbols, pictures, and ceremonies, the Orthodox Church sees a glorious theophany. The Lord appears to man, sanctifies him, deifies him. The Lord descends in the form of the Sacrament and unites Himself with man: "He that eateth my flesh, and drinketh my blood, dwelleth in me, and I in him" (John 6:56).

The idea of this theophany found visual expression in the hands of humble, unknown artists. Reading the Holy Word, contemplating the Liturgy and its meaning, these artists were able to experience the transcendental and to give it form in the pictures they composed for sacred manuscripts. Theophanic visions are depicted in a number of Gospel books. Their main theme is the Hymn of Glory, the triumphal song sung around the throne of God by the "thousands of archangels and ten thousands of angels, cherubim, and seraphim, having six wings and full of eyes, who all, aloft, upon the wing, sing . . ." (Divine Liturgy). Evangelist symbols and tetramorphs are part of these illustrations, distinct from other liturgical pictures (cat. 55). They take us beyond the ritual into the realm of the invisible. They are visual renderings of a hymn intoned by the entire creation, the visible and the invisible world, angels and men, and are offered to the believer for the contemplation and understanding of higher truths.

These illustrations, like the festival cycle and the liturgical representations contained in homiletic literature, have parallels in the great monuments of Byzantine art; in icon painting as well as frescoes and mosaics on the walls and vaults of churches. All these media interpenetrate one another through iconography and often through style, for they all are integral elements of the Liturgy and are permeated by its themes and its rhythm. Nevertheless, it will not be an exaggeration to say that the history of the impact of the Liturgy on Byzantine art is best reflected in the history of the liturgical book, the material vehicle of the Incarnation of God, and of the deification of man: ". . . render to the image that

which is according to the image . . . let us recognize the force of the mystery, and for whom Christ died. Let us become like unto Christ because Christ became like unto us also, let us become gods for his sake because he too became man for our sake" (Gregory Nazianzenus, *First Homily on Easter, PG*, xxv, 397).

BIBLIOGRAPHY: N. P. Kondakov, *Histoire de l'art Byzantin considéré principalement dans les miniatures*, 2 vols., Paris, 1886, 1891; A. Dmitrievskij, *Opisanie liturgitchskich rukopiseij*, 3 vols., Kiev, 1895; F. E. Brightman, *Liturgies Eastern and Western*, i, Oxford, 1896; Millet, *Recherches*; Ehrhard *Überlieferung*; L. Brehier, "Les Peintures du rouleau liturgique no. 2 du monastère de Lavra," *Annales de l'Institut Kondakov* (Seminarium Kondakovianum), xi, 1940; Weitzmann, "Gospel Illustrations"; idem, "Morgan 639"; A. Grabar, "Un Rouleau liturgique Constantinopolitain et ses peintures," *Dumbarton Oaks Papers*, viii, 1954, 161f.; Weitzmann, *Grundlagen*; idem, "Eleventh Century"; Galavaris, *Gregory*; idem, *Bread and the Liturgy*, Madison, Milwaukee, London, 1970; idem, "The Illustrations of the Prefaces to Byzantine Gospels" (forthcoming).

# 2.

# Hymnography and Illustrated Manuscripts

Doula Mouriki

Hymns have formed an integral part of the Offices of the church from the Early Christian period to the present day. In their capacity of directing the mind and soul of the faithful towards the truths of the divine scheme of human salvation, ecclesiastical hymns have undoubtedly reflected the main theses of Byzantine theology. It would be natural therefore to assume that these were systematically illustrated during the Byzantine period; but this was not the case. In fact, a very limited number of illustrated hymnographic texts have been preserved and it may be safely assumed that the relevant material was always scarce. The explanation lies in the fact that, owing to the allegorical nature of poetic texts in general, they did not readily lend themselves to illustration.

Of all the ecclesiastical hymns, the one that has come down to us in several illustrated copies is the *Akathistos*, a hymn written in honor of the Virgin, of which an example is included in this volume (cat. 63). The *Akathistos*—its name signifies that the congregation stood while it was sung—is no doubt the most famous Byzantine hymn. There is a great deal of controversy about its author, date, and the circumstances of its creation. Many specialists assign it to Romanos, the "prince of melodes," whose works date from the sixth century.

The *Akathistos* is in the form of a *kontakion*, the most popular poetic form during the Early Byzantine period. The *kontakion* includes a variable number of stanzas or *oikoi* (eighteen to thirty, or even more), which are all structurally alike; it is, moreover, preceded by a short prelude, the *prooemium*. The *Akathistos*, in particular, consists of one *prooemium*—some editions have two—and twenty-four *oikoi*, which form an acrostic of the letters of the alphabet. It is sung today in four sections on the Friday evenings of the first four weeks in Lent and, in its entirety, at matins of the fifth Saturday in Lent.

The *Akathistos* is divided into two sections of twelve *oikoi* each. The first, the historical part, relates the story of Christ from the Annunciation to the Virgin to the Flight into Egypt and Simeon's recognition of God in the Child Jesus. The second part, which can be characterized as the theological and dogmatic section of the hymn, constitutes a glorification of the mystery of the Incarnation and of its redemption of mankind.

The earliest preserved illustrated copies of the *Akathistos* are found in two Slavonic Psalters, the Tomič Psalter in Moscow (Hist. Mus. cod. 2752) and the Serbian Psalter in Munich (State Lib. cod. slav. 4), which are datable to the latter part of the fourteenth century. Two more illustrated copies of the hymn have been preserved from the Byzantine period: Moscow, Hist. Mus. cod. gr. 429, and Escorial cod. 19. R.I.19, both datable to the late fourteenth or early fifteenth century. Both copies include, in addition to the *Akathistos,* other hymns written in honor of the Virgin; only the *Akathistos*, however, was illustrated. Of the several illustrated *Akathistos* manuscripts of the Post-Byzantine period, a notable example is that in the Princeton University Library (cat. 63).

The *Akathistos* enjoyed considerable popularity in monumental art during the Byzantine and Post-Byzantine periods. In fact, the earliest extant illustrations of the hymn occur not in manuscripts, but in wall paintings, the earliest dated example being probably that in the Church of the Olympiotissa at Elasson (1296). Macedonian and Serbian frescoes, in particular, frequently include a cycle of the *Akathistos* (e.g., the Panaghia Chalceon and Saint Nicholas Orphanos in Thessaloniki, and the monasteries at Markov and Dečani). The question may thus be raised whether the pictorial cycle of the *Akathistos* was invented for monumental art rather than for miniature painting. The possibility of the existence of earlier miniature cycles of the *Akathistos* cannot be denied. An answer to this question, however, may be attempted only after a systematic iconographical study of all *Akathistos* scenes in Byzantine art, which has not so far been undertaken.

It has more than once been emphasized that the compositions of the *Akathistos* scenes corresponding to the first twelve *oikoi* were taken over literally from the relevant depictions of the Gospels. On the other hand, illustrations of the last twelve *oikoi* had to be conceived either partially or entirely for this particular hymn. Various terms in the text have provided the possibility for different pictorial interpretations. Consequently, the illustrations of the last section of the *Akathistos* vary considerably and it is difficult to classify them into groups. In fact, the method of distinguishing iconographic recensions, applicable to other groups of illuminated manuscripts, can hardly be adopted for this hymn.

Besides the *Akathistos*, another hymnographical text, the so-called *Penitential Canon*, was frequently illustrated both during and after the Byzantine period. This hymn consists of eight Odes in accordance with the new poetic form of the canon, which came into fashion later than the *kontakion* and eventually replaced it altogether. It is an epitome of the various heroic deeds of penitence of the "holy criminals," described in detail in the *Heavenly Ladder* by John Climacus, the famous sixth-century abbot of the Monastery on Mount Sinai (see cat. 19). No evidence has yet been found of the actual use of the *Penitential Canon* in the Offices of the church. However, a brief consideration of its illustrations is useful, for it sheds light on the problems of illustrated hymns.

The earliest preserved example of an illustrated *Penitential Canon*, datable to the eleventh or twelfth century, is found in Bucharest (Library of the Academy cod. gr. 1294), while several illustrated copies from a later period have been incorporated into manuscripts of the *Heavenly Ladder* from which, as already indicated, the canon of the "holy criminals" ultimately derives. The illustrations of these two texts are closely related. Slight changes in the traditional iconography, and even the creation of new compositions when the contents of the hymn did not correspond to those of the *Heavenly Ladder*, were eventually found necessary. It may be added that all surviving illustrated copies of the *Penitential Canon* reveal only insignificant differences, thus indicating a common archetype.

In addition to these two hymns, several *troparia*, short hymnographical pieces, were occasionally illustrated within larger textual units during the Byzantine period. Moreover, entire musical books of the Greek Church on several occasions possessed illustrations. For example, at least five illustrated *Sticheraria*, collections of short poetical pieces (*stichera*) arranged in a definite order and chanted during the Offices, have been preserved from the Byzantine and Post-Byzantine periods. A characteristic example is in the possession of the Library of the Monastery of Saint Catherine on Mount Sinai (cod. gr. 1216). This manuscript, datable to the thirteenth century, includes numerous illustrations that were not created for the *Sticherarion*. For the most part, they consist of depictions of saints and scenes of Christ and the Virgin which were no doubt borrowed from picture cycles of other texts. The main reason for this borrowing may be sought in the inherent difficulty presented by the illustration of hymns.

A survey of the illustrated hymnographical material of the Byzantine period might lead one to conclude that hymnography exerted a small impact upon Byzantine art in general. That, however, is far from the case. Byzantine hymnography made a forceful impression on all the arts in one way or the other, although it was on monumental art in particular that it exerted a major influence. This is easily understandable: hymns are, after all, a permanent feature of the Offices. Moreover, hymnography greatly influenced the iconography of portative icons, many of which were used in the church for liturgical purposes.

The impact of hymns in both these media varied considerably. It asserted itself more forcefully from the Comnenian period onwards, although it may be detected in the pre-iconoclastic period in an encaustic icon on Mount Sinai of the Chairete, which appears to have been influenced by a hymn of Romanos. It may be observed in the texts on the scrolls held by saints or in the inscriptions accompanying scenes borrowed from hymns. Moreover, it may be revealed in the inclusion of specific iconographic features in compositions derived from non-hymnographical texts. Finally, hymnography may have stimulated the creation of new scenes or cycles. Particular reference should be made to a few examples illustrating these influences.

The *Sticheron* for Christmas, sung at vespers on Christmas Day, was illustrated in monumental art by the depiction of the Virgin holding the Child and approached by various figures offering gifts to the Infant in gratitude for His Birth, the first step in mankind's salvation. This composition appears in the narthex of Saint Clement's Church in Ochrid (1295) and becomes a frequent feature of monumental ensembles during the fourteenth century and later. Among the best-known examples, the frescoes of the Holy Apostles's Churches in Thessaloniki and at Žiča may be mentioned. On the other hand, no example of an illustrated Christmas *Sticheron* has been preserved, so far as we know, in manuscripts.

A similar group of liturgical hymns glorifying the Virgin has also been depicted, especially in portative icons, in the Late Byzantine and Post-Byzantine periods. One of these hymns, called *In Thee Rejoice*, constitutes a *sticheron theotikon*; forming part of the Liturgy of Basil, it is chanted on the days assigned to this particular Liturgy, as well as on certain other occasions. Another hymn of related content, a *troparion* sung by the bishop wearing liturgical garments, has provided the title of a popular composition, the so-called *Prophets on High*. This scene depicts the Virgin and Child surrounded by Prophets who announce by the inscriptions on their scrolls and their attributes the Incarnation through the instrumentality of the Virgin. The earliest extant illustration of this theme appears in a Comnenian icon on Mount Sinai, but there is no reason to assume a direct relationship between this icon and the *troparion*.

To these scenes may be added pictorial representations inspired by the various hymns that form an integral part of the three Liturgies of the Orthodox Church. Their impact on monumental art, especially from the Palaeologan period on, is very considerable but cannot be recorded explicitly at this point.

A further cycle, known so far only from monumental art, has its source in the hymnographical material of the Office of the Dead. More precisely, the so-called *Canon for Someone Who Is Struggling with Death* has been illustrated by a series of scenes in two fresco ensembles of the Late Byzantine period: one in the Chapel of Saint George of the homonymous tower at the monastery of Chilandar on Mount Athos, and the other in the exonarthex of Saint Sophia at Ochrid. They are datable to the mid-thirteenth and mid-fourteenth centuries respectively.

From the survey of the extant pictorial material two conclusions may be reached regarding the sources of hymnographical scenes: the illustration of hymns occupies a limited place in the medium of illuminated manuscripts, while it is far more widespread in monumental art and in portative icons; and the illustration of hymns in all these contexts characterizes, in particular, the developments in Byzantine iconography during the Late Byzantine and Post-Byzantine periods.

These two basic conclusions require further elaboration. Except for the Psalter, discussed in Chapter 3, no liturgical book with hymnographical contents would have been suitable for illustration either in part or *in toto*. In addition to the difficulty inherent in the illustration of poetic texts, a more practical reason may have discouraged initiative of this kind: the very structure of the liturgical books with hymns makes the task of their illustration very difficult. One may thus formulate the hypothesis that a number of scenes inspired by hymnographic texts were not created for manuscripts. In fact the majority of the hymnographic representations reviewed thus far possess a pronounced monumental character. Their compositional devices usually follow a specific formula, with Christ or the

Virgin disposed along the central axis, and groups of praying or adoring figures placed symmetrically at either side in accordance with an old usage in imperial iconography. Such scenes would therefore have found their most proper place in monumental ensembles and in icons, which often reveal a strong monumental character.

It is well known that during the Late Byzantine period ecclesiastical art was enriched with new themes of a pronounced allegorical content, reflecting contemporary tendencies familiar in those theological circles that encouraged the production of numerous commentaries on the liturgical texts and the use of a large number of typological interpretations. Unlike most iconographic cycles in church decoration, which reveal a conservative approach in their form, the themes inspired by hymns were fairly flexible as, for example, shown in *Akathistos* scenes. This feature is well in accordance with the prevailing tendencies of the Late Byzantine period.

The problem of the impact of hymnography upon the art of the Byzantine and Post-Byzantine periods has previously been treated in an incomplete or incidental manner—a factor that does not allow for the definition of this subject within its proper framework. The basic difficulty is nevertheless of a more general character, applying to Byzantine art in its total expression. To what extent are we able to decide which particular text or group of texts may have determined the pictorial form of non-narrative representations, since all Byzantine religious texts reveal a similar phraseology regarding the basic tenets of Byzantine theology?

BIBLIOGRAPHY: Millet, *Recherches*; A. Baumstark, "Bild und Lied des christlichen Orients," *Festschrift zum 60. Geburtstag von P. Clemen*, Düsseldorf, 1926, 168f.; J. Myslivic, "Ikonografie Akathistu Panny Marie," *Annales de l'Institut Kondakov* (Seminarium Kondakovianum), v, 1932, 97f.; A. Xyngopoulos, "Θεοτόκος ἡ Φωτοδόχος Λαμπάς," Ἐπετηρὶς τῆς Ἑταιρείας Βυζαντινῶν Σπουδῶν, x, 1933, 321f.; A. Grabar, *L'Empereur dans l'art byzantin*, Paris, 1936, 259f.; Martin, *Climacus*; K. Weitzmann, "Eine vorikonoklastische Ikone des Sinai mit der Darstellung des Chairete," *Tortulae: Studien zu altchristlichen und byzantinischen Monumenten*, Rome, 1966, 317f.; E. Wellesz, *A History of Byzantine Music and Hymnography*, 2nd ed., Oxford, 1971.

# 3.

# The Psalter

Herbert L. Kessler

Comprising one hundred and fifty-one Psalms and a series of Psalm-like Odes excerpted from the Old and New Testaments, the Psalter occupied a major place in the Byzantine Liturgy. Consequently, it was illustrated more frequently than any Old Testament book, despite the fact that the rendering of its metaphoric lyrics demanded a special kind of imagination not required by narrative texts.

To illustrate the poetic imagery, Byzantine artists favored two methods. The more popular procedure was to ignore the text completely and to furnish the Psalter manuscript with a set of "author portraits" of the Psalmist David and the canticlers, placed, as frontispieces, before the first, fiftieth, and seventy-seventh Psalms and before the Odes (see cat. 20, 23, 32, 47). Most commonly, these title pictures consisted not simply of standing figures but of narrative episodes from the lives of the authors, illustrated in full-page miniatures or—for David and Moses—distributed over several frontispieces. For example, in the most famous of the frontispiece Psalters, the tenth-century manuscript in Paris (Bibl. Nat. cod. gr. 139), eight grand miniatures are devoted to the life of David, two to Moses, and one each to the canticlers Hannah, Jonah, Isaiah, and Hezekiah.

Granting preeminence to the Paris Psalter, a luxurious product of the Macedonian Renaissance, J. J. Tikkanen termed this family of Psalters the "aristocratic group." His appellation is misleading, however, for whereas the Paris codex is a magnificent creation of the court workshop, the aulic origin of various, more modest frontispiece Psalters cannot be proven. In other important aspects as well, the Paris Psalter is an exceptional work within this recension. As several scholars, most notably K. Weitzmann, have demonstrated, the Paris manuscript is the result of a creative Renaissance impulse; its illustrations, therefore, are not the most faithful replicas of the early archetype but reflect instead an imaginative reinterpretation of the basic model to which personifications and architectural settings have been added and in which compositions have been unified to create a more classical effect. In fact, the Paris codex may not even be the prime Renaissance Psalter, but rather the finest surviving copy of an earlier tenth-century work, which must have been an extraordinary product of the Macedonian court school. Thus, although the Paris manuscript remains a masterpiece of Middle Byzantine art, its relationship to the archetype is quite indirect.

The impact of the impressive Renaissance Psalter is also evident in such later manuscripts as Washington, Dumbarton Oaks cod. 3 (cat. 20); but in other members of the recension, including the single leaf from Mount Athos, Vatopedi cod. 761, now in Baltimore (cat. 23), aspects of the early archetype are preserved more accurately. In the Baltimore miniature, for instance, three separate episodes from the life of Moses are incorporated into one frontispiece, while in the comparable miniatures in the Paris and Dumbarton Oaks Psalters, individual scenes are conflated to form more monumental compositions. We can be certain that in its episodic quality the Baltimore illustration is closer to the basic model. After

all, the archetype of the frontispiece Psalters was not composed from the Psalter texts but was compiled from suitable narrative illustrations taken over from the Book of Kings; and for the Odes, from Exodus, the Prophets, and the Gospels. Therefore, the closer a frontispiece miniature is to its narrative source, the more faithful to the Psalter archetype it is likely to be.

Reflections of a frontispiece Psalter in the Paris homilies of Gregory Nazianzenus (Bibl. Nat. cod. gr. 510), dated 883 to 886, and in the set of seventh-century silver plates from Cyprus decorated with the exploits of David suggest strongly that the archetype of the frontispiece Psalter recension originated during the preiconoclastic period; but a full reconstruction of this model, based on a study of the more than fifty extant replicas and related material, has yet to be made. Such a study is likely to reveal that the archetype comprised, like the Dumbarton Oaks Psalter, many more than the fourteen frontispieces of the Paris Psalter, and that these miniatures were arranged in complementary pairs as they are in New York, Public Lib. Spencer Coll. gr. cod. 1 (cat. 47). In addition to the narrative sources of these migrated miniatures, this study should also identify later modifications of the basic model. Methodical investigations have already demonstrated that, of these, the classicizing revision undertaken during the Macedonian Renaissance was the most consequential.

The second principal method employed by Byzantine artists in the illumination of the Psalter was the illustration of individual words or verses in the margins of the pages (see cat. 29). Occasionally the illuminators invented the illustrations for the Psalter texts, but more often they culled appropriate images from other books, including the Septuagint, the Gospels, and the menologion, to render ideas suggested by the poetical passages. Thus, on folio 40r of Baltimore, Walters Art Gallery cod. W733 (cat. 29), the Byzantine illustrator copied from an Octateuch scenes of the Israelites gathering quail and manna to depict the verse of Psalm 77 (78), "And man did eat angel's food." In certain instances, the marginal scenes relate to the commentaries that accompany the Psalter texts rather than to the poetic verses, while in other cases, the miniatures in themselves form a kind of visual exegesis. Compiled in a vast library from diverse pictorial models, these Psalters are among the richest polycyclic manuscripts and, at the same time, are elegant witnesses to the ingenious and creative utilization of traditional sources by Byzantine illuminators.

Nine marginal Psalters have been known for some time, but the origin of the recension is still being debated. Internal evidence favors a date shortly after the end of Iconoclasm for the creation of the archetype, but at present there is consensus neither on this nor on the place of origin. Tikkanen called the marginal Psalters the "monastic-theological" group, and although the appropriateness of this appellation also must be questioned, the milieu in which this family of manuscripts arose was certainly ecclesiastical.

Whereas Tikkanen's categories are fundamentally correct and quite useful, they do not include all known Byzantine Psalters and, in light of recent studies, seem somewhat rigid (see cat. 30). An unusual eleventh-century Psalter in the Vatican Library (cod. gr. 752), for instance, contains miniatures borrowed from a Lectionary; a unique manuscript in the same library (cod. gr. 1927) has original, literal illustrations of the Psalms; and there is a marginal Psalter on Mount Sinai (cod. gr. 48) that appears to be an inventive masterpiece essentially independent of the two principal recensions. Even more important, however, are the significant variations within each of Tikkanen's classifications. We have already noted the impact of Macedonian classicism on the frontispiece recension. In turn, the intensified liturgical and ascetic emphasis of the eleventh century had its effect on Psalter illustration. In the Dumbarton Oaks manuscript, for example, the life of David was refashioned as a kind of saint's *vita* under the influence of the menologion and Lectionary; and an explicitly liturgical depiction of the Virgin and Child with saints was introduced. Further evidence of liturgical influence during this period is seen in the use of two feast pictures to decorate Psalm 9 on a detached leaf in The Art Museum, Princeton University (cat. 30), and in the more numerous borrowings from the menologion and more frequent christological references in the marginal Psalters. The distinctions between the two basic recensions also becomes less obvious during this period. The impact of marginal illustration may be identified in the Dumbarton Oaks Psalter, and clear reflections of the frontispiece recension appear in the marginal illustrations of the so-called Bristol Psalter (London, Brit. Mus. cod. add. 40731).

Thus, Byzantine Psalter illustration manifests considerable variety and richness. To provide this poetic service book with suitable decoration, Greek artists occasionally invented metaphorical images, but more frequently they borrowed compositions from other Biblical books and rearranged these as title miniatures or as a kind of marginal commentary on the pages of the Psalter. Their derivation from a few basic sources enables us to differentiate families of Psalter manuscripts —most notably the frontispiece and marginal recensions—but within these classes we can also discover a keen sensitivity to special contemporary interests such as classical antiquity or the Liturgy. In this, the history of Psalter illustration fully reveals the unique ability of Byzantine creativity to produce inventive new works of art within a strict, traditional framework.

BIBLIOGRAPHY: Tikkanen, "Psalterillustration"; K. Weitzmann, "Der Pariser Psalter ms. grec. 139 und die mittelbyzantinische Renaissance," *Jahrbuch für Kunstwissenschaft*, 1929, 178f.; H. Buchthal, *The Miniatures of the Paris Psalter*, London, 1938; E. T. DeWald, *Vaticanus graecus 1927*, Princeton, 1941; idem, *Vaticanus graecus 752*, Princeton, 1942; Weitzmann, "Vatopedi 761"; idem, "Septuaginta"; Miner, "Monastic"; Weitzmann, *Grundlagen*; Der Nersessian, "Dumbarton Oaks"; I. Ševčenko, "The Anti-iconoclastic Poem in the Pantocrator Psalter," *Cahiers archéologiques*, XV, 1965, 39f.; Dufrenne, *Psautiers*; Weitzmann, "Eleventh Century"; idem, "Prolegomena to a Study of the Cyprus Plates," *Metropolitan Museum Journal*, III, 1970, 97f.; Der Nersessian, *Psautiers*; K. Weitzmann, "The Sinai Psalter cod. 48 and Three Leaves in Leningrad" (in press).

# 4.

# Byzantine Lectionary Illustration

Shigebumi Tsuji

After about the ninth century the Byzantine Gospel Lectionary (usually called simply the Lectionary) normally consisted of two parts: the first is often called the synaxarion and the second, the menologion.

The synaxarion consists mainly of pericopes (lections) excerpted from the four Gospels. These pericopes are arranged to be read in sequence each day throughout the year, beginning with Easter Sunday and following the order of the movable feasts. The synaxarion can be divided into six sections. The majority of the lections in the first section are derived from the Gospel of John, those of the second from Matthew, the third from Luke, and the fourth from Mark. In the concluding two sections, for Holy Week and the Morning lections (sometimes placed after the menologion), pericopes from all four Gospels are found.

The second part of the Lectionary, the menologion (occasionally labeled, inaccurately, "synaxarion"), likewise comprises pericopes from the four Gospels, but in cases where they repeat readings from the synaxarion the text is not duplicated. In addition we find citations of saints and events from church history on the day of their commemoration. Here the sequence of lections begins with September 1 and ends with August 31. In distinction from the Lectionary or *Evangelion*, a manuscript containing the four Gospels in the canonical order is called a Gospel book or *Tetraevangelon*.

Since miniatures tend to travel with the text they originally accompany, the majority of Lectionary text illustrations are narrative Gospel scenes (see cat. 28, 35, 62). In addition, we find portraits of the Evangelists—often full-page miniatures —at the beginning of each of the first four sections (see cat. 16, 28, 35, 62), scenes from the life of the Virgin, portraits of saints and scenes of their lives (see cat. 24), and representations of important events in church history, which occur mostly in the menologion. In fact, most Lectionary illustrations derive from other pictorial sources: Evangelist portraits and Gospel scenes from Gospel books, mariological scenes from the apocryphal Gospels, and hagiographical scenes from illustrated saints's lives. Consequently, very few illustrations were invented especially for the Lectionary text. Such a heterogeneous combination of scenes from various iconographic sources has been called by K. Weitzmann in *Roll and Codex* "polycyclic illustration."

The illustration of the Byzantine Lectionary is not, however, a mere collection of borrowings from various pictorial recensions. As we shall shortly observe, there are certain unique features that distinguish Lectionary illustrations from their models. Although a number of illustrated Lectionaries were studied, mostly for their high artistic quality or importance in the history of Gospel iconography, early twentieth-century scholars were not very much aware of the stylistic and iconographic uniqueness of Lectionary illustration. The work of K. Weitzmann has been instrumental in opening this very special branch of manuscript studies.

The reading of the Gospels, Epistles, and saints's lives in the church derived

from the practice of reading from the Holy Scriptures in the synagogue, as Luke 4:16 attests. Until the fourth or fifth century, however, no uniformity had been established for these readings. Apparently in early stages of development, small marginal marks or numbers were used as guides at the beginning of each lection in the Gospel book (see cat. 2). Only gradually did the Lectionary come to take its present shape.

It would be incorrect to regard the Lectionary as merely a book invented for a practical purpose. To understand the reasons for the development of new stylistic and iconographic features in Lectionary illustration, we must comprehend the intrinsic nature of the book.

First, we note that the Lectionary is deposited on the altar, the holiest place in the church, on which occurs the mystery of redemption through the sacrifice of Christ. The book is removed only during the procession of the Little Entrance at the end of the Mass of the Catechumens. During this procession, it is carried by the deacon or the priest so that the faithful can look upon it. Then, in the middle of the nave, the procession pauses briefly while the bearer raises the book, saying with a loud voice, "Σοφία ὀρθοί" (Wisdom, stand up!). In the Orthodox Church, "Holy Wisdom" is Christ the Saviour Himself. Therefore, it is obvious that the Lectionary is a most precious symbol of Christ. Shortly afterwards, the book is carried into the sanctuary through the royal doors of the iconostasis, to be deposited on the altar.

The procession of the symbol of Christ and its entry into the Holy of Holies is the metaphorical enactment of the Advent of Christ. In fact, the hymns of the choir and the words of the priest that greet the arrival of the Lectionary clearly allude to the eschatological appearance, the theophany, of Christ. This explains why in the Greek Church the cover of the Lectionary alone is luxuriously decorated: it is *ipso facto* the vehicle of Christ Logos (see cat. 61).

Second, we must not forget that the liturgical calendar, upon which the order of the lections is based, ultimately reflects the efforts of the Orthodox Church to sanctify earthly time (*chronos*) by elevating it into the spiritual sphere of eternity (*aion*). Such a concept of time, first conceived by Plato in his famous dialogue *Timaeus*, and then adopted by Greek theologians such as Maximos the Confessor, is most clearly manifested in the liturgical organization of time into two different, annually perpetuated liturgical systems: the movable calendar cycle beginning with Easter, and the immovable calendar cycle beginning on September 1. In these time cycles, the Life of Christ and the lives of all the saints are contemplated not as historical events but as imperishable facts in an eternal present. This is the true meaning of the commemoration of the historical figures and events in the liturgical calendar. Not once did Christ die for us in our worldly time. He dies each day for the salvation of mankind from eternity to eternity.

Byzantine artists were no doubt fully aware of the intrinsic qualities of the

Lectionary as well as of the liturgical calendar. Thus, when they borrowed scenes from model cycles, they rendered the original narrative iconography hieratically, making it more appropriate for the expression of supernatural events. Even the script of the Lectionary tends to be more hieratic and to continue longer than any other text the time-honored uncial.

We should now like to survey briefly the unique aspects of Lectionary illustrations, which may be divided into three categories according to their format.

*Decoration of the initial letters and marginal illustration*
(see cat. 25, 28, 35)

We have already learned that before the Lectionary was edited for its specific purpose, the Byzantines used to mark the beginning of each lection in the margins of the page. Apparently the large initial letters in Lectionaries—mostly 'T' and 'E,' since the most frequent introductory phrases of lessons are τῷ καιρῷ ἐκείνῳ (In that day) and εἶπεν ὁ κύριος (The Lord said)—are not so much decoration as an index for finding the first line of each lection. Quite often simple images are combined with such initials. These are most commonly standing figures of the protagonists in the lesson or the author, an Evangelist. Narrative scenes are less frequent.

Small scenes painted in the margins can also be regarded as guiding marks more or less like the initials since they tend to be placed as close as possible to their related texts. For instance, the Lectionary in S. Giorgio dei Greci, Venice, which is prolifically illustrated with marginal miniatures, illustrates the parable of the Prodigal Son (Luke 15:11f.) in twelve scenes. These scenes are executed in the margins around or between the two text columns in such a way that each is placed next to the relevant text lines. Thus, we may call such scenes pictorial indices to the story.

As K. Weitzmann has pointed out, Byzantine artists refrained from interrupting the text of a lesson. Since there are comparatively few Lectionaries embellished with column pictures at the beginnings of the lessons (e.g., Mount Athos, Dionysiou cod. 587), marginal illustrations must have been found more suitable to a painter wanting to illustrate a lection as extensively as possible without interrupting the text column and, at the same time, to maintain the closest possible physical relation between text and picture. Despite the fact that marginal miniatures lack background and are much simplified in iconographic detail, their basic elements remain so faithful to the text that in most cases we may well assume that they were directly borrowed from a richly illustrated Gospel book, such as Paris, Bibl. Nat. cod. gr. 74 or Florence, Laur. Lib. cod. Plut. VI, 23. If the number of scenes illustrating one lection is limited, the artist tends to depict not the climax of the story but rather its beginning. This seems almost to be an established rule in rich marginal illustration.

Marginal pictures can be considered the basic form of Lectionary illustration. They were never totally abandoned, even after the introduction of more developed framed or full-page pictures. As a result, different formats are often employed side by side in the same manuscript.

*Small framed pictures*
(see cat. 28, 62)

As we observed above, when Byzantine artists came to understand the liturgical and dogmatic importance of the Lectionary, they began to employ a more grandiose, hieratic illustration. The most common practice was to enclose one or two scenes together within a picture frame and to surround them with illusionistic background motifs. This made it possible to enrich the iconography with more details, and to render the whole composition more unified and hieratic as well. The result was increased visual impact as well as higher artistic quality, both more appropriate to the basic notion of Lectionary illustration.

Even in this type of illustration, the principle that the first verse or verses of a lection should be given priority in pictorialization was followed at first, only to be gradually neglected. The width of such a framed picture is usually that of one text column, but occasionally extends over two columns.

With the introduction of framed pictures, which allowed the artists to achieve a more classical and hieratic composition, models were sought not only in simple narrative miniatures, but also in large scale works such as icons, frescoes, and mosaics. More important, however, was the introduction of new scenes, which occurred simultaneously with the intrusion of new stylistic features. Depictions from the twelve-feast cycle, which had been an essential component of church decoration and icon painting as well as of full-page Lectionary illustration, became the main features of a more advanced type of small framed pictures. Evangelist portraits, which had also been rendered as full-page miniatures, were included in this type of Lectionary illustration.

Generally, the choice of scenes or figures to be enframed was dependent on their iconographic importance: that many scenes from the life of John the Baptist are elaborately depicted in the famous Lectionary on Mount Athos, Dionysiou cod. 587, proves a special affiliation of the artist or patron with the veneration of the Prodromos.

*Full-page illustration*

Full-page miniatures were best suited to the classicizing and hieratic tendencies in Lectionary illustration. The earliest extant richly illustrated Lectionary, Leningrad, Public Lib. cod. gr. 21, has a set of full-page miniatures. Although incom-

plete in its present condition, the choice of scenes clearly reflects a preference for the great feasts. Two other manuscripts with full-page feast pictures, both of very high artistic quality, are preserved on Mount Athos: the Lectionary in the Skevophylakion in Lavra, and Iviron cod. 1. In this highly developed pictorial format the artist could introduce hieratic compositions drawn directly from icons or church decoration. The likeliest source for the iconography of some of the twelve feasts was the mosaic decoration of the famous Church of the Holy Apostles in Constantinople.

But even the earliest of these masterpieces, Leningrad cod. 21, is not an original creation of the tenth century but a provincial copy of a Constantinopolitan model that must have reflected the "renaissance" quality of contemporary court art. We may safely assume that such luxurious Lectionary illustration was invented to satisfy the aristocratic taste that also produced a number of magnificent renaissance works in other pictorial recensions, among them the Paris Psalter (Bibl. Nat. cod. gr. 139) and the Joshua Roll (Vatican Lib. cod. Palat. gr. 431).

Recently K. Weitzmann has attempted to reconstruct the lost original of such a metropolitan Lectionary (see Weitzmann, "Imperial Lectionary"). He utilized surviving ivory plaques from the tenth and early eleventh centuries with feast pictures. According to him, these plaques reflect the characteristics of the lost tenth-century Lectionary.

Gradually this sumptuous format of Lectionary illustration came to be applied to less important Gospel scenes, both canonical and apocryphal. This development is observable in Mount Athos, Panteleimon cod. 2, where two related miniatures form an antithetic pair, reflecting most clearly the influence of the renaissance type of book illumination.

The order of the three different types of Lectionary illustration described above does not necessarily reflect their chronological development; they were certainly practiced simultaneously (see cat. 28). The process we have discussed above is only a methodological one, in which a scene changes its artistic format while expanding its stylistic and iconographical features.

It is beyond doubt that from the tenth to the twelfth century Lectionary illustration, along with monumental and icon painting, played a most important role in developing typical Mid-Byzantine artistic formulae. The scriptorium in which the sumptuous Lectionaries were produced was almost like a laboratory in which a new artistic vocabulary was created. The mutual exchange of such vocabulary with other artistic media can be widely observed. Icons, especially those with feast cycles and saints, contain exact counterparts to Lectionary illustration.

Even a kind of retroactive Lectionary influence can be observed in some eleventh-century illustrated Gospel books. Their miniatures, which once had supplied the iconographic models for a Lectionary, now came under the influence

of the latter, as has clearly been demonstrated by K. Weitzmann in the case of Paris, Bibl. Nat. cod. gr. 74 (see "Gospel Illustrations"), where certain scenes follow their liturgical and not their narrative sequence (see chapter 5).

In examining Lectionary illustration, we have had a rare chance to witness the formative process of a new phase in the history of Byzantine art, which not only developed a number of unique artistic formulae, but also reflected a new *Weltanschauung* centered around the mystery of the Liturgy, the mystery of the perpetual presence of the transcendental being in this world.

BIBLIOGRAPHY: Gregory, *Textkritik*; C. R. Morey, "Notes on East Christian Miniatures," *Art Bulletin*, XI, 1929, 5f.; E. C. Colwell and D. W. Riddle, *Prolegomena to the Study of the Lectionary Text of the Gospels*, Chicago, 1933; K. Weitzmann, "Das Evangeliar im Skevophylakion zu Lawra," *Annales de l'Institut Kondakov* (Seminarium Kondakovianum), XIII, 1936, 83f.; idem, "Gospel Illustration"; idem, "Morgan 639"; idem, "Various Aspects of Byzantine Influence on the Latin Countries from the Sixth to the Twelfth Century," *Dumbarton Oaks Papers*, XX, 1966, 1f.; idem, "Eleventh Century"; idem, "Imperial Lectionary"; idem, "A 10th Century Lectionary: A Lost Masterpiece of the Macedonian Renaissance," *Revue des études sud-est européennes*, IX, 1971, 617f.

# 5.     The Illustrated Gospels

Robert Deshman

Of the large number of surviving illuminated Byzantine Gospel books, comparatively few contain narrative text illustration. This may be explained in part by the Lectionary's predominance in the Liturgy and its absorption on a large scale of Gospel illustration. Yet, at times, Byzantine artists accorded the Gospels, as the sacred canonical account of the Life of Christ, narrative miniature cycles of a density equal to or greater than that of any other text. Even apparently insignificant passages were deemed worthy of lavish illustration, and hundreds of miniatures narrated the text in a manner that has aptly been termed "cinematographic."

The earliest phases of Gospel illustration are obscured by the lack of pre-iconoclastic material. Only four illustrated Gospels, all of the sixth century, survive from the pre-iconoclastic East. The Rossano Gospels (Rossano, cathedral) and the Sinope Gospels (Paris, Bibl. Nat. cod. suppl. gr. 1286) are closely related fragments of Greek luxury manuscripts written in silver and gold on purple vellum, probably originating in Asia Minor or Syria-Palestine. The two other manuscripts are Syriac: a Gospel book in Paris (Bibl. Nat. cod. Syr. 33) and the Rabula Gospels (Florence, Laur. Lib. cod. Plut. 1, 56), written in 586 in the Mesopotamian monastery of Zagba.

An interest in precise illustration of narrative content shows most clearly in the Sinope Gospels. Each miniature, in a frameless frieze at the bottom of the page, faithfully illustrates the text immediately preceding or following. At the same time, however, these pre-iconoclastic manuscripts introduce to various degrees features not literally derived from the Gospel text in order to explicate the meaning of Christ's Life. The typological significance of the miniatures in three of the Gospel books is emphasized through the addition of Old Testament prophet figures. The liturgical importance of certain events is expressed by the inclusion of hieratic, non-historical representations like the Communion of the Apostles in the Rabula and Rossano Gospels. In these two works, especially rich concentrations of non-narrative elements are found in some of the framed, full-page compositions that may reflect monumental art.

The full scope of Byzantine Gospel illustration becomes evident only after Iconoclasm, when comparatively large numbers of Gospels with miniature cycles survive. These cycles are far more extensive than the existing early Christian examples. The eleventh-century Gospel books in Florence (Laur. Lib. cod. Plut. VI, 23) and Paris (Bibl. Nat. cod. gr. 74) are the richest, with approximately 750 and 500 iconographic units respectively. But these dense narrative cycles were inherited from pre-iconoclastic models. In the Florence Gospels the scenes of the Healing of the Man Born Blind, the Raising of Lazarus, and the Last Supper compare well with the same themes in the Rossano Gospels. The similar conflation in both manuscripts of the Samaritan's journey to the inn with his departure the next day is especially striking and justifies the assumption of a common archetype. Both

the Florence and Paris Gospels do not substitute Christ for the anonymous Samaritan required by the text and thus in some respects reflect better than the Rossano Gospels the original narrative character of the early archetype.

Even in post-iconoclastic art such full cycles were rare, and more commonly the artists would select a smaller number of themes from their models. Sometimes the miniatures are distributed more-or-less evenly among the four Gospels and the subjects freely duplicated (see Mount Athos, Iviron cod. 5). But the intelligent illuminator of the tenth-century Paris Gospels (Bibl. Nat. cod. gr. 115) sought to avoid repetition by illustrating only the first synoptic Gospel, Matthew, and the exceptional events in John. And the artist of an eleventh-century Paris Gospels (Bibl. Nat. cod. gr. 64) simply depicted a few subjects from the first chapter of each Gospel. Each could choose as he or his patron wished.

The major new force in post-iconoclastic Gospel illustration was the influence of the Lectionary, which soon after the end of Iconoclasm prefaced the pericopes of important feasts with a cycle of hieratic, full-page miniatures. The impact of this liturgical book is already apparent in the early tenth-century New Testament fragment in Baltimore (cat. 5), where full-page feast pictures of the Nativity, Baptism, Annunciation, and Anastasis each originally faced an Evangelist portrait. The selection and placement of these four miniatures were not determined by narrative considerations, but by the prologue text and the first lection of each Gospel. For instance, the apocryphal scene of the Anastasis, the standard Lectionary picture for Easter, here prefaces the Gospel of John whose first chapter is read on this feast. This liturgical system becomes a standard way to decorate post-iconoclastic Gospel books (see cat. 5, 37; 44) although in some cases the full-page feast pictures were reduced to headpieces or placed in the arches above the Evangelists.

The influence of liturgical feast cycles on Gospels increased in the eleventh century when Lectionary illustration reached its full maturity. The most important example of this is the Gospels in Paris (Bibl. Nat. cod. gr. 74), which fused a series of feast pictures with a dense, comprehensive narrative cycle. The most obvious manifestations of the Lectionary source are the presence of a scene of the Anastasis and the rearrangement of some miniatures into liturgical rather than narrative sequence. Yet the Lectionary also cast its spell more subtly and pervasively over the entire narrative cycle. To imitate the splendid dignity and monumentality of feast pictures, even many of the non-liturgical scenes were recast into hieratic, symmetrical compositions that emphasized the sacred character of the images, often at the expense of narrative accuracy. The alterations in the Paris manuscript help to explain its many differences from the more conservative, contemporary Gospel book in Florence (Laur. Lib. cod. Plut. vi, 23).

Eleventh-century illuminators also drew from other media to increase the hieratic qualities of their Gospel images. The Paris Gospel book contains two

large miniatures of the Last Judgement with many non-Gospel elements. Ultimately these miniature compositions reflect a source in monumental art, but the immediate model could just as easily have been an icon where the theme is also found. Sometimes icons rather than Lectionaries may have been the direct source for the liturgical cycles in Gospel books. By the mid-eleventh century, feast scenes had been gathered together on one or more icons. The Parma Gospels (Bibl. Palatina cod. 5) group in a similar manner twelve feast pictures on three pages between the texts of Matthew and Mark. The particularly strong interrelations between these media may be explained by illuminators painting both icons and manuscripts.

The trend toward the displacement of narrative by liturgical images continued into the Late Byzantine period. A thirteenth-century Gospel book in London (Brit. Mus. cod. Harley 1810) placed no fewer than seventeen feast scenes (including such non-Gospel subjects as the Koimesis, Anastasis, and Pentecost) into the text at the appropriate lections. In some respects the contemporary Karahissar Gospels in Leningrad (Public Lib. cod. gr. 105) are more extreme. Often this manuscript drastically abbreviates nominally narrative scenes to achieve large-scale hieratic, iconic effects: the Apostles in the Transfiguration are simply omitted, or the figures in the Blessing of the Apostles are depicted half-length. In several cases the artist abandons any pretense of narrative. The Crucifixion is twice replaced by the "Man of Sorrows," a devotional bust of Christ borrowed from an icon or monumental apse decoration. More unusual is the illustration of the Presentation in the Temple with an isolated, half-length figure of Zacharias holding the Christ Child, obviously modeled after an icon. These replacements of narrative scenes with devotional images mark the final stage of a long liturgical development in Gospel illustration. But even in the Karahissar Gospels there are still other miniatures that very accurately illustrate relatively insignificant passages of the text. The original, age-old tradition of narrative depiction was never totally abandoned in Byzantine art.

Among the other New Testament texts, the Acts was also illustrated with a narrative cycle. The only extant example is in the thirteenth-century Rockefeller McCormick New Testament (cat. 45), but the scenes of Paul's Conversion in the Vatican Cosmas manuscript (Vatican Lib. cod. gr. 699) demonstrate that the Acts cycle had originated by the ninth century, if not earlier. The theological character of the Epistles did not lend itself to narrative illustration. Occasionally, however, an Epistle is prefaced by a full-page miniature with scenes from the life of the author (see cat. 5). This practice was probably derived from the menologion, which customarily prefaced a saint's reading with several scenes from his life. Thus, even the lesser New Testament texts did not escape the powerful influence of liturgical illustration. The full illustration of the Apocalypse began only

in the sixteenth century under Western influence. The forbearance on the part of Greek artists undoubtedly resulted from the reluctance of the Orthodox Church to accept this text as canonical (see cat. 64). It is only natural that the illustration of all other New Testament texts was insignificant compared to that of the Gospels.

BIBLIOGRAPHY: C. Rohault de Fleury, *L'Évangile*, 2 vols., Tours, 1874; O. von Gebhardt and A. Harnack, *Evangeliorum Codex graecus purpureus Rossanensis*, Berlin, 1880; A. Haseloff, *Codex Purpureus Rossanensis*, Berlin-Leipzig, 1889; S. Beissel, *Geschichte der Evangelienbücher in der ersten Hälfte des Mittelalters*, Freiburg, 1906; Muñoz, *Rossano*; H. Omont, *Évangiles avec peintures byzantines du XIᵉ siècle*, 2 vols., Paris, 1908; J. Reil, *Die altchristlichen Bildzyklen des Lebens Jesu*, Leipzig, 1910; Millet, *Recherches*; Goodspeed, Riddle, and Willoughby, *Rockefeller McCormick*; Colwell and Willoughby, *Karahissar*; A. Grabar, *Les Peintures de l'évangélaire de Sinope*, Paris, 1948; Weitzmann, "Gospel Illustration"; C. Cecchelli, J. Furlani, and M. Salmi, *The Rabbula Gospels*, Olten, 1959; W. C. Loerke, "The Miniatures of the Trial in the Rossano Gospels," *Art Bulletin*, XLIII, 1961, 171f.; Meredith, "Ebnerianus"; H. Buchthal, "Some Representations from the Life of St. Paul in Byzantine and Carolingian Art," *Tortulae: Studien zu altchristlichen und byzantinischen Monumenten*, Rome, 1966, 43f.; Weitzmann, "Eleventh Century"; S. Tsuji, "The Study of the Byzantine Gospel Illustrations in Florence, Laur. Plut. VI, 23, and Paris, Bibl. Nat. cod. gr. 74," Ph.D. thesis, Princeton University, 1968; Weitzmann, *Roll*; T. Velmans, *Le Tétraévangile de la Laurentienne*, Paris, 1971; K. Wessel, "Evangelienzyklen," *Reallexikon zur byzantinischen Kunst*, II, Stuttgart, 1971, 433f.; Weitzmann, "Greek N. T."

# 6.      Portraits of the Evangelists in Greek Manuscripts

Robert P. Bergman

The Evangelist portrait is by far the most prevalent type of figurative decoration appearing in Byzantine manuscripts. That the early Christians chose to illuminate codices containing the Gospel texts with portraits of their authors—usually placed at the head of each Gospel—should come as no surprise, since there is substantial evidence that the inclusion of the author's portrait at the beginning of his work was a well-known and often-practiced classical tradition. Thus, when Christians began to include such portraits in books of their sacred Gospels, they were simply continuing a far more ancient tradition. Indeed, it was perhaps the very antiquity of this tradition that was attractive to a church seeking to affirm the authenticity of its holy writings.

Although we have but one preserved pre-iconoclastic Evangelist portrait in a Greek manuscript (the language of the original four Gospels)—the sixth-century Rossano Gospels—corroborative evidence from manuscripts of other versions (particularly the Syriac, Armenian, and Latin) as well as from representations in other media indicates the widespread existence of such portraits in early Christian times. We cannot be certain of the precise date of their earliest appearance, although it is difficult to imagine their invention before the establishment of the Gospel canon toward the end of the second century. Indeed, many would find it hard to conceive of such a form of manuscript decoration before the time of Constantine in the early fourth century.

Regardless of exactly when the first portraits of the Evangelists were made, it is certain that they were not conceived early enough to be considered likenesses in any way. Instead, the facial characteristics employed for the four, remarkably consistent throughout the Byzantine period, must be viewed as conventional types. The Apostles Matthew and John are generally shown as old men with white hair and beards, while Mark and Luke, the followers of Apostles, are usually younger and have dark hair. Mark normally has a short, dark beard while Luke is often depicted beardless.

From the very earliest period of their history the Evangelist portraits were cast in several markedly different formats. The most obvious distinction is between seated and standing types. Although the former are by far the more common, the standing figures have perhaps an even more ancient heritage. Albert M. Friend, Jr., whose studies of the Evangelist portraits remain the basis for any investigation of the problem, suggested that the standing types were originally conceived as part of a much larger cycle of Biblical authors of both the Old and New Testaments that might have been employed as the system of decoration for a complete Bible (such an economical method would be desirable in so extensive a compilation). The standing portrait, aptly suited to the restricted width of a writing column, may very well have had its origins in illuminated rolls before the introduction of the codex in the first centuries of the Christian era. As such it may have been used not only for pagan classical authors but perhaps even for Old

Testament authors in Jewish, pre-Christian luxury manuscripts. However, this must for the present remain hypothetical.

Although extant representations of standing Evangelists—which Friend believed originated in Alexandria—are comparatively rare, we are fortunate to have in the Princeton exhibition a Gospel book, Princeton, Univ. Lib. cod. Garrett 6 (cat. 1), whose Evangelist portraits are the earliest (ninth-century) extant examples of standing types from a Greek manuscript. Generally, standing Evangelists are placed against neutral backgrounds, although in the Princeton manuscript they stand beneath decorative arches that add to their monumentality. In the figure of Luke we see the most common pose for the standing Evangelist: frontal, displaying the book in his covered left hand and holding his right hand up in a gesture of speech. As is usual in Evangelist portraits, he is given a nimbus.

Aside from these frontal standing Evangelists, there also appear figures in profile, sometimes reading from their Gospels, and often moving to the left or right. These Evangelists are probably derived from a pair of antithetical miniatures that showed the four Evangelists gathered on one page offering their Gospels to Christ on the facing page. An example of such a pair, called by Friend the "presentation picture," is preserved in a manuscript in the Vatican (cod. gr. 756).

Seated Evangelists are not only far more numerous than standing ones; they are also far more complex in their origins. Fortunately Friend assessed the almost embarrassing wealth of material related to the seated Evangelist (literally thousands of examples) and was able to isolate a remarkably small number of basic types and variations to which the mass of material could be reduced. Specifically, he discovered eight different types of seated Evangelists (in his article he mentions ten but these were later, in an unpublished study, reduced to eight, since two were recognized as variants of other types). He found these eight types to recur with such regularity among Byzantine (and Western) manuscripts as to indicate that they had assumed some sort of authority, at least by virtue of long-standing tradition. According to Friend, these types—which were often set against architectural backgrounds and almost invariably included a bench, a desk with writing implements, and a lectern—were invented in the great Hellenistic centers of the Early Christian world and were passed on to the Middle Ages. They were especially popular during the Macedonian Renaissance as being representative of an antique heritage. As Friend pointed out, other Evangelist types may emerge from further investigation, but even today we must return to those that he isolated many years ago. The examples that Friend chose to illustrate the different seated types—all of which are used interchangeably to depict the different Evangelists—were:

*Set One*:  1. Venice, San Lazzaro Lib. cod. 1144/86 (Mlke Gospels—Armenian), Matthew (Friend, "Evangelists," II, fig. 25)

2. Same codex. Mark (Friend, "Evangelists," II, fig. 26)
3. Florence, Laur. Lib. Plut. I, 56 (Rabula Gospels—Syriac), Matthew (Friend, "Evangelists," II, fig. 1)
4. Same codex. John (Friend, "Evangelists," II, fig. 1)

*Set Two*:   5. Mount Athos, Stavronikita cod. 43, Matthew (Friend, "Evangelists," I, fig. 95)
6. Same codex. Mark (Friend, "Evangelists," I, fig. 96)
7. Same codex. John ( Friend, "Evangelists," I, fig. 98)
8. Vatican Lib. cod. gr. 364, John (Friend, "Evangelists," I, fig. 106)

We have no example of type 1 in the exhibition, but each of the other three in the first set does occur. The John portrait in Baltimore, Walters Art Gallery cod. W531 (cat. 44) presents type 2 even more "authentically" than the Mlke Gospels since in the Baltimore manuscript the figure reads from a scroll, as Friend claims the prototype of the Armenian figure would have. Mark in Princeton, Univ. Lib. cod. Garrett 2 (cat. 50), relates very closely to type 3 except that the right hand, which is held aloft in a gesture of speech in the Rabula Gospels, is here given a pen, transforming the figure into a writer. This is a typical Mediaeval transformation that occurs among the Evangelist portraits. Type 4 is a very complex case that exists in a number of variations. Very close to John in the Rabula Gospels is the figure of Matthew in Baltimore, Walters Art Gallery cod. W529 (cat. 40), except that the scroll held by the figure in the Rabula Gospels is replaced by the more modern codex in the later Walters example. Although the figure in this instance is semifrontal, there are two variations of the type that present a more nearly profile view. One of these is represented by four examples in this volume (cat. 13, 14, 51, 59) and shows the Evangelist, codex in his lap, engaged in writing his Gospel, while the other can be seen three times (cat. 34, 36, 42) and depicts the figure leaning toward the writing desk to dip his pen into the inkwell (this last may well turn out to be an independent type). These variations of type 4 are more often used for Luke than for the others.

Of set two, type 7 is illustrated here only in one radically transformed derivative (see cat. 57). Type 5 is most often represented and may be seen in no fewer than seven examples (cat. 7, 8, 15, 16, 35, 43, 53). These show the more exaggerated version of this pose as seen in the Mark of Vatican Lib. cod. gr. 364, rather than the more relaxed Mark figure of Mount Athos, Stravronikita cod. 43. Type 6 appears in three examples (cat. 12, 38, 52). A change has taken place between the Luke of Baltimore, Walters Art Gallery cod. W530f., and the authentic type. Instead of simply contemplating his Gospel with one hand raised to the lectern and the other on his lap, the Evangelist in the Baltimore leaf holds a codex on his lap and writes in it with a pen in his right hand. Again, this is clearly a Mediaeval addition to the type. Type 8 is particularly interesting since it involves not only a spe-

cific figural type but an unusual accessory as well. The figure of John in Yale, Univ. Lib. cod. 150 (cat. 9), is the only example of this type illustrated in this volume. We see here the old Evangelist sitting, almost stooped, in a high-backed chair, his right hand resting on his lap, his left somewhat awkwardly holding a scroll. The wicker chair, already present in the Rossano Gospels's portrait of Mark, becomes an almost inseparable element in representations of this Evangelist type (used most often for John). Again, however, a change has occurred between the more authentic version and the example from Yale. Whereas in the Yale manuscript John holds a scroll in one hand, in the more original examples of the type he sits with both hands on his lap quietly contemplating his work.

In his research Friend progressed considerably beyond the isolation of a number of figural types used for the Evangelists. In fact (and here his later, unpublished research went far beyond his two articles), he was able to suggest in a very convincing manner that the seated Evangelist types were based on specific classical prototypes. In his 1927 article Friend indicated the direction of this line of research in comparing type 6 with a famous statue of Epicurus. Analyzing the architectural backgrounds that often appear behind the seated Evangelists, he was able to recognize details of the classical theater's *scenae frons* (see cat. 21, in this case Peter, author of the Epistle) and proposed that the ancestors of the seated Evangelist portraits were famous statues of poets and philosophers that often formed part of the decoration of the Roman theater. Thus, famous portrait types of the great authors of antiquity—all of which Friend eventually could identify—were adapted for the Christian authors of the Gospels.* In the light of later research into the sources of early Christian art and literature, this theory seems remarkably advanced.

From about the turn of the tenth to the eleventh century the traditional miniature of John seated at his desk or, less often, standing alone, is frequently replaced by a composition that shows the Evangelist standing in the rocky landscape of Patmos dictating his Gospel to the seated figure of the young Prochoros (cat. 28, 39, 56, 62). Although the legend of John and Prochoros goes back to early Christian sources, no miniature of this type appears before the end of the tenth century and there is good reason to believe, as K. Weitzmann has suggested, that the composition was first invented as the title miniature for the *vita* of John that formed part of the famous hagiographical compilation of Symeon Metaphrastes

* Bruce M. Metzger (*The Text of the New Testament*, London, 1964, 28) reveals Friend's identifications of the specific classical authors on whose images the seated Evangelists were based: the philosophers Plato, Aristotle, Zeno, and Epicurus, and the poets Euripides, Sophocles, Aristophanes, and Menander. Information concerning these identifications, which were not completely worked out in the two articles of 1927 and 1929, was communicated to Metzger orally by Friend not long before he died, and will be published, along with all the supporting evidence, by K. Weitzmann in a posthumous publication of Friend's research.

written at the end of the tenth century. From there it would have been taken over as a portrait type for John in Gospel books and Lectionaries.

Of the number of variations on the simple Evangelist portrait, two of the most interesting appear in this volume. The first shows the Evangelist accompanied by a second figure (other than the John and Prochoros type). In New York, Morgan Lib. cod. M748 (cat. 17), John and Matthew (both seated) are accompanied by unidentified standing figures. More significant is a second manuscript, Baltimore, Walters Art Gallery cod. W524 (cat. 5), whose tenth-century date makes it the earliest Mid-Byzantine manuscript with miniatures of accompanied Evangelists. The Evangelist Luke is depicted in profile and is writing. On the right side of his lectern sits a second figure, this time frontal, who gestures with his right hand. Although he too is based on a familiar Evangelist type (type 3), his inscription identifies him as Paul, seen here in his role as the Apostle who, according to certain Early Christian sources, dictated the Gospel to Luke. Peter plays the same role in the Mark portrait as Paul does here. While the Evangelist Mark in the Rossano Gospels is shown receiving inspiration from a female personification, the portraits of Luke and Mark in the Walters manuscript demonstrate a far more historically tangible form of inspiration for the writing of the Gospels. That this sort of Evangelist-Apostle composition is older than the tenth century is proven by an ivory in the Victoria and Albert Museum that shows Mark and Peter and has most recently been dated by K. Weitzmann in the seventh to eighth century.

Another departure from the simple Evangelist portrait shows the figure accompanied by his symbol (cat. 38, 39, 55, 62). Christian writers from the earliest times had interpreted the beasts of Ezekiel (1:5–10) and the Apocalypse (Revelations 4:6–8) as symbols of the Evangelists, and they were standard motifs in Western art throughout the Middle Ages. It has often been assumed that the symbols were not used in Byzantium before the late Palaeologan period, when the Apocalypse was finally accepted as canonical in the East. In fact, as C. R. Morey pointed out years ago, this is simply not true. We can find them as early as the tenth century and rather frequently in the twelfth (see cat. 38). Although some Byzantine manuscripts show the beasts in the order established by Jerome, which became virtually canonical in the West (Matthew=man, Mark=lion, Luke=calf, John= eagle), a manuscript shown here, Cambridge, Harvard College Lib. cod. TYP 215H (cat. 38), depicts them in the arrangement according to Irenaeus, Bishop of Lyons toward the end of the second century (Matthew=man, Mark=eagle, Luke=calf, John=lion).

It should be noted that the Evangelists were not the only New Testament authors whose portraits were included in manuscripts. Luke, as the author of the Acts, and the writers of the Epistles are also found in New Testament codices. The types employed for these authors are usually similar to the Evangelists (cat. 21, Peter standing) and, in fact, are often based on the Evangelist portraits. The

influence of Evangelist types extends even further and often dictates the manner in which numerous Early Christian Fathers are represented (cat. 31, Gregory Nazianzenus, type 4).

It will be noticed that in general we have paid little attention to the dates of the manuscripts in considering the Evangelist portraits. This is not to say that there is no variation over the course of centuries (we have already alluded to some), but in the present context it seems most important to understand that we are dealing with pictorial types hallowed by tradition and not quickly abandoned. The power and continuity of that tradition is eloquently expressed in a comparison of six portraits of Mark that range in date over the course of almost three centuries (cat. 7, 8, both end of tenth century; cat. 15, 16, both eleventh century; cat. 35, twelfth century; and cat. 43, 53, both thirteenth century). Regardless of the obvious changes in style that have occurred, and despite the more elaborate decorative frame of the latest example in the series, the figures of the Evangelist (this type is particularly popular for Mark) have maintained an extraordinary consistency in pose and disposition. The left hand supporting the head, the right hand balancing the codex on the lap, the left leg thrust characteristically forward—all have remained remarkably fixed within the context of the figural type. Even the kind of bench on which Mark sits, the footstool, the desk with the writing implements, and the simple lectern are extremely similar.

We have seen that Evangelist portraits were conceived in response to the tradition of author portraits in antiquity and that in many cases the Evangelist types were based on images of classical authors. Although to many it might seem a startling phenomenon that figural types of pagan writers became endowed with an almost sacred authority as representative of the authors of the Gospels, in reality this fact is in perfect harmony with what we have come to learn concerning the relationship of Early Christian and Byzantine intellectual and artistic life to its classical past.

BIBLIOGRAPHY: J. Strzygowski, *Kleinarmenische Miniaturenmalerei*, Tübingen, 1907; Morey, *Freer*; Friend, "Evangelists," I, II; J. Weitzmann-Fiedler, "Ein Evangelientyp mit Aposteln als Begleitfiguren," *Festschrift zum 70. Geburtstag von A. Goldschmidt*, Berlin, 1935, 30f.; Weitzmann, *Buchmalerei*; idem, "Latin Conquest"; idem, "Morgan 639"; C. Cecchelli, J. Furlani, and M. Salmi, *The Rabbula Gospels*, Olten, 1959; H. Buchthal, "A Byzantine Miniature of the Fourth Evangelist and Its Relatives," *Dumbarton Oaks Papers*, XV, 1961, 129f.; C. Nordenfalk, "The Apostolic Canon Tables," *Gazette des beaux-arts*, LXII, 1963, 17f.; Weitzmann, *Grundlagen*; idem, "Book Illustration of the Fourth Century: Tradition and Innovation," *Akten des VII. Internationalen Kongresses für Christliche Archäologie: Trier 5–11 September, 1965 (Studi di antichità cristiana,* XXVII), Rome and Berlin, 1969, 257f. (*Studies,* 96f.); K. Wessel, "Evangelisten," *Reallexikon zur byzantinischen Kunst,* II, Stuttgart, 1971, 452f.; K. Weitzmann, "The Ivories of the So-Called Grado Chair," *Dumbarton Oaks Papers*, XXVI, 1972, 72; idem, "Greek N. T."

# Catalogue of the Exhibition

# 1.

Princeton, Univ. Lib. cod. Garrett 6. In Greek on vellum. 164 folios (18.3 x 14.2 cm.). Minuscule script. One column of 29 lines (13.2 x 9.5 cm.). Five full-page miniatures (inserted). Four headpieces and ten canon tables. Colophon: folio 164v, non-scribal. Binding: red velvet over heavy wooden boards; five metal bosses front and back. Condition: inserted miniatures trimmed but show only minor flaking; headpieces heavily flaked.

PROVENANCE: Once property of the metropolitan patriarch of Kosinitza (fol. 164v). Until the early twentieth century in the monastery of Saint Andrew on Mount Athos. Brought to the United States by T. Whittemore. Purchased in 1925 by R. Garrett who gave it to the Princeton University Library in 1942.

EXHIBITED: Boston 1940, no. 7, pl. II; Baltimore 1947, no. 693, pl. XCIII; Athens 1964, no. 304; Brandeis 1968, no. 47, ill.

BIBLIOGRAPHY: DeRicci and Wilson, *Census*, 866; Bond and Faye, *Supplement*, 311; Clark, *N. T. Manuscripts*, 71f. (with further bibliography), pl. XI; A. Frantz, "Byzantine Illuminated Ornament," *Art Bulletin*, XVI, 1934, pl. XX, figs. 6, 19; pl. XXIII, figs. 17, 18; Weitzmann, *Buchmalerei*, 56f., pl. LXIII, figs. 374–78; Friend, "Garrett," 131f., pl.; K. Weitzmann, "An Early Copto-Arabic Miniature in Leningrad," *Ars Islamica*, X, 1943, 128f., fig. 14; idem, "Byzantine Art and Scholarship in America," *American Journal of Archaeology*, LI, 1947, 400, pl. CIXa; Martin, *Climacus*, 87f., 90f.; Aland, *Liste*, 109; Chatzidakis and Grabar, *Painting*, 16, pl. 87; S. Dufrenne, *Psautiers*, 19; Lazarev, *Storia*, 137, 172n.; E. Kirschbaum et al., *Lexikon der Christlichen Ikonographie*, Rome, 1968, 381, fig. 9; W. F. Volbach and J. Lafontaine-Dosogne, *Byzanz und der Christliche Osten*, Berlin, 1968, 102, 184, pl. XIV.

This provincial twelfth-century Gospel book, decorated with four rough flower-petal headpieces (fols. 12r, 55r, 84r, 131r), contains five inserted full-page portraits, produced in an earlier period, severely trimmed to accommodate their positions.[1] Included are author portraits of Mark (fol. 54v), Luke (fol. 83v, frontispiece), and John (fol. 130v), as well as juxtaposed iconic frontispiece miniatures of Christ and the Virgin *Orans* (fols. 10v, 11r, fig. 1). Each figure, standing frontally on an ornamented pedestal, is flanked by a pair of sturdy marble columns. Above Luke, John, and the Virgin rise wide decorated horseshoe arches; above Christ is a grass-covered gable, and above Mark is a circular architrave, precariously balanced on two balls. Mark, Luke, and Christ hold jewel-studded codices in their draped left hands; John's codex, completely gold, is held open. Colors in all five miniatures are light and thin, with a preponderance of pink, light blue, light rust brown, and rose. Christ wears a purple mantle over a light reddish brown tunic highlighted with fine gold lines; the Virgin is dressed entirely in purple. The face of each figure is delicately modeled in creamy flesh tones and greenish gray shadows. Touches of red may be seen above the eyes and on the cheeks and lips. Halos are outlined in light blue and all backgrounds are gold. Contemporary inscriptions in elegant red uncial letters flank the columns; minuscule inscriptions were added later around each figure's head.[2]

These broad high-waisted figures, with their long, straight noses, low brows, and sharply outlined faces, dressed in light pastel colored garments modeled in bold patterns of double lines, have for some time been associated with a small but highly accomplished school of illumination organized around the Chloudov

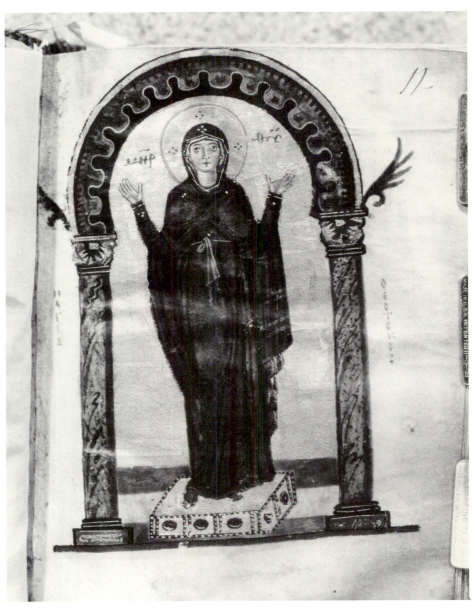

FIGURE I.  The Virgin *Orans*
Princeton, Univ. Lib. cod. Garrett 6, fol. 11r

Psalter (Moscow, Hist. Mus. cod. add. gr. 129) and Mount Athos, Pantocrator cod. 61, two of the three earliest Psalters with marginal miniatures.[3] To this group, which also includes the washdrawing portraits on the title page of a copy of the *Amphilochia* of Photios (Mount Athos, Lavra cod. 449), may be added two severely flaked standing Evangelist portraits pasted in a Post-Byzantine liturgical manuscript in the monastery of the Metamorphosis in Meteora (cod. 106).[4] The pose, facial type, and drapery of Luke (fol. 176v) correspond so closely to the Princeton Luke that its companion Matthew portrait (fol. 12v) may be considered as reflecting the now lost Matthew of codex Garrett 6.

The portrayal in several miniatures of the Moscow and Pantocrator Psalters of adversaries and events from the Iconoclastic Controversy has prompted most scholars to date these manuscripts soon after the triumph of Orthodoxy, that is, to the second half of the ninth century.[5] A. Grabar has been more specific in assigning the Psalters to a workshop organized during the first reign of the scholarly patriarch Photios (857–68), pointing out that Photios assembled an anti-iconoclastic council and wrote a (now lost) commentary on the Psalms.[6] S. Dufrenne has added strong supportive evidence to this hypothesis recently by citing close similarities between Photios's commentary on Psalm 113:12–16 (115:4–8) found in his *Amphilochia* and the marginal miniature accompanying that Psalm in the Mount Athos Psalter.[7] The Virgin *Orans* of the Princeton manuscript is especially interesting in this respect. Unusually monumental and hieratic, she is probably copied from an apse mosaic like that of Saint Sophia at Kiev (eleventh century).[8] The tenth homily of Photios delivered at the *encaenia*, in 864, of the (now destroyed) Palace Church of Our Lady of the Pharos describes in the apse of that church a Virgin with arms outstretched, i.e., the standing *Orans*.[9]

Any hypothesis placing this workshop in Constantinople during the second half of the ninth century encounters the difficulty of reconciling its figure style with the much more classical style of the Paris homilies of Gregory Nazianzenus (Bibl. Nat. cod. gr. 510), produced between 880 and 883 for Basil I, and tentatively placed, in a recent study, within the circle of Photios.[10] While even the least accomplished miniatures of the Gregory codex show illusionistic tonal drapery modeling, garments in the Chloudov Psalter group are almost invariably articulated with lines. On the other hand, a linear technique, as well as low-browed, sharply outlined faces, broad bodies, and horseshoe arches covered with foliage and flanked by birds are to be found in Eastern manuscripts of all periods, including the Rabula Gospels (Syriac, dated 586),[11] the Armenian Gospels formerly in Etschmiadzin and now at Erivan (Matenadaran cod. 2374; dated 989),[12] and a set of tenth-century Evangelist portraits on Mount Sinai with Georgian inscriptions (cod. georg. 38).[13] The high refinement of the Princeton portraits, however, as well as certain stylistic similarities to ninth-century mosaics in Nicaea (the Church of the Dormition, now destroyed)[14] and Thessaloniki (Hagia Sophia)[15] would seem to make a Constantinopolitan origin a likely possibility.[16]

Whatever their origin, the Princeton miniatures are probably the earliest extant standing Evangelist portraits from a Greek manuscript. The inclusion of frontispiece miniatures of Christ and the Virgin, although not common in Greek codices, may be paralleled in a handsome Macedonian Renaissance Lectionary on Mount Sinai, cod. 204.[17]

G.V.

Lent by Firestone Library, Princeton University

NOTES

1. The folios bearing Christ, the Virgin, and John are pasted onto inserted stubs. The Mark and Luke folios are inserted directly into the binding. The reverse sides of all five miniatures are blank. The Luke leaf alone shows a basic rectangular ruling pattern.

2. The earlier inscription designates the Virgin as Η ΑΓΙΑ ΘΕΟΤΟΚΟC, "the Holy Begetter of God," and the later as $\overline{μηρ}$ $\overline{θυ}$, the "Mother of God."

3. Weitzmann, *Buchmalerei*, 53f., pls. LIX–LXII.

4. N. A. Bees, Τὰ χειρόγραφα τῶν Μετεώρων, Athens, 1967, 137f., pl. LXXIII.

5. For an excellent review of this scholarship, see A. Grabar, "Quelques notes sur les psautiers illustrés byzantins du IXᵉ siècle," *Cahiers archéologiques*, XV, 1965, 75f.

6. A. Grabar, *L'Iconoclasme byzantin, dossier archéologique*, Paris, 1957, 196f. This opinion was reviewed and given new supporting evidence in the article cited in note 5.

7. S. Dufrenne, "Une Illustration historique, inconnue, du psautier du Mont-Athos, Pantocrator no. 61," *Cahiers archéologiques*, XV, 1965, 83f.

8. H. Logvin, *Kiev's Hagia Sophia*, Kiev, 1971, pls. 21, 50.

9. R. J. H. Jenkins and C. A. Mango, "The Date and Significance of the Tenth Homily of Photius," *Dumbarton Oaks Papers*, IX–X, 1955–56, 133.

10. S. Der Nersessian, "The Illustrations of the Homilies of Gregory of Nazianzus, Paris gr. 510," *Dumbarton Oaks Papers*, XVI, 1962, 227f.

11. C. Cecchelli, J. Furlani, and M. Salmi, *The Rabbula Gospels*, Olten, 1959.

12. Friend, "Evangelists," II, figs. 20, 21.

13. The format of these portraits is especially close to that of the Princeton leaves. Although not integral to the manuscript in which they are now found (dated 979), these miniatures are ascribed by K. Weitzmann on stylistic grounds to the tenth century. Photographs in the Department of Art and Archaeology, Princeton University. See K. Weitzmann, "Illustrated Manuscripts at St. Catherine's Monastery on Mount Sinai" (in press).

14. The apse mosaic of the Virgin is especially close to the Princeton Virgin miniature. See Lazarev, *Storia*, pls. 77, 78.

15. Low-browed, sharply outlined faces, as well as broad linear garments, may be seen among the Apostles of the Ascension dome. See Lazarev, *Storia*, pls. 85, 86.

16. In addition to being conceptually similar in the theological erudition evident in their picture cycles, the Paris Gregory and the marginal Psalters show specific iconographic relationships among their Old Testament scenes. The depictions of the Sale of Joseph are exactly analogous (reversed left to right) on folio 106r of the Chloudov Psalter (photographs in the Department of Art and Archaeology, Princeton University) and folio 69v of Paris, Bibl. Nat. cod. gr. 510 (Omont, *Miniatures*, pl. XXVI).

17. Weitzmann, *Buchmalerei*, 28, pl. XXXVIII, figs. 211, 212.

# 2.

# The Four Gospels

Princeton, Univ. Lib. cod. Garrett 1. In Greek on vellum. 152 folios (20.3 x 15.4 cm.). Uncial script. One cruciform column of 37–38 lines (ruled area: 14.8 x 9.7 cm.). Four headpieces and five tailpieces. Cover missing. Dark brown leather spine. Condition: first quire missing; ends with John 18:34; a number of lacunae; large portion of first headpiece torn out; illuminations flaked and rubbed.

PROVENANCE: In the monastery of Saint Andrew on Mount Athos (cod. 1). Brought to the United States by T. Whittemore. Purchased in 1925 by R. Garrett and given by him to the Princeton University Library in 1942.

EXHIBITED: Baltimore 1947, no. 692, pl. xcv; Brandeis 1968, no. 42, ill.

BIBLIOGRAPHY: DeRicci and Wilson, *Census,* 865; Bond and Faye, *Supplement,* 310 (with further bibliography); Clark, *N. T. Manuscripts,* 61f. (with further bibliography), pl. vii; Erhard, *Überlieferung,* i, 28; Aland, *Liste,* 41.

NOTES

1. The only other Byzantine manuscripts known to me with a cruciform text throughout are: New York, Pierpont Morgan Lib. cod. M692 (cat. 35) and London, Brit. Mus. cod. add. 39603, both twelfth-century Lectionaries.
2. Weitzmann, *Buchmalerei,* 40, pls. xlvi, xlvii, figs. 275–82. According to K. Weitzmann the miniatures of Vatican Lib. cod. Reg. gr. 1, which are Constantinopolitan, were inserted at the end of the tenth century. For the stylized Sassanian birds, see Patmos cod. 70 (Weitzmann, *Buchmalerei,* pls. lxxi, lxxii, figs. 430–37), dated to the tenth century and also localized to Asia Minor.

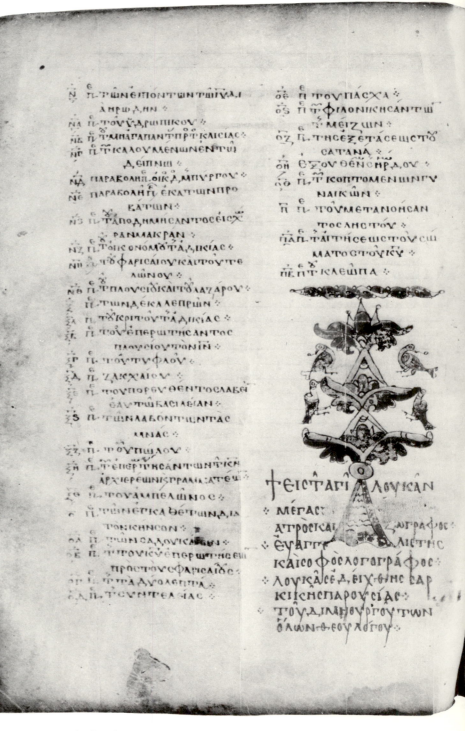

FIGURE 2. Gospel of Luke
Princeton, Univ. Lib. cod. Garrett 1, fols. 75v–76r

The tailpieces (fols. 46v, 74r, 75v, fig. 2; 123v, 124v) found throughout the cruciform text[1] of codex Garrett 1 consist of early orientalizing motifs, including goblets and multitiered candelabra on triangular pedestals, almond petal rosettes, and Sassanian birds. Muted rose, dark green (often flaked), grayish blue-green, and ochre wash are used to color these fanciful constructions executed in brown ink.

The narrow headpieces (fols. 1r, 47r, 76r, fig. 2; 125r) are more minute and intricate in design. Berry-tipped palmettes, an interlace pattern, an undulating band with foliage, and facing birds are the principal motifs. The colors are the same as those of the tailpieces with the addition of a bright carmine red. On folios 76r and 125r a blessing hand forms the crossbar of the initial 'E' at the beginning of the Gospels of Luke and John.

The Sassanian motifs, especially the large multiblossomed palmettes of the tailpieces, recall similar decorative forms in manuscripts originating in Asia Minor during the late ninth and early tenth centuries, such as the Leo Bible, Vatican Lib. cod. Reg. gr. 1.[2] Although the decorative motifs in the Vatican Bible are more compact, the stylized foliate forms are very close to those in the Garrett Gospels. The comparison, however, points out the looser structure and more provincial character of codex Garrett 1, which also must have been produced in an East Byzantine province—probably in the late ninth century.

B.A.V.

Lent by Firestone Library, Princeton University

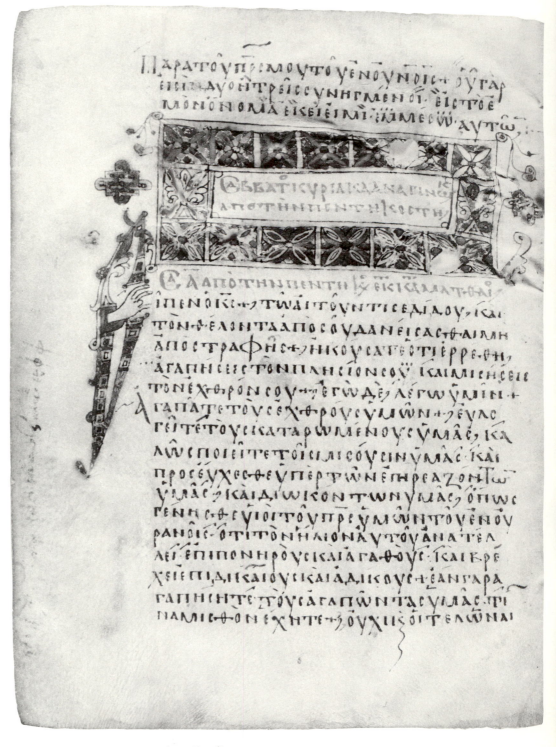

FIGURE 3. Matthew Readings
Princeton, Scheide Lib. cod. M2, fol. 35v

Princeton, Scheide Lib. cod. M2. In Greek on vellum. 174 folios (19.5 x 15.0 cm.). Uncial script. One column of (usually) 26 lines (15.0 x 9.5 cm.). Fifteen headpieces and many ornamental initials. Colophons: folios 103v, 174r, 174v, non-scribal. Binding: brown leather over wooden boards. Outlines of metal crosses remain on both covers. Condition: more than 50 folios missing; several leaves at beginning and end are extensively stained; tears and holes in many folios; the chemicals in the paint of some of the illuminations have eaten through the vellum.

PROVENANCE: Once belonged to a monk Leontios (fol. 174v, uncial colophon). In the monastery of the Prodromos at Serres in the beginning of the twentieth century (cod. $\bar{\gamma}$ 20). Purchased in 1922 by J. Scheide from J. Baer.

BIBLIOGRAPHY: DeRicci and Wilson, *Census*, 2120; Clark, *N. T. Manuscripts*, 197f. (with further bibliography), pl. XXXVIII; Aland, *Liste*, 274.

The chief divisional titles of the Scheide Lectionary (fig. 3) are enclosed in or accompanied by purely ornamental headpieces. Large capital letters indicate the beginning of each lection. Flat hues of blue, green, and red predominate.

This type of manuscript, written in large uncial script and containing decorative panels and initials but no miniatures, is common to Asia Minor and the East Byzantine provinces in the tenth century.[1] Certain decorative motifs support the attribution of the Scheide Lectionary to this area, especially the use of anthropomorphic and zoomorphic initials.[2] Also typical of Asia Minor are the almond-shaped rosettes in square compartments used to decorate the headpieces. Close parallels may be found in Patmos cod. 70, which dates in the early tenth century.[3] The knots and shaft-rings that decorate many of the initials in Scheide codex M2 did not become fashionable before this time.[4]

T.J.-W.

Lent by the Scheide Library, Princeton

NOTES

1. Weitzmann, *Buchmalerei*, 68f.
2. Ibid., 65f.
3. Ibid., 66, pl. LXXII, fig. 434.
4. Ibid., 69.

# John Chrysostom  *955 A.D.*

## HOMILIES ON THE GOSPEL OF MATTHEW

Princeton, Univ. Lib. cod. Garrett 14. In Greek on vellum and paper. 311 folios (31 x 24 cm.). (Folios 1–26, 35–38 are paper. Watermark: Lucca 1547–1550.)[1] Minuscule script. Two columns of 35–36 lines (26.0 x 7.8 x 17.0 cm.). 19 portrait medallions forming part of 47 headpieces and 41 initials. Colophons: folio 295r, scribal dated 955. Folios 295r, 295v, several non-scribal. Binding: light grayish brown vellum over wooden boards. Condition: text incomplete and disordered; folios 233–49 are placed after folio 272; folios 1–26 and 35–38 are fragments from Princeton, Univ. Lib. cod. 81;[2] many leaves repaired; decoration after folio 106v is left uncolored.

PROVENANCE: Formerly in the Kosinitza monastery (cod. 32). Acquired from J. Baer in 1921 by R. Garrett who gave it to the Princeton University Library in 1942.

EXHIBITED: Baltimore 1947, no. 694.

BIBLIOGRAPHY: DeRicci and Wilson, *Census*, 867; Bond and Faye, *Supplement*, 311; A. Papadopoulos-Kerameus, Ἔκθεσις παλαιογραφικῶν καὶ φιλολογικῶν ἐρευνῶν ἐν Θράκῃ καὶ Μακεδονία, in Ὁ ἐν Κωνσταντινουπόλει Ἑλληνικὸς Φιλολογικὸς Σύλλογος, XVII, 1882–83, Constantinople, 1886, appendix; Vogel and Gardthausen, *Schreiber*, 341; "Mitteilungen aus dem Antiquariat J. Baer," *Frankfurter Bücherfreund*, III, 1921, 6; J. Baer and Co., *Catalogus DCLXXV, No. 2*, Frankfurt, 1921, no. 14, pls. IV, V; Friend, "Garrett," 133; Lazarev, *Storia*, 176n.; R. E. Carter, "Codices Chrysostomici Graeci," *Éditions du centre national de la recherche scientifique*, Paris, 1970, nos. 23, 24.

This manuscript contains forty-five homilies by John Chrysostom on the first thirteen chapters of the Gospel of Matthew.[3] The beginning of each homily of the original tenth-century text (fols. 27–295) is marked by a one-column ornamental headpiece. The Matthew text is set off by a simple frame. Below, the beginning of the homily is marked by an elaborate ornamental initial or a medallion portrait. A larger medallion portrait, perhaps intended to represent John Chrysostom, is found at the end of the forty-fifth homily (fol. 295r, fig. 4). The ornamental headpieces consist of: rosettes, crosses or portrait busts enclosed by looped medallions, running diamond-grid patterns; and various guilloche and interlace designs. The medallion portraits represent: Christ between archangels (fol. 172r), John Chrysostom (fol. 29r, 151v), Basil (151v), Matthew, Patriarch of Jerusalem (151v), and three unidentified emperors (fol. 134v), as well as a number of unidentified ecclesiastics. The decorations on folios 27r to 106v are colored in green, red, and yellow earth tones. Those in the rest of the manuscript are drawn in pen.

Folio 295r bears a scribal colophon (fig. 4):

The scribes rejoice at the end of the book, like travelers at the sight of their native land. This holy book of the Monk John was completed by Nicephoros the Notary . . . on the 3rd of the month of May in the 13th indiction in the year 6463 [955].[4]

The roughness of the ornament and figure style suggest a provincial milieu. The decorative motifs used in the initials and the headpieces find parallels in manuscripts of Cappadocian origin.[5] The figurative busts, however, with their skull-shaped heads, bear a striking resemblance to those of a Gospel book in Jerusalem, Saba cod. 82, dated 1027 and attributed to the scriptorium of the Saint Saba monastery, near Jerusalem.[6] The significance of this relationship is enhanced by the inscribed portrait of Matthew, Patriarch of Jerusalem, on folio 151v of the Princeton manuscript.

T.J.-W.

Lent by Firestone Library, Princeton University

NOTES

1. C. M. Briquet, *Les Filigranes*, II, Geneva, 1907, No. 5929.
2. Bond and Faye, *Supplement*, 309.
3. Folios 296 to 311 bear three other texts in a later hand.
4. ὥσπερ ξένοι χαίρουσιν πατρίδα βλέπειν, οὕτως καὶ τοῖς γράφουσιν βιβλίου τέλος. ἐπληρώθ[η] ἡ ἱερὰ αὕτη ἡ β[ί]βλο[ς] παρὰ Νικηφό[ρου] νοτ[αρίου] Ἰω[άννου] μονάχου . . . . μαῒ [φ]· Γ· ΙΝΔ· ΙΓ· ἔτου[ς] ,ϛυξγ. Baer (see bibliography) noted another manuscript, Mount Athos, Dionysiou cod. 70, a commentary by John Chrysostom on I Corinthians and Titus, dated 955 and signed by Nicephoros the Notary. Neither the script, nor ornament, nor colophon formula of this manuscript has anything in common with codex Garrett 14 (see Weitzmann, *Buchmalerei*, 22, pl. XXIX, figs. 160–66).
5. See Leningrad, Public Lib. cod. gr. Б. I, 5 (Weitzmann, *Buchmalerei*, pl. LXXV, figs. 461, 463); Mount Athos, Lavra cod. 102 (Weitzmann, *Buchmalerei*, pl. LXXVII, fig. 477); and Moscow, Hist. Mus. cod. gr. 135 (Weitzmann, *Buchmalerei*, pl. LXXV, fig. 453).
6. Weitzmann, *Buchmalerei*, 75, pl. LXXXI, figs. 508–10.

FIGURE 4. John Chrysostom (?)
Princeton, Univ. Lib. cod. Garrett 14, fol. 295r

# 5. New Testament (fragment)

Baltimore, Walters Art Gallery cod. W524. In Greek on vellum. 254 folios (17.7 x 12.3 cm.). Minuscule script. One column of 21 lines (12 x 8 cm.). Four full-page miniatures and four headpieces. Four canon tables. Colophon: folio 89r, non-scribal. Binding: twentieth-century yellow velvet. Condition: text breaks off in John 6 and shows lacunae and misplacements; miniatures badly flaked, especially flesh areas; the Anastasis miniature (now cut from the manuscript) shows overpainting in a late oriental style.

PROVENANCE: Ex coll. R. Forrer, Strasbourg. Bought from Gruel by H. Walters.

EXHIBITED: Baltimore 1947, no. 695, pl. C.

BIBLIOGRAPHY: DeRicci and Wilson, *Census*, 758; Clark, *N. T. Manuscripts*, 351f., pl. LVI; Goodspeed, Riddle, and Willoughby, *Rockefeller McCormick*, III, 235, pl. LXXX; K. Weitzmann, "Byzantine Art and Scholarship in America," *American Journal of Archaeology*, LI, 1947, 405; Aland, *Liste*, 185; Diringer, *Book*, pl. II-19a; Lazarev, *Storia*, 175n.; M. Chatzidakis, V. Djurić, and M. Lazović, *Les Icones dans les collections suisses*, Bern, 1968, nos. 1–4, figs. 1–4; K. Weitzmann, "The Ivories of the So-Called Grado Chair," *Dumbarton Oaks Papers*, XXVI, 1972, 72, fig. 43; idem, "Greek N. T."

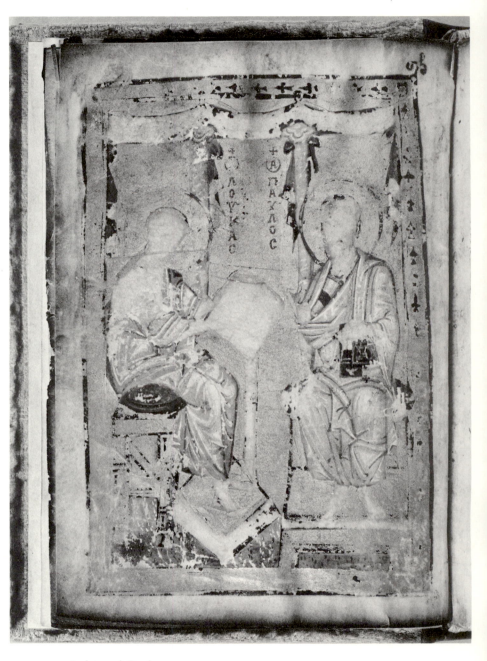

FIGURE 5. Luke and Paul
Baltimore, Walters Art Gallery cod. W524, fol. 6v

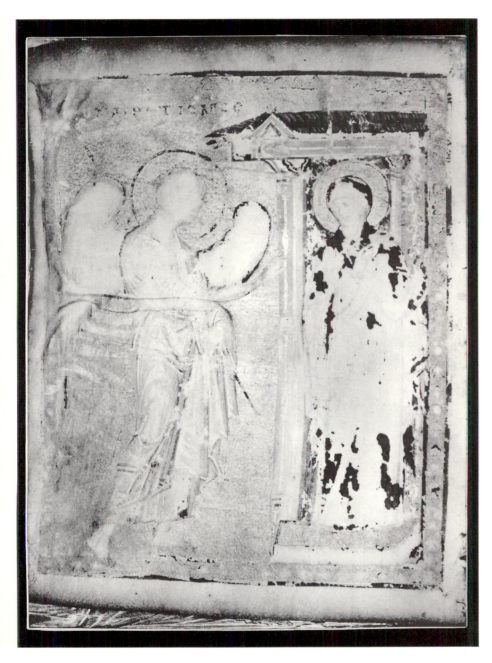

FIGURE 6. The Annunciation
Kölliken, Switzerland, Coll. S. Amberg-Herzog

Mark is depicted (fol. 89v) seated to the left of a central desk, taking dictation from Peter who is seated at the right making a gesture of speech with his right hand. Behind them are placed colored marble columns to which curtains are attached derived from the *scenae frons* of the Roman theater. As the result of a modern rebinding, the miniature of Luke taking dictation from Paul (fol. 6v, fig. 5) is found before the Gospel of Matthew (the Matthew portrait has been lost). It is composed as a precise counterpart to the Mark miniature. In the third miniature, John (fol. 231r) is shown standing at the right with his head raised in prayer toward the Hand of God while Prochoros, holding an open book on his lap, is dipping his pen into an inkwell placed on the table in the center. Preceding the Gospel of Luke is a misplaced full-page miniature representing James (fol. 146r) seated at the left on a throne, preaching to a crowd at the right. The setting is identical to that of the Mark and Luke portraits. Generally, the figures and architecture are modeled in delicate shades of light blue and green with touches of rich red and deep blue. All miniatures have gold backgrounds and frames of alternating red and blue floral design.

The headpieces to the Gospels of Matthew and Mark (fols. 7r, 90r) are formed of flat, geometrically designed rosettes with four, six, or eight petals either lined up or in a guilloche. The Luke and John headpieces (fols. 149r, fig. 7, and 232r) are filled with different types of rinceaux, the former of lush leaves with sprouts and the latter of cornucopiae. In the Mark headpiece, two amphorae with elegant handles fill the sides of the Π-shaped headpiece, and in the title to John two typical Sassanian palmettes occupy the corresponding space. An incomplete set

of Eusebian canon tables (fols. 2r–3v), framed by simple arches of gold and blue with red outlines, precedes the Gospels.

These are miniatures of great quality; however, when compared to the finest creations of the Macedonian Renaissance, the figures appear constrained by their draperies, unable to move freely. The highlights have been reduced to an abstract pattern, as have the architectural elements, which do not form a coherent structure but are attached to the outer frame and divide the picture surface into sections, denying the scene any sense of space. The figure style has close similarities to two Gospel books: Vatican Lib. cod. gr. 1522 (late ninth or early tenth century) and Oxford, Bodl. Lib. cod. Auct. E. 5.11 (early tenth century).[1] According to K. Weitzmann, the predominance of decorative, unclassical elements indicates a provincial origin for the Baltimore codex.[2]

An early tenth-century Lectionary, Patmos cod. 70,[3] has a similar repertory of ornaments, although codex W524 is closer to the elegant style of the capital; this is made clear by a comparison with the late ninth- or early tenth-century Constantinopolitan manuscript of the Nichomachaean Ethics of Aristotle in Florence (Laur. Lib. cod. Plut. LXXXI, 11).[4]

The upright, rounded letters and the careful script are close to those of a manuscript in Jerusalem (Stavrou cod. 55), dated 927.[5] Although the writing in the Baltimore manuscript is more elegant, the relationship is close enough to support a date for it in the first half of the tenth century.

Although the figures of Peter and Paul are based on standard Evangelist types, their presence at the sides of the Gospel authors is unusual in Byzantine art.[6] The miniature of James preaching, which orig-

inally must have preceded his Epistle, indicates that the Baltimore codex once contained the Epistles and, most likely, the Acts also. Portraits of the four other Epistle writers and Luke, the author of the Acts, quite surely were included among the original illustrations of this manuscript.

Still other miniatures are now missing from codex W524. Four leaves containing feast scenes (the Nativity, Baptism, Annunciation [fig. 6], and Anastasis) are now in the collection of Dr. Siegfried Amberg-Herzog in Kölliken, Switzerland.[7] Their dimensions, style, and coloration, as well as common origin in the R. Forrer collection, leave no doubt that these leaves belonged originally to the Baltimore manuscript. Definite proof is afforded by the offprint of a headpiece and an initial 'B,' matching exactly the first page of Matthew's Gospel,[8] on the reverse of the Nativity miniature. Thus the Nativity originally faced the portrait of Matthew and it may be assumed that the remaining feast scenes also faced Evangelist miniatures.

The association of these four feast scenes with the four Evangelists corresponds to the selection in the Codex Ebnerianus (Oxford, Bodl. Lib. cod. Auct. T. inf. 1.10), a Constantinopolitan manuscript of the early twelfth century. Miss C. Meredith has recognized the liturgical nature of such feast scenes and has explained their relationship to the text of the prologues to the Gospels (see cat. 37, 44).[9] However, the early tenth-century date of the Baltimore codex contradicts her contention that this association is an invention of the Comnenian period.

If the Acts and the Epistles were each preceded by a full-page scene and an author portrait, the Baltimore manuscript would originally have had twenty full-

page miniatures. As reconstructed, this manuscript contains the earliest known antithetical full-page miniatures either preceding the Gospels or the other New Testament books. In addition, its feast scenes reflect the influence of a luxurious late ninth- or early tenth-century Lectionary of which no representative survives.

T.J.-W.

Lent by the Walters Art Gallery

NOTES

1. Weitzmann, *Buchmalerei*, 6, pl. V, figs. 21–24; pl. XXII, figs. 119–20.
2. Weitzmann, "Greek N. T."
3. Weitzmann, *Buchmalerei*, pls. LXXI–LXXIII, figs. 430–37, 440–47.
4. Ibid., 8, pl. VII, fig. 36.
5. Lake, *Manuscripts*, I, pl. 3.
6. J. Weitzmann-Fiedler, "Ein Evangelientyp mit Aposteln als Begleitfiguren," *Festschrift zum 70. Geburtstag von A. Goldschmidt*, Berlin, 1935, 30f.
7. Chatzidakis, Djurić, and Lazović, *Suisses*.
8. Weitzmann, "Greek N. T."
9. Meredith, "Ebnerianus."

+ ΕΥΑΓΓΕΛΙ
ΟΝ ΚΑΤΑ
ΛΟΥΚΑΝ

FIGURE 7. Gospel of Luke
Baltimore, Walters Art Gallery cod. W524, fol. 149r

New York, Pierpont Morgan Lib. cod. M652. *De Materia Medica* and minor works; paraphrases of the *Theriaca* and the *Alexipharmaca* of Nicander and of the *Halieutica* of Oppian. In Greek on vellum. 385 folios (39.0 x 29.0 cm.). Minuscule script. One column of 30 lines (28.9 x 19.3 cm.). 769 half- and quarter-page miniatures. Several simple headpieces and tailpieces. Colophon: folio 89v, non-scribal. Binding: blind-tooled dark brown leather over wooden boards. Condition: miniatures show only minor flaking; several gatherings missing at the beginning.

PROVENANCE: Ex colls. Manuel Eugenicos, Constantinople (1578); Domenico Sestini (ca. 1820); Marchese C. Rinuccini, Florence (1820–49, cod. 69); Payne and Foss, London (1849–57); Charles (1857–ca. 1860/65); and T. Phillipps (ca. 1860/65–1920, cod. 21975). Purchased by The Pierpont Morgan Library in 1920 from the Phillipps estate.

EXHIBITED: New York 1933–34, no. 12, pl. 11; The Pierpont Morgan Library, New York, 1939, *Exhibition Held on the Occasion of the New York World's Fair*, no. 14; The Pierpont Morgan Library, New York, 1947, *Flowers of Ten Centuries*, no. 1, pl. 11; Albright-Knox Art Gallery, Buffalo, 1953–54, *Art in the Book*, no. 2; The Pierpont Morgan Library, New York, 1957, *Treasures from The Pierpont Morgan Library . . .*, no. 9, pl. 2.

BIBLIOGRAPHY (selected): DeRicci and Wilson, *Census*, 1479; Bond and Faye, *Supplement*, 352; O. M. Dalton, *Byzantine Art and Archaeology*, Oxford, 1911, 461; J. Ebersolt, *La Miniature byzantine*, Paris, 1926, 75; C. Singer, "The Herbal in Antiquity and Its Transmission to Later Ages," *Journal of Hellenic Studies*, XLVII, 1927, 25f., ill.; *Pedanii Dioscuridis Anazarbaei de Materia Medica*, I–II, Paris, 1935; Weitzmann, *Buchmalerei*, 34, pl. XLI, figs. 231–33; idem, *Mythology*, 27f., 77, 95, fig. 28; idem, "Das klassische Erbe in der Kunst Konstantinopels," *Alte und Neue Kunst*, III, 1954, 50f., figs. 11, 12, 23, 24 (*Studies*, 138f., figs. 114, 115, 126, 127); E. Mioni, "Un Ignoto Dioscuride miniato. Il codice greco 194 del seminario da Padova," *Libri e stampatori da Padova. Miscellanea di*

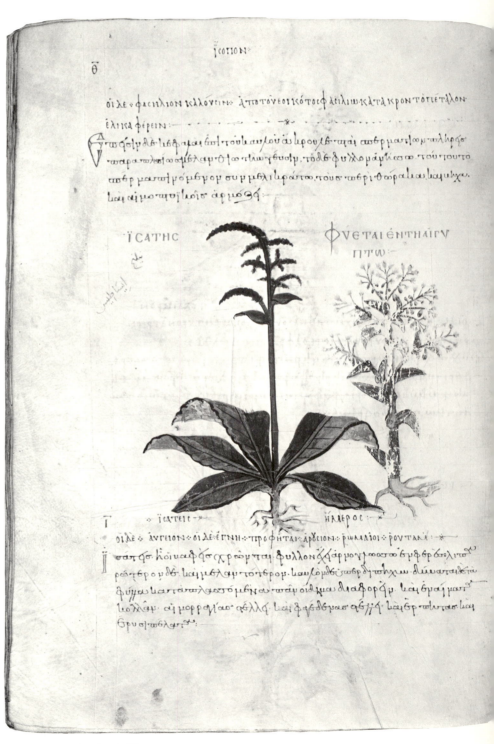

FIGURE 8. The *Isatis Hemeros*
New York, Pierpont Morgan Lib. cod. M652, fol. 68v

*studi storici in onore del Monsignore Giuseppe Bellini*, Padua, 1959, 346f.; K. Weitzmann, *Ancient Book Illumination*, Cambridge, Mass., 1959, 13, 15, figs. 14, 17; Lazarev, *Storia*, 175n.; H. Gerstinger, *Dioscurides, Codex Vindobonensis med. gr. 1 der Österreichischen Nationalbibliothek. Kommentarband zu der Faksimileausgabe*, Graz, 1970, 2f., 8, 51n., ill.; Weitzmann, *Roll*, 86f., 135f., 145, 166f.

Every aspect of this monument of Byzantine science and art points to a date in the mid-tenth century. The widely spaced letters of its upright minuscule script are unmixed with uncials and are accompanied by few breathing marks;[1] the initials and sparse guilloche decoration are unfilled.[2] The palette of the more than 750 unframed illustrations is restricted to green and blue, with only an occasional touch of red or brown.[3] Most of the subjects are plants (fig. 8) or simple animals, but in two pictures there are anatomically correct human figures. One of them, a nude man pouring oil from a jar (fig. 9), resembles an ancient Aquarius.

There is a close parallel to the style of these figures in a Mount Sinai icon, which is probably a faithful contemporary copy of a Constantinopolitan triptych, depicting King Abgarus of Edessa with the features of Constantine Porphyrogennetos, who died in 959.[4] The Apostle Thaddaeus, on the King's right, closely resembles two men in the Morgan Dioscurides who are shown scraping a boat (fol. 240r). Like theirs, his short-nosed face in three-quarter view is delineated by thick dark strokes, and the contours of his bulky garments are emphasized by double lines of folds. The Morgan manuscript, which was once in a collection containing many codices from the Imperial Library, may have been made in the Imperial workshop that presumably produced the original Abgarus triptych. It is, moreover, known that Dioscurides's work was appreciated in the Imperial family: Constantine's son and coregent, Romanos II, sent a monk with an illustrated copy of it to the Caliph of Cordoba to instruct the Arabs in medicine and Greek.[5]

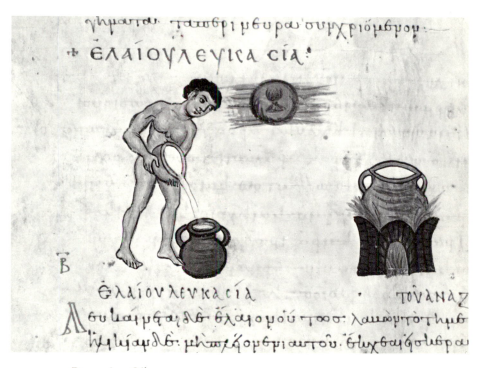

FIGURE 9. Processing Oil
New York, Pierpont Morgan Lib. cod. M652, fol. 225v

Throughout Antiquity and the Middle Ages Dioscurides's *De Materia Medica* was the most popular treatise on remedies in Europe and the Near East.[6] Three of its five books discuss the medicinal uses of animal products, trees, wines, and stones; the other two constitute an herbal describing plants and their uses. Around the third century A.D. the herbal was separated and transformed into a pharmacopoeia, or reference book of medicines, by arranging the plants in alphabetical order. The Greek text was abbreviated and illustrations (borrowed from a pre-alphabetical archetype) were added. The name of each plant was given in fifteen ancient languages, many of which are now extinct. Material from older herbals (including that of Crateuas, the first to be illustrated) was added. The earliest example of this first alphabetical group is the splendid codex now in Vienna produced in Constantinople shortly before 512 for the Princess Juliana Anicia (Nat. Lib. cod. med. gr. 1).[7] A more modest, but still sumptuous, copy in Naples, apparently dating from the seventh century, derives from the same textual model (Bibl. Naz. cod. suppl. gr. 28).[8]

The nonalphabetical, complete, uncontaminated text continued to be copied all the while, in Latin, Arabic, and Syriac, as well as in Greek, often with illustrations. Eventually the individual books of the Greek text were put into alphabetical order. To this second alphabetical group belong the Morgan Dioscurides, a tenth-century manuscript in the Vatican (cod. gr. 284),[9] and later copies in the Great Lavra on Mount Athos (cod. Ω 75),[10] in Venice (Marciana cod. gr. 92),[11] in the Escorial (cod. E. v. 17),[12] and in the Vatican (cod. Urb. gr. 66).[13] The difference between the herbal texts of this alphabetical group and those of the earlier group lies in the greater completeness of the later text, the more systematic nature of its alphabetization, and in the absence of the polyglot names.

The recension of illustration follows a different and still inadequately understood pattern. In many of the extant manuscripts (including those in Vienna and Naples), the text was transcribed around pre-existing pictures, and at least two late copies (Cambridge, Univ. Lib. cod. E.e.5[14] and Vatican Lib. cod. Chigi F.CII, 159[15]) are entirely or partly picture books. This suggests that the pictures sometimes existed independently of the text. A separate picture cycle would account for the persistence of the same illustrations in texts belonging to the two alphabetical groups. Almost all Dioscurides picture cycles, including those accompanying translations in many languages and even the textually unrelated Latin herbal of Pseudo-Apuleus, repeat some of the pictures of the sixth-century Vienna codex. On the other hand, some Dioscurides manuscripts (including Morgan codex M652) show evidence of the existence of a second cycle of illustrations.

In the Morgan codex over half of the plants (245 out of 448) are practically identical to the naturalistic plants in the Vienna codex. Although their size is reduced, they correspond closely in their lower parts, while their upper parts are slightly truncated or condensed to fit into the space allowed by the scribe. There are 41 more plants that presumably would correspond to pictures now lost from the Vienna manuscript. The present first gathering of the New York codex is mutilated and the first plant to come in alphabetical order corresponds to that on folio 49v of the Juliana codex. This means that the original first gatherings, probably containing, in addition to several plant pictures, the same four author portraits as the Vienna manuscript as well as a presentation picture of its own, have been lost. And, among the added texts that are the same as those in the Juliana manuscript, a paraphrase of Nicander's *Theriaca* (concerning remedies for snake and insect bites) also has the same pictures. The added song on the powers of herbs must have had a coral picture like that in the Vienna Dioscurides (fol. 391v).

The Morgan herbal shows evidence of a second model as well. Fifty-eight of the plants described in both the Vienna and the Morgan codices are illustrated by different pictures. Sometimes a second version is set alongside a plant that has a counterpart in the Vienna manuscript (fig. 8). Since some of these alternate plants occur in other Dioscurides manuscripts, notably in the one in Naples,[16] it seems that an alternate cycle of illustrations existed for at least these 58 plants. This second set of paintings was originally made either for a different herbal text, or for some independent edition of Dioscurides.

There is also a third group of miniatures in the Morgan herbal: the 104 rudimentary plants illustrating parts of the text omitted from the Vienna codex. Those same textual passages have quite different and more naturalistic illustrations in the thirteenth-century Mount Athos Dioscurides. The schematic character of the Morgan illustrations and the presence among them of unfilled picture spaces indicate that the model of the Athos illustrations was unknown to the painters of the Morgan manuscript. Perhaps those painters had no model at all for this part of their text.

In spite of its correspondences with the Juliana manuscript, the Morgan Dios-

curides probably depends on a common model rather than on the Vienna codex itself. Of the 245 plant pictures common to both, 121 in the Morgan have suppler, more overlapping forms that suggest more spatial depth and the energy of the plants' growth. Sixty-four are either equally naturalistic or are made up of contradictory elements. Only 60 are less naturalistic than in the Vienna manuscript, and they seem to be by a less skillful hand (fig. 8). Whenever comparisons with the tenth-century Vatican Dioscurides are possible, however, the naturalism of the Morgan and the Juliana codices is always surpassed by that of the modest plants set into the margins of that work.

In conclusion, the Morgan manuscript is representative of a new Renaissance redaction of Dioscurides's complete text. Its illustrators were obliged to rely on two incomplete ancient models that occasionally overlapped, at least in the herbal books. The fuller model is represented in the sixth-century Vienna codex, whose painters, working in the late antique style, made the naturalistic plants of their model more rigid, straightening curves, separating forms, and bringing them into the picture plane. In the tenth century, however, the painters of the Vatican and Morgan manuscripts reproduced more faithfully the suppleness and foreshortening of their antique model.

The illustrations of other parts of the Morgan codex also belong to long traditions. The trees, jars, men, animals, and stones in the other three books of *De Materia Medica* find counterparts both in the Vatican marginal Dioscurides and in the two fifteenth-century picture books. Some of the illustrations of the *Theriaca* paraphrase are present in the Juliana and Lavra manuscripts, and in the two late picture books. They are also present in the

eleventh-century copy in Paris of Nicander's complete text, where they are amplified by explanatory human figures (Bibl. Nat. cod. suppl. gr. 247).[17] Richly documenting several pictorial traditions, the Morgan manuscript, as a luxurious edition of an ancient text apparently made under Imperial patronage with high quality illustrations faithful to antique models, testifies to the effort of the Macedonian emperors to infuse the scientific as well as the literary and religious books of their time with the standards of Antiquity.

A. van B.

Lent by The Pierpont Morgan Library

NOTES

1. See Venice, Marciana cod. 454, dated 968 (Lake, *Manuscripts*, ii, pl. 83).

2. See Oxford, Bodl. Lib. cod. Auct. D.4.1, a Psalter dated 951 (Weitzmann, *Buchmalerei*, pl. lxviii, fig. 406; additional photographs in the Department of Art and Archaeology, Princeton University).

3. The palette of the Joshua Roll (Vatican Lib. cod. Palat. gr. 431) is similarly limited to blue and tan. See *Il Rotulo di Giosuè* (Codices e Vaticanis selecti, v), Milan, 1905.

4. K. Weitzmann, "The Mandylion and Constantine Porphyrogennetos," *Cahiers archéologiques*, xi, 1960, 163f. (*Studies*, 224f.).

5. M. Wellmann, "Dioscurides," *Paulys Real-Encyclopädie der classischen Altertumswissenschaft*, v, 1, Stuttgart, 1903, 1136f.

6. Ibid., 1131f.

7. Gerstinger, *Vindobonensis* (with earlier bibliography).

8. M. Anichini, "Il Dioscuride di Napoli," *Atti della Accademia Nazionale dei Lincei, rendiconti. Classe di scienze morali, storiche e filologiche*, ser. viii, xi, 1956, 77f.; R. Bianchi Bandinelli, "Il Dioscuride Napoletano," *Parola del Passato*, ii, 1956, 48f.

9. Weitzmann, *Buchmalerei*, 34, pl. xli, figs. 229–30. Additional photographs in the Department of Art and Archaeology, Princeton University.

10. Weitzmann, *Roll*, 86, fig. 68; idem, "The Greek Sources of Islamic Scientific Illustrations," *Archaeologica Orientalia in Memoriam Ernst Herzfeld*, Locust Valley, New York, 1952, 253, fig. 9 (*Studies*, 30, fig. 13). Additional photographs in the Department of Art and Archaeology, Princeton University.

11. Photographs in the Department of Art and Archaeology, Princeton University.

12. Photographs in the Department of Art and Archaeology, Princeton University.

13. C. Stornajolo, *Biblioteca Apostolica Vaticana codices manuscriptae*, Rome, 1895, 77f.

14. Photographs in the Department of Art and Archaeology, Princeton University.

15. Weitzmann, "Erbe," 57, figs. 20, 22 (with further bibliography); A. Muñoz, *I Codici greci miniati delle minore bibliotheche di Roma*, Florence, 1906, 45f., pls. 11–14. Additional photographs in the Department of Art and Archaeology, Princeton University.

16. Anichini, "Dioscuride," 96f.

17. Omont, *Miniatures*, pls. lxv–lxxii. See Weitzmann, "Erbe," 53, figs. 14, 15.

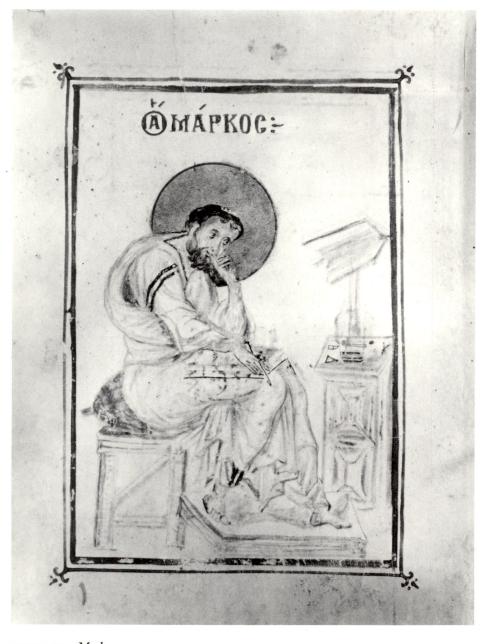

FIGURE 10.  Mark
Baltimore, Walters Art Gallery cod. W527, fol. 1v

Baltimore, Walters Art Gallery cod. W527. In Greek on vellum. 135 folios (20.5 x 14.8 cm.). Minuscule script. One column of 20 lines (13.2 x 8.8 cm.). One full-page miniature and one headpiece. Binding: blind-stamped brown calf over thin wooden boards. Condition: miniature shows only minor flaking; text is incomplete and disordered.

PROVENANCE: Formerly on Mount Athos, Dochiariu monastery. Purchased from Gruel by H. Walters.

EXHIBITED: Boston 1940, no. 1; Baltimore 1947, no. 714, pl. XCVI.

BIBLIOGRAPHY: DeRicci and Wilson, *Census*, 759; Clark, *N. T. Manuscripts*, 357f.; Aland, *Liste*, 185; Diringer, *Book*, pl. II-16c; Lazarev, *Storia*, 252n.

NOTES

1. Weitzmann, *Buchmalerei*, 46, pl. LI, fig. 302; Huber, *Athos*, pl. 39.
2. Weitzmann, *Buchmalerei*, pl. XXV, fig. 141.
3. Ibid., pl. XXVII, fig. 151.
4. Although the miniature is inserted before a full quire of eight leaves, it bears a clear offprint of the facing headpiece, which itself shows close similarities to Vatican Lib. cod. gr. 364 (fol. 85r) and Vienna, Nat. Lib. cod. suppl. gr. 50* (fol. 107r), both dated by K. Weitzmann to the late tenth century (Weitzmann, *Buchmalerei*, 25, 26; photographs in the Department of Art and Archaeology, Princeton University).—Ed.
5. Identification: K. Weitzmann. Cut down, it measures 17.4 x 11.0 cm. Photographs in the Department of Art and Archaeology, Princeton University.
6. Weitzmann, *Buchmalerei*, pl. XXVII, fig. 152.

This Gospel book contains one full-page miniature of the Evangelist Mark framed by a red and blue line (fol. 1v, fig. 10). The Evangelist's name is inscribed above his head in red uncial letters. He is seated in profile at the left before an unpainted background. His right arm rests on a codex in his lap and his left hand touches his cheek thoughtfully. A cabinet and a lectern supporting a codex stand at the right. His garments are very delicately executed in soft pink and blue shadows. The Evangelist's hair and beard are rendered in browns, while the writing implements, his fingers, and facial features are sharply delineated by fine black lines. His halo is golden, outlined in red. The headpiece to the Gospel of Mark (fol. 2r) is a narrow, ⊓-shaped band of alternating leaves and circles filled with petal ornament in the finest style. Palmettes project from its upper corners and small treelike motifs decorate the margins. Its colors include brilliant shades of red, blue, and green against a gold ground.

The miniature's high quality and subtle technique suggest a Constantinopolitan origin. The use of a delicate color harmony creating the effect of watercolor in which the only strong accent is the solid gold nimbus is paralleled in an early tenth-century Gospel book on Mount Athos (Philotheu cod. 33).[1] The soft, painterly treatment of Mark's face and his wide-open eyes are comparable to features of a later tenth-century manuscript from Mount Athos (Vatopedi cod. 456).[2] Figure proportions, pose, and drapery, however, are extremely close to those of Matthew in Athens, Nat. Lib. cod. 56 (fol. 4v), datable to the third quarter of the tenth century.[3] A similar date is indicated for the Mark miniature.[4] The only significant difference between the Baltimore and the Athens miniatures

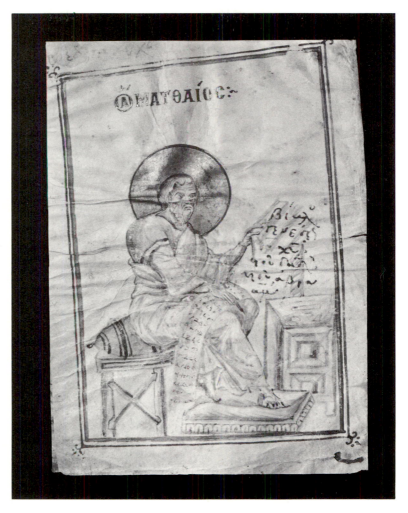

FIGURE 11. Matthew
Mount Athos, Dochiariu cod. 56

is the head types distinguishing the two Evangelists.

A companion miniature,[5] identical in style, technique, and dimensions, has been found inserted in a twelfth-century Gospel book, Mount Athos, Dochiariu cod. 56 (fig. 11). It represents Matthew and must originally have belonged to the same set as the Baltimore Mark. The pose, drapery, and proportions of the Dochiariu Matthew correspond closely to those of Mark in the Athens Gospel book except for the characteristic difference in head type and the omission in the Athens miniature of the scroll on the Evangelist's lap.[6]

T.J.-W.

Lent by the Walters Art Gallery

# Leaf from a Lectionary: Mark

Baltimore, Walters Art Gallery cod. W530a. Single vellum leaf (26.5 x 19.0 cm.). One full-page miniature. Reverse blank. Condition: minor flaking.

PARENT MANUSCRIPT: Serres, Prodromos cod. 17. Lectionary (27 x 19 cm.). Baltimore leaf preceded Mark readings. Identification: K. Weitzmann.

PROVENANCE: Purchased from Gruel by H. Walters.

EXHIBITED: Boston 1940, no. 2, pl. II; Baltimore 1947, no. 701, pl. xcvi; Oberlin 1957, 43, no. 2, fig. 2.

BIBLIOGRAPHY: DeRicci and Wilson, *Census*, 826; Clark, *N. T. Manuscripts*, 360f. (with further bibliography); Aland, *Liste*, 149; Diringer, *Book*, pl. II-16a; Lazarev, *Storia*, 174n.

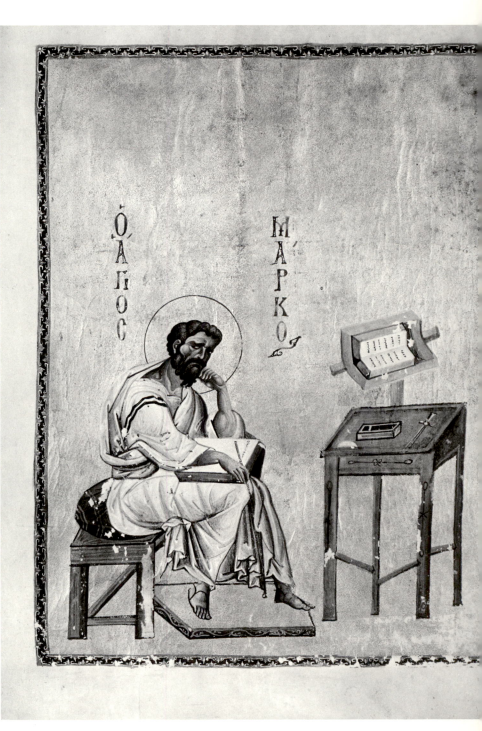

FIGURE 12. Mark
Baltimore, Walters Art Gallery cod. W530a

This single folio (fig. 12) bears a full-page portrait of the Evangelist Mark, framed by a narrow ornamental band. Mark's name is inscribed in red uncial letters on the plain gold background; he is seated on a cushioned bench and faces toward the right. His feet are placed on a low footstool, his right arm rests on an open codex on his lap, and his left hand is raised to his chin in a pensive gesture. At the right stands a desk, with compass and inkwell, and a lectern supporting an open book. The Evangelist's head and draperies are modeled with great care. Clear shades of white, pale blue, and rose predominate.

The miniature is executed in the finest Constantinopolitan style, with the plasticity of the forms fully apparent. Nevertheless, the tense attitude of the Evangelist, with his head pushed forward and his legs thrown vigorously apart, and the mannered draperies with a tendency to bunch up indicate a date somewhat later than the purest creations of the Macedonian Renaissance, such as Mount Athos, Stavronikita cod. 43. The intense contraction of Mark's eyebrows and forehead produces a restless, searching gaze typical of Constantinopolitan manuscripts of the very late tenth century, such as Vatican Lib. cod. gr. 364.[1] In style and pose the Baltimore leaf is closely related to the Vatican Mark. Only the architectural setting etched on the gold ground of the Vatican portrait is omitted.

The identification of the Walters Art Gallery leaf with its parent manuscript, Serres, Prodromos cod. 17, is based on an old photograph (fig. 13) which shows the miniature in its original position opposite a title page whose text and classical petal ornament support the date proposed on the basis of the miniature's style.

T.J.W.

Lent by the Walters Art Gallery

NOTE

1. Weitzmann, *Buchmalerei*, 25, pl. xxxiv, figs. 192–93.

FIGURE 13. Mark
Olim Serres, Prodromos
cod. 17

9.

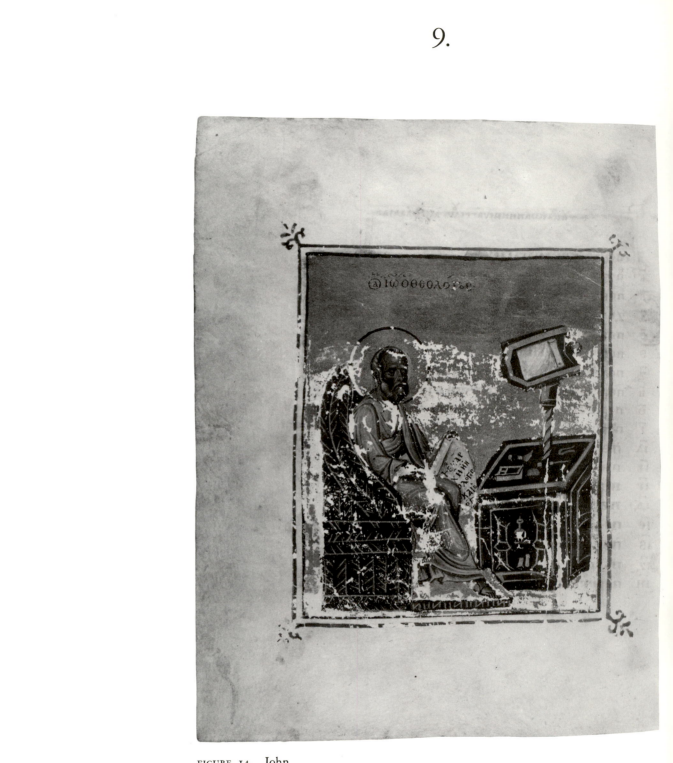

FIGURE 14. John
New Haven, Yale Univ. Lib. cod. 150, vol. II, fol. 87v

# The Four Gospels *Early Eleventh Century*

New Haven, Yale Univ. Lib. cod. 150. The four Gospels bound in two volumes. In Greek on vellum. Vol. I (Matthew, Mark): 117 folios; vol. II (Luke, John): 148 folios (both 17.0 x 13.7 cm.). Minuscule script. One column of 20 lines (10.5 x 7.5 cm.). Three full-page miniatures and three headpieces. Binding: vol. I: bound about 1904 in white vellum; vol. II: bound in orange morocco in 1961. Condition: vol. I: folios 1–8 damaged, text begins with Matthew 5:17; miniatures and headpieces of both volumes show extensive flaking.

PROVENANCE: Volume I purchased in two parts by T. D. Seymour in Serres in 1903. Given by Mrs. Seymour to her daughter, Mrs. G. C. St. John, in 1914. Given by Mrs. St. John to the Yale University Library in 1947. Volume II purchased by H. P. Kraus through Sotheby in London, 1960. Acquired in 1967 from Kraus by Yale University.

BIBLIOGRAPHY: DeRicci and Wilson, *Census,* 178; Bond and Faye, *Supplement,* 35, 103; Clark, *N. T. Manuscripts,* 194f. (with further bibliography), pl. XXXVI; H. P. Kraus and Co., *Catalogue 100: Thirty-five Manuscripts,* New York, n.d., no. 2, ill., pls. II, III; Aland, *Liste,* 149; T. E. Marston, "The Seymour Gospels Reunited," *Yale University Library Gazette,* XLII, 1967, 211f.

The Evangelist Mark (I, fol. 68v), dressed in a blue tunic and rose mantle, is seated in profile to the left of an open desk in which are visible an ink bottle and several rotuli. He holds a jewel-studded codex in his left hand and touches his chin contemplatively with his right. Luke (II, fol. 3v), seated in profile on a blue cushion before a dark brown desk, is clothed in garments of brownish gray and rose. Hunched over, he writes intently in an open codex held on his lap. Seated in a high-backed wicker chair to the left in his miniature, John (II, fol. 87v, fig. 14) gazes ahead thoughtfully. Dressed in a gray mantle and blue tunic, he holds a rotulus bearing the opening words of his Gospel in red uncial letters.

An illuminated headpiece and a large ornamental initial mark the beginnings of the Gospels of Mark, Luke, and John (Matthew's portrait and the first five chapters of his Gospel are lost). Each consists of simplified palmettes enclosed either by circles or an interlace and rendered in green, blue, red, and purple against a gold background. Lush berry-tipped leaves sprout from the upper corners of the Mark and Luke headpieces, and a large multitiered palmette crowns their centers.

The portraits of Luke and John, as well as the manuscript's spidery, hieratic minuscule script, show close similarities to the Vienna Gospel book, Nat. Lib. cod. suppl. gr. 50*, dated by K. Weitzmann to the late tenth century.[1] Lighter figural proportions as well as the relaxation of the tense poses of the overmuscular Vienna Evangelists and the absence of mannered, reduplicated drapery motifs characteristic of the late tenth century would seem to indicate a slightly later date for the Yale Gospels, in the early decades of the eleventh century.

G.V.

Lent by Beinecke Rare Book and Manuscript Library, Yale University

NOTE

1. Weitzmann, *Buchmalerei,* 26, pl. XXXV, figs. 196, 197; P. Buberl and H. Gerstinger, *Die Byzantinischen Handschriften: 2. Die Handschriften des X.-XVIII. Jahrhunderts,* Leipzig, 1938, pls. IV, V.

Princeton, Scheide Lib. cod. M1. In Greek on vellum. 268 folios (19.8 x 16.0 cm.). Minuscule script. Two columns of 22 lines (12.5 x 4.3 x 9.5 cm.). Two full-page text frames, eight canon tables, and four headpieces. Colophons: folios 6r, 268v, non-scribal. Binding: blind-stamped dark red leather over wooden boards. Condition: illumination shows only minor flaking and rubbing.

PROVENANCE: In the early twentieth century in the monastery of the Prodromos, Serres (cod. $\overline{\gamma}$ 14). Acquired by J. Scheide in 1922 from J. Baer.

BIBLIOGRAPHY: DeRicci and Wilson, *Census*, 2120; Clark, *N. T. Manuscripts*, 196f. (with further bibliography), pl. XXXVII; Aland, *Liste*, 149.

The letter of Eusebius to Carpianus (fols. 1v–2r) occupies a quatrefoil field within a large rectangular frame decorated by a simple red carpet pattern. Two peacocks confront one another at the top of both leaves. Eight canon tables in four matching pairs follow on folios 2v to 6r (fig. 15). Each consists of two small arches spanned by a larger arch supported on two slender columns. The tympana and arches are ornamented with fretwork palmettes and tendrils, crenellations, and netlike carpet patterns. A liberal use of red ink is combined with a generally subdued palette of prussian blue, blue-green, and touches of coral. The pairs of birds juxtaposed above each arch are rendered in more subtle and varied tones of yellow, pink, purple, and orange.

In contrast to the canon tables, the headpieces of the four Gospels (fols. 9r, fig. 16; 83r, 133r, 211r) are characterized by sumptuous vegetal forms. Fleshy acanthus foliage, intricate tendrils, miniature flowers, and small naturalistic birds stand out against a dazzling gold ground. The large initials marking the beginning of each Gospel are lined with numerous delicate flower blossoms.

These two types of ornament, both integral to the Scheide Gospels,[1] represent two different traditions in Byzantine manuscript illumination. The fretwork motifs of the canon tables are characteristic of Constantinopolitan illumination of the tenth century.[2] The colorful palette and absence of gold indicate that the Scheide canon tables belong to the last phase of the ornament's evolution.[3] The head-

pieces, on the other hand, are filled with leafy flower-petal motifs, a form of decoration that appeared for the first time around the mid-tenth century and soon thereafter dominated Byzantine manuscript illumination.[4] The varied leafy tendrils inhabited by naturalistic birds found in the Scheide headpieces may be compared with the ornament in Turin, Univ. Lib. cod. B.I,2, datable around 1000.[5]

B.A.V.

Lent by the Scheide Library, Princeton

NOTES

1. Although the Eusebius letter and canon tables form an independent quire, their association with the Gospel texts is established by an exact correspondence of script as well as by the presence of naturalistically rendered birds in both the canon tables and headpieces. For the presence of fretwork and flower-petal ornament in the same manuscript, see Athens, Nat. Lib. cod. 56 (Weitzmann, *Buchmalerei*, pl. XXVII, figs. 148, 150).
2. Weitzmann, *Buchmalerei*, 18f.
3. Ibid., 21f. See Paris, Bibl. Nat. cod. suppl. gr. 75 (J. Ebersolt, *La Miniature byzantine*, Paris, 1926, pl. XLI).
4. Weitzmann, *Buchmalerei*, 22f.
5. Ibid., 28, pl. XXXVII, fig. 208.

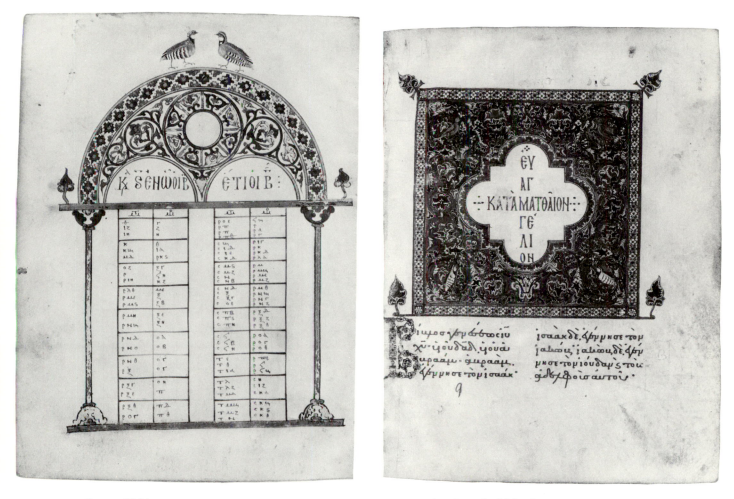

FIGURE 15.  Canon Table
Princeton, Scheide Lib. cod. M1, fol. 4v

FIGURE 16.  Gospel of Matthew
Princeton, Scheide Lib. cod. M1, fol. 9r

† ἄθλησις τῶν ἁγίων καὶ
ἐνδόξων τοῦ χυ μ̅ρ̅τ̅ θε
οπέμπτου καὶ θεωνᾶ :

Πολλοὶ μὲν καὶ πολλάκις και
ρὰχ · ἰσι ἂμ̅ βασιλεῖσ θ
κιρήθησαμ · καὶ ὥσ θῆρες
ἄγριοι τὰ τοῦ ἀληθινοῦ καὶ
πρώτου ποιμένος χυ δὲ
διαχαραζαμ πρόβατα τὰ
ἀλλότρια πᾶν τὸ σ ἄκολὸ
θωσ τε· ὅμ καὶ ἂμ̅ ρατω
κτόμ ὁ βζάρχισ ἔιμαὶ ὅ π̅ρ̅
ἂπ̅ ε̅δ̅ήλατο· τοῦτομ δὲ
πᾶμ τομ̅ τὴμ πομηρίαμ̅ ὁ
ἀτομ̅ώτατοσ γάρμ ὁ· διο
κλητιαμοσ ὁ πᾶράμομοσ

τύραμμοσ· καὶ τοσ̅ υπομ· ῶσ
τε καὶ τὰ τομ̅ ἄλλομ̅ κατὰ
τομ̅ δοβιωμ̅ τω̅ ὑπηρολί
μαται· ὁ ποικίλα μασαμι
στήρια· τοῖσ τούτου πᾶρα
τιθομένω φιλαγίαμ αὐτοῖσ
προσμαρτυρεῖν καὶ πᾶρα
ότηματ· φιλοτιμότερο
γὰρ ἄχμρο ἁλιτήριοσ· π̅ῶ
τὸ. πᾶμ τομ̅ δ ειχθῆμαι τῶ
κατὰ χῦ καὶ τωμ̅ αὐτοῦ μα
νερ̅ ωτ· ὴ καὶ μαμ̅ σομ̅ βμ̅ ρ̅ω̅
πωστ̅· ὡ μὅτεροσ τ̅ε καὶ
φορικώτεροσ· ἐκαὶ ἂμ̅ ρμύ
τοισ ὁωιχιραῦμ ἄρ̅· δ̅υ̅μ̅οσ
διάδεκτου πῶμ̅ ἐρ̅ τρος

FIGURE 17. Martyrdom of Theopemptos and Theonas (January 4)
Baltimore, Walters Art Gallery cod. W521, fol. 25r

# Menologion for January

*Circa 1040 A.D.*

Baltimore, Walters Art Gallery cod. W521. In Greek on vellum and paper. 295 folios (30.1 x 23.2 cm.). (Folios 1–11, 22, 34, 178–91, 256–95 are paper.) Minuscule script. Two columns of 26 lines (23.0 x 6.4 x 14.8 cm.). Twenty-four two-column, one-third page miniatures. Binding: rebound in 1963 with red leather over wooden boards. Condition: some miniatures are flaked and the worn edges of some folios have been repaired; a number of missing leaves have been restored by a later hand on paper.

PROVENANCE: Once in the hands of an Armenian who added quire numbers at the beginning. Until shortly before 1914 in the Greek Patriarchal Library of Alexandria (cod. 33). Purchased around 1930 in Paris by H. Walters.

EXHIBITED: Boston 1940, no. 3, pl. II; Baltimore 1947, no. 707, pl. XCIX; Athens 1964, no. 360.

BIBLIOGRAPHY: DeRicci and Wilson, *Census*, 760; Bond and Faye, *Supplement*, 194; P. Van den Ven, "Inventaire sommaire des mss. grecs de la bibliothèque patriarcale du Caire," *Le Muséon*, XV, 1914, 65f.; F. Halkin, "Le Mois de janvier du 'ménologe impérial' byzantin," *Analecta Bollandiana*, LVII, 1939, 225f.; Ehrhard, *Überlieferung*, III, 1, 396f.; H. Swarzenski, *The Berthold Missal*, New York, 1943, 43n.; T. D. Moschonas, "Histoire étrange d'un manuscrit enluminé alexandrin du XIe siècle, perdu et retrouvé," *Revue des conférences françaises en orient*, 1946, 1f., ill.; K. Weitzmann, "Byzantine Art and Scholarship in America," *American Journal of Archaeology*, LI, 1947, 399, 405, pl. CIXb; Martin, *Climacus*, 33, 38; S. Der Nersessian, "The Illustrations of the Metaphrastian Menologium," *Late Classical and Mediaeval Studies in Honor of Albert Mathias Friend, Jr.*, ed. K. Weitzmann, Princeton, 1955, 231; Miner, "Monastic," 238n.; G. and M. Sotiriou, *Icones du Mont Sinai*, II, Athens, 1958, 122; I. Ševčenko, "The Illuminators of the Menologium of Basil II," *Dumbarton Oaks Papers*, XVI, 1962, 267, figs. 7, 9; P. Mijović, "Une Classification iconographique de ménologes enluminés," *Actes du XIIe congrès international d'études byzantines, Ochrid, 1961*, III, Belgrade, 1964, 276, 279; Lazarev, *Storia*, 175n.; Weitzmann, "Eleventh Century," 208f., pls. 2, 5; Weitzmann, *Roll*, 204, 261; C. Walter, "Liturgy and the Illustration of Gregory of Nazianzen's Homilies," *Revue des études byzantines*, XXIX, 1971, 189, 196.

The Baltimore menologion consists of twenty-one saints' lives and three related texts arranged on consecutive days during the month of January.[1] Each text is preceded by a horizontal, two-column miniature. Ten of these miniatures depict dramatic scenes of martyrdom, most often in a mountainous landscape. In some a single saint is represented with his executioner (fols. 50v, 56v, 86r, 200r) while in others several saints are shown dying together (fols. 25r, fig. 17; 88r, 92v, 207v). Two miniatures include both the martyrdom and burial of the saint (fols. 36r, 203v, fig. 18). In nearly every case the face of the executioner and his weapon have been later scratched out.

The second largest group of miniatures (eight) are frontal portraits of church fathers, bishops, and holy men standing before draped architectural backgrounds which ultimately derive from the *scenae frons* of the Roman theater (fols. 61r, 70v, 96r, fig. 19; 129v, 151r, 155v, 158v, 234v). The one exception is Euthymios (fol. 158v), who is depicted in a mountainous landscape appropriate to his hermit life. A third group of miniatures represents the natural death of a saint in the presence of his closest followers (fols. 28r, 113v, 228r). In addition to these hagiographic illustrations, there are two New Testament scenes—the Baptism of Christ (fol. 38r) and John the Baptist Preaching (fol. 48v)—as well as a liturgical scene—the Veneration of the Chains of Peter (fol. 105r).

Each miniature is framed by two thin lines, the inner blue and the outer red. The figures, whether lively or dignified, are depicted against dazzling gold backgrounds. Foregrounds are usually decorated with delicate flowers and stylized plants on an undulating groundline. Spatial recession is implied by means of

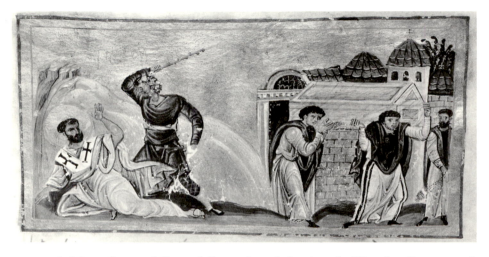

FIGURE 18. Martyrdom and Funeral Procession of the Apostle Timothy (January 22) Baltimore, Walters Art Gallery cod. W521, fol. 203v

small obliquely placed buildings nestled between hillocks and mountains. A church with three cupolas, possibly reflecting the now destroyed Church of the Holy Apostles in Constantinople, is depicted behind the martyrdom and funeral procession of the Apostle Timothy on folio 203v (fig. 18).

The Baltimore miniatures are distinguished by an unusually rich palette. Warm browns, ochres, blue-greens, lavenders, and purples, as well as dark blues and reds are used in the landscapes. In several of the scenes with architectural backdrops a more strident, garish color scheme predominates, consisting of pinks and reds, yellows, oranges, and bright greens. These coloristic differences suggest that at least two artists were responsible for the miniatures, although the possibility of several hands should not be excluded.

Walters Art Gallery codex W521 is the only surviving text of the lives of the saints honored in Constantinople for January in the redaction known as the Imperial Menologion.[2] Although it is generally agreed that the pictorial model for the Baltimore manuscript is the Menologion of Basil II (Vatican Lib. cod. gr. 1613), datable to the late tenth century,[3] several scenes demonstrate that the artists of the January menologion were not slavish copyists. Lacking a specific model for the representation of Zoticos (fol. 50v), the Baltimore illuminator borrowed elements from the martyrdom of Orestes of Tyana (Vatican Lib. cod. gr. 1613, p. 172) and freely combined them with other invented or borrowed motifs. The figures of the Baltimore manuscript are elongated and somewhat more ethereal, reflecting eleventh-century Constantinopolitan stylistic trends.[4]

An acrostic at the end of each of the twenty-four texts of codex W521 spells out the name 'Michael P.' F. Halkin interpreted this to mean that the meno-

logion was written for Emperor Michael IV, the Paphlagonian (1034–41).[5] I. Ševčenko, on the other hand, has pointed out two weaknesses in this theory: there is no evidence that Emperor Michael was called Paphlagonian in official addresses during his lifetime; and in most cases an acrostic indicates the author or instigator of a text rather than its addressee. He has further pointed out that the closing prayers on behalf of the emperor contained in the Imperial Menologion end with a phrase starting with the word *kai* (and). If the letter 'K' of *kai* were considered as part of the acrostic, one would obtain 'Michael P K'; this might be interpreted as Michael the *Patriarch, Keroullarios* (1043–58).[6]

Restored sections, which bring the number of biographies in the Baltimore menologion to thirty-two (there is none for January 29), indicate that at least eight additional miniatures were probably in the original codex. A badly flaked single leaf in Berlin (Staatsbibl. cod. gr. fol. 31) depicting Silvester (January 2) is one of these, having been detached from its parent manuscript before 1866.[7]

Codex W521 may have been part of an ambitious set of hagiographic volumes that perhaps included the Moscow menologion for February and March (Hist. Mus. cod. gr. 183), whose size and format correspond closely to the Baltimore manuscript.[8] Several leaves in the Benaki Museum in Athens also appear to be related.[9] On the other hand, further evidence suggests that several sets of menologia may have been produced in Constantinople during the mid-eleventh century. Their immediate influence is clearly reflected in Lectionaries such as Mount Athos, Dionysiou cod. 587, and calendar icons such as those on Mount Sinai.[10]

B.A.V.

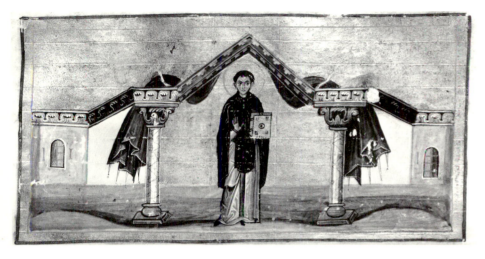

FIGURE 19. John the Calybite (January 15)
Baltimore, Walters Art Gallery cod. W521, fol. 96r

Lent by the Walters Art Gallery

NOTES

1. The lives run from January 4 to January 25 with two lives each for January 5 and 18. January 1–3 and 26–31 (excluding January 29) are restorations on paper. Folios 291v–295v include the eulogy of John Chrysostom on Meletios, Archbishop of Antioch.

List of miniatures:

Jan. 4 Theopemptos and Theonas, fol. 25r.
5 Paul the Thebaite, fol. 28r.
5 Micah the Prophet, fol. 36r.
6 Baptism of Christ, fol. 38r.
7 John the Baptist Preaching, fol. 48v.
8 Zoticos the Guardian, fol. 50v.
9 Polyeuctos of Armenia, fol. 56v.
10 Marcian of Constantinople, fol. 61r.
11 Theodosius the Coenobiarch, fol. 70v.
12 Tatiana of Rome, fol. 86r.
13 Hermylos and Stratonicos, fol. 88r.
14 The Holy Fathers Martyred at Raithou, fol. 92v.
15 John the Calybite, fol. 96r.
16 Veneration of Chains of Peter, fol. 105r.
17 Anthony the Great, fol. 113v.
18 Athanasios Patriarch of Alexandria, fol. 129v.
18 Cyril Patriarch of Alexandria, fol. 151r.
19 Theodoros of Cyrenia, fol. 155v.
20 Euthymios the Great, fol. 158v.
21 Neophytos of Nicaea, fol. 200r.
22 Apostle Timothy, fol. 203v.
23 Clement of Ancyra, fol. 207v.
24 Eusebia of Mylassa, fol. 228r.
25 Gregory Nazianzenus, fol. 234v.

2. Halkin, "Janvier," 227f.
3. *Il Menologio di Basilio II* (Codices e Vaticanis selecti, VIII), Turin, 1907; S. Der Nersessian, "Remarks on the Date of the Menologium and Psalter Written for Basil II," *Byzantion*, xv, 1940–41, 104f.
4. Weitzmann, "Eleventh Century."
5. Halkin, "Janvier," 228f.
6. This information was kindly communicated to me by Professor Ševčenko in a letter dated October 2, 1972.
7. Olim cod. gr. 269. Halkin, "Janvier," 231.
8. D. Tréneff, *Miniatures du ménologe grec du XIe siècle No. 183 de la Bibliothèque Synodale à Moscou*, Moscow, 1911. 259 folios (32 x 23 cm.). Two columns of 29 lines (same writing area as cod. W521).
9. Photographs in the Department of Art and Archaeology, Princeton University.
10. Weitzmann, "Eleventh Century," 213f.

Cleveland, Museum of Art cod. acc. no. 42.152. The four Gospels with commentary. In Greek on vellum. 428 folios (28.0 x 23.4 cm.). Minuscule script. One column of 29 lines (20.0 x 12.5 cm.). Four headpieces and four historiated initials. Colophon: folio 427r, non-scribal. Binding: dark brown leather over wooden boards. Condition: beginning and end mutilated and discolored by red mold; some water damage, repairs; folio 324 is cut out of the manuscript.

PROVENANCE: Said to have come from a Greek monastery at Trebizond. Ex coll. D. G. Kelekian (1931–42). Purchased from Kelekian in 1942 by the Cleveland Museum of Art.

EXHIBITED: Baltimore 1947, no. 704, pl. XCIX; Cleveland Museum of Art, Cleveland, 1964, *Twelve Masterpieces of Mediaeval and Renaissance Book Illumination*, no. 3, fig. 3 (*Bulletin of the Cleveland Museum of Art*, LI, 1964, 41f.).

BIBLIOGRAPHY: Bond and Faye, *Supplement*, 428; Clark, *N. T. Manuscripts*, 122f., pl. XXVII; W. Milliken, "Byzantine Manuscript Illumination," *Bulletin of the Cleveland Museum of Art*, XXXIV, 1947, 5of., ill.; W. Milliken, "Early Christian and Byzantine Art in America," *Journal of Aesthetics and Art Criticism*, V, 1947, fig. 2; C. Diehl, *Byzantium— Greatness and Decline*, New Brunswick, N.J., 1957, 231, ill.; Aland, *Liste*, 149; Lazarev, *Storia*, 250n.

FIGURE 20. John Cleveland, Museum of Art cod. acc. no. 42.152, fol. 324r

The four Gospels in this manuscript are adorned with ornamental headpieces and initials containing tiny Evangelist portraits (figs. 20, 21). Each of the four headpieces consists of a rectangular frame decorated with floral or geometric designs and surmounted by a "fountain of life" flanked by peacocks or quail. Several of the birds and fountains have been pricked, presumably for pouncing. The portrait of Matthew has been completely obliterated, but the other figures are meticulously rendered despite their minute size. They seem superior in quality to the flat, rather broadly handled animals and headpiece decoration. The faces, especially, convey vividly a sense of internal life, even pathos.

The refined miniaturistic style and use of striated gold highlights in the garments are characteristic of much eleventh-century Byzantine illumination; but the figure style of the Cleveland Evangelists, in particular the softly painted faces with their intense glances, closely recalls certain of the finest manuscripts from the third quarter of the century, such as a Gospel book in Vienna (Nat. Lib. cod. theol. gr. 154)[1] and the homilies of Gregory Nazianzenus in the Vatican Library (cod. gr. 463), dated 1062.[2]

H.L.K.

Lent by the Cleveland Museum of Art, J. H. Wade Fund

NOTES

1. Lazarev, *Storia*, figs. 195–201.
2. Galavaris, *Gregory*, figs. 78–93.

ΕΥΑΓΓΕΛΙΟΝ ΚΑΤΑ Λ

FIGURE 21.  Luke
Cleveland, Museum of Art cod. acc. no. 42.152, fol. 200r

13.

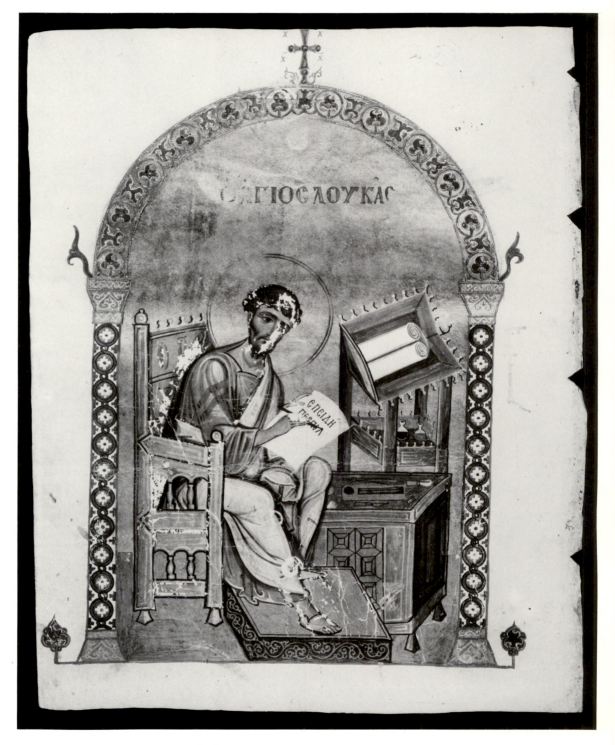

FIGURE 22. Luke
Cleveland, Museum of Art cod. acc. no. 42.1511

# Leaf from a Lectionary: Luke

Cleveland, Museum of Art cod. acc. no. 42.-1511. Single vellum leaf (28.7 x 22.7 cm.). One full-page miniature. Reverse blank. Condition: flaked around the Evangelist's face and in areas of the throne.

PARENT MANUSCRIPT: Istanbul, Library of the Phanar School, Lectionary. Cleveland leaf preceded Luke readings.

PROVENANCE: Monastery of the Holy Trinity at Chalki. Until the 1920s in the library of the Phanar School, Istanbul. Ex coll. D. G. Kelekian, New York. Purchased in 1942 by the Cleveland Museum of Art. (For a short time inserted into a Gospel book, Cleveland, Museum of Art cod. acc. no. 42.152, cat. 12.)

EXHIBITED: Baltimore 1947, no. 700, pl. XCVIII; Seattle Museum of Art, Seattle, 1949, "Early Christian and Medieval Art"; Chapman Gallery, Milwaukee-Downer College, Milwaukee, 1955, "Liturgical Arts"; Oberlin 1957, 43, no. 4, fig. 4; Athens 1964, no. 309.

BIBLIOGRAPHY: Bond and Faye, *Supplement*, 428; Clark, *N. T. Manuscripts*, 122f. (with further bibliography); V. Lazarev, "The Mosaics of Cefalu," *Art Bulletin*, XVII, 1935, 209n.; W. Koehler, "Byzantine Art in the West," *Dumbarton Oaks Papers*, I, 1941, 77n.; W. Milliken, "Byzantine Manuscript Illumination," *Bulletin of the Cleveland Museum of Art*, XXXIV, 1947, 50f., ill.; R. Devreesse, *Introduction à l'étude des manuscrits grecs*, Paris, 1954, 98; W. Wixom, "The Byzantine Art Exhibition at Athens," *Art Quarterly*, XXVII, 1964, 468, fig. 21; Lazarev, *Storia*, 188, 248n.; W. Wixom, "A Manuscript Painting from Cluny," *Bulletin of the Cleveland Museum of Art*, LVI, 1969, 131n., fig. 2; Putzko, "1061," 38.

A youthful Luke (fig. 22), clad in pale blue and pink robes, is seated on a high-backed throne writing his Gospel. Behind him, set against the gold background, are a desk and a tall lectern with his writing implements and a rotulus. The miniature is framed by pillars with chain-circle patterns surmounted by an arch of blue floral design.

This leaf was cut from a Lectionary[1] once in the Phanar School, Istanbul, which according to its colophon was commissioned shortly after 1057 by the Empress Catherine Comnene and presented by her to the monastery of the Holy Trinity at Chalki in 1063.[2] It is characteristic of Constantinopolitan style around the middle of the eleventh century. The classicizing aspects of the Macedonian Renaissance are not entirely lost in the fully modeled face and garments of the seated Evangelist; but the drapery folds and the treatment of light on the furniture have become conventional. Furthermore, the flat ornament of the frame and the tilting of the lectern reveal a planarity that is also found in such contemporary manuscripts as Paris, Bibl. Nat. cod. Coislin 21,[3] but is absent from the finest products of the previous century.

Of the three other Evangelist portraits from the Phanar Lectionary, that of Matthew is also in Cleveland (cat. 14); that of Mark was in the Guerson collection in Paris but has not recently been located (fig. 23)[4]; and that of John seems to have been lost.

H.L.K.

Lent by the Cleveland Museum of Art, J. H. Wade Fund

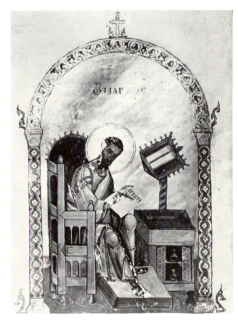

FIGURE 23. Mark
Location unknown

NOTES

1. The Matthew, Mark, and Luke pages all bear offprints of the opening initials of their Lectionary texts.
2. C. Diehl, "L'Évangélaire de l'impératrice Catherine Comnène," *Comptes rendus de séances de l'Académie des Inscriptions et Belles-lettres*, Paris, 1922, 243f.; and idem, "Monuments byzantins inédits du onzième siècle," *Art Studies*, V, 1927, 9.
3. Omont, *Miniatures*, pl. LXXXIII; Lazarev, *Storia*, 188, 248n.
4. Musée des Arts Décoratifs, Paris, 1931, *Exposition internationale d'art byzantin*, no. 653 (Mark). Diehl, "Monuments," reproduced all four Evangelist portraits.

# Leaf from a Lectionary: Matthew

Cleveland, Museum of Art cod. acc. no. 42.-1512. Single vellum leaf (28.4 x 24.5 cm.). One full-page miniature. Reverse blank. Condition: some flaking on Matthew's right shoulder and along the bottom of the miniature.

PARENT MANUSCRIPT: Istanbul, Library of the Phanar School, Lectionary. Cleveland leaf preceded Matthew readings.

PROVENANCE: Same as cat. 13.

EXHIBITED: Baltimore 1947, no. 700, pl. XCVIII; Seattle Museum of Art, Seattle, 1949, "Early Christian and Medieval Art"; William Rockhill Nelson Gallery of Art, Kansas City, 1954–55, "Ecclesiastical Art"; Oberlin 1957, 43, no. 3, fig. 3; University of California, Berkeley, 1963, *Pages from Medieval and Renaissance Illuminated Manuscripts*, no. 5, pl. VI; Athens 1964, no. 309.

BIBLIOGRAPHY: Bond and Faye, *Supplement*, 428; Clark, *N. T. Manuscripts*, 122f. (with further bibliography); V. Lazarev, "The Mosaics of Cefalu," *Art Bulletin*, XVII, 1935, 209n.; W. Koehler, "Byzantine Art in the West," *Dumbarton Oaks Papers*, I, 1941, 77, fig. 16; W. Milliken, "Byzantine Manuscript Illumination," *Bulletin of the Cleveland Museum of Art*, XXXIV, 1947, 50f., ill.; Devreesse, *Introduction à l'étude des manuscrits grecs*, Paris, 1954, 98; Cleveland Museum of Art, *Handbook*, Cleveland, 1958, no. 84, ill.; ibid., 1966, 40, ill.; K. Weitzmann, "Various Aspects of Byzantine Influence on the Latin Countries from the Sixth to the Twelfth Century," *Dumbarton Oaks Papers*, XX, 1966, 21, fig. 37; Lazarev, *Storia*, 188, 248n.; W. Wixom, "A Manuscript Painting from Cluny," *Bulletin of the Cleveland Museum of Art*, LVI, 1969, 131n., fig. 1; Putzko, "1061," 38.

Matthew (fig. 24), clothed in robes of ochre, pale blue, and ivory, is seated at work on a benchlike throne with a red cushion. Upon the desk in the background are his writing tools, which include an ink bottle, scraping knives, a stylus, and a small chain. The miniature is framed by a delicately patterned arch resting on two brown marble columns with acanthus leaf capitals and bases.

The portrait of Matthew stands apart from its companion miniatures excised from the Phanar Lectionary (see cat. 13). Taking advantage of a wider, higher frame, its illuminator placed the seated Evangelist in the middle ground and did not crowd the space with a lectern or high-backed throne. As a result, this miniature is at once less cramped and more monumental than its companions. Differences in the design of the frames, the furniture, and even the haloes confirm the hypothesis that the Evangelist portraits from the Phanar Lectionary are not all by the same artist. Although in certain aspects it is more illusionistic, the figure of Matthew betrays a loss of anatomical understanding in its dissolving left shoulder and poorly rendered left thigh, which is not apparent in the Mark and Luke portraits, and at the same time it reveals greater patternization in the tight, linear conventions of its draperies.

The fact that the arch is trimmed at the top suggests that the miniature was produced separately and was later cut to fit the Phanar codex. Its general correspondence to the other portraits in format, rulings, and style,[1] however, indicates that it is a contemporary product of a different illuminator whose work reflects the advanced abstraction of the second half of the eleventh century. This suggestion is supported by the Leningrad Gospels (Public Lib. cod. gr. 72),[2] dated 1061, whose miniatures display the same abstract qualities as the Cleveland Matthew, and by the fact that the lost John from the Phanar Lectionary seems to combine elements of both styles.[3]

H.L.K.

Lent by the Cleveland Museum of Art, J. H. Wade Fund

NOTES

1. The lower right sleeves of Matthew and Luke are very similar.
2. Putzko, "1061."
3. C. Diehl, "Monuments byzantins inédits du onzième siècle," *Art Studies*, V, 1927, fig. 6.

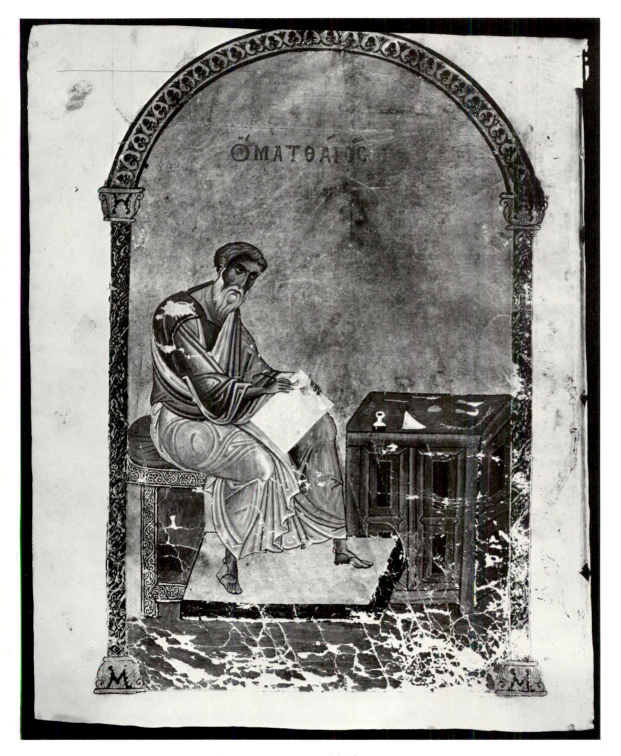

FIGURE 24.  Matthew
Cleveland, Museum of Art cod. acc. no. 42.1512

Lent anonymously. Two single vellum leaves (Matthew: 25.7 x 19.5 cm.; Mark: 26.0 x 19.2 cm.). Two full-page miniatures. Reverse of each blank. Condition: both miniatures show flaking, especially around the desks; upper right corner of both leaves lost.

PROVENANCE: Said to have been purchased in Bursa.

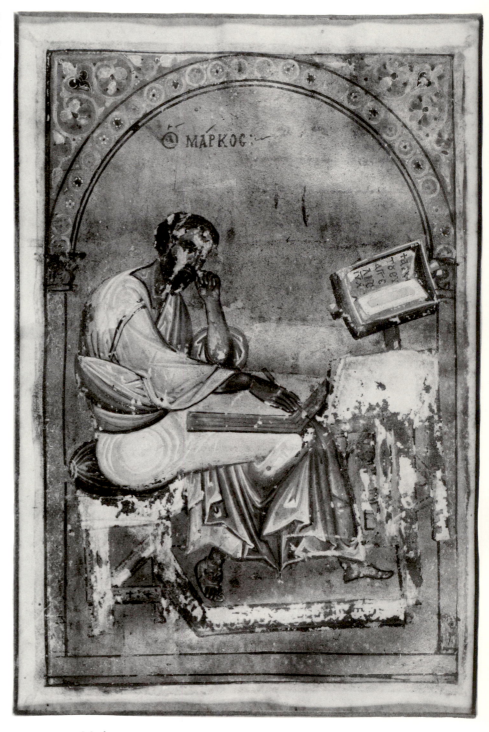

FIGURE 25. Mark
Lent anonymously

The Evangelists are shown seated in profile beneath arches within rectangular frames. The spandrels are filled with flower-petal ornament: floral forms in ultramarine tints are symmetrically disposed about a magenta trefoil. The arches, supported by simple marble columns, are decorated by rosettes of various colors within unattached circles. A band along the bottom of each miniature is ornamented with tesserae. Above each Evangelist is his name written in red uncials.

The accessories for both are virtually the same: a decorated gold bench with magenta cushion, a gray decorated footrest, and a gold table surmounted by a magenta lectern in the form of a deep, slightly curved box containing an open codex bearing the first words of the respective Evangelist's Gospel.

Matthew, a meditative old man with blue-gray hair and beard, and without nimbus, sits with feet wide apart holding a book between his knees, his right forearm in a sling raised before him, pen in hand. He wears a mantle showing many tints of violet and shading to blue. Mark (fig. 25), a mature young man with dark brown hair and beard, nimbed, sits with feet wide apart, his right hand with pen resting on a green codex which lies across his thighs, his left hand raised to his cheek, pensively. He wears an ultramarine tunic and a magenta mantle showing delicate tints of violet.

These portraits clearly echo their Macedonian models. Matthew and Mark appear in attitudes of quiet reflection in firm, stable postures. The miniature of Mark, with only stylistic differences, is to be found in the tenth-century manuscripts Paris, Bibl. Nat. cod. Coislin 195, and Athens, Nat. Lib. cod. 56,[1] this latter providing a virtual one-to-one correspondence to the folds in Mark's garments. Mat-

thew's portrait is somewhat unusual in that the right hand is raised rather than being merely poised above a writing surface. However, the traditional nature of this uncommon pose is proved by its occurrence in an eleventh-century fresco in the Cappadocian church, Qaranleq Kilisse.[2]

The voluminous, angular drapery also harks back to an earlier period but its treatment here constitutes the major departure from Macedonian models. Three-dimensional folds have been replaced by lines and swirls, causing loss of volume not only of the drapery but of the figure beneath, and leaving only pure design, a goal foreign to the art of the Macedonian Dynasty. K. Weitzmann and others have discussed the linearizing tendencies of the second half of the eleventh century in Byzantium, emphasizing the contemporary impulse toward asceticism in religious thought.[3] By the turn of the twelfth century the relationship of drapery to underlying figure structure was sometimes completely lost and proportions were noticeably weakened, as for example in Berlin, Staatsbibl. cod. gr. qu. 55, dated 1103.[4] At this time also, modeling of faces and drapery was carried out largely by highlighting in white, as in Vienna, Nat. Lib. cod. suppl. gr. 164, dated 1109,[5] rather than by more subtle tonal modeling. The return to more naturalistic rendering of figures and drapery as seen in Vatican Lib. cod. Urb. gr. 2, datable around 1122,[6] restored corporeality and proportion, but tended also to exaggerate the depth of folds and the angularity of faces and did not entirely abandon excessive highlighting.

In the present miniatures, pattern has taken precedence over proportion and, while a certain naturalism is evident in the delicately modeled faces, the figures

are more symbolic representations than portraits of the Evangelists. Also, when compared with the manuscripts cited above they show a judicious use of highlighting and only a moderate degree of intensity of facial expression. For these reasons and others cited above, and because they retain so much of the strength and dignity of their Macedonian models, they are to be assigned to the second half of the eleventh century, and by reason of the delicacy and harmony of the colors and the refinement of the decoration, to Constantinople or some center under the immediate influence of the capital.

L.D.A.

Lent anonymously

NOTES

1. Weitzmann, *Buchmalerei*, 11, pl. XII, fig. 59; 21, pl. XXVII, fig. 151.
2. See Chatzidakis and Grabar, *Painting*, pl. 29. (Matthew corresponds to the Matthew portraits in Mount Athos, Stavronikita cod. 43, and Patmos cod. 72, both datable to the tenth century [Weitzmann, *Buchmalerei*, 23, pl. XXX, fig. 169; 43, pl. XLIX, fig. 291]. The double-jointed right forearm of Matthew in this leaf may be easily recognized as a confusion of arm positions in a model such as Patmos cod. 72.—Ed.)
3. Weitzmann, "Eleventh Century."
4. Lake, *Manuscripts*, v, pl. 347.
5. P. Buberl and H. Gerstinger, *Die Byzantinischen Handschriften; 2. Die Handschriften des X.–XVIII. Jahrhunderts*, Leipzig, 1938, pls. xx, xxi.
6. Stornajolo, *Giacomo*, pls. 83–93; Bonicatti, "Urb. gr. 2."

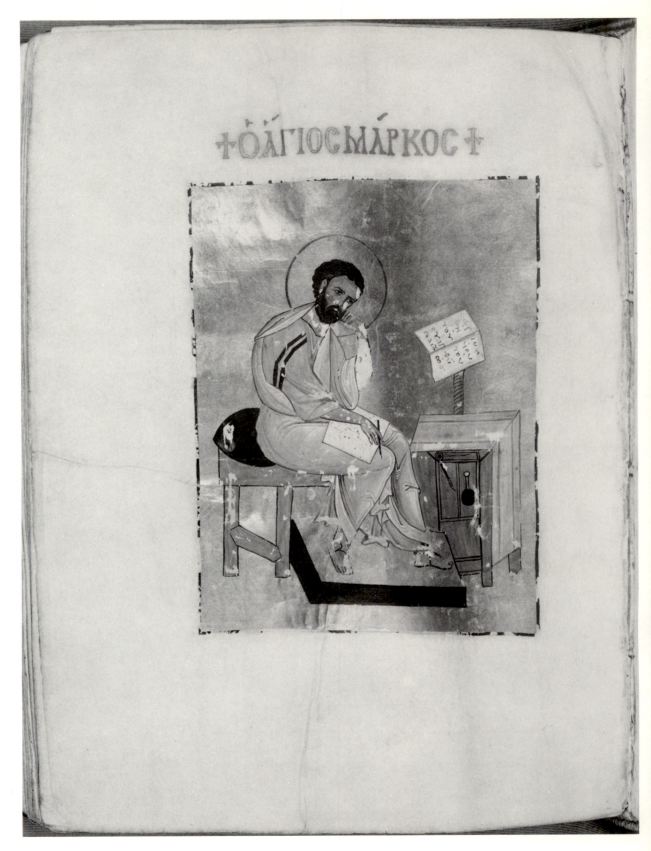

FIGURE 26. Mark
New York, Pierpont Morgan Lib. cod. M647, fol. 167v

New York, Pierpont Morgan Lib. cod. M647. In Greek on vellum. A + 374 folios (33.5 x 24.5 cm.). Two columns of 17 lines (20.3 x 6.5 x 15.5 cm.). Four full-page miniatures. Five large and twelve small headpieces. Ornamental initials throughout. Colophons: folio 374v, non-scribal. Binding: brown leather over wooden boards. Condition: miniatures show flaking, especially in flesh areas; folio A, bearing the miniature of John, is detached and heavily damaged.

PROVENANCE: In the nineteenth century in the collection of T. Brooke. Purchased in 1920 by Morgan from H. Kevorkian.

EXHIBITED: New York 1933–34, no. 25.

BIBLIOGRAPHY: DeRicci and Wilson, *Census*, 1478; Clark, *N. T. Manuscripts*, 159f. (with further bibliography); Friend, "Evangelists," I, figs. 125–28; W. Molè, "Les Miniatures de l'évangéliaire de Ławryszew," *L'Art byzantin chez les Slaves*, II, Paris, 1932, 429n.; Aland, *Liste*, 296; Lazarev, *Storia*, 253n.

The figural decoration of codex M647 is limited to four Evangelist portraits (John, fol. Av; Matthew, fol. 79v; Luke, fol. 118v; and Mark, fol. 167v, fig. 26), serving as frontispieces to the synaxarion sections composed chiefly of readings drawn from their respective Gospels. Each Evangelist is seated in profile, facing toward the right, his feet resting on a large rectangular footstool. To the right, partially behind the footstool, is an open writing desk displaying typical scribal utensils: pens, scrapers, and a flask of ink. From behind the desk rises a lectern with an open codex bearing the first words of the Evangelist's Gospel. Light shades of blue, violet-gray, and yellowish brown predominate against a flat gold background. Above each portrait the author's name is inscribed in hieratic gold uncials. The precious quality of the miniatures is enhanced by the wide margins of white vellum.

Although the Evangelist types and inscriptions of this codex correspond closely to those of a late tenth-century Gospel book in the Vatican (cod. gr. 364),[1] they lack the plasticity and energy characteristic of Macedonian Renaissance illumination (see cat. 8). Their flat linear treatment with its disregard of spatial and structural logic (see Mark's unsupported left elbow, fig. 26) is much closer to the Evangelist portraits in Leningrad, Public Lib. cod. gr. 72, dated 1061.[2] Although

the Morgan portraits have carried the process of dematerialization beyond that in the Leningrad Gospels, a date in the second half of the eleventh century still seems justified.

The ornament of codex M647, consisting of stylized birds enclosed within geometricized flower-petal tendrils, is similar to that in a copy of the homilies of Gregory Nazianzenus in the Vatican (cod. gr. 463), dated 1062.[3] Further, the script of the Morgan manuscript may be compared with Patmos cod. 245, dated 1057.[4]

J.C.A.

Lent by The Pierpont Morgan Library

NOTES

1. Weitzmann, *Buchmalerei*, 25, pl. XXXIV, figs. 192, 193.
2. Putzko, "1061."
3. Galavaris, *Gregory*, pl. XI, fig. 80.
4. Lake, *Manuscripts*, I, pl. 40.

17.

FIGURE 27. Calling of Matthew
New York, Pierpont Morgan Lib. cod.
M748, fol. 65r

New York, Pierpont Morgan Lib. cod. M748. In Greek on vellum. 195 folios (26.8 x 22.0 cm.). Minuscule script. Two columns of 27 lines (20.5 x 7.0 x 15.5 cm.). Two full-page and three marginal miniatures. Two canon tables with figural decoration. Two full-page text frames, one with figural decoration. Five headpieces and six anthropomorphic initials. Colophon: folio 193v, non-scribal. Binding: dark brown stamped leather over wooden boards. Condition: miniatures moderately flaked; two Evangelist portraits and canon tables I to the middle of II and VI to X are lost; parts of canon table decoration lost in trimming.

PROVENANCE: Once the property of the Orthodox Church at Keiroussis. Later (1906) owned by the archbishop of Samsoun on the Black Sea. By 1928 in the possession of the dealer M. Stora. Acquired by The Pierpont Morgan Library in 1929.

EXHIBITED: New York 1933–34, no. 26, pl. 25; Baltimore 1947, no. 702, pl. c; The Pierpont Morgan Library, New York, 1949, *The First Quarter Century of The Pierpont Morgan Library*, no. 11; Oberlin 1957, no. 6, pl. 7; Brandeis 1968, no. 45, ill.

BIBLIOGRAPHY: DeRicci and Wilson, *Census*, 1495; Clark, *N. T. Manuscripts*, 168f. (with further bibliography), pl. XXXIII; A. Frantz, "Byzantine Illuminated Ornament," *Art Bulletin*, XVI, 1934, numerous citations; J. Weitzmann-Fiedler, "Ein Evangelientyp mit Aposteln als Begleitfiguren," *Festschrift zum 70. Geburtstag von A. Goldschmidt*, Berlin, 1935, 32f., figs. 7, 8; R. P. Blake and S. Der Nersessian, "The Gospels of Bert'ay: An Old-Georgian MS. of the Tenth Century," *Byzantion*, XVI, 1942–43, 273; L. W. Jones, "Pricking Systems in New York Manuscripts," *Miscellanea Giovanni Mercati*, VI, 1946, 8on.; J. Irigoin, "Pour une étude des centres de copie byzantin," *Scriptorium*, XII, 1958, 214f.; Aland, *Liste*, 186; C. Nordenfalk, "The Apostolic Canon Tables," *Gazette des beaux-arts*, LXII, 1963, 22f., 32f., figs. 6, 7, 16; Lazarev, *Storia*, 250n.

While the eleventh-century date of codex M748 is hardly open to question, there is equally little doubt that this East Byzantine provincial Gospel book follows a considerably more ancient model. Both its provenance and style indicate an origin in Asia Minor, and it has been dated in the third quarter of the eleventh century on palaeographic grounds.[1] At the bottom of folio 193v, a non-scribal note referring to a total eclipse of the sun is dated 1086.[2] The illustrations of this manuscript can be divided into four categories: frontispiece miniature (see cat. 18), canon tables, Evangelist portraits, and narrative scenes.

Of the three frameless marginal narrative miniatures, the first, at the bottom of folio 65r (fig. 27), represents the Calling of Matthew (Mark 2:14). To the left Matthew is seated, inscribed as Levi, son of Alphaios, and to the right is Christ, gesturing for Matthew to follow Him. Between them is the inscription: ". . . and immediately he followed Him." Christ wears a light blue tunic and a purple mantle; the figure of Matthew has been left unfinished.

Abraham is represented at the bottom of folio 132r, sitting in a garden with a tree bearing red fruit and holding in his lap the tiny figure of Lazarus. To the right the rich man suffers amid the flames of hell, holding forth his hand in an imploring gesture (Luke 16:19–25). This miniature is painted in a wash technique with Abraham wearing a bright blue mantle. A later hand has clumsily retouched the figure of the rich man and the face of Abraham.

The third scene (fol. 134v, Luke 18:19–24; the Pharisee and the Publican) is rendered in brown ink, in a shade different from that of the script. At the left the publican is depicted in a half-kneeling position while the Pharisee stands pride-fully at the right, face and arms uplifted. Each figure is inscribed, as is the curiously schematic temple at the right.

The choice of these three scenes is certainly intentional. They are linked through the presence of a tax collector or a rich man. It is difficult, however, to decide whether a note of admonition against avarice or one of salvation is being sounded, for in two of the scenes the tax collector is not cast in the role of the damned sinner, but in that of the penitent.

The second group of illustrations includes Evangelist portraits of which, unfortunately, only two survive. Matthew (fol. 8v) and John (fol. 150v; fig. 28) are shown seated in profile before an unidentified standing figure. Portraits of authors accompanied by a second figure are rare in Byzantine illumination.[3] In the Morgan Gospels the original *raison d'être* of the second figure seems to have been lost to the illuminator, a fact that makes interpretation and identification difficult. It does seem clear, however, that the double author portrait harks back to the earliest period of Christian book illumination, when painters adopted the classical author and muse composition.[4] The portrait of Mark in the sixth-century Rossano Gospels (fol. 121r) shows the author seated before a standing female figure whose gesture indicates that she is leading or inspiring him in his writing.[5] In codex M748 the second figure does not inspire the author but seems rather to function as a secretary.

The almost square format of the portraits in the Morgan Gospels as well as their wide frames and complex backgrounds are unusual in eleventh-century illumination (see cat. 16). They correspond, however, quite closely with several author miniatures in the six-century Vien-na Dioscurides (Vienna, Nat. Lib. cod. med. gr. 1).[6] The highly developed interior views of the Morgan miniatures are conceptually similar to those in the early fifth-century Vatican Virgil (cod. lat. 3225).[7]

The letter of Eusebius to Carpianus fills arched frames on two pages, while canons II to V, unfortunately the only ones to have survived, are found on the recto and verso of folio 6 (fig. 29). All four pages are decorated by heavy marble or porphyry columns with large bases and gilt capitals. A single arch spanning two columns frames the Eusebian letter pages while a pair of smaller arches spanning three columns frames the canons. Even though the ornament is particularly rich, the architectural function of the elements is clearly stressed.

In the spandrels of the arch on folio 7r angels with orange boots, green wings, and short red tunics approach with veiled hands the bust of Christ surmounting the arch. A portrait medallion is found between the two arches of the canon tables. The head on folio 6r has thin, ascetic features with long gray hair and a medium length square-cut beard. The figure on folio 6v (fig. 29) has rounder features, full brownish hair and moustache, and possibly also a beard.

There are several possible identifications for these portraits. The least likely is that they represent two Apostles, since, as C. Nordenfalk has shown, the full set of canon tables in codex M748 would have had room for a maximum of only eight medallions. A second possibility, to which Professor Nordenfalk has kindly referred me, is presented in the twelfth-century commentary on the Gospel of Matthew by Nerses the Graceful, Catholicos of Armenia (1166–73). In his commentary Nerses assigns a specific symbol to each

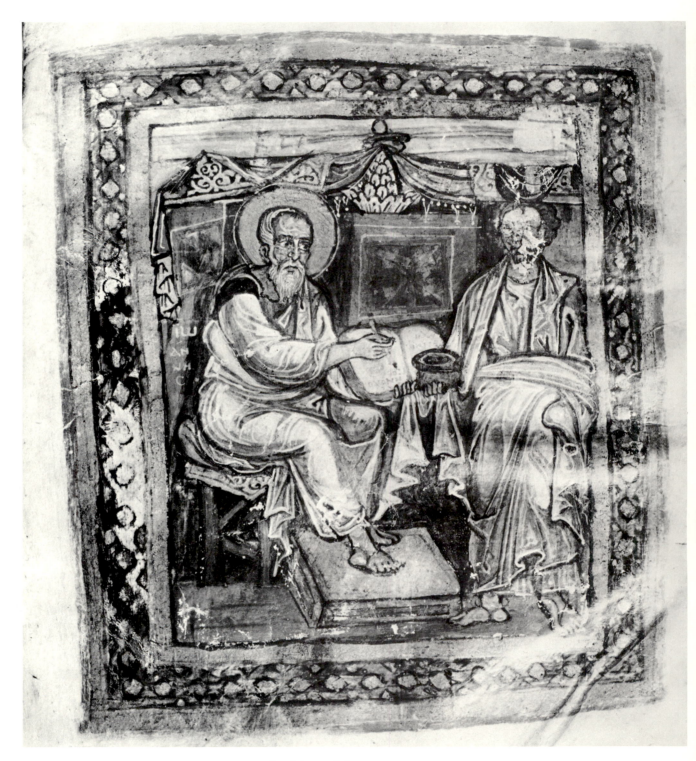

FIGURE 28.  John and Secretary
New York, Pierpont Morgan Lib. cod. M748, fol. 150v

canon, with canons II and III dedicated to the angels, IV to the paradise of Adam, and V to Noah's ark. Although the commentary postdates the Morgan Gospels, it is likely that Nerses drew on earlier sources. According to this commentary, the medallion on folio 6r would represent Adam and that on folio 6v (fig. 29), Noah.

It is also possible that the medallions represent Old Testament Prophets. In the Rabula Gospels (Florence, Laur. Lib. cod. Plut. 1, 56), dated 586, Prophets and other Old Testament figures flank the canon table arches,[8] visually stressing the link between the Old and New Testament. The Morgan Gospel figures are probably from the Old Testament, but at this point it is difficult to tell what system lies behind them.

<div align="right">J.C.A.</div>

Lent by The Pierpont Morgan Library

NOTES

1. Nordenfalk, "Apostolic," 34n.
2. Ibid.
3. Weitzmann-Fiedler, "Begleitfiguren."
4. Friend, "Evangelists," I, 141f.
5. Muñoz, *Rossano*, pl. xv.
6. *Dioscurides, Codex Vindobonensis med. gr. 1 der Österreichischen Nationalbibliothek* (Codices selecti, facsimile XII), Graz, 1970, fols. 4v, 5v.
7. Nordenfalk, "Apostolic," 32. J. de Wit, *Die Miniaturen des Vergilius Vaticanus*, Amsterdam, 1959, 88f., pl. 26.
8. C. Cecchelli, J. Furlani, and M. Salmi, *The Rabbula Gospels*, Olten, 1959.

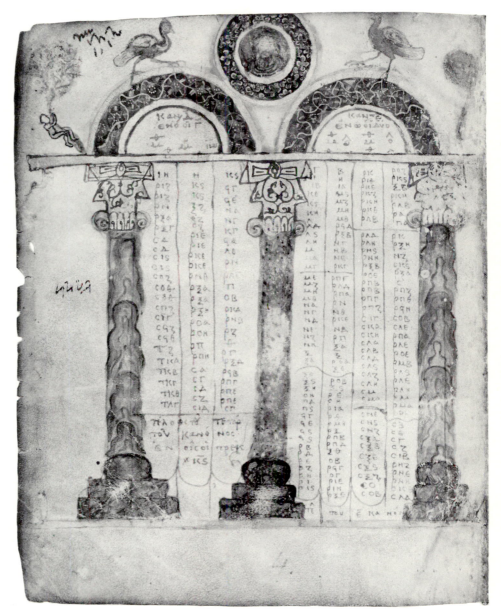

FIGURE 29.   Canon Table
New York, Pierpont Morgan Lib. cod. M748, fol. 6v

## Second Half
## of the Eleventh Century

Princeton, Art Museum cod. acc. no. 32.14. Single vellum leaf (22.3 x 17.5 cm.). One full-page miniature. Reverse blank. Condition: smudged and soiled along left border; some flaking and rubbing around the head.

PARENT MANUSCRIPT: New York, Pierpont Morgan Lib. cod. M748 (cat. 17). The four Gospels. 195 folios (26.8 x 22.0 cm.). Princeton leaf probably served as frontispiece.

PROVENANCE: See cat. 17. Still part of parent manuscript in 1906 (see below). Purchased from the dealer M. Stora and given anonymously to The Art Museum, Princeton University, in 1932.

EXHIBITED: Musée des Arts Décoratifs, Paris, 1931, *Exposition internationale d'art byzantin*; Boston 1940, no. 5, fig. 5; Baltimore 1947, no. 709, pl. CI.

BIBLIOGRAPHY: Bond and Faye, *Supplement*, 304 (with further bibliography); J. Deér, "Der Globus des spätrömischen und des byzantinischen Kaisers. Symbol oder Insigne?" *Byzantinische Zeitschrift*, LIV, 1961, 72, pl. VI, fig. 3; C. Nordenfalk, "The Apostolic Canon Tables," *Gazette des beaux-arts*, LXII, 1963, 32, fig. 17; Lazarev, *Storia*, 251n.

This vellum leaf (fig. 30) bears the representation of a single figure standing frontally against a gold background, his halo and slippers overlapping a border of blue and green quatrefoils over a red ground. He is dressed in the regalia of a Mid-Byzantine emperor: diadem with pendulia and triple pearls, loros, orb, and pearl-decorated red slippers. In his right hand he holds a staff surmounted by a pearl-studded cross, in his left he supports an orb inscribed in its lower half with a red cross. Several years ago C. Nordenfalk was able to make out the inscription next to the figure's right arm as: H[?]ΑΓΙΟC ΚѠΝCΤΑΝΤΙΝΟC, Saint Constantine.[1] In a recent examination only the letters ѠΝCΤΑΝΤ were visible; nonetheless, his identification as Constantine the Great is not to be doubted.

That this leaf once belonged to New York, Pierpont Morgan Lib. cod. M748 (cat. 17) is demonstrated not only by a correspondence in size and style, but also by a letter written September 19, 1906, by Archbishop Anthimos of Samsoun, describing the Princeton leaf as being pasted on the inside of the front cover of the Morgan Gospels.[2]

The provinciality of the miniature is immediately apparent in such details as the misshapen right forearm, the oversized orb, the blue instead of purple robe, and the improperly decorated loros. An origin in East Byzantium is suggested not only by the provenance of this leaf but also by its close similarities to a tenth-century fresco representation of Constantine the Great in the so-called New Church of Tokali Kilisse in Göreme, Cappadocia.[3]

K. Weitzmann has suggested that the illuminator of the Princeton leaf gave the figure of Constantine the Great facial characteristics of a contemporary Constantine.[4] The short beard with a notch in the middle accords well with representations of Constantine IX Monomachos in Mount Sinai cod. 364,[5] and Modena, Bibl. Estense cod. a.S.5.5.[6] The period of his reign (1042–54) agrees with the date proposed for the Morgan Gospels (see cat. 17).

J.C.A.

Lent by The Art Museum, Princeton University

NOTES

1. Nordenfalk, "Apostolic," 32f.
2. Ibid., 32.
3. M. Restle, *Byzantine Wall Painting in Asia Minor*, Recklinghausen, 1967, I, 35f.; G. de Jerphanion, *Les Églises rupestres de Cappadoce*, Paris, 1928, II, pl. 85, fig. 1.
4. See tenth-century Abgarus icon on Mount Sinai. King Abgarus has the features of Constantine VII Porphyrogennetos (K. Weitzmann, "The Mandylion and Constantine Porphyrogennetos," *Cahiers archéologiques*, XI, 1960, 163f.; *Studies*, 224 f.).
5. V. Beneševič, *Monumenta Sinaitica Archaeologica et Palaeographica*, I, St. Petersburg, 1925, pl. 30.
6. S. P. Lambros, Λεύκωμα Βυσζαντινῶν Αὐτοκρατόρων, Athens, 1930, pl. 58.

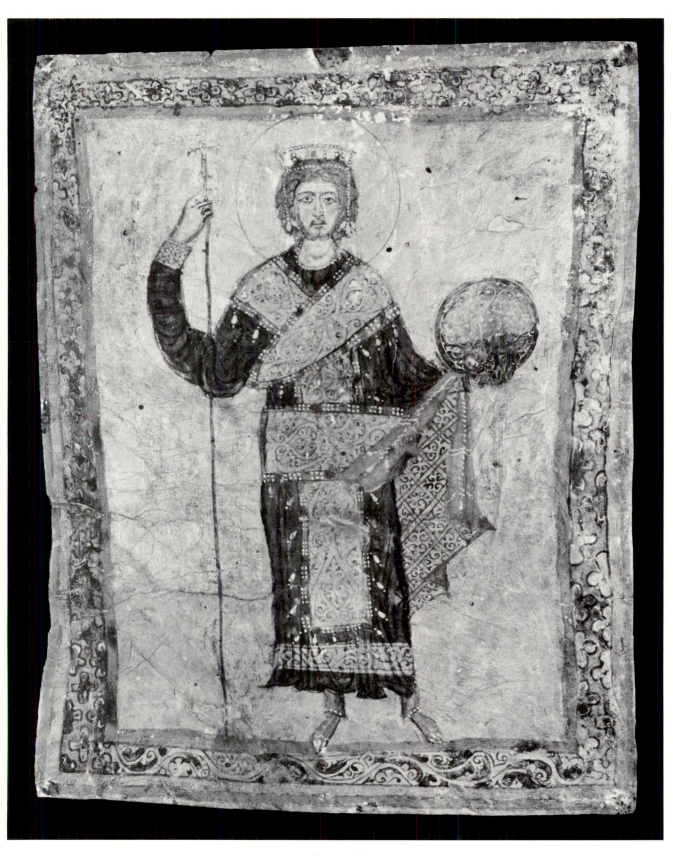

FIGURE 30. Constantine
Princeton, Art Museum cod. acc. no. 32.14

# 19.

Princeton, Univ. Lib. cod. Garrett 16. In Greek on vellum. 209 folios (27.2 x 19.8 cm.). Minuscule script. One column of 25 lines (18.3 x 13.2 cm.). Thirty-six marginal miniatures and one headpiece. Colophon: folio 208r, scribal, dated 1081. Folios 208v, 209r, nonscribal. Binding: rebound in 1963 with oak boards and a dark leather spine. Condition: seven miniatures cut out and several others damaged; demons are consistently rubbed.

PROVENANCE: Later nineteenth century in the monastery of Kosinitza (cod. 112). By 1920 it was in the hands of J. Baer, from whom it was purchased by R. Garrett. Presented by R. Garrett to the Princeton University Library in 1942.

EXHIBITED: Walters Art Gallery, Baltimore, 1940, "A Thousand Years of Bookbinding"; Boston 1940, no. 4; Baltimore 1947, no. 708, pl. xcv; Princeton University Library, Princeton, 1960, "Mount Sinai and the Monastery of St. Catherine" (see H. C. Rice, Jr., "Mount Sinai Exhibition," *The Princeton University Library Chronicle*, XXI, 1960, 238); Athens 1964, no. 352; Princeton University Library, Princeton, 1966, "Mirrors of the Mediaeval World" (see R. B. Green, "Checklist of Miniatures Shown in 'Mirrors of the Mediaeval World' Exhibition," *The Princeton University Library Chronicle*, XXVII, 1965–66, no. 17); Princeton University Library, Princeton, 1972, *Five Themes from Genesis*, 19.

BIBLIOGRAPHY: DeRicci and Wilson, *Census*, 868; Bond and Faye, *Supplement*, 311f.; Martin, *Climacus*, passim (with earlier bibliography); Chatzidakis and Grabar, *Painting*, 18, pl. 90; Lazarev, *Storia*, 251n.; Galavaris, *Gregory*, 58n., 69, 225, 238; Der Nersessian, *Psautiers*, 15.

FIGURE 31. John Climacus Exhorting Monks to Climb the Heavenly Ladder Princeton, Univ. Lib. cod. Garrett 16, fol. 194r

# Heavenly Ladder of John Climacus     *1081 A.D.*

FIGURE 32.  Monastery of Mount Sinai Princeton, Univ. Lib. cod. Garrett 16, fol. 165r

The *Heavenly Ladder*, written in the late sixth century by Abbot John of Mount Sinai, contains thirty chapters of spiritual exercises for monks, offering a means of ascent to heaven. Each chapter is conceived as a rung on a ladder reaching from earth to Christ. The ladder and Abbot John exhorting the monks to climb are depicted at the beginning (fol. 4r, table of contents) and at the end (fol. 194r, fig. 31) of the manuscript. In the second miniature, three monks are seen ascending while two fall headlong back toward the gaping mouth of a dragon. One has fallen just as he was about to receive the crown of immortality offered by Christ.

All other miniatures, placed in the margins without frames, illustrate the requirements of religious life (fig. 32). These include the virtues that a monk must cultivate and the vices he must avoid, as well as the phases of his ascetic inner life as he ascends toward heaven.

The illustrations of the Princeton manuscript are characterized by a subtle use of color. Garments are varied in delicate hues ranging from yellowish brown to gray-green, while touches of light blue are visible in the hair and beards of the monks. In general, celestial beings wear clothing of violet, light blue, and rose, while demons are portrayed in much more brilliant reds, blues, and greens. Filling the entire right margin of folios 4r and 194r, the ladder adds a degree of monumentality to the prevailing delicacy of the manuscript.

Most miniatures have no background, although occasionally a tree and a strip of ground appear, providing a rudimentary landscape. Small animals enliven the ornament of the Princeton Climacus. The headpiece preceding the text (fol. 1r) deserves special attention. In its five medallions are two ducks, a stag, a horse, and a lion.

A scribal colophon is found at the end of the manuscript (fol. 208r): "This book was completed in the month of September during the fifth indiction of the year 6590 [1081]. It was written for the edification of those who read it."[1]

The figure style and ornament as well as the subtlety and brilliance of the colors indicate a Constantinopolitan scriptorium. The figures are elegant yet dry. Denied physical reality and bodily weight, they are poised, slightly frozen in their movements. Together they are distinguished by a patternized rhythm. All these qualities reflect a spiritualized style characteristic of Constantinople in the second half of the eleventh century and corresponding to the mystical movement of Symeon the New Theologian.[2] The ornamental birds and animals find counterparts in manuscripts of the second half of the eleventh and the early part of the twelfth century, such as Vatican Lib. cod. gr. 463 (dated 1062) and Oxford, Bodl. Lib. cod. Canon. gr. 103 (datable around 1100).[3]

A study of the iconography of this and related codices by J. R. Martin has shown that its program of illustration does not follow an old tradition but is compiled from a variety of sources, some of which could not be earlier than the eleventh century. It is possible that the process of compilation took place in this very manuscript.

<div style="text-align: right">G.G.</div>

Lent by Firestone Library, Princeton University

NOTES

1. ἐτελειώθ[η] ἡ βίβλος αὕτη μη[νὶ] σεπτ[εμβ]ρ[ίω] ἰνδ[ικτιῶνος] έ ἔτους ,ϛΦϛ′. γραφεῖσα διὰ τὴν τῶν ἐντυγχανόντ[ων] ὠφέλει[αν].
2. See Lazarev, *Storia*, 186f.; Weitzmann, "Eleventh Century"; and A. Grabar, "L'Art byzantin au XIe siècle," *Cahiers archéologiques*, XVII, 1967, 257f.
3. Galavaris, *Gregory*, 232f., pls. LIII–LVI, figs. 275–86; 250f., pls. XI–XIII, figs. 78–93.

FIGURE 33. Paul (with Christ)
Speaking to a Group of Hebrews
Washington, Dumbarton Oaks cod. 3,
fol. 331v

Washington, Dumbarton Oaks cod. 3. In Greek on vellum and paper. 357 folios (16.2 x 10.5 cm.). (Folios numbered 1–362. Folios 341–62 are paper.) Minuscule script. One column of 36 lines (12 x 7 cm.). Eleven half-page and eleven three-quarters to full-page miniatures. Many marginal figures and anthropomorphic initials. Ten canon tables. Paschal tables on folio 3v for 1084–1101. Binding: worn yellow velvet over wooden boards. Condition: some miniatures badly flaked; seven folios (with eight miniatures) have been excised.

PROVENANCE: Mount Athos, Pantocrator monastery (cod. 49). When K. Weitzmann studied the manuscript on Mount Athos in 1932, it was still intact save for folio 78, which by 1936 was in the Benaki Museum, Athens. The other six leaves were excised after the manuscript left Mount Athos, sometime between 1941, when F. Dölger photographed it in the monastery, and 1950, when the Cleveland Museum of Art acquired folio 254 (cat. 21) from V. G. Simkhovitch of New York. The present location of five folios (4, 86, 87, 187, 187bis) is unknown.[1] The remainder of the manuscript was purchased from a Swiss dealer by Dumbarton Oaks in September, 1962.

BIBLIOGRAPHY (selected): H. Brockhaus, *Die Kunst in den Athos-Klöstern*, Leipzig, 1891, 170, 174f., 205f., fig. 14; Lambros, *Athos*, I, 98; Tikkanen, "Psalterillustration," 128f.; F. Dölger, *Mönchsland Athos*, Munich, 1943, 178, 180, figs. 98–101; K. Weitzmann, *Aus den Bibliotheken des Athos*, Hamburg, 1963, 37f., ill.; Der Nersessian, "Dumbarton Oaks" (with further bibliography); Weitzmann, "Eleventh Century," 210f., 214f., pls. 9, 12, 22; Lazarev, *Storia*, 190f., 249n. (with further bibliography), 332n, figs. 234–36; Weitzmann, *Roll*, 111, 149, 152, 162, 170, 185, 249, figs. 140, 157, 164.

Two full-page miniatures with three scenes from the life of David (fol. 5r, 5v) preface the Psalter section. One nearly full-page and three half-page miniatures are found within the body of the Psalms text: David, seated in the pose of an Evangelist, appears as author in the headpiece to Psalm 1 (fol. 6r); Nathan's reproach of David is illustrated before Psalm 50 (51) (fol. 27r); a bust portrait of Christ Pantocrator precedes Psalm 77 (78) (fol. 39r); and David's combat with Goliath is represented in a double register miniature before Psalm 151 (fol. 71r). Ten of the eleven Odes are introduced by nearly full-page miniatures while the Ode of Zacharias (fol. 81r) is illustrated with a marginal figure and an anthropomorphic initial.

The cycle of New Testament illustrations includes three half-page portraits of seated Evangelists: Matthew (fol. 95r), Mark (fol. 129r), and Luke (fol. 151r). The full-page portrait of John dictating to Prochoros (fol. 187r) is now missing. Half-page portraits of four Epistle authors are also included (for that of Peter, see cat. 21). The remaining illustration is comprised of marginal figures and anthropomorphic initials.

The colors throughout the manuscript are vivid, with a noticeable predominance of blues. There is frequent use of brilliant tones of red, vermilion, orange, and purple, often contrasted by brown, mauve, and shades of lilac, pink, and pale green. The half-page miniatures are framed with borders of gold and red enclosing blue or green foliated strips. Highlights are executed in a series of thin white lines and the backgrounds are consistently gold.

The Dumbarton Oaks manuscript must have been produced in 1084 since its Paschal tables (fol. 3v) begin with that year. Stylistically, its miniatures conform

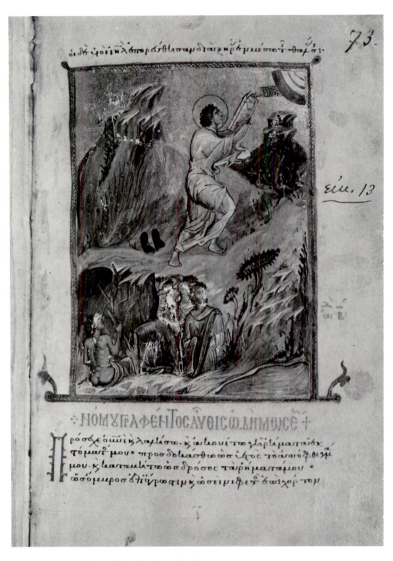

FIGURE 34. Moses Receiving the Law
Washington, Dumbarton Oaks cod. 3, fol. 73r

to Constantinopolitan products of the last quarter of the eleventh century. The flat, decorative treatment of drapery and the attenuated figure style are characteristics that recur in a manuscript of the homilies of John Chrysostom in Paris (Bibl. Nat. cod. Coislin 79), dated 1078–81.[2] The treatment of landscape and architecture as theatrical backdrops for figures is also characteristic of late eleventh-century Constantinopolitan manuscripts (see Mount Athos, Dionysiou cod. 587).[3]

The New Testament section of the Dumbarton Oaks codex is illustrated almost exclusively with portraits. The Evangelists are represented by various portrait types standard for the period. Similarly, the authors of the Epistles are shown either seated or standing in conventional poses deriving from Evangelist portraits or representations of Prophets, saints, or church fathers. The portraits of Luke, as author of the Acts, and Paul have been only slightly modified through the inclusion of other figures.

Such a profusion of marginal figures and anthropomorphic initials is rare in New Testament manuscripts. Similar illustrations, however, are found in an early twelfth-century Gospel book in Baltimore (Walters Art Gallery cod. W522),[4] where, as in the Dumbarton Oaks manuscript, marginal figures are used to illustrate the genealogy of Christ on the opening page of Matthew's Gospel. The only scenic illustration in the New Testament section of codex 3 is found at the beginning of the Epistle to the Hebrews (fol. 331v, fig. 33), where Paul is represented with Christ as part of the initial Π, and a group of Hebrews, apparently responding to the Apostle's words, appears in the lower margin.

The iconographic significance of the Psalter section of the Dumbarton Oaks manuscript lies in its relationship to the Paris Psalter (Bibl. Nat. cod. gr. 139)[5] and, ultimately, to the lost archetype of the aristocratic Psalter recension (see chapter 3). Compared with two important manuscripts of this recension on Mount Athos (Vatopedi cod. 760 and cod. 761),[6] codex 3 stands in closest iconographic proximity to the Paris Psalter. For example, the illustration of Moses Receiving the Law is found in its more usual location before Psalm 77 (78) in the Athos Psalters (see cat. 23), while in both the Paris and Washington manuscripts (fig. 34) it is placed before the Exodus Ode. In addition, the miniatures in these two codices include personifications of Mount Sinai, lacking in the Vatopedi manuscripts.

Despite these similarities, however, Dumbarton Oaks cod. 3 cannot be considered a copy of the Paris Psalter since it preserves pictorial elements that had entered the aristocratic Psalter recension during the Macedonian Renaissance, but that are not included in the Paris manuscript. For example, the personification of βυθός in the frontispiece to the Jonah Ode (fol. 78r, now in the Benaki Museum, Athens)[7] is not found in the Paris Psalter. Furthermore, the Washington manuscript preserves some elements of the archetype more accurately than the Paris manuscript. David's Fight with Goliath (fol. 71r), for example, is very similar to the source illustration from the Book of Kings (see Vatican Lib. cod. gr. 333, fols. 23v, 24r),[8] lacking the Renaissance personifications of the Paris manuscript.

The frontispiece illustrations to the Odes juxtapose portraits of the canticlers with scenes from their lives. For the Ode of the Virgin (fol. 80v, fig. 35) the artist has represented the Annunciation to the Virgin in the upper register, the Visitation

within the initial 'M,' and in the lower register, the enthroned Virgin holding an open codex. Although no exact parallel to the last representation is known, K. Weitzmann has suggested that a reflection of the iconography may be seen in a leaf in Leningrad (Public Lib. cod. gr. 269, fol. 4r) excised from the thirteenth-century copy of the Paris Psalter on Mount Sinai (cod. gr. 38).[9] In that miniature the enthroned Virgin holds the Christ Child on her knee and displays not a codex, but a scroll on which are written the first words of her Ode.

<div align="right">S.G.</div>

Lent by Dumbarton Oaks Research Library and Collection

NOTES

1. See Der Nersessian, "Dumbarton Oaks," pls. 1, 2, 26, 27, 31.
2. Omont, *Miniatures*, pls. LXI–LXIV.
3. See Weitzmann, "Imperial Lectionary."
4. H. Buchthal, *Miniature Painting in the Latin Kingdom of Jerusalem*, Oxford, 1957, pl. 141e.
5. H. Buchthal, *The Miniatures of the Paris Psalter*, London, 1938.
6. For Vatopedi cod. 760, see Weitzmann, *Roll*, 131, 148, 186, 190, figs. 113, 139. For Vatopedi cod. 761, see Weitzmann, "Vatopedi 761," and cat. 23.
7. Der Nersessian, "Dumbarton Oaks," pl. 17.
8. Lassus, "Rois," figs. 6–7.
9. K. Weitzmann, "Eine Pariser-Psalter-Kopie des 13. Jahrhunderts auf dem Sinai," *Jahrbuch der Österreichischen Byzantinischen Gesellschaft*, VI, 1957, 131f., fig. 6.

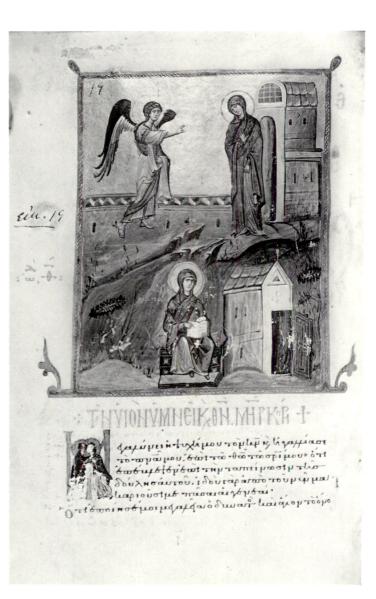

FIGURE 35. The Annunciation, the Virgin Enthroned, and the Visitation Washington, Dumbarton Oaks cod. 3, fol. 80v

# 21.

Cleveland, Museum of Art cod. acc. no. 50.-154. Single vellum leaf (16.2 x 10.8 cm.). One half-page miniature and one anthropomorphic initial. Text: I Peter 1:1–21 in Greek. One column of 37 lines (12 x 7 cm.). Minuscule script. Condition: slight crease across anthropomorphic initial.

PARENT MANUSCRIPT: Washington, Dumbarton Oaks cod. 3. Psalter-New Testament (see cat. 20). Cleveland miniature was folio 254r, heading the First Epistle of Peter.

PROVENANCE: Mount Athos, Pantocrator monastery (cod. 49). Acquired in 1950 from the V. G. Simkhovitch collection, New York.

EXHIBITED: Mint Museum, Charlotte, North Carolina, 1954, "Exhibition of Byzantine and Medieval Art"; Chapman Gallery, Milwaukee-Downer College, Milwaukee, 1955, "Liturgical Arts"; Oberlin 1957, no. 5, fig. 5.

BIBLIOGRAPHY: Cleveland Museum of Art, *Handbook*, Cleveland, 1958, no. 82, ill.; ibid., 1966, 40, ill.; Der Nersessian, "Dumbarton Oaks," 155f., 162, 166, 181, fig. 35; Weitzmann, "Eleventh Century," 210, pl. 10.

# Leaf from a Psalter—New Testament: Peter

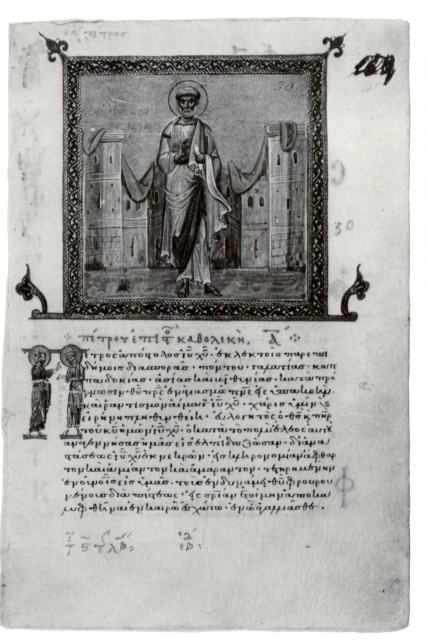

FIGURE 36. Peter
Cleveland, Museum of Art
cod. acc. no. 50.154

This single leaf (fig. 36), bearing a portrait of Peter, the initial Π formed by figures of Christ and Peter, and fifty lines of the First Epistle of Peter, was originally folio 254 of the Psalter-New Testament now at Dumbarton Oaks (cat. 20). Like the other New Testament illustrations in the Dumbarton Oaks manuscript, the Cleveland leaf is a simple author portrait. Peter, garbed in pale blue and light brown, stands frontally before a draped wall deriving ultimately from the *scenae frons* of the Roman theater. The cool pastels of the wall and blue-green ground form a subtle harmony with Peter's garments, which is accented by the red draped cloth and gold sky.

H.L.K.

Lent by the Cleveland Museum of Art, J. H. Wade Fund

# Leaf from a Psalter—New Testament:

Baltimore, Walters Art Gallery cod. W530c. Single vellum leaf (15.0 x 9.7 cm.). One full-page miniature. Text: end of John 21:16 to John 21:25 in Greek. Minuscule script. One column of 24 lines (incomplete). Column 6.3 cm. wide. Condition: some flaking, especially in lower left quarter.

PARENT MANUSCRIPT: Mount Athos, Vatopedi cod. 762. Psalter-New Testament. 348 folios (16 x 9 cm.). Baltimore miniature was folio 211r, preceding the Acts. Identification: K. Weitzmann.

PROVENANCE: Acquired from Gruel by H. Walters.

EXHIBITED: Baltimore 1947, no. 706, pl. XCVII.

BIBLIOGRAPHY: DeRicci and Wilson, *Census*, 826; Clark, *N. T. Manuscripts*, 361; Eustratiades and Arcadios, *Vatopedi*, 150f.; Aland, *Liste*, 175; Diringer, *Book*, 101, pl. II-19c; Lazarev, *Storia*, 250n.

In the two registers of the Baltimore miniature (fig. 37) are depicted Paul, Peter, and John above, Luke, Matthew, and Mark below. They stand frontally on a dark green base against a blue background. Paul and John are turning slightly inward toward Peter. Each figure holds a codex in his left hand, except Peter, who holds a scroll. Their mantles are rendered in subtle shades of lavender, green, salmon pink, and brown, usually over blue tunics. The simple frame is of bright red.

This leaf and the manuscript from which it was excised (fig. 38) may be dated to the later eleventh century on the basis of comparisons with dated manuscripts of that period (cat. 19–21, 23). With the Dumbarton Oaks Psalter-New Testament (cat. 19, 20), dated 1084, it shares similar figure proportions, drapery motifs, head types, and subtle colorations.

The Acts of the Apostles was often preceded in Byzantine manuscripts by an author portrait similar to those serving as frontispieces to the Gospels. There are also representations of Luke together with the Apostles, as in the Dumbarton Oaks Psalter-New Testament[1] and Mount Athos, Pantocrator cod. 234,[2] in both of which Luke sits while the Apostles stand opposite him. In Athens, Nat. Lib. cod. 2251, Luke stands beneath an arch surrounded by busts of the Apostles.[3]

Much closer to the Baltimore leaf is a leaf in the collection of Paul Canellopoulos of Athens,[4] which was formerly part of Mount Athos, Dionysiou cod. 8,[5] in which it served as the frontispiece to the Acts. Here busts of the Apostles fill twelve compartments, distributed in four rows. Significantly, the first six are Peter, Paul, and Luke; John, Mark, and Matthew, the same six represented in the Baltimore leaf. K. Weitzmann has sug-

gested that Vatopedi cod. 762 originally possessed a companion miniature to that now in the Walters Art Gallery, with portraits of six more Apostles. Their organization into two registers can be explained as reflecting the influence of the Lectionary and the menologion, in which individual saints are aligned in rows on a single page.

C.L.B.

Lent by the Walters Art Gallery

NOTES

1. Der Nersessian, "Dumbarton Oaks," pl. 32.
2. Photographs in the Department of Art and Archaeology, Princeton University.
3. Photographs in the Department of Art and Archaeology, Princeton University. In other New Testament manuscripts Christ stands or sits in the midst of the Apostles. See Der Nersessian, "Dumbarton Oaks," 178.
4. Athens 1964, no. 313, fig. 313.
5. Dionysiou cod. 8 is now in the possession of a dealer.

# Paul, Peter, John, Luke, Matthew, Mark   <span style="float:right">*Late Eleventh Century*</span>

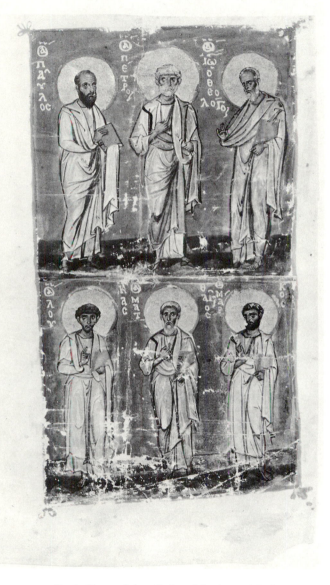

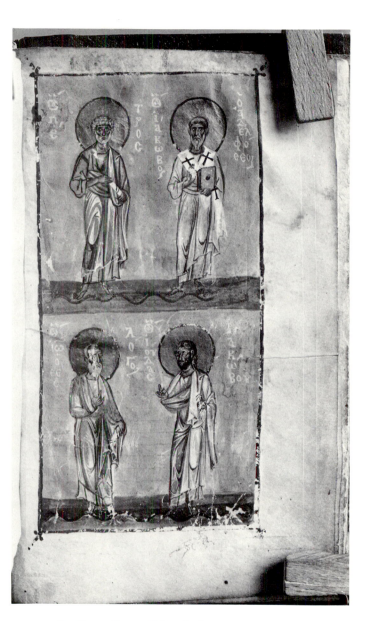

FIGURE 37.  Paul, Peter, John, Luke, Matthew, Mark
Baltimore, Walters Art Gallery cod. W530c

FIGURE 38.  Peter, James, John, Jude
Mount Athos, Vatopedi cod. 762, fol. 330r

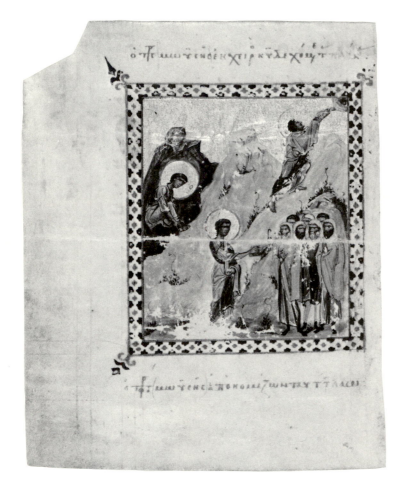

FIGURE 39.  Moses and the Law
Baltimore, Walters Art Gallery cod. W530b

Baltimore, Walters Art Gallery cod. W530b. Single vellum leaf (11.7 x 9.2 cm.). One full-page miniature. Text: Psalm 76 (77):12–20 in Greek. Minuscule script. One column of 20 lines (7.2 x 6.0 cm.). Condition: horizontal crease across center; some flaking in lower third.

PARENT MANUSCRIPT: Mount Athos, Vatopedi cod. 761. Psalter. 236 folios (11.8 x 9.7 cm.). Baltimore miniature was folio 111v, preceding Psalm 77 (78). Paschal tables (fols. 3r–4v) for 1088–1111. Identification: K. Weitzmann.

PROVENANCE: During the twelfth or thirteenth century in the possession of an Armenian who added inscriptions and extra ornament to many folios. In the early sixteenth century in the possession of Makarios, Archbishop of Corinth and Thessaloniki. Millet[1] states that in 1894 he saw this leaf still in the manuscript. His remark that it was later lost implies that on a subsequent visit (probably during the First World War) it was no longer in the manuscript. Purchased by H. Walters from Gruel.

EXHIBITED: Baltimore 1947, no. 699, pl. XCVII; Oberlin 1957, 43, no. 1, fig. 1; Andrew Dickson White Museum of Art, Cornell University, Ithaca, New York, and Munson-Williams-Proctor Institute, Utica, New York, 1968, *A Medieval Treasury*, no. 18.

BIBLIOGRAPHY: DeRicci and Wilson, *Census*, 826; Clark, *N. T. Manuscripts*, 360; H. Brockhaus, *Die Kunst in den Athos-Klöstern*, Leipzig, 1891, 208; G. Millet and S. Der Nersessian, "Le Psautier arménien illustré," *Revue des études arméniennes*, IX, 1929, 169; Weitzmann, "Vatopedi 761"; Der Nersessian, "Dumbarton Oaks," 169, 173; Diringer, *Book*, pl. II-19d; Lazarev, *Storia*, 250n.

# Leaf from a Psalter: Moses and the Law   *1088 A.D.*

This full-page miniature (fig. 39) presents three separate episodes in the story of Moses and the Law: at the upper left Moses removes his sandals; at the upper right he receives the Tablets of the Law from the Hand of God; and at the lower right he presents—or teaches—the Law to the Israelite Elders.

The frame of the miniature is comprised of two red borders between which is a series of red crosses and blue "stair-step" patterns. The colors in this leaf and throughout the parent manuscript are rather pale, as may be seen here in the use of cream and salmon tones, as well as light blues and greens. These colors are occasionally contrasted by darker shades of red, blue, and brown. The sparing use of any sort of highlighting contributes to the somewhat flat overall effect.

Because its Paschal tables begin in 1088, the Psalter Mount Athos, Vatopedi cod. 761 (fig. 40) and the Baltimore leaf, excised from it, must have been produced very close to that year.[2] The style of the leaf approaches that of Constantinopolitan manuscripts of the period (see cat. 20), although it is generally of lower quality. K. Weitzmann believes that the manuscript was copied in a provincial center from a Constantinopolitan model, and has tentatively suggested an origin in Anatolia, although there is no firm evidence to support such an hypothesis.[3]

Almost every aristocratic Psalter includes at least one episode from the story of Moses and the Law, usually as a frontispiece to Psalm 77 (78), illustrating the first verse: "Give ear, O my people, to my law." The Baltimore leaf, like a number of manuscripts, including the Paris Psalter (Bibl. Nat. cod. gr. 139), includes not one, but several episodes within a single miniature. These multi-scenic compositions are clearly condensa-

tions of what in the archetype had been represented in several full-page miniatures. K. Weitzmann has shown that the archetype must have had at least five, and perhaps more, episodes from this story.[4]

The ultimate source for the iconography of the scenes on the Baltimore leaf is an illustrated Octateuch. The episodes of Moses removing his sandals and receiving the Law are dependent, with only minor alterations, on the Octateuch illustrations for Exodus 3:5 and 31:18, respectively. Yet nowhere in the Octateuchs is there a representation of Moses actually presenting the Law to the people. The occurrence of this scene in the Baltimore leaf as well as in other aristocratic Psalters[5] is probably due to a desire to summarize concisely the conditions surrounding God's gift of the Law—to make clear, in the simplest way, that Moses received the Law and then presented it to the people. This is, of course, a great simplification of the Exodus story, but one that quite suffices for the Psalter text.

The composition of this third episode is borrowed from the Octateuch illustration for Exodus 19:7, where Moses, holding a scroll, discusses with the Elders the possibility of a covenant with God. In order to render the meaning of the Psalter scene more intelligible, manuscripts such as the Psalter formerly in the Berlin Theological Seminary (cod. no. 3807)[6] represent Moses holding not a scroll but the Tablets of the Law. While the Tablets are not clearly represented in the Walters miniature, K. Weitzmann has suggested that the slab-shaped object just behind, but not grasped by Moses's outstretched hand, is meant to indicate the Tablets, and accordingly reflects the influence of manuscripts such as the Berlin Psalter.[7]   S.G.

Lent by the Walters Art Gallery

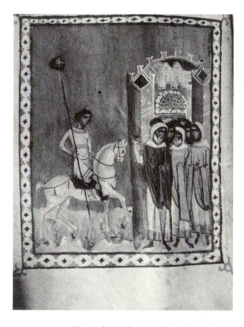

FIGURE 40. David Welcomed in Jerusalem Mount Athos, Vatopedi cod. 761, fol. 13v

NOTES

1. Millet and Der Nersessian, "Arménien," 169.
2. The inscription (fol. 2v) mentioning Constantine Monomachos, who died in 1054, must be a later falsification attempting to imply an imperial origin for the manuscript.
3. Weitzmann, "Vatopedi 761," 30f.
4. Ibid., 47f.
5. With the exception of the Theodore Psalter (London, Brit. Mus. cod. add. 19352, fol. 193v; see Der Nersessian, *Psautiers*, pl. 109, fig. 304), the scene occurs exclusively in aristocratic Psalter manuscripts.
6. Late eleventh century. G. Stuhlfauth, "A Greek Psalter with Byzantine Miniatures," *Art Bulletin*, xv, 1933, 322, fig. 11; Weitzmann, "Vatopedi 761," 33f., fig. 19.
7. Weitzmann, "Vatopedi 761," 36.

24.

FIGURE 41.   Symeon Stylites Worshiped by His Mother
Chicago, Univ. Lib. cod. 947, fol. 151v

FIGURE 42. Ornamental initial Chicago, Univ. Lib. cod. 947, fol. 167v

Chicago, Univ. Lib. cod. 947. In Greek on vellum with paper additions. 207 folios (23.0 x 17.5 cm.). (Folios 1–52 and 197–202 are paper.) Minuscule script. Two columns of 25 lines (16.5 x 5.0 x 12.0 cm.). Four quarter-page miniatures and five headpieces. Ornamental initials. Colophons: folio 151v, scribal (names illuminator). Folio 202v, by scribe of paper additions, dated 1465. Binding: black painted leather over wooden boards. Condition: folios 1–52 are restorations; miniatures are rubbed.

PROVENANCE: Acquired in Upper Berat, Albania, by Miss Trini Kouzoutzakis in the 1930s. Purchased from her in 1940 by the University of Chicago.

EXHIBITED: University of Chicago Library, Chicago, 1973, *New Testament Manuscript Traditions*, no. 60, ill.

BIBLIOGRAPHY: Bond and Faye, *Supplement*, 163.

Western characteristics of the script noted by E. C. Colwell,[1] as well as the style of the ornamental initials and miniatures, point clearly to an Italian origin for this Greek Lectionary (fig. 41). The foliate initials that terminate in biting dog and bird heads (fig. 42) parallel closely those in certain Latin manuscripts produced in Apulia during the eleventh century;[2] and the stylized faces with H-shaped mouths and firmly arched brows flowing smoothly into the outlines of the noses recall, in particular, such Bari manuscripts as the Oxford Virgil (Bodl. Lib. cod. Canon. class. lat. 50),[3] and a document dated 1028 still in the cathedral archives of Bari.[4] Therefore, even though it was illuminated by a Greek artist, Basilios Auximos (?), who signed one miniature (fol. 151v, fig. 41),[5] and although it features the Cappadocian saint, Symeon Stylites,[6] the Chicago Lectionary is to be counted among the many Greek manuscripts produced in southern Italy during the eleventh century.[7] Affinities with K. Weitzmann's Capuan school[8] are found in the initials and interlace ornament. However, a later date, perhaps toward the end of the century, seems most likely for this manuscript.

The four miniatures depict Mark (fol. 82v), Matthew (fol. 92v), Symeon Stylites Worshipped by His Mother (fol. 151v, fig. 41), and the Presentation in the Temple (fol. 181v). Except for the faces, which are delineated with firm, regular lines, the rendering of the figures is rather heavy and coarse. As in the ornament, brown, green, and salmon pigments predominate, enhanced by lavender and blue. These are applied in broad, opaque strokes within dark contours.

H.L.K.

Lent by the Joseph Regenstein Library, University of Chicago

NOTES

1. Letter to E. J. Goodspeed, April 29, 1940, preserved in the University of Chicago archives.
2. E. A. Loew, *The Beneventan Script*, Oxford, 1914, 150f.
3. O. Pächt and J. J. G. Alexander, *Illuminated Manuscripts in the Bodleian Library, Oxford*, II, Oxford, 1970, no. 12.
4. M. Avery, *The Exultet Rolls of South Italy*, II, Princeton, 1936, pl. ccia.
5. ἅγιε Συμεῶν Στυλίτα·
   σκέπε, φρούρει, φυλάττε
   τὸν σὸν δοῦλον βασίλειον
   αὔξημον τὸν κε βεργὴν
   ἐκ πόθου γὰρ ἡστόρησεν
   τὴν σὴν εἴκονα·
   Holy Symeon Stylites,
   Protect, watch, guard
   your servant, Basilios
   Auximos and also [named] Vergis [?]
   for with love he painted
   this icon of you.
6. Symeon Stylites was venerated in Italy. See H. Belting, *Die Basilica dei SS. Martini in Cimitile*, Wiesbaden, 1962, 110f.
7. Weitzmann, *Buchmalerei*, 77f.; R. Devreesse, *Les Manuscrits grecs de l'Italie méridionale*, Vatican, 1955; M.-L. Concasty, "Manuscrits grecs originaires de l'Italie méridionale conservés à Paris," *Atti del 3° congresso internazionale di studi sull' alto medioevo*, Spoleto, 1959, 22f.
8. Weitzmann, *Buchmalerei*, 85f.

Washington, Dumbarton Oaks cod. 1. In Greek on vellum. 149 folios (32.6 x 24.8 cm.). Minuscule script. Folios 1–42: two columns of 24 lines (24 x 8 x 18 cm.). Folios 43–149: cruciform column[1] of 24 lines (24 x 17 cm.). Twenty-five anthropomorphic initials (eight with accompanying elements in the margins), and one miniature within the text column (fig. 43). Three full-page ornamental text frames, three headpieces, and over 140 illuminated initials. Binding: blind-tooled dark brown leather over wooden boards. Condition: many leaves missing, especially in the menologion section.

PROVENANCE: Purchased through Sotheby in 1939 by Mr. and Mrs. R. W. Bliss. Part of the Dumbarton Oaks Research Library and Collection from November 1940.

BIBLIOGRAPHY: Bond and Faye, *Supplement*, 103; Sotheby and Co., London, July 12, 1939, *Catalogue of Valuable Western and Oriental Manuscripts*, lot 1; Der Nersessian, "Dumbarton Oaks," 155n.

Of the twenty-six initial, marginal, and text illustrations in the Dumbarton Oaks Lectionary, twenty-three are found in the readings from John (fols. 1r–41r), one begins the Passion readings for Holy Thursday (fol. 111v), one falls before the fourth Passion lection (fol. 122v), and the last begins the menologion text for September 14 (fol. 145r, fig. 43). Compared to other Lectionaries with marginal illustrations (see cat. 28, 35), a greater proportion of the scenes in the Dumbarton Oaks manuscript are contracted to a single figure. Other elements are found occasionally, as on folio 2v where Christ's tomb is added across the text column from the running figure of Peter, or on folio 32r (fig. 44), where the Apostles of the Ascension are dotted over the page. The representation of Christ Crucified directly within the body of the text (fol. 145r, fig. 43) is, to my knowledge, unique in Lectionary illustration.

The figures are rather clumsily drawn, tending to be short with oversized heads and hands. The blond colors are thinly applied with little modeling; the shadow side of flesh areas is often rendered by a red-orange line.

It would be incorrect to assume a provincial origin simply on the basis of the rough figure style. Until any certain provincial traits have been isolated and localized, it seems reasonable to place its manufacture in Constantinople. General correspondences exist with a menologion in Moscow, Hist. Mus. cod. gr. 382, dated 1063.[2] The miniatures of the menologion exhibit a similar sketchiness and unconcern for elegant proportion and movement.                                    J.C.A.

Lent by Dumbarton Oaks Research Library and Collection

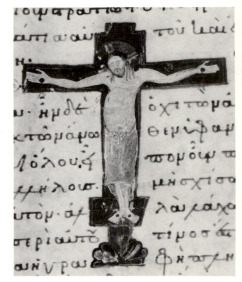

FIGURE 43.   The Crucifixion Washington, Dumbarton Oaks cod. 1, fol. 145r

NOTES

1. The change from two columns to a cruciform column occurs between gatherings but within a single reading. There is no change in script or miniature style. For the cruciform text, see cat. 2, 35.
2. Lake, *Manuscripts*, VI, pls. 408–11.

ὁ τω . . δο . . σε ἐμὲ  
ερ τὴν σκοτίαν μὴ  
μείνη· καὶ ἐάν τίϲ  
μου ἀκούϲη τῶν  
ῥημάτων καὶ μὴ  
. . τα θο . ου κρί  
νω αὐτόν· οὐ γὰρ  
ἦλθον ἵνα κρίνω  
τὸν κόϲμον ἀλλ ἵνα  
ϲώϲω τὸν κόϲμ(ον)·  
προκεί: ΗΔ: ΔΝΕ ΒΝΟΘ  
CTI: π.ν τα τα δε θνη:

## ΕΚ ΚΑ(ΤΑ) ΜΑΡΚ(ΟΝ)

ναϲ ταϲ δὲ πρωῒ πρώτη  
ϲαββάτου ἐφά  
νη πρῶτον μα  
ρία τῆ μαγδαληνῆ  
ἀφ ῆϲ ἐκβεβλήκει  
ἑπτὰ δαιμόνια·  
ἐκείνη πορευθεῖϲα  
ἀπήγγειλε τοῖϲ  
μετ αὐτοῦ γ(ε)νο(μένοιϲ)

μέροιϲ τοῦ ρ υθ  
οι καὶ κλαίουϲι·  
κἀκεῖνοι ἀκούϲαν  
τεϲ ὅτι ζῆ καὶ ἐθε  
άθη ὑπ αὐτῆϲ ἠπί  
ϲτηϲαν· μετὰ δὲ  
ταῦτα δυϲὶν ἐξ αυ  
τῶν περιπατοῦϲι  
ἐφανερώθη ἐν ἑτέ  
ρα μορφῆ πορευο  
μένοιϲ εἰϲ ἀ  
γρόν· καὶ ἐκεῖνοι  
ἀπελθόντεϲ ἀ  
πήγγειλαν τοῖϲ  
λοιποῖϲ· οὐδ(ὲ)  
ἐκείνοιϲ ἐπίϲτευ  
ϲαν· ὕϲτερον ἀνα  
κειμένοιϲ αὐτοῖϲ  
τοῖϲ ἕνδεκα ἐφα  
νερώθη καὶ ὠνεί  
διϲε τὴν ἀπιϲτίαν  
αὐτῶν καὶ ϲκληρο  
καρδίαν ὅτι τοῖϲ  
θεαϲαμ(έν)οιϲ

FIGURE 44. The Ascension  
Washington, Dumbarton Oaks cod. 1, fol. 32r

# Single Leaf Inserted into a Lectionary:

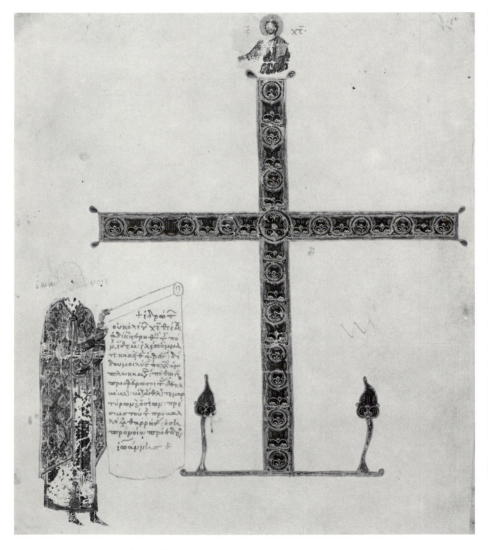

FIGURE 45.  Cross and the *Proedros* John
Princeton, Theological Seminary Lib. cod. acc. no. 11.21.1900, fol. 1*r

Princeton, Theological Seminary Lib. cod. acc. no. 11.21.1900. In Greek on vellum. 338 folios (31.0 x 26.5 cm.). Minuscule script. Two columns of 20–23 lines (24.2 x 8.0 x 17.5 cm.). One full-page miniature (inserted). One large and three small headpieces. Colophons: folio 1v (one Greek and one Arabic), non-scribal. Folio 279v (Arabic), non-scribal. Binding: nineteenth-century stamped pigskin over wooden boards. Condition: bound in disorder; trimmed; upper margins crumbling from rot; heavy candle wax staining; parts of text retraced; miniature flaked and rubbed.

PROVENANCE:  Formerly in the Church of Saint Saba near Alexandria; later in the Iviron monastery on Mount Athos. Ex colls. Sebastianoff (1857–69), A. Firmin-Didot (1869–83), and Labitte (1883–85). Acquired by C. R. Gregory for the Princeton Theological Seminary in 1885.

EXHIBITED:  Baltimore 1947, no. 711, pl. XCII.

BIBLIOGRAPHY:  DeRicci and Wilson, *Census*, 1185; Clark, *N. T. Manuscripts*, 175f. (with further bibliography); B. M. Metzger, "Studies in a Greek Gospel Lectionary (Greg. 303)," Ph.D. diss., Princeton University, 1942; idem, "A Treasure in the Seminary Library," *Princeton Seminary Bulletin*, XXXVI, 1943, 14f.; idem, *The Saturday and Sunday Lessons from Luke in the Greek Gospel Lectionary*, Chicago, 1944; Buchthal, "Gospel Book," 13n.; Lazarev, *Storia*, 251n.

In the center of folio 1*r (fig. 45) stands a large cross of conventional flower-petal ornament rendered in dull flat tones of rose, blue, and green on gold and outlined in rose. Surmounting the cross is a half-length figure of Christ, now partially flaked but identified by the inscription IC̄ XC̄. He holds a closed book to His left side and extends His right hand in blessing toward a large, full-length figure in rose and blue robes standing in the lower left quarter of the page. An inscription, now barely visible, identifies this figure as John. In his left hand he holds a large open scroll bearing a Greek inscription dedicating his book to Christ:

Unjustly deprived of not a little sweat, O Christ my God, look at my labors with compassionate eye, and for this fact give me forgiveness, [even] remission of many faults. For with love do I offer to Thee the ten books, [namely the] lives and struggles of martyrs and saints; as an old man do I present these, having taken courage in such great providence [of Thine]—Bishop John[1]

On the opening page of the Lectionary text (fol. 1r) is a broad rectangular head-piece executed in flower-petal style and enframing a quatrefoil field on which the title to the first lesson, that of Easter Sunday, is written in gold uncial letters on the plain vellum.

That folio 1* is not an integral part of the Lectionary is indicated by its ruling pattern, which does not correspond to that of the rest of the manuscript, and by the inscription on the scroll held by the *Proedros* John. Its text is inappropriate for a Lectionary, indicating rather that this miniature originally decorated the first of ten volumes with the lives of ten saints

and martyrs. Although the inscription does not serve to localize more closely the origin of this miniature, stylistic parallels may be drawn with certain Constantinopolitan manuscripts. The elongated body and tiny, unstable feet of John may be compared with those of the court officers of Nicephoros Botaniates on folio 2r of Paris, Bibl. Nat. cod. Coislin 79, dated 1078–81.[2] Not only are the proportions of the figures similar, but the pattern on the textile of their robes is also extremely close.

The inscription of folio 1*r identifies the figure of John as the scribe of a now lost collection of saints' lives. Although signatures of scribes and portraits of donors are not uncommon in Byzantine manuscripts, this portrait of a scribe has few parallels.[3]

The unique character of this frontispiece with its austere cross, bust of Christ, and portrait of the scribe has been noted.[4] It may well represent the conflation of a type of frontispiece covering two folios, one containing a full-page cross and the other a holy figure such as Christ or the Virgin, to whom a donor presents his book. [5]

T.J.-W.

Lent by the Robert E. Speer Library, Princeton Theological Seminary

NOTES

1. + ἰδρώτων
οὐκ ὀλίγων χριστὲ θεέ μου·
ἀδίκωσ στερηθεὶσ τουσ πό-
νουσ, ἴδε μου· ἰλέω ὄμμα-
τι· κἀκεῖθεν ἄφεσιν· δί-
δου μοι λύσιν πολλῶν ἀμ-
πλακημάτων· πόθω γὰρ
προσφέρω σοι τὰς δέκα
βίβλουσ· βίουσ ἄθλουσ τε μαρ-
τύρων καὶ ὁσίων· πρέ-
σβισ τούτουσ προβαλ-
λομενοσ θαρρήσασ· ὁσῆ
προνοία πρόεδροσ
Ἰωάννησ :+:
Transcription and translation from Metzger, *Studies*, 39f. Although πρόεδρος can mean bishop, it also designates a secular "president." A title of *proedros* was created in 963 by Nicephoros Phocas designating the highest office of the senatorial order. By the end of the eleventh century this title was carried by heads of bureaus as well as doctors (see L. Brehier, *Le Monde byzantin*, II: *Les Institutions de l'empire byzantine*, Paris, 1949, 106, 117). A secular designation is suggested by John's clothing.

2. Omont, *Miniatures*, pl. LXIII. See a similar figure (Prince?) on folio 1v of the homilies of Gregory Nazianzenus, Mount Athos, Dionysiou cod. 61 (Galavaris, *Gregory*, 205f., pl. LXVII, fig. 355).

3. Buchthal, "Gospel Book," 1.

4. Metzger, "Treasure," 16 (with earlier references).

5. See Jerusalem, Megale Panagia cod. 1 (fols. 1v, 2r), dated 1060–62. Photographs in the Department of Art and Archaeology, Princeton University.

FIGURE 46. The Four Evangelists
Toronto, Univ. Lib. cod. DeRicci 1, fol. 2r

Toronto, Univ. Lib. cod. DeRicci 1. In Greek on vellum. 263 folios (15 x 13 cm.). Minuscule script. One column of 18 lines (10.5 x 8.5 cm.). Four headpieces; two with figural decoration. Four ornamental initials. Colophon: folio 261v, non-scribal. Binding: black leather over wooden boards with modern backing. Condition: headpieces partially flaked; folios 228–63 are later additions.

PROVENANCE: Purchased in London around 1890 by Rev. Canon H. C. Scadding; bequeathed in 1901 to the University of Toronto.

EXHIBITED: Upper Canada Bible Society, Toronto, 1911, *Tercentenary Bible Exhibition*, no. 10.

BIBLIOGRAPHY: DeRicci and Wilson, *Census*, 2237; Clark, *N. T. Manuscripts*, 345f. (with further bibliography), pl. LII; Aland, *Liste*, 182.

The decoration of the Toronto Gospels is limited to a headpiece and initial marking the beginning of each Gospel. In the four corners of the headpiece to Matthew (fol. 2r, fig., 46) are somewhat flaked portrait heads of the Evangelists against a gold background. Matthew, at the upper left, is gray-haired and bearded, and wears green and purple garments. At the upper right, Mark has deep purple facial accents, black hair and beard, and gray and purple robes. Below to the left, Luke is depicted with short brown hair, and green and purple costume. Finally, the balding John at the lower right has gray facial tones, and green and orange clothing. The areas between the portrait medallions are decorated with blue and green rosettes and curling leaves.

The headpieces of both Mark (fol. 68r) and Luke (fol. 112r) are purely ornamental. The former consists of decorative motifs similar in type and color to those of the Matthew headpiece. In the latter a rectangular field is filled with a series of roundels outlined in blue and white dots. The center of each contains a red or gold star on a blue ground surrounded by concentric scrolls of purple, red, and green. The headpiece of John (fol. 180r, fig. 47) includes a bust of the Pantocrator clad in a blue mantle and purple tunic on a dark green background. The flesh tones are delicately modeled with red. His cross-nimbus is red and gold. His hair and beard brown. The quatrefoil enclosing the portrait medallion is filled with a blue and green scroll modeled in white and outlined in purple. In the four corners of the headpiece are blue, green, and purple rosettes. Green scrollwork fills the area between the rosettes and the quatrefoil. The background of all the ornamental areas is gold.

The Toronto Gospels have been related

palaeographically to Paris, Bibl. Nat. cod. gr. 164, dated 1070.[1] The ornament of the Mark headpiece, on the other hand, compares closely with that in London, Brit. Mus. cod. add. 24381, written in 1088.[2] Stylistically, the head of Christ is similar to that of a twelfth-century icon on Mount Sinai,[3] but the fuller proportions of the former suggest that it is earlier, dating from the second half of the eleventh century.

Despite its small scale the Pantocrator achieves a degree of monumentality through the symmetrical placement of gold on the *clavus* of the tunic and on the book ends. The practice of grouping together busts of the Evangelists occurs as early as the sixth century in the hypothesis frame of the Rossano Gospels.[4] In post-iconoclastic manuscripts, headpieces with various combinations of Christ, the Evangelists, and other saints are not uncommon.

Although the style of the ornament is rather rough, it does not necessarily mean that the manuscript could not have been executed in Constantinople.

R.D.

Lent by the University of Toronto Library

NOTES

1. E. J. Goodspeed, "The Toronto Gospels," *American Journal of Theology*, xv, 1911, 269. See Lake, *Manuscripts*, iv, pl. 298.
2. Galavaris, *Gregory*, 227, fig. 96.
3. K. Weitzmann, "Various Aspects of Byzantine Influence on the Latin Countries from the Sixth to the Twelfth Century," *Dumbarton Oaks Papers*, xx, 1966, 4, fig. 3.
4. Muñoz, *Rossano*, pl. ix.

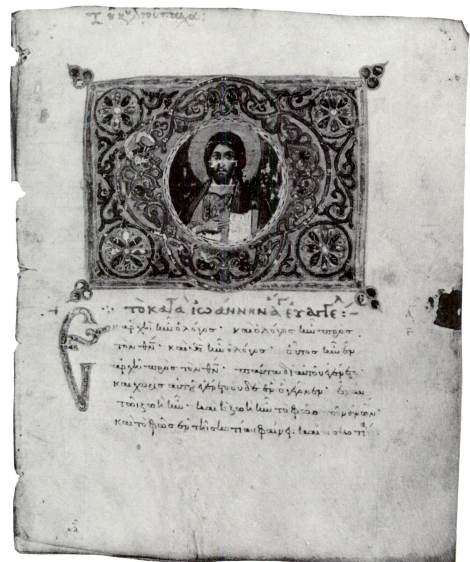

FIGURE 47. Christ Pantocrator
Toronto, Univ. Lib. cod. DeRicci 1, fol. 180r

FIGURE 48. The Anastasis, and John with Prochoros
New York, Pierpont Morgan Lib. cod. M639, fol. 1r

New York, Pierpont Morgan Lib. cod. M639. In Greek on vellum. 378 folios (33.5 x 25.4 cm.). Minuscule script. Two columns of 21–22 lines (20.5 x 6.5 x 15.4 cm.). Five two-column and eight one-column miniatures. Three marginal miniatures, ten historiated initials, and eight portrait initials. Fifteen one-column headpieces and a number of ornamental initials. Binding: purple velvet over wooden boards. Condition: only minor rubbing of several miniatures; one miniature has been repainted (fol. 323r) and one cut out (fol. 363r).

PROVENANCE: According to J. Dent sale catalogue of 1827, the manuscript was stolen from the Escorial Library in 1810 by an aide-de-camp of Marshal Soult, who sold it to Woodburn, who sold it to Dent. Purchased through the Dent sale of 1827 by W. Beckford, father-in-law of the Duke of Hamilton. In 1882 it was sold through Sotheby from the Hamilton Library (cod. 245) to the Royal Museum of Berlin. A protest by Prince Bismarck against the "extravagant" expenditure resulted in its resale in 1889 through Sotheby to Trubner from whom it was purchased by Ellis and Elory. In 1898 it was sold by Leighton to H. Y. Thompson. Purchased through Sotheby from the Thompson collection in 1919.

EXHIBITED: New York 1933–34, no. 24, pl. 24; Worcester Art Museum, Worcester, Mass., 1937, *The Dark Ages*, no. 32, ill.; The Pierpont Morgan Library, New York, 1945, *The Written Word*, 24; The Pierpont Morgan Library, New York, 1947, *The Bible, IV–XIX Century*, no. 22; Baltimore 1947, no. 705, pl. xciv; Albright-Knox Art Gallery, Buffalo, *Art in the Book*, 1953–54, no. 3; The Pierpont Morgan Library, New York, 1957, *Treasures from The Pierpont Morgan Library*, no. 11, pl. 10.

BIBLIOGRAPHY (selected): DeRicci and Wilson, *Census*, 1475; Bond and Faye, *Supplement*, 350f. (with further bibliography); Clark, *N. T. Manuscripts*, 155f. (with further bibliography), pl. xxx; Goodspeed, Riddle, and Willoughby, *Rockefeller McCormick* III, 318; Weitzmann, "Morgan 639" (with further bibliography); Buchthal, "Gospel Book," 12; Aland, *Liste*, 227; Lazarev, *Storia*, 250n; Galavaris, *Gregory*, 79, 126, 141, 148, 212, 256.

The Morgan Library Lectionary is divided into five parts by two-column miniatures acting as highly finished headpieces. Four of these richly ornamented headpieces contain author portraits of the Evangelists from whose Gospel the majority of the subsequent lections are taken (John, fol. 1r; Matthew, fol. 49r; Luke, fol. 125r; Mark, fol. 218r). The opening miniature (fol. 1r, fig. 48) is divided in two with the Anastasis on the left and John dictating to Prochoros on the right. The other three Evangelists are shown seated in profile before complex architectural backgrounds. The headpiece marking the beginning of the menologion readings (fol. 294r) is also divided into two halves. To the left Christ is seated in the Synagogue returning the book of Isaiah (Luke 4:20) and to the right is the death of Symeon Stylites. All five miniatures bear complex flower-petal borders in red, green, and blue.

Next in importance are eight framed one-column miniatures with narrative and liturgical scenes. Four illustrate lections from Passion Week (fol. 252v, fig. 49, Washing of the Feet; 268v, Betrayal; 271v, Denial and Repentance of Peter; 280r, Deposition and Burial) and four illustrate major calendar feasts within the menologion (fol. 323r, Nativity; 336v, Presentation; 342v, Annunciation; 366r, Koimesis). The composition of each is balanced and hieratic, suggesting an ultimate source in monumental art.[1] In the miniature of the Washing of the Feet (fol. 252v, fig. 49) Christ and Peter are depicted in the center with symmetrical groups of Disciples standing to the right and left. In the sixth-century Rossano Gospels[2] the Disciples are similarly standing but are not divided into framing groups. The eleventh-century mosaics at Hosios Lukas and Daphni,[3] on the other hand, show some of the Disciples seated, removing their sandals—an iconographic innovation of the Macedonian Renaissance seen for the first time in a tenth-century ivory.[4] Thus, the Morgan miniature reflects an earlier iconographic tradition.

Stylistically, this group of miniatures stands apart from the rest of the illustrations. The figures are more summarily painted, and gold is used for linear drapery highlights, creating a flat, dematerialized effect. K. Weitzmann has suggested, on the basis of a similar technique in the Theodore Psalter (London, Brit. Mus. cod. add. 19352), dated 1066 and produced in the Studios monastery of Constantinople,[5] that the artist of these scenes in the Morgan Lectionary was trained at Studios around the time of the painting of the Psalter.[6]

Marginal miniatures and anthropomorphic initials constitute the third type of illustration in codex M639. The majority (thirteen) fall within the readings from John; there is also one on each folio beginning a new textual division and five more in the menologion readings. The figures are tall, thin, and elegantly proportioned. Their faces are rendered in ochre, their garments in blue, green, red, and orange. Like the portrait figures, they are finely modeled. Whenever possible, the miniaturist has kept the figures close to the initial marking the beginning of the pericope, thus forming small tight groups like the 'T' on folio 39r (fig. 50) with the representation of the Ascension. Occasionally, however, figures are separated by the text column in order to indicate a separation of time or distance, as on folio 3v, where Peter in the left margin runs towards Christ's tomb, placed between the two columns.

The figures in the Morgan Lectionary are attenuated and less well proportioned

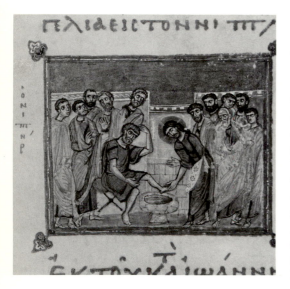

FIGURE 49. The Washing of the Feet
New York, Pierpont Morgan Lib.
cod. M639, fol. 252v

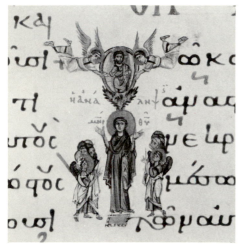

FIGURE 50. The Ascension
New York, Pierpont Morgan Lib.
cod. M639, fol. 39r

than those in manuscripts dating from the first half of the eleventh century, such as the Walters Art Gallery menologion (cat. 11). They lack, on the other hand, the hard schematization and mannerism of Vatican Lib. cod. Urb. gr. 2, datable around 1122.[7] Between these poles, codex M639 clearly reveals elements of the ascetic style begun around the time of the Theodore Psalter; but like the Dumbarton Oaks Psalter-New Testament (cat. 20), dated 1084, it shows a development away from extreme forms of dematerialization. A date in the second half of the eleventh century is supported by close similarities of ornament to a Psalter in Leningrad, Public Lib. cod. gr. 214, dated 1074–81.[8]

The elegance of the figures and the high level of craftsmanship and materials throughout indicate a Constantinopolitan origin for the Morgan Lectionary.

<div style="text-align: right">J.C.A.</div>

Lent by The Pierpont Morgan Library

NOTES

1. Weitzmann, "Morgan 639," 366.
2. Muñoz, *Rossano*, pl. v.
3. E. Diez and O. Demus, *Byzantine Mosaics in Greece: Hosios Lucas and Daphni*, Cambridge, Mass., 1931, pl. XII, fig. 94.
4. K. Weitzmann, "A 10th Century Lectionary: A Lost Masterpiece of the Macedonian Renaissance," *Revue des études sud-est européennes*, IX, 1971, 626.
5. Der Nersessian, *Psautiers*.
6. Weitzmann, "Morgan 639," 360.
7. Stornajolo, *Giacomo*, pls. 83–93; Bonicatti, "Urb. gr. 2."
8. Lazarev, *Storia*, 189, pl. 219.

Baltimore, Walters Art Gallery cod. W733. In Greek on vellum. 102 folios (22.0 x 16.5 cm.). Minuscule script. One column of 23–28 lines (13.5 x 9.2 cm.). 155 marginal miniatures. Binding: gold-tooled Italian vellum. Condition: damage from fire and water; deficient at beginning and end (begins with Psalm 28:5 and ends with Psalm 120:7); some lacunae; several miniatures excised; some figures and parts of script retouched; doodling in margins.

PROVENANCE: In the eighteenth century in the possession of an Italian schoolboy who scribbled on many folios and signed his name, "Theodosio Cacuri Dattene" (fol. 176v), and the date, "11 Agosti 1724." Ex colls. F. North, and T. Phillipps (cod. 10384), who acquired it from Payne in London shortly before 1840. Purchased by the Walters Art Gallery through Sotheby (Phillipps collection) on July 1, 1946.

EXHIBITED: Baltimore 1947, no. 698, pl. XCIV; The Grolier Club, New York, 1962–63, "Additions to DeRicci"; Athens 1964, no. 278, fig. 278.

BIBLIOGRAPHY: Bond and Faye, *Supplement*, 197; Sotheby and Co., London, July 1, 1946, *Bibliotheca Phillippica, Catalogue of a Further Portion of the Renowned Library . . .*, lot 2, pl. II; Weitzmann, "Septuaginta," 109n.; Miner, "Monastic"; E. Eszlary, "On the Development of Early Christian Iconography . . . ," *Acta Historiae Artium Academiae Scientarum Hungaricae*, VIII, Budapest, 1962, 222f., 239f., fig. 14; S. Dufrenne, "Le Psautier de Bristol et les autres psautiers byzantins," *Cahiers archéologiques*, XIV, 1964, 159n.; Der Nersessian, "Dumbarton Oaks," 174; D. Miner, "Since DeRicci—Western Illuminated Manuscripts Acquired Since 1934: A Report in Two Parts: Part I," *Journal of the Walters Art Gallery*, XXIX–XXX, 1966–67, 72f., figs. 4, 5; Lazarev, *Storia*, 250n.; Der Nersessian, *Psautiers*, 63, 78, 79n., 82n., 85, 87, 92, 94, 97n.; K. A. Wirth, "Notes on Some Didactic Illustrations," *Journal of the Warburg and Courtauld Institutes*, XXXIII, 1970, 30n.; K. Weitzmann, "The Sinai Psalter cod. 48 and Three Leaves in Leningrad" (in press).

The Baltimore Psalter (figs. 51, 52) is illustrated with 155 marginal miniatures, ranging from portraits of single praying figures to complete feast scenes. The small size of the figures and the compactness of most compositions permit, in many instances, several scenes to be included in the wide margins of a single leaf. The colors, which are rather dull, tend toward shades of blue, rose, tan, mauve, and ochre, with occasional accents of bright red. Highlights are executed through networks of gold hatching. The scenes are generally devoid of groundline and background, although some elements of landscape and architecture are occasionally included.

On stylistic grounds, the Walters manuscript must be assigned a date in the late eleventh century. Although the quality of its miniatures varies greatly, certain elements of style remain constant. Most of the figures are ill proportioned, in some cases to the point of awkwardness; volume and perspective have been neglected in favor of overall decorative flatness; and, while drapery is generally angular and two-dimensional, it is often enriched with gold highlights and lively flying folds. These characteristics recur to a great extent in two other marginal Psalters of the same period, the Theodore Psalter (London, Brit. Mus. cod. add. 19352), dated 1066,[1] and the Barberini Psalter (Vatican Lib. cod. Barb. gr. 372), which has been dated around 1092.[2]

The relationship of the style of codex W733 to both of these manuscripts, and particularly to the Barberini Psalter, indicates that it should be dated in the second half, and perhaps even in the last quarter, of the eleventh century. These related Psalters are generally assumed to have been produced in Constantinople and, although the Baltimore manuscript does not match their quality, it must be assumed that it also is a Constantinopolitan product.

Like the Theodore and Barberini Psalters, and five other known manuscripts of the monastic Psalter recension,[3] the Psalter in Baltimore is illustrated with marginal miniatures. Certain of these miniatures are common to almost all marginal Psalters, among them representations of Old Testament incidents specifically mentioned in the Psalm text (e.g., episodes from the story of Joseph with Psalm 104 [105], fols. 75v–76r). With regard to these scenes, the Baltimore codex is more closely connected with the Theodore and Barberini Psalters than with the others.

There are, however, a large number of illustrations in codex 733 that have no parallel among the other monastic Psalters. One example is the illustration of Psalm 33:21 (34:20): "He keepeth all their bones; not one of them shall be broken." The illuminator of the Baltimore Psalter has depicted the bodies of righteous men lying on a marble altar beneath a ciborium (fol. 6v).[4]

Such scenes might suggest that the Baltimore manuscript is an isolated deviant from the marginal Psalter recension were it not for the existence in Leningrad of another Psalter with the same cycle of illustrations (Public Lib. cod. 1252 F VI).[5] Commonly known as the "Russian Psalter of 1397," the year of its production, this manuscript was written in Kiev. It lacks only a few leaves and can be used to reconstruct the lost miniatures of the Baltimore codex. The relationship of the two manuscripts goes beyond their almost complete agreement in iconography and layout to correspondence in drapery, composition, and gesture.

Miss D. Miner has shown that, al-

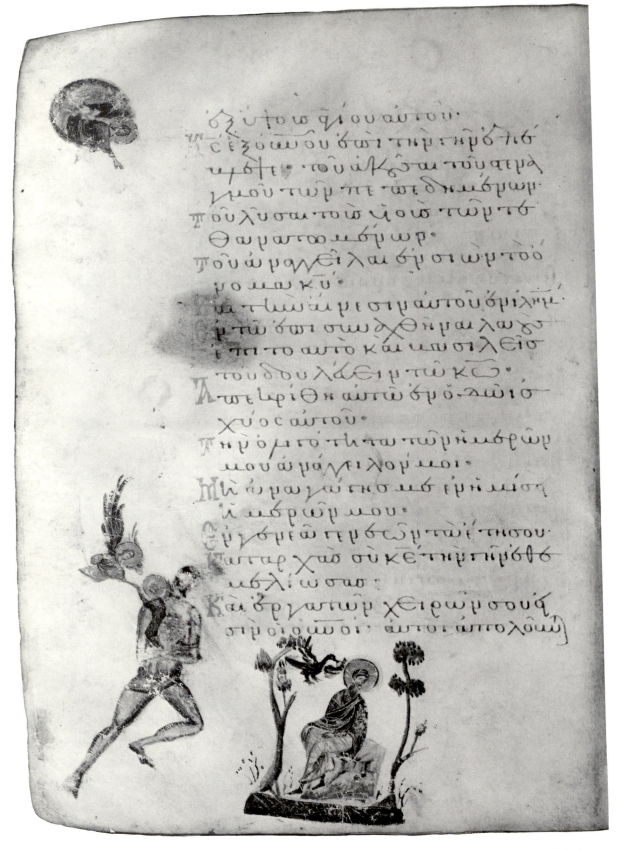

FIGURE 51.  A Soul Released from Hades, and Paul of Thebes
Baltimore, Walters Art Gallery cod. W733, fol. 69v

though the same illustrations occur in both Psalters, the artist of the Baltimore manuscript was occasionally forced, perhaps by spatial limitations, to rearrange the sequence of some episodes.[6] This has led to a confusion that does not trouble the Russian Psalter. Because the Russian manuscript preserves a closer connection of text and picture, provides clearer illustration of certain passages, and allows for fewer misunderstandings of the original cycle, Miss Miner quite correctly concludes that it cannot be a copy of the Walters manuscript. Instead, she argues that both Psalters derive from a common model produced about the middle of the eleventh century. Thus, she adds further evidence that the second half of the eleventh century was a flourishing period for the production of both traditional and innovative Psalters.                                             S.G.

Lent by the Walters Art Gallery

NOTES

1. Der Nersessian, *Psautiers.*
2. E. T. De Wald, "The Comnenian Portraits in the Barberini Psalter," *Hesperia,* XIII, 1944, 78f.
3. Tikkanen, "Psalterillustration." He recognized six members of the group. A seventh, the Bristol Psalter (London, Brit. Mus. cod. add. 40731), was discovered in 1921.
4. Miner, "Monastic," fig. 1.
5. The manuscript is reproduced in a lithographic facsimile edition: *Licevaja psaltir 1397 goda prinadležaščaja Imperatorskomu Obščestvu ljubitelej drevnej pis' mennosti* (no. 1252Fvi), St. Petersburg, 1890.
6. Miner, "Monastic," 242f.

FIGURE 52.
The Striking of the *Semandron*
(The Call to Worship)
Baltimore, Walters Art Gallery
cod. W733, fol. 63r

# Leaf from a Psalter:

Princeton, Art Museum cod. acc. no. 30.20. Single vellum leaf (11.1 x 8.0 cm.; with mount: 14.7 x 11.4 cm.). One full-page miniature. Text: Psalm 8:7–10 in Greek. Minuscule script. One column of 14 lines (incomplete). Column 7.6 cm. wide. Condition: only minor flaking.

PROVENANCE: Given to The Art Museum, Princeton University, in 1930 by Miss Ida Farman.

EXHIBITED: Baltimore 1947, no. 713, pl. xcvii; Oberlin 1957, 45, no. 7, fig. 6.

BIBLIOGRAPHY: Bond and Faye, *Supplement*, 304; Clark, *N. T. Manuscripts*, 180f.; K. Weitzmann, "Aristocratic Psalter and Lectionary," *Record of The Art Museum, Princeton University*, xix, 1960, 98f.; idem, *Grundlagen*, 40n.; Der Nersessian, "Dumbarton Oaks," 176; Lazarev, *Storia*, 253n.; Weitzmann, "Eleventh Century," 217n.

The leaf (fig. 53) preserves a full-page, double-register miniature, painted in shades of red, blue, and green on gold ground, and representing two feast scenes. In the upper register, the Crucifixion assumes its standard, Mid-Byzantine form with Christ in the center, flanked by the Virgin with upraised arms at the left and the weeping John at the right. To the left of the cross are traces of the inscription: H CTAV[PωCIC]. The Anastasis below takes the very rare iconographic form of Christ standing frontally over the broken gates of Hell, displaying the wounds on his outstretched hands. Adam and Eve, kneeling in attitudes of prayer, are symmetrically disposed to the left and right. To the right of Christ's head are traces of the inscription: [H ANA]CTACIC.[1]

Various elements in the miniature suggest that the leaf should be dated in the late eleventh century.[2] Foremost among these is the obvious abstraction both of the figures and the settings, which is characteristic for the period; the landscape is stylized and the figures, although solid, are strangely lacking in physical reality. A late eleventh-century date is further supported by the hieratic, non-narrative compositions, which undoubtedly reflect the increasing influence of the Lectionary in which the great feast cycle had crystallized during the eleventh century.[3] The figure types, drapery conventions, and color choices are typical for the period, and especially for the highly developed workshops of Constantinople, where this leaf must have been produced.

The abbreviation καθ (*kathisma*) at the end of the text passage on the reverse of the leaf indicates that the parent manuscript was a Psalter Lectionary, that is, a Psalter divided into twenty *kathismata*, or lections, to be read in the course of a week. K. Weitzmann has shown that the miniature must have formed the verso of the leaf.[4] We may thus conclude that it was placed after Psalm 8 and, therefore, before the second *kathisma*.

A tentative attempt at the reconstruction of the parent manuscript suggests two alternatives: either it contained scattered full-page miniatures—some of which were feast scenes—like the Psalter on Mount Athos, Vatopedi cod. 760;[5] or it included a full-page miniature at the beginning of each *kathisma*.

The first alternative is unlikely since Vatopedi cod. 760 seems to have been illustrated in a rather random fashion and its miniatures lack the Princeton leaf's hieratic quality. The second alternative, although unsupported by surviving parallels, is more plausible. If this manuscript was, as we believe, illustrated with full-page feast scenes and related liturgical miniatures at the beginning of every *kathisma*, it would afford extraordinary evidence of the migration of pictures from the Gospel Lectionary into the body of the Psalter.[6]

Because this illustration is full page, we must suppose that the parent manuscript belonged to J. J. Tikkanen's group of aristocratic Psalters. Yet, for two reasons it does not comfortably conform to the manuscripts of that recension: its emphasis on feast scenes is odd; and, more significantly, its inclusion of these two feast scenes before Psalm 9 is completely unprecedented.

On the other hand, the cycle of illustration in a manuscript such as we propose would surely have depended heavily on Tikkanen's monastic Psalter recension. While the exclusively christological nature of the Princeton leaf is quite out of keeping with the Old Testament emphasis of the aristocratic Psalters, it is, at the same time, easily reconcilable with the increas-

ing importance of christological elements in the late eleventh-century marginal Psalters (see cat. 29).

Furthermore, the division of the text into *kathismata* indicates that, although it had full-page miniatures, the parent manuscript of the Princeton leaf was intended for liturgical and not private use; by Tikkanen's definition, liturgical usage and marginal illustration went hand-in-hand. Thus the Princeton Psalter leaf shows Tikkanen's classifications to have been a bit too rigid and, along with other manuscripts, it suggests a more extensive interrelation between his two Psalter recensions.                                  S.G.

Lent by The Art Museum, Princeton University

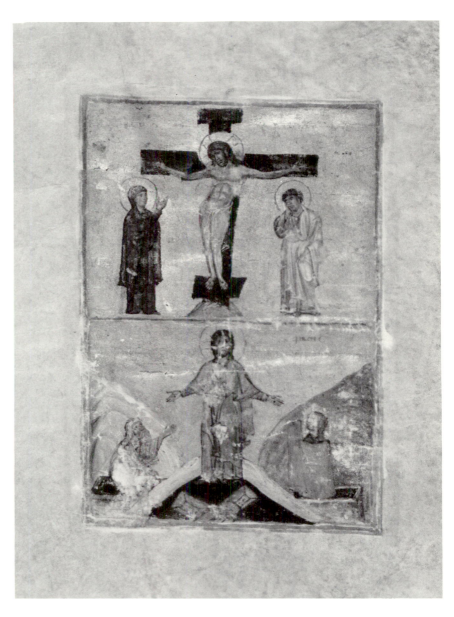

FIGURE 53. The Crucifixion and the Anastasis
Princeton, Art Museum cod. acc. no. 30.20

NOTES

1. Weitzmann, "Aristocratic," 99f.
2. Weitzmann, "Eleventh Century"; Lazarev, *Storia*, 185f.
3. Likewise, the strict symmetry indicates that the immediate model was probably a monumental composition such as Hosios Lukas or Daphni, or an icon, where the feast cycle had also become dominant during the eleventh century.
4. Weitzmann, "Aristocratic," 104.
5. Vatopedi cod. 760 dates from the eleventh to twelfth century and includes representations of the Entry into Jerusalem (fol. 19v) and the Anastasis (fol. 119v). See Weitzmann, "Aristocratic," figs. 4–5.
6. Shortly before the production of the Princeton leaf, the complete cycle of twelve great feasts (plus a thirteenth) had been included as a frontispiece to the marginal Psalter, Vatican Lib. cod. gr. 752, dated 1059.

# 31.  Homilies of Gregory Nazianzenus

Princeton, Art Museum cod. acc. no. 41.26. Sixteen liturgical homilies of Gregory; commentaries on four homilies by Pseudo-Nonnos; Gregory's testament. In Greek on vellum. 230 folios (34 x 25 cm.). Minuscule script. Two columns of 32 lines (24.0 x 7.5 x 17.0 cm.). One full-page miniature (inserted). Six headpieces and part of one historiated initial. Binding: crimson velvet over wooden boards. Silver plaque with relief portrait of Gregory (fig. 54, late seventeenth or eighteenth century; modeled on the full-page miniature). Four silver rosettes on back cover. Condition: right side of inserted miniature badly cut (indicating larger parent manuscript); areas of portrait rubbed; all sixteen title miniatures cut out.

PROVENANCE: Ex coll. L. F. Gruber, Maywood, Illinois. Purchased in 1941 by The Art Museum, Princeton University, from Kraus.

BIBLIOGRAPHY: DeRicci and Wilson, *Census*, 693; Bond and Faye, *Supplement*, 304f.; K. Weitzmann, "A Codex with the Homilies of Gregory of Nazianzus," *Record of the Museum of Historic Art, Princeton University*, I, 1942, 14f., figs. 1–3; idem, *Mythology*, numerous citations; Lazarev, *Storia*, 176n.; Galavaris, *Gregory*, 13, 20, 24n., 250, fig. 256.

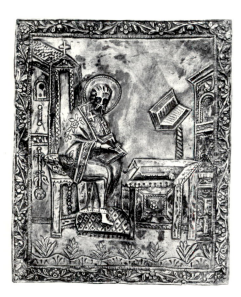

FIGURE 54.  Gregory Nazianzenus
Princeton, Art Museum
cod. acc. no. 41.26, cover

The inserted miniature (fig. 55) represents Gregory, in bishop's garments of brown and dark violet, seated before a desk and writing in a codex on his lap. The dark brown furniture contrasts with the red cushions of the seat and the footstool. The architecture is rendered in lighter colors—the building on the left is lilac with a greenish blue door, while that on the right is blue. The ground at the bottom of the composition is a darker blue. At its base flows a green river on whose shores grow small bushes painted in grisaille. A frame in a degenerate flower-petal style, different from that of the headpieces, encloses the composition. Both the saint's name, inscribed on the flaked gold ground, and the text displayed on the lectern were written by a later hand.

Square, one-column miniatures—now cut out—were originally placed above the title of each homily. The flower-petal ornament of the six headpieces still intact consists of palmettes with curled leaves of blue, green, pink, and crimson.

The flower-petal ornament in the manuscript finds its closest parallels in manuscripts of the tenth and the beginning of the eleventh century.[1] The high technical quality and brilliant, enamel-like colors indicate Constantinople as the place of origin. Palaeographic evidence supports this dating.

The inserted portrait of Gregory is of a later date. Although the head of the figure is slightly rubbed, the linear treatment of the drapery and architecture recalls similar Gregory manuscripts dating from the late eleventh or early twelfth century. Specifically, the Princeton miniature shows a more mannered treatment than the portrait of Gregory in Florence, Laur. Lib. cod. Plut. VII, 24, dated 1091. It is closer to Florence, Laur. Lib. cod. Plut. VII, 32, datable to the last years of the eleventh or the early twelfth century.[2]

The Princeton Gregory manuscript is an early copy of an illustrated edition of sixteen Gregory homilies made specifically for liturgical use. The first codex of this edition was probably produced in the tenth century but the earliest surviving copies are from the eleventh.

G.G.

Lent by The Art Museum, Princeton University

NOTES

1. Weitzmann, *Buchmalerei*, pl. XXXVII, fig. 206, dated from the year 1007.
2. Galavaris, *Gregory*, 218, fig. 97; 218f., fig. 263.

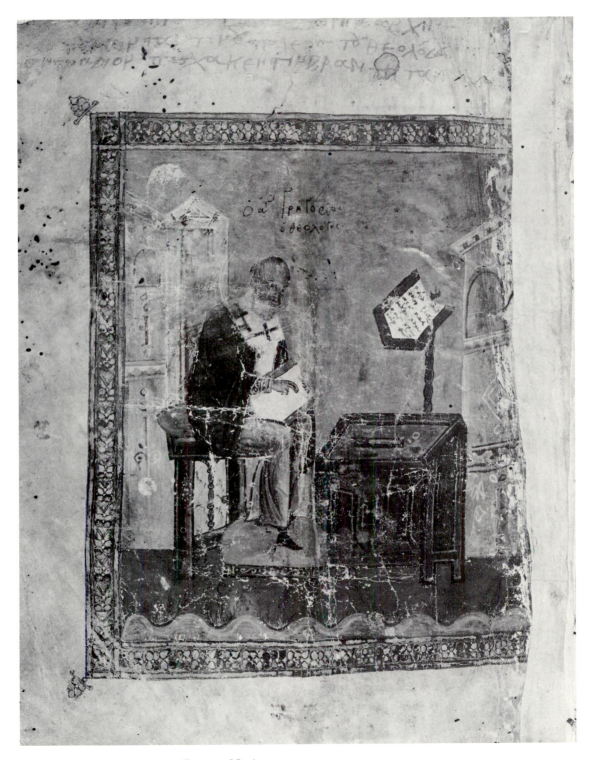

FIGURE 55. Gregory Nazianzenus
Princeton, Art Museum cod. acc. no. 41.26, fol. 1v

Cambridge, Harvard College Lib. cod. gr. 3. Folios 1–7, 233–89 contain the commentary of Psellos, various prayers, a menologion, and a *troparion*. In Greek on vellum. 289 folios (22.5 x 17.8 cm.). Minuscule script. One column of 21–22 lines (17.5 x 12.5 cm.). Three full-page miniatures, three headpieces (two with figural decoration), and one anthropomorphic initial. Paschal tables on folios 282r–289v for 1105–24. Colophons: folios A and B, non-scribal. Binding: early nineteenth-century Russian leather. Condition: miniatures rubbed and partially flaked; folio 216v repainted.

PROVENANCE: A sixteenth-century colophon (fol. A) states that Michael Cantacuzenos "took this Psalter in order to learn it" on Saint Catherine's Day, 1589. A second non-scribal colophon (fol. B) of the eighteenth or nineteenth century contains excerpts from several texts related to the life of another Michael Cantacuzenos, who died in 1578. The manuscript was purchased in 1819 in Istanbul from "the family of a Greek prince in decay"[1] by E. Everett, and was given to Harvard in the following year.

EXHIBITED: Fogg Art Museum and Houghton Library, Harvard University, Cambridge, Mass., 1955, *Illuminated and Calligraphic Manuscripts*, no. 7.

BIBLIOGRAPHY: DeRicci and Wilson, *Census*, 971 (with further bibliography); E. Boer, "Description of Greek Manuscripts in the Possession of the Harvard University Library," unpublished catalogue, Cambridge, 1928, fol. 7.

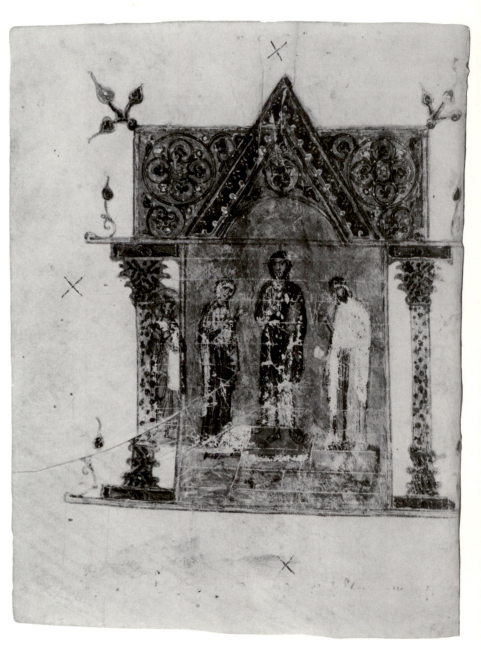

FIGURE 56.  The Deesis and David
Cambridge, Harvard College Lib. cod. gr. 3, fol. 8v

On folio 8v, facing the opening verses of the first Psalm, is a full-page representation of the Deesis (fig. 56) set against a gold ground within an elaborate ornamental frame, which includes a pediment supported on columns. David stands to the inside of the left column holding an open scroll, and a small donor figure appears in *proskynesis* at the feet of Christ. On folio 113r, within the small headpiece to Psalm 77 (78), Moses is shown presenting the Tablets of the Law to the Israelites. A small medallion attached to the initial Π commencing the Psalm contains a portrait of the author, Asaph. Two full-page miniatures follow the last Psalm: folio 215v shows in two registers David's Fight with Goliath; and folio 216v, unfortunately in ruinous condition and apparently repainted by another hand, depicts the Crossing of the Red Sea. Facing this miniature, within the headpiece to the first Ode, is another small portrait of the author, in this case Moses (fol. 217r). A large ornamental headpiece is found over the beginning of Psalm 1 (fol. 9r). The manuscript's ornament consists chiefly of large circular tendrils with attached floral motifs.

The Harvard Psalter must have been produced in 1105 since its Paschal tables (fols. 282r–289v) begin with that year. Through figure style and ornament it forms a group with two other manuscripts. The concentric circular tendrils and large flowers on the corners of the headpiece to Psalm 1 (fol. 9r) are nearly identical to the ornament on folio 35r of a *Praxapostolos* in Paris, Bibl. Nat. cod. suppl. gr. 1262, dated 1101 and localized to Constantinople.[2] Many details of format and figure style as well as ornament are closely paralleled in a Gospel book in the Megaspelaion monastery (cod. 8).[3] Also similar, but not as closely related,

is the ornament in the headpiece to a liturgical roll in Jerusalem, Stavrou cod. 109, another Constantinopolitan manuscript from around the year 1100.[4]

Although the figure style of the Harvard Psalter varies according to the type of scene depicted—the figures of the hieratic Deesis are considerably more elongated than those of the narrative battles of David and Goliath—it is generally characterized by elongated figures and by garments rendered in flat colors with folds and highlights indicated by frameworks of black and white lines.

The only other example of a full-page Deesis miniature used as a frontispiece in a Byzantine Psalter[5] is a manuscript formerly in the Berlin Theological Seminary (cod. no. 3807),[6] whose miniature cycle is in many respects closely related to that of the Harvard Psalter. The presence of David in the Harvard Deesis is surely to be understood as a conflation. The Deesis in the Berlin Psalter is followed by a full-page author portrait of David.

The use of the Deesis, "the pictorialization of the Commemoration or Intercession Prayer of the Byzantine liturgy," as the frontispiece to a Psalter instead of the more typical life cycle of David is an example of the impact of the Liturgy on Byzantine art, which is particularly noticeable in the later eleventh century.[7]

L.N.

Lent by the Houghton Library, Harvard University

NOTES

1. E. Everett, "An Account of Some Greek Manuscripts Procured at Constantinople in 1819 and Now Belonging to the Library of the University at Cambridge," *Memoirs of the American Academy of Arts and Sciences*, IV, 1820, 412.

2. J. Beckwith, *The Art of Constantinople*, London, 1961, 124, fig. 164. Additional photographs in the Department of Art and Archaeology, Princeton University.

3. E. Tsimas and S. Papachadjidakis, Χειρόγραφα Εὐαγγέλια Μονῆς Μεγάλου Σπηλαίου, Athens, n.d., pls. 34–58.

4. A. Grabar, "Un Rouleau liturgique constantinopolitain et ses peintures," *Dumbarton Oaks Papers*, VIII, 1954, 163f., fig. 1.

5. Discounting the Latin Crusader manuscript in London, Brit. Mus. cod. Egerton 1139.

6. G. Stuhlfauth, "A Greek Psalter with Byzantine Miniatures," *Art Bulletin*, XV, 1933, 311f.

7. Weitzmann, "Eleventh Century," 207f.

# The Four Gospels    *Circa 1100 A.D.*

Princeton, Scheide Lib. cod. M70. In Greek on vellum. 192 folios (22 x 17 cm.). Minuscule script. One column of 27 lines (14.5 x 11.0 cm.). Ten illuminated canon tables and four headpieces. Binding: old red velvet over wooden boards. Traces of metal plaque ornaments. Condition: illumination partially flaked.

PROVENANCE: Early twentieth century in the Church of the Anastasis, Jerusalem (cod. 14). By 1915 in the Jerusalem monastery of Abraham (cod. 59). In 1934 its whereabouts was unknown. Sold by Sotheby to Maggs in 1938. Obtained by J. Scheide from Maggs in the same year.

BIBLIOGRAPHY: Bond and Faye, *Supplement*, 314; Papadopoulos-Kerameus, *Jerusalem*, III, 213f.; ibid., v, 425; Gregory, *Textkritik*, 257, 1141, no. 1357; H. von Soden, *Die Schriften des Neuen Testaments*, Göttingen, 1911, 135, no. 1041; Sotheby and Co., London, July 1, 1938, sale catalogue, 74, no. 555; Aland, *Liste*, 132.

The canon tables of the Scheide Gospels (fols. 5v–10r, fig. 57) are set between columns executed in mottled colors, imitating marble, with decorated bases and capitals. The central support consists of two slender shafts broken at midpoint by a foliate capital and surmounted by a zoomorphic capital. These supports carry an entablature, from which hang votive crowns. Above, arches or pediments are set into rectangular frames containing carefully illuminated foliate ornament in rich, dark shades of blue, green, and wine red on a deep gold ground. At the top of each rectangle a pair of birds confront one another over a water-filled vase.

The headpieces to each of the four Gospels (fols. 12r, 59r, 93r, 147r) contain either foliate or interlace ornament. Although their style corresponds closely to that of the canon tables, their colors— green, blue, rose, scarlet, and gold—are lighter and more brilliant.

In the ornament of the Scheide Gospels, linear elements and geometric patterns predominate over floral motifs. The brilliant, enamel-like quality of eleventh-century ornament is absent (see cat. 28). Close comparisons may be found in a Gospel book in Melbourne dated around 1100[1] and in the Harvard Psalter (cat. 32), dated 1105.

T.J.-W.

Lent by the Scheide Library, Princeton

NOTE

1. Buchthal, "Gospel Book," pl. 5.

FIGURE 57. Canon Table
Princeton, Scheide Lib. cod. M70, fol. 9v

# The Four Gospels

Princeton, Univ. Lib. cod. Garrett 5. In Greek on vellum. 226 folios (28.2 x 19.4 cm.). Minuscule script. One column of 28 lines (19.0 x 12.8 cm.). Five full-page miniatures and three headpieces. Colophons: folios 224v–225r, scribal, mostly erased. Folios 13v and 225v, non-scribal. Binding: stamped dark red leather over wooden boards. Condition: the miniatures are flaked, the Virgin and John portraits most severely; the Virgin and Matthew leaves have been cut back and repaired; Matthew headpiece lacking.

PROVENANCE: Formerly in the Koshtinsky monastery. Presented to the monastery of Saint Andrew on Mount Athos in 1879 (cod. 3). Brought to the United States by T. Whittemore. Acquired in 1925 by Robert Garrett, who presented it to the Princeton University Library in 1942.

EXHIBITED: Boston 1940, no. 8, pl. III; Baltimore 1947, no. 710, pl. XCIII.

BIBLIOGRAPHY: DeRicci and Wilson, *Census*, 866; Bond and Faye, *Supplement*, 311; Clark, *N. T. Manuscripts*, 69, pl. x; K. Weitzmann, *Die armenische Buchmalerei des 10. und beginnenden 11. Jahrhunderts*, Bamberg, 1933, 18f., Beilage 2, fig. 6 (reprinted Amsterdam, 1970); Friend, "Greek Manuscripts," 132, ill.; H. Buchthal, *Miniature Painting in the Latin Kingdom of Jerusalem*, Oxford, 1957, 9f., pl. 143a; Lazarev, *Storia*, 253n., 270n.; M. Frazer, "Byzantine Art and the West," *The Year 1200: II, A Background Survey*, ed. F. Deuchler, New York, 1970, 226, no. 256, ill.

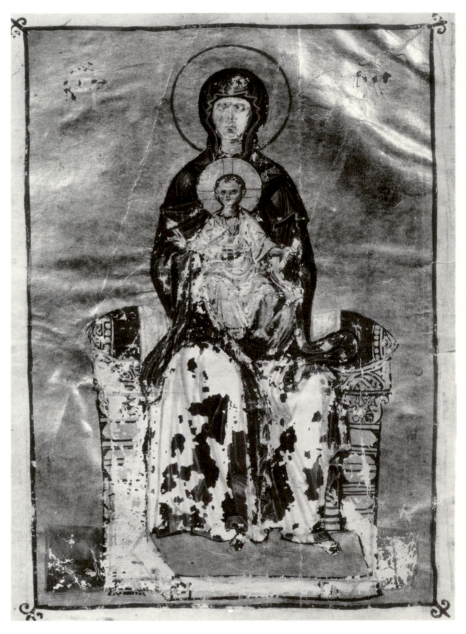

FIGURE 58. Virgin and Child
Princeton, Univ. Lib. cod. Garrett 5, fol. 12v

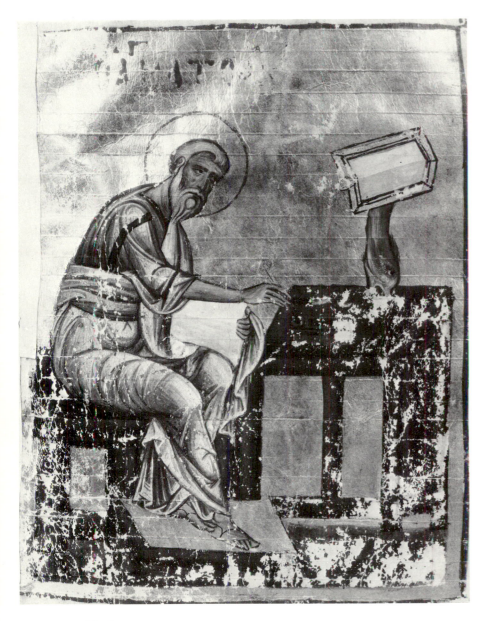

FIGURE 59.  Matthew
Princeton, Univ. Lib. cod. Garrett 5, fol. 13r

The nimbed Virgin (fol. 12v, fig. 58), seated frontally on a gold throne with a crimson cushion, supports in her lap the seated cross-nimbed Christ Child holding a roll in His left hand and blessing with His right. The Child's golden robes are flaked. The Virgin wears a dark purple mantle, highlighted in white, over a blue tunic, now badly flaked, revealing partially the preparatory sketch beneath. In the upper corners are inscribed $\overline{\text{M–P}}$ and $\overline{\Theta\text{V}}$ in blue uncial letters.

Four nimbed and bearded Evangelists are shown seated in profile before low brown desks, their feet resting on footstools. Luke's desk (fol. 114v) is flanked to the right by a tall lectern from which hangs a long blank scroll. The other desks have dolphin lecterns supporting open codices.

Matthew (fol., 13r, fig. 59), Mark (fol. 74v), and Luke sit on cushioned benches, while John (fol. 178v) is seated in a wicker chair. Matthew and Luke both dip their pens into inkwells on their desks and hold open books on their laps; Mark touches the lectern with his left hand and holds his right upraised. John rests both hands contemplatively on his knees. The gaze of all four Evangelists is directed to some point beyond the immediate picture space.

The gray-haired Matthew wears a cobalt blue tunic with a blue-green mantle wrapped high around his waist and draped over his left shoulder. The form-revealing drapery is strongly highlighted in white. Mark and Luke, dark haired, wear blue tunics with purple mantles. John's portrait is the least well preserved, with only a portion of the face and traces of the blue tunic and grayish green mantle remaining. The names of the Evangelists are inscribed above their heads in large uncial letters. All five figures in

this Gospel book are depicted against dazzling gold backgrounds. Below, in every miniature, a wide, dark green strip serves as ground.

The three headpieces (that for Matthew on fol. 14r was never executed, although space was provided) consist of stylized blue and green palmettes generally enclosed by blue circles on a gold ground. The headpieces for Mark (fol. 75r) and Luke (115r) are Π-shaped, while that of John (fol. 179r) is rectangular.

In the early post-iconoclastic period the image of the enthroned Virgin and Child, closely associated with the dogma of the Incarnation, was symbolic of triumph over Iconoclasm.[1] The iconic frontispiece in the Princeton Gospels ultimately derives from such popular monumental images of this theme as are found in the apse mosaics of Hagia Sophia in Constantinople and Hosios Lukas.[2]

The strong drapery highlights of these miniatures indicate a twelfth-century date for their production. Specifically the head type of the massive figure of John finds a close parallel in the John portrait of London, Brit. Mus. cod. add. 5112, dated 1189.[3] On the other hand, the broad flickering drapery highlights of the Mark portrait, as well as his distant, anxious expression, are very similar to the Mark portrait in Athens, Bibl. Nat. cod. 2251,[4] datable through the agitated garments of its Matthew portrait to the late twelfth century. A similarly monumental Enthroned Virgin and Child are found in a Lectionary in Jerusalem, Anastaseos cod. 9 (fol. 148v), dated 1152.[5]

B.A.V.

Lent by Firestone Library, Princeton University

NOTES

1. J. Beckwith, *Early Christian and Byzantine Art*, Suffolk and London, 1970, 86f.
2. Ibid., pl. 154; E. Diez and O. Demus, *Byzantine Mosaics in Greece: Hosios Lucas and Daphni*, Cambridge, Mass., 1931, pl. v, fig. 13.
3. Photographs in the Department of Art and Archaeology, Princeton University.
4. Photographs in the Department of Art and Archaeology, Princeton University.
5. Olim Abraham cod. 9. Lake, *Manuscripts*, I, pl. 20.

New York, Pierpont Morgan Lib. cod. M692. In Greek on vellum. 293 folios (34.0 x 23.8 cm.). Minuscule script. Cruciform column of 23 lines (25 x 17 cm.; after fol. 215, 21 lines, 24.0 x 17.5 cm.). Two full-page and 33 marginal miniatures. Three anthropomorphic and five zoomorphic initials. Four full-page cruciform frames, two with miniatures. Twelve headpieces. Eight palmettes decorate the text corners of each page. Colophons: folios 1r, 2r, non-scribal. Binding: dark brown tooled leather over wooden boards. Condition: two full-page miniatures missing; many marginal miniatures left unfinished; some miniatures partially flaked.

PROVENANCE: Formerly belonged to the Church of Saint George in the Cypresses, Constantinople (fol. 2r). Purchased from Kennerley in October 1925.

EXHIBITED: New York 1933–34, no. 36, pl. 36; The Pierpont Morgan Library, New York, 1949, *The First Quarter Century of The Pierpont Morgan Library*, no. 16, pl. 7; Baltimore 1947, no. 717, pl. xcii; Oberlin 1957, no. 10, figs. 11–13.

BIBLIOGRAPHY: DeRicci and Wilson, *Census*, 1483; Clark, *N. T. Manuscripts*, 162f. (with further bibliography), pl. xxxi; A. P. Wikgren, "The Lectionary Text of the Pericope, John 8:1–11," *Journal of Biblical Literature*, LIII, 1934; A. Frantz, "Byzantine Illuminated Ornament," *Art Bulletin*, xvi, 1934, 49, pl. III, no. 7; L. W. Jones, "Pricking Systems in New York Manuscripts," *Miscellanea Giovanni Mercati*, vi, 1946, 85n., 90; Weitzmann, "Gospel Illustrations," 158, pl. xv; idem, "Morgan 639," 365n., 371n.; Aland, *Liste*, 296; M. Schapiro, *The Parma Ildefonsus: A Romanesque Manuscript from Cluny and Related Works*, New York, 1964, 41n.; Diringer, *Book*, II-20b; Lazarev, *Storia*, 253n.

# Lectionary

This Morgan Library manuscript is part of a group of eleventh- and twelfth-century Lectionaries whose decoration consists of unframed initial and marginal scenes borrowed mainly from narrative Gospel cycles. Although the cruciform text column used throughout codex M692 is unusual (see cat. 2), it is found in at least two other Lectionaries of this period: Dumbarton Oaks cod. 1 (cat. 25, fols. 43–149) and London, Brit. Mus. cod. add. 39603.[1] The British Museum Lectionary has no figural decoration but does contain cruciform title pages that, although simpler than those of the Morgan codex, are close enough to indicate that the two manuscripts are probably related.

Two full-page Evangelist portraits remain from what was, no doubt, originally a set of four. John (fol. 1v), dressed in a pink mantle over a blue tunic, sits in a high-backed, brown wicker chair before a desk and a lectern supporting a codex. On the shelves of the open desk are visible a book, scrolls, and a bottle tied with a red ribbon. On its surface are an ink-pot and various writing instruments. Mark (fol. 123v, fig. 60) is seated on a greenish brown bench with a bright red cushion. Dressed in garments of pink and blue, he leans gently forward, his left hand touching his chin in a pensive gesture, his right resting on an open codex supported on his knees. Before him is a large desk and a lectern bearing a second open codex. His head, like that of John, is modeled in dark tones, its features outlined in sharp strokes of black. Both miniatures are framed by simple blue crenellated borders.

In figure style, iconography, and border ornament the Morgan Library Evangelists closely correspond to those in two other manuscripts: Paris, Bibl. Nat. cod. gr. 189,[2] and Mount Athos, Panteleimon cod.

2.[3] Similarities are close enough to permit the assumption of a common workshop. Although of lower quality, the figural initials of the synaxarion section of the Athos codex are related to those by one illuminator in the Morgan Lectionary.[4]

The initial and marginal illustrations of codex M692 constitute its most interesting feature.[5] They exist in various stages of completion; some left as drawings, others with colors partially laid on, and some completed. Even among the completed miniatures striking stylistic differences are immediately apparent allowing the identification of at least two hands. The illuminator whose work is exemplified in figure 62 (fol. 6r) applied thin earth-colored washes over highly finished outline drawings. His figures are flat and broad with over-large heads and hands. The illuminator exemplified in figure 61 (fol. 57r), on the other hand, paints energetic figures with schematized drapery and tense, worried expressions. His colors, usually applied in heavy gouache over a perfunctory underdrawing, are predominantly blue, green, and purple. His finished miniatures show strong, schematic highlights.

On the basis of figure style and overall quality, the Lectionary may be attributed to a Constantinopolitan workshop of the first half of the twelfth century. It fits well within that phase of art in the capital, which saw a change from the spiritualized style of the second half of the eleventh century.[6] Specifically, it should be compared with Vatican Lib. cod. Urb. gr. 2, dated around 1122.[7] This Gospel book displays a schematic, mannered drapery style similar to but less extreme than that of the second Morgan Lectionary illuminator. Also to be found are similar profile heads with heavy sagging jaws and deep-set eyes.                                J.C.A.

Lent by The Pierpont Morgan Library

NOTES

1. British Museum, *Catalogue of Additions to the Manuscripts, 1916–1920*, London, 1933, 84f. Photographs in the Department of Art and Archaeology, Princeton University.
2. Omont, *Miniatures*, pls. LXXXVIII, LXXXIX.
3. Huber, *Athos*, pls. 89–91.
4. Ibid., pls. 84–85, 88.
5. Of the thirty-six marginal miniatures and anthropomorphic initials, twelve are found in the John readings, one in Matthew, three in Luke, six in the Holy Week readings, and fourteen in the menologion.
6. Weitzmann, "Eleventh Century."
7. Stornajolo, *Giacomo*, pls. 83–93; Bonicatti, "Urb. gr. 2."

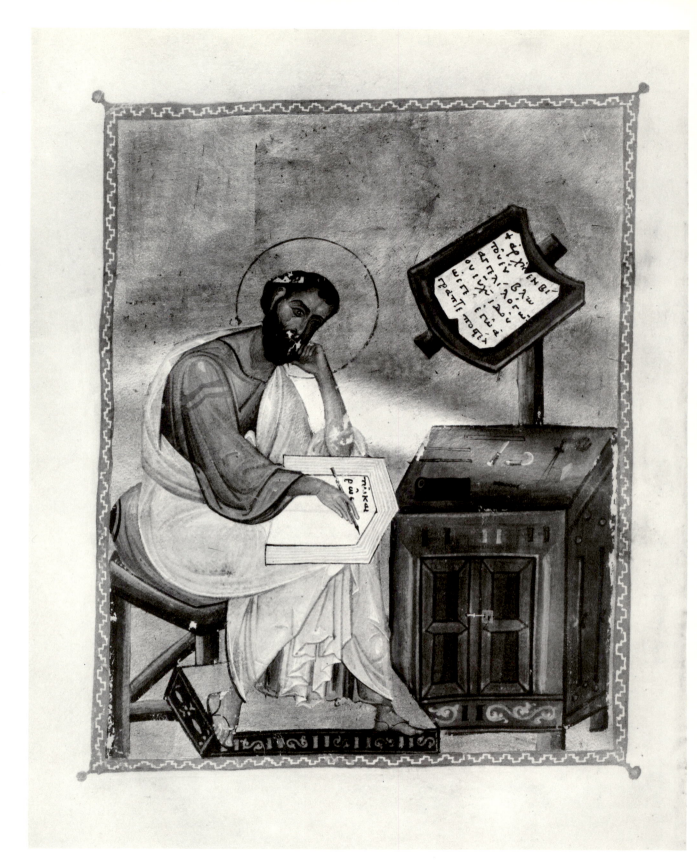

FIGURE 60. Mark
New York, Pierpont Morgan Lib. cod. M692, fol. 123v

FIGURE 61.  Christ Among the Jews
New York, Pierpont Morgan Lib. cod. M692, fol. 57r

FIGURE 62.  The Testimony of John the Baptist
New York, Pierpont Morgan Lib. cod. M692, fol. 6r

# Two Leaves from a Gospel Book:

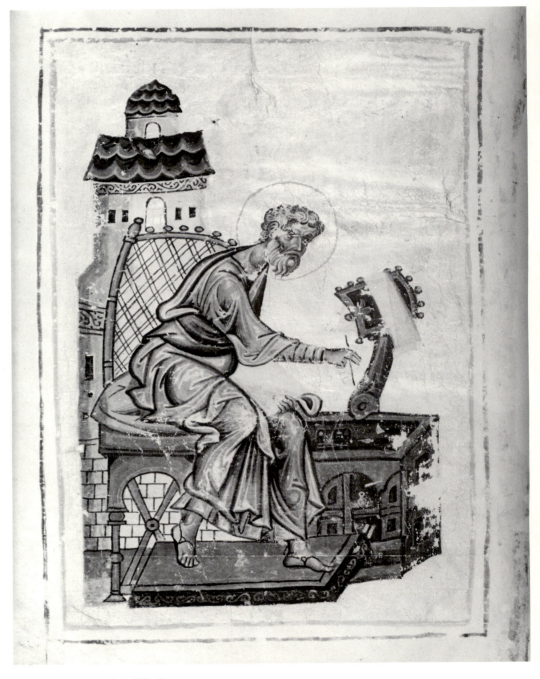

FIGURE 63.   Matthew
Baltimore, Walters Art Gallery cod. W530e

Baltimore, Walters Art Gallery cod. W530d, e. Two single vellum leaves (23.0 x 15.2 cm.). Two full-page miniatures. Reverse of both blank. Condition: both miniatures slightly rubbed and flaked in the area of the desk.

PARENT MANUSCRIPT: Mount Athos, Lavra cod. A44. Gospel book. 416 folios (22.7 x 16.8 cm.). Baltimore miniatures preceded the Gospels of Matthew and Mark. Identification: K. Weitzmann.

PROVENANCE: Purchased from Gruel by H. Walters.

EXHIBITED: Baltimore 1947, no. 718, pl. XCVI; Oberlin 1957, 43, nos. 8, 9, figs. 9, 10; Andrew Dickson White Museum of Art, Cornell University, Ithaca, New York, and Munson-Williams-Proctor Institute, Utica, New York, 1968, *A Medieval Treasury*, no. 19, fig. 19.

BIBLIOGRAPHY: DeRicci and Wilson, *Census*, 826; Clark, *N. T. Manuscripts*, 361; Aland, *Liste*, 138; Diringer, *Book*, II-16d, II-17c; Lazarev, *Storia*, 252n.

NOTES

1. Stornajolo, *Giacomo*, pls. 83–93; Bonicatti, "Urb gr. 2."
2. This group includes, in addition to a number of Gospel books with Evangelist portraits, Paris, Bibl. Nat. cod. gr. 1208, and Vatican Lib. cod. gr. 1162 (homilies of the monk James of the monastery of Kokkinobaphos), as well as the Codex Ebnerianus, Oxford, Bodl. Lib. cod. Auct. T. inf. 1.10.
3. Omont, *Miniatures*, pl. LXXXVII.
4. Huber, *Athos*, pls. 112–15.
5. Photographs in the Department of Art and Archaeology, Princeton University.

Matthew (fig. 63), dressed in a light blue mantle over a violet tunic, is seated in profile on a red cushion in a high-backed chair. He leans forward, about to dip his pen into an inkwell on the brown desk in front of him. The tall building behind is shaded in yellow and green; its roofs are blue. Seated contemplatively, with his chin resting on his left hand, Mark is turned in profile toward the right. The red cushion upon which he sits contrasts with the light blue and violet hues of his clothing. The architectural structure in the background is greenish yellow, with a blue facade and a red roof. The highly modeled faces of both figures are rendered in shades of brown and olive green.

The two Baltimore Evangelists and the codex from which they were excised, Mount Athos, Lavra cod. A44 (fig. 64), may be dated in the first half of the twelfth century on the basis of their close stylistic and iconographic similarities to Vatican Lib. cod. Urb. gr. 2, dated near 1122.[1] The miniatures from both manuscripts are members of a closely related group[2] characterized by a mannered over-articulation and multiplication of drapery folds, a protruding narrow forehead, and a stereotyped iconography for the Evangelist portraits. The correspondence of one Matthew portrait to another goes beyond pose, facial type, furniture, architecture, and color scheme to include a characteristic 'S' fold of drapery beneath the Evangelist's right knee. Those Evangelists most closely related to the Baltimore leaves include: Paris, Bibl. Nat. cod. gr. 71,[3] Mount Athos, Panteleimon cod. 25,[4]

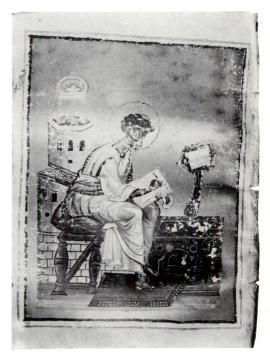

FIGURE 64. Luke
Mount Athos, Lavra cod. A44, fol. 190v

and Oxford, Christ Church cod. gr. 32.[5]

On the basis of these other sets of Evangelist portraits we may assume that the now lost fourth portrait of Lavra cod. A44 would have represented John standing in the open landscape of Patmos dictating to a seated Prochoros.

G.V.

Lent by the Walters Art Gallery

# The Four Gospels

Princeton, Univ. Lib. cod. Garrett 3. In Greek on vellum. 278 folios (17.0 x 12.8 cm.). Minuscule script. One column of 23 lines (11.8 x 7.8 cm.). Two full-page miniatures. Four headpieces, one containing figural decoration and flanked by a marginal miniature. Eight canon tables (incomplete). Colophons: folios 124v, 277r, 278v, non-scribal. Folio 260v, scribal dated 1136. Binding: brown stamped leather over wooden boards. Condition: missing four folios from canon tables, *kephalaia* for Matthew, and Matthew and Luke author portraits; all miniatures severely flaked.

PROVENANCE: Written in 1136 in the monastery of Saint Saba near Jerusalem (fol. 260v). Owned in 1572 by Luke, a priest in prison (fol. 124v). Early twentieth century in the monastery of Saint Andrew on Mount Athos (cod. 705). Acquired in 1930 from T. Whittemore by R. Garrett and given by him to the Princeton University Library in 1942.

EXHIBITED: Baltimore 1947, no. 716.

BIBLIOGRAPHY: DeRicci and Wilson, *Census*, 866; Bond and Faye, *Supplement*, 311; Clark, *N. T. Manuscripts*, 66f., pls. VII, LXIII; Friend, "Garrett," 132f.; Martin, *Climacus*, 189; R. Devreesse, *Introduction à l'étude des manuscrits grecs*, Paris, 1954, 57; H. Buchthal, *Miniature Painting in the Latin Kingdom of Jerusalem*, Oxford, 1957, 42; Buchthal, "Gospel Book," n. 25; Aland, *Liste*, 141; Meredith, "Ebnerianus," 421; Lazarev, *Storia*, 253n.; Galavaris, *Gregory*, 248.

Two Evangelist portraits remain in this Gospel book (Mark, fol. 78v, and John with Prochoros, fol. 204v), and on the first folio of Matthew's Gospel the figure of Isaiah in the right margin is shown pointing to a Nativity scene set in the quatrefoil medallion of the headpiece (fol. 5r, fig. 65). Here, as in the rest of the manuscript, the palette is limited mainly to blue and red on a gold ground. Surrounded by simplified flower-petal motifs repeated in scroll designs, the Nativity miniature shows the Virgin, wrapped in blue garments, sitting on a red couch, and reaching toward a crib bearing the Christ Child, swaddled in brown on a blue cushion. Above her a bust-length, blue-clad angel points to red rays descending upon the Child. All halos as well as the marginal Isaiah miniature are outlined in red. As in the Evangelist miniatures, faces are brown with closely set black eyes, and backgrounds are gold.

Folio 260v bears a scribal colophon:[1]

This Gospel book was written in Jerusalem in the most venerable and great lavra of the blessed Saba, our inspired father, which lies in the desert, to the order, due to his great devotion, of the most honorable monk John, the guest-master and steward of the same holy lavra, in the year 6644 (1136) in the fourteenth indiction of the reign of John, the purple-born, at which time the Pansebastos and Sebastos Constantine Kamytzes was governor of the island of Cyprus.[2]

The Garrett manuscript combines Constantinopolitan elements with others that seem to be peculiarly Palestinian. Its model, as indicated by the motifs of its flower-petal ornament and by the juxtaposition of a feast scene and a (now lost) Evangelist portrait (see cat. 5, 44),[3] probably came from the capital. Since the portraits of Mark and John correspond iconographically to those in Paris, Bibl. Nat. cod. gr. 71[4] (which was probably made in the same Constantinopolitan workshop as Vatican Lib. cod. Urb. gr. 2, datable 1122[5]), the lost Matthew and Luke figures were most likely similar to those of the Paris manuscript.

The style of the ornament and the miniatures may be peculiar to Palestine. It is slack and haphazard compared to Constantinopolitan work: the frame of the Mark miniature, for example, extends only across the top of the picture. The short, round-jointed figures, with large heads and torsos, pressing so close to the picture plane that they overlap the frames, are dressed in garments with loose curving folds, fluttering hems, and broad white highlights that appear almost to float on the surface. Such figures with similar drapery may be seen in Syrian manuscripts,[6] in Latin manuscripts made for the Crusaders' court in Jerusalem,[7] and in several manuscripts that were once in the Saint Saba Library.[8] Strikingly similar figures are found in a Gospel book in Paris (Bibl. Nat. cod. gr. 85), whose palette and ornament (including a frame extending across the top of one of its miniatures) reveal it as the work of the same hand as codex Garrett 3.[9] The Evangelist portraits inserted into Mount Athos Vatopedi cod. 960, dated 1128, are in a similar style.[10]

Although typological figures like the Garrett Isaiah (whose prophecy is quoted in Matthew 1:28) are found in the margins of Mid-Byzantine manuscripts from Constantinople,[11] they reflect a pre-iconoclastic tradition, seen in three manuscripts from Asia Minor or Syria-Palestine: the Rabula, Sinope, and Rossano Gospels. The Garrett manuscript seems to be continuing this tradition, and because of its firm date and localization it may help

to define the still inadequately understood style of mediaeval Palestine.

A.vanB.

Lent by Firestone Library, Princeton University

NOTES

1. ἐγράφη τὸ παρὸν τετραεβάγγε[λον] ἐν ἱεροσολύμ[οις] · ἐν τῇ σεβασμίᾳ καὶ μεγίστῃ λαύ[ρᾳ] τοῦ ὁσ[ίου] καὶ θεοφό[ρου] π[ατ]ρ[ὸ]ς ἡμ[ῶν] σαβα· τῇ κειμ[έν]ῃ ἐν τῇ ἐρήμῳ· διὰ προστά[γης] καὶ πόθον πολλ[οῦ] τ[οῦ] τιμιωτάτ[ου] [μον]αχ[οῦ] κυ[ρίου] ἰω[άννου] ξενοδόχου τ[οῦ] κ[αὶ] μ[ε]γ[ά]λ[ου] οἰκονό[μου] τ[ῆς] αὐτ[ῆς] ἁγ[ίας] λαύ[ρας] ἐν ἔτει ͵ϛχμδ ἰν[δικτιῶνος] ιδ βασιλεύοντ[ος] ἰω[άννου] τ[οῦ] πορφυρογενίτ[ου]· ὅτε καὶ τ[ὴν] ἀρχὴ[ν] διεῖπεν ὁ πανσέ[βαστος] σέβαστ[ος] κωνσταντῖνος ὁ καμύτξης τῆς νήσ[ου] κύπρ[ου].

2. I owe this reading to Professor I. Ševčenko. Constantine Kamytzes was married to the first cousin of Manuel I Comnenos. See F. Chalandon, *Jean II Comnène et Manuel I Comnène*, Paris, 1912, 217, 219n.

3. Meredith, "Ebnerianus."

4. Omont, *Miniatures*, pl. LXXXVII.

5. Stornajolo, *Giacomo*, pls. 83–93.

6. See the Homs Gospels (dated 1054) and Cambridge, Univ. Lib. cod. 01.02 (late twelfth century); J. Leroy, *Les Manuscrits syriaques à peintures*, Paris, 1964, 222, pls. 51–53; 241f., pls. 61, 3–64.

7. See London, Brit. Mus. cod. Egerton 1139 and Paris, Bibl. Nat. cod. lat. 276 (H. Buchthal, *Miniature Painting in the Latin Kingdom of Jerusalem*, Oxford, 1957, pls. 1–12, 36b).

8. E.g., Jerusalem, Taphou cod. 38 (eleventh century) and Taphou cod. 56 (twelfth century). See W. H. Hatch, *Greek and Syrian Miniatures in Jerusalem*, Cambridge, Mass., 1931, pls. XXIII, XXVIII–XXXI; W. H. Hatch, *The Greek Manuscripts of the New Testament in Jerusalem*, Paris, 1934, pls. XIII, XVI; and Lazarev, *Storia*, 252n.

9. Photographs in the Department of Art and Archaeology, Princeton University.

10. Lake, *Manuscripts*, III, pl. 196.

11. Buchthal, "Gospel Book," 8, figs. 6–7.

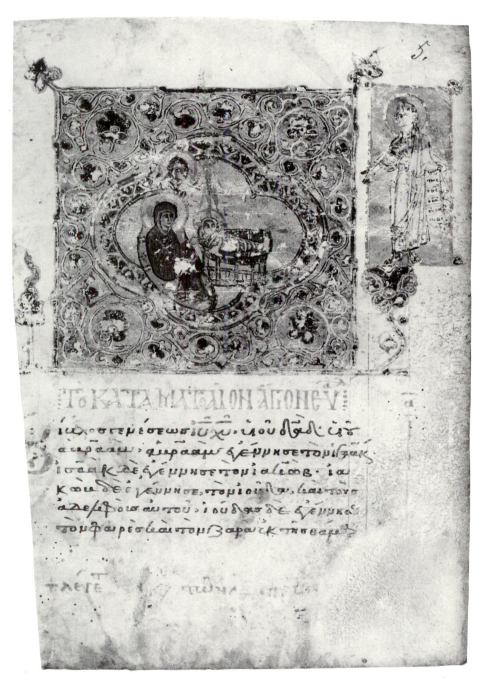

FIGURE 65. The Nativity and Isaiah
Princeton, Univ. Lib. cod. Garrett 3, fol. 5r

Cambridge, Harvard College Lib. cod. TYP 215H. In Greek on vellum. 250 folios (not foliated; 27.0 x 20.5 cm.). Minuscule script. One column of 24 lines (16.5 x 11.3 cm.). Two full-page miniatures (once inserted, now excised) and four full-page drawings. Five canon tables and four headpieces. Colophon: folio 250r, non-scribal. Binding: modern white doeskin over wooden boards. Condition: Eusebius letter and one bifolio of canon tables missing; Matthew miniature shows considerable flaking.

PROVENANCE: In the thirteenth century in a certain Eleousa monastery (fol. 250r). Purchased in 1954 from H. P. Kraus by P. Hofer.

EXHIBITED: Fogg Art Museum and Houghton Library, Harvard University, Cambridge, Mass., 1955. *Illuminated and Calligraphic Manuscripts*, no. 6, pl. 2.

BIBLIOGRAPHY: Bond and Faye, *Supplement*, 271; M. C. Ross, *Catalogue of the Byzantine and Early Medieval Antiquities in the Dumbarton Oaks Collection*, 1, Washington, D.C., 1962, 107f.; Bodleian Library, Oxford, 1966, *Greek Manuscripts in the Bodleian Library*, 42.

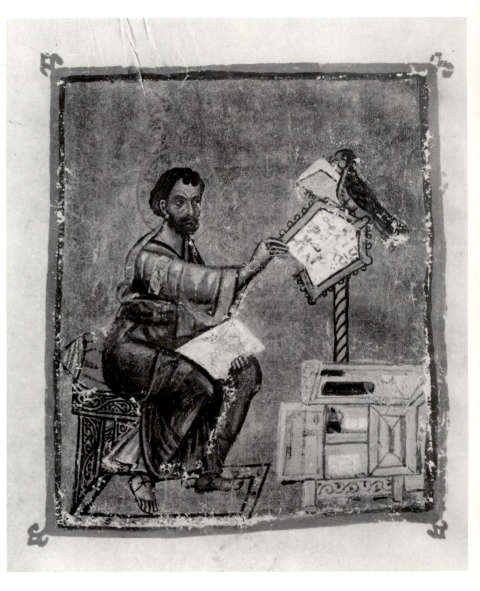

FIGURE 66.  Mark
Cambridge, Harvard College Lib. cod. TYP 215H

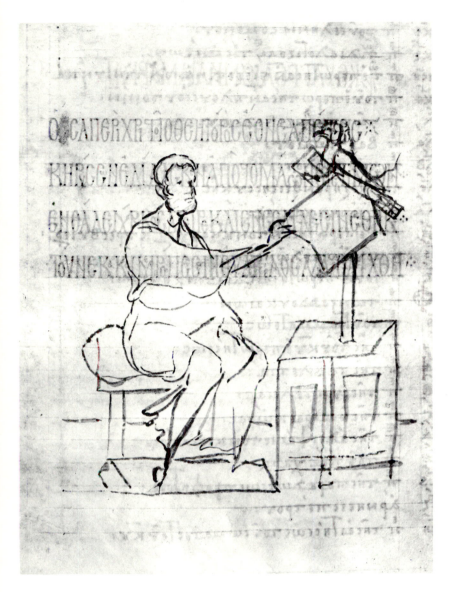

FIGURE 67. Mark
Cambridge, Harvard College Lib. cod. TYP 215H, fol. 75v

The Harvard Gospels included until recently three inserted Evangelist portraits. The miniatures of Matthew and Mark (fig. 66) are still kept with the manuscript; that of John has been given to Dumbarton Oaks (cat. 39). Each Evangelist is depicted in profile, seated on a decorated gold bench before an open writing desk bearing an inkwell and several writing implements. From the desk rises a lectern supporting an open codex and surmounted by the Evangelist's symbol. Mark leans gently forward to touch the lectern with his right hand, while Matthew writes intently in a codex held on his lap. Both dress in garments of blue and green and are seated on bright red cushions.

The leaves facing the headpieces to the Gospels each originally bore a four-line eulogistic poem in large gold uncial letters.[1] Those leaves, after having been substantially erased, were filled with portraits of the four Evangelists sketched in light brown ink on bare vellum (fols. 5v, 75v, 121v, 195v). Matthew and Mark (fig. 67) correspond exactly to the miniatures that were until recently inserted next to them. Luke is rendered in profile before a writing desk and lectern bearing his symbol, the calf. He leans forward to write in a codex held on his lap. John, matching his companion leaf at Dumbarton Oaks (cat. 39), is shown standing frontally in an open landscape dictating to a seated Prochoros. He turns his head slightly toward the right in the direction of his symbol, the lion, standing atop a mountain.

Five ornamental canon tables (fols. 1r–3r), consisting of arches within rectangular frames supported on a pair of columns, and four headpieces (fols. 6r, 76r, 122r, fig. 68; 196r) testify to the original decorative program of the Harvard

Gospels. They are decorated with leafy, freely varied flower-petal motifs in red, green, blue, and burgundy, and often include crenellated border ornament.

The production of the original manuscript may be dated to the eleventh century on the basis of its ornamental motifs. Specifically, the title script and decorative initials of the headpieces (fig. 68) find close parallels in Athens, Nat. Lib. cod. 57, datable to the third quarter of the century through similarities of figure style to Leningrad, Public Lib. cod. gr. 72, dated 1061.[2] For similarly varied and three-dimensional flower petals, however, closer comparisons may be found in earlier manuscripts (cat. 10), such as Turin, Univ. Lib. cod. B.I.2, datable ca. 1000, and Florence, Laur. Lib. cod. Plut. v, 9, datable in the early eleventh century.[3]

The inserted Evangelist portraits (fig. 66), with their thick, murky colors and rough figure style, contrast sharply with the enamel-like headpieces. The squat inelegant proportions, garish color contrasts, and broad illogical highlights, as well as the inclusion of multiple windblown pleats behind the right knee, indicate a date in the second half of the twelfth century for these miniatures (see cat. 40, 41). Specifically the proportions, drapery, and ornamented benches find comparisons in the Evangelist portraits of a Lectionary on Mount Athos, Koutloumousi cod. 60, dedicated in 1171.[4] Closer correspondences of head types, highlighting, chrysography, and drapery motifs may be found in Athens, Nat. Lib. cod. 2251, datable by the mannered drapery of its Matthew portrait to the late twelfth century.[5]

Although corresponding to the inserted leaves in details of iconography and pose, the Evangelist drawings in the Harvard Gospels are by a different, more accom-plished miniaturist. Each figure is taller and more elegant, his solid body resting firmly on his bench. The breadth of his chest and the area between his knees are more convincingly rendered, as is the spatial relationship of the lectern to the desk. Even in a few simple strokes the artist of the drawing shows a far clearer understanding of the nature of drapery and its relationship to the body. These monumental, yet elegant portraits find their closest comparisons in miniatures attributed to the early thirteenth century (see cat. 43 and 51, fig. 93). The concentration of weight in Luke's thighs and lower torso (fol. 121v), as well as the long sweeping arch of his back, and his small head with receding chin find counterparts in the Luke miniature in Berlin, Staatsbibl. cod. gr. qu. 66, recently shown to date prior to 1219.[6]

The close correspondence of the Evangelist drawings to the three extant inserted miniatures (see cat. 39), considered with the relative dates of their production, leads inevitably to the conclusion that the drawings were copied from the miniatures. A non-scribal colophon on folio 250r indicates that the Gospel book was given to a certain monastery of the Eleousa[7] by the uncle of Theodore Lascares I,[8] Emperor of Nicaea (1204–22). It seems reasonable to suppose that the donor desired to enhance his gift through the inclusion[9] of Evangelist portraits. The gold eulogistic poems facing the headpieces were erased and preparatory sketches[10] added, modeled on the slightly earlier set of gouache portraits. Apparently the project was abandoned, and the model miniatures were tipped in.[11]

The pairing of the Evangelist's symbol with his portrait, although not uncommon in Greek manuscripts (see cat. 55, 62), does not follow a consistent pattern.[12]

Of the sixteen sets of Evangelists with symbols known to me from the twelfth century or earlier,[13] only one, Athens, Nat. Lib. cod. 2251,[14] follows the pairing system of Jerome, so common in the West: Matthew=man, Mark=lion, Luke=calf, John=eagle. Four manuscripts, including the Harvard Gospels and Mount Athos, Stavronikita cod. 43,[15] the earliest representative of any type, follow the order of Irenaeus: Matthew=man, Mark=eagle, Luke=calf, John=lion. The remaining eight complete sets use four different pairing systems.

Before the twelfth century the symbol is not found within the frame of the portrait miniature. Mount Athos, Stavronikita cod. 43, of the mid-tenth century, includes medallion symbols flanking the text column within the body of the appropriate Gospel. Athens, Nat. Lib. cod. 57,[16] and Moscow, Hist. Mus. cod. gr. 518,[17] both eleventh-century Gospel books, place the symbol over the headpiece facing the Evangelist's portrait. This arrangement, including the modified form of allocating a full facing page to the symbol, continued throughout Byzantine and Post-Byzantine illumination (cat. 55, 62).

Among twelfth-century manuscripts two methods are used to include the symbol within the portrait miniature. Either it enters the miniature above the Evangelist, as in Moscow, Hist. Mus. cod. gr. 519,[18] or it appears on or behind the Evangelist's lectern as in the Harvard Gospels. The earliest example of this latter arrangement is Megaspelaion cod. 8,[19] datable to the very beginning of the century through its close similarities to Paris, Bibl. Nat. cod. suppl. gr. 1262, dated 1101, and the Harvard Psalter dated 1105 (see cat. 32).                    G.V.

Lent anonymously

FIGURE 68. Gospel of Luke
Cambridge, Harvard College Lib. cod. TYP 215H, fol. 122r

details (see Mark's feet) and the incomplete erasure of the earlier inscription indicate that these are preparatory sketches and not finished outline drawings (see cat. 41, 57).

11. It is very unlikely that the miniatures were inserted before they were copied, since once inserted they faced away from their corresponding drawings.

12. Morey, *Freer*, 38f.; C. Nordenfalk, in *Zeitschrift für Kunstgeschichte*, VIII, 1939, 74f.; A. Boeckler, "Die Evangelistenbilder der Adagruppe," *Münchner Jahrbuch der bildenden Kunst*, III–IV, 1952–53, 134f. (Boeckler suggests that pre-iconoclastic Greek Gospel books contained symbols); H. Buchthal, "A Byzantine Miniature of the Fourth Evangelist and Its Relatives," *Dumbarton Oaks Papers*, XV, 1961, 137f.

13. (1) Mount Athos, Stavronikita cod. 43; (2) Athens, Nat. Lib. cod. 57; (3) Moscow, Hist. Mus. cod. gr. 518; (4) Athens, Nat. Lib. cod. 163; (5) Megaspelaion cod. 8; (6) Vienna, Nat. Lib. cod. suppl. gr. 164; (7) Oxford, Bodl. Lib. cod. Auct. T. inf. 1.3; (8) Istanbul, Patr. Lib. cod. 5; (9) Moscow, Hist. Mus. cod. gr. 519; (10) Geneva, Bibl. Publique et Universitaire, cod. gr. 19; (11) Istanbul, Patr. Lib. cod. 3; (12) Manchester, John Rylands Lib. cod. gr. 13; (13) Holkham Hall, Coll. Earl of Leicester, cod. 4; (14) Mount Athos, Dochiariu cod. 52; (15) Athens, Bibl. Nat. cod. 2251; and (16) Cambridge, Mass., Harvard College Lib. cod. TYP 215H. See also Vatican Lib. cod. gr. 2138, a South Italian manuscript dated 991 with Evangelist symbol initials.

14. Photographs in the Department of Art and Archaeology, Princeton University.

15. Photographs in the Department of Art and Archaeology, Princeton University.

16. P. Buberl, *Die Miniaturenhandschriften der Nationalbibliothek in Athen*, Vienna, 1917, pl. XIII, figs. 27–28.

17. Photographs in the Department of Art and Archaeology, Princeton University.

18. Lazarev, *Storia*, pl. 265.

19. E. Tsimas and S. Papachadjidakis, Χειρόγραφα Εὐαγγέλια Μονῆς Μεγάλου Σπηλαίου, Athens, n.d., pls. 49, 55, 57.

NOTES

1. H. von Soden, *Die Schriften des Neuen Testaments*, Göttingen, 1911, 378. The text is clearly visible in fig. 67.

2. Putzko, "1061."

3. Weitzmann, *Buchmalerei*, 28, pl. XXXVII, fig. 208; 26f., pl. XXXV, fig. 199.

4. Huber, *Athos*, pl. 131–35.

5. Photographs in the Department of Art and Archaeology, Princeton University.

6. Hamann-MacLean, "Quarto 66," pl. 24.

7. I wish to acknowledge the assistance of Professor I. Ševčenko with this colophon. This particular Eleousa monastery was "κ[α]τ[ὰ] τὴν νεάμουλην" (?).

8. "Theodore Comnenes Lascares" would be Theodore Lascares I, since Theodore Lascares II, Emperor of Nicaea from 1254 to 1258, called himself "Ducas."

9. Although the original eleventh-century manuscript was of very high quality, including luxurious ornament and gold script, there is no evidence (stubs or offprints) that it contained Evangelist portraits. In fact, before they were erased the eulogistic poems left heavy offprints on the opening pages of each Gospel, indicating that they and not Evangelist portraits faced the ornamental headpieces.

10. The absence of halos and inscriptions as well as the superficial rendering of many

# 39. Leaf from a Gospel Book:

Washington, Dumbarton Oaks cod. acc. no. 58.105. Single vellum leaf (27.0 x 20.7 cm.). One full-page miniature. Reverse blank. Condition: minor flaking and rubbing.

PARENT MANUSCRIPT: Cambridge, Harvard College Lib. cod. TYP 215H. Gospel book (see cat. 38). Washington leaf was inserted before folio 122, preceding the Gospel of John.

PROVENANCE: Part of parent manuscript when purchased by P. Hofer from H. P. Kraus in 1954 (see cat. 38). Given by Hofer to Dumbarton Oaks in 1958.

EXHIBITED: Fogg Art Museum and Houghton Library, Harvard University, Cambridge, Mass., 1955, *Illuminated and Calligraphic Manuscripts*, no. 6.

BIBLIOGRAPHY: Bond and Faye, *Supplement*, 271; M. C. Ross, *Catalogue of the Byzantine and Early Medieval Antiquities in the Dumbarton Oaks Collection*, I, Washington, D.C., 1962, no. 128, pl. LXV; Dumbarton Oaks, *Handbook of the Byzantine Collection*, Washington, D.C., 1967, no. 359, pl. 359.

The Evangelist John (fig. 69) is shown standing in the mountainous landscape of Patmos dictating to Prochoros who, seated in profile on a bench at the left, is writing intently on a large vellum leaf propped against his left thigh. The mountain at the right, from which emerges the upper half of a lion, John's symbol (see cat. 38), is painted in shades of cool greenish blue, while the plants sprouting from it and the ground beneath the Evangelist's feet are dark green. John wears a lilac mantle over a blue tunic with gold *clavi*; Prochoros is dressed in garments of plum and green. The bench upon which Prochoros sits is brown with gold striations. Halos, inscriptions, and the miniature's frame are rendered in bright red.

The head of John as well as the broad areas of highlighting on the right leg of Prochoros and the gold striations of his bench find close parallels in Athens, Nat. Lib. cod. 2251, datable to the second half of the twelfth century by the agitated drapery of its Matthew portrait (see cat. 38).

G.V.

Lent by Dumbarton Oaks Research Library and Collection

# John and Prochoros

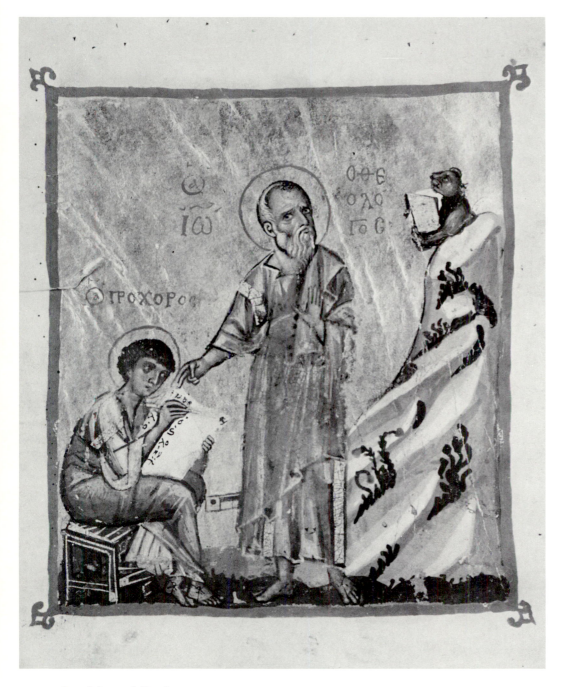

FIGURE 69.  John and Prochoros
Washington, Dumbarton Oaks cod. acc. no. 58.105

40.

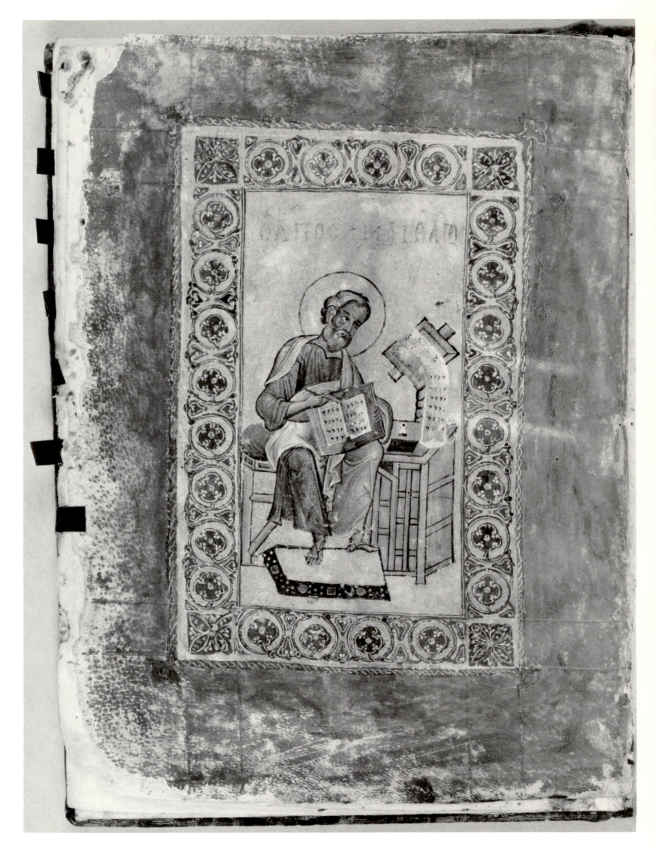

FIGURE 70. Matthew
Baltimore, Walters Art Gallery cod. W529, fol. 9v

Baltimore, Walters Art Gallery cod. W529. In Greek on vellum. 298 folios (25.0 x 18.0 cm.). Minuscule script. Two columns of 25 lines (15.7 x 4.7 x 11.5 cm.). Four full-page miniatures. Ten canon tables and five headpieces. Colophons: folio 8r, non-scribal. Folio 217v, scribal.[1] Binding: olive velvet. Condition: miniatures show minor rubbing and flaking; ornament moderately flaked.

PROVENANCE: Acquired from Gruel by H. Walters in 1925.

EXHIBITED: Baltimore 1947, no. 728.

BIBLIOGRAPHY: DeRicci and Wilson, *Census*, 759; Clark, *N. T. Manuscripts*, 359f., pls. LIX, LXXI; Aland, *Liste*, 185.

This Gospel book contains four full-page Evangelist portraits (Matthew, fol. 9v, fig. 70; Mark, fol. 87v; Luke, fol. 139v; John, fol. 218v).[2] Each author is seated with an open codex in his lap to the left of a desk from which rises a lectern. The sandaled feet of each rest on a footstool ornamented with precious stones. Matthew and Mark are actively writing in their codices; Luke leans gently forward to dip his pen into an inkwell on his desk; and John sits contemplatively, his right hand with pen resting on an open codex in his lap. Unlike his companions who sit on cushioned benches, John is placed in a high-backed wooden chair. On the gold background of each miniature is inscribed the Evangelist's name in large uncial letters. Frames consist of wide bands of rough, stylized palmettes enclosed in circles. The Evangelists's garments are rendered in shades of blue, olive-gray, and light brown, which contrast with the stronger blue, red, and green of the border ornament. Each portrait leaf is painted red in imitation of purple-dyed vellum (see cat. 45).

Although the drapery of the Baltimore Evangelists is essentially shallow, with many areas articulated only by simple dark and light lines, the figures have a greater degree of plasticity than the Evangelists in New York, Pierpont Morgan Lib. cod. M692 (cat. 35), datable to the first half of the twelfth century. Closer comparisons may be found in two dated manuscripts of the second half of the twelfth century: Mount Athos, Koutloumousi cod. 60, dated 1171,[3] and London, Brit. Mus. cod. add. 5112, dated 1189.[4] Portraits in both manuscripts show similarities to the Baltimore Mark and John miniatures in the darker tonalities used to render portions of the figure removed from the foreground plane. Also, the

heads in the Athos Lectionary are, like those in codex W529, disproportionately large, while the folds of the sleeve of its Luke portrait follow a form similar to those of the Baltimore Luke.

Compared with the Mark portrait in Princeton, Univ. Lib. cod. Garrett 2 of the thirteenth century (cat. 50), the Baltimore Matthew appears flat and constrained, lacking the later portrait's sculptural drapery, monumental form, and sense of space.

The ornamental decoration of Codex W529 consists of ten canon tables and five headpieces decorated with stereotyped, degenerate flower-petal ornament in red, blue, and green. Its general quality agrees with the late Comnenian date indicated by the figure style.

J.C.A.

Lent by the Walters Art Gallery

NOTES

1. The scribe's name, Manuel, has been inserted in a six-line poem preceding the Gospel of John; see H. von Soden, *Die Schriften des Neuen Testaments*, Göttingen, 1911, 380, no. 19.
2. Although these leaves are inserted and bear no script, close similarities between the ornament in the portrait frames and that in the canon tables and headpieces indicate that the miniatures are contemporary with the text.
3. Huber, *Athos*, pls. 131–35.
4. Although the miniatures are inserted, they apparently belong to the same period as the text. Photographs in the Department of Art and Archaeology, Princeton University.

# The Four Gospels

Princeton, Univ. Lib. cod. Garrett 7. In Greek on vellum. 240 folios (18.6 x 15.0 cm.). Minuscule script. One column of 22 lines (12.3 x 10.2 cm.). Four full-page miniatures (three inserted leaves). Seven headpieces. Colophon: 240r, non-scribal.[1] Binding: bound for the Duke of Marlborough in brown leather over wooden boards. His coat of arms is gilt-stamped on both covers. Condition: first quire missing; extensively trimmed; doodling on several blank folios; parts of miniatures retouched.

PROVENANCE: Ex coll. Duke of Marlborough. Later half of the nineteenth century in the Sunderland Library, Blenheim Palace. Acquired in 1883 by B. Quaritch, from whom it was purchased in 1902 by Garrett.

EXHIBITED: Baltimore 1947, no. 726, pl. CI; Athens 1964, no. 322; Brandeis 1968, no. 47, ill.

BIBLIOGRAPHY: DeRicci and Wilson, *Census*, 866 (with further bibliography); Bond and Faye, *Supplement*, 311; Clark, *N. T. Manuscripts*, 73f. (with further bibliography), pls. XII, LXIII; Friend, "Garrett," 135; B. Degenhart, "Autonome Zeichnungen bei mittelalterlichen Künstlern," *Münchner Jahrbuch der Bildenden Kunst*, I, 1950, 102, fig. 30; O. Pächt, "The 'Avignon Diptych' and Its Eastern Ancestry," *De Artibus Opuscula*, XL, *Essays in Honor of Erwin Panofsky*, 2 vols., ed. M. Meiss, New York, 1961, I, 410f.; II, 131, fig. 10; Aland, *Liste*, 109; K. Weitzmann, "Icon Painting in the Crusader Kingdom," *Dumbarton Oaks Papers*, XX, 1966, 77, figs. 56–57; Lazarev, *Storia*, 336n.

Mark (fol. 65v) and Luke (fol. 107v) are depicted in profile, turned toward the right, while John (fol. 178v, fig. 71) is frontal. All three Evangelists (Matthew's portrait is missing) sit on cushioned benches to the left of a desk with a lectern. Luke and John are flanked left and right by narrow buildings, Mark by a building and a domed baldachin. Robed in loose fitting garments, all are represented in pensive repose. Placed horizontally below John is a small unfinished sketch of a bearded male head.

A bust of Christ Pantocrator (fig. 72) occupies the center of folio 178r. His left hand holds a closed book while His right, resting in the sling of His mantle, makes a gesture of blessing. In the upper left corner of the same folio is depicted the veiled head of the Virgin, partially lost as a result of trimming. The inscriptions of both figures as well as Christ's halo are later additions.

These unframed washdrawings are executed in brown ink with pale blue and light brown washes, recalling the tonality of the tenth-century Joshua Roll (Vatican Lib. cod. Palat. gr. 431).[2] Traces of rose are visible on the cheeks and lips of the figures.

The seven cross-surmounted headpieces, roughly executed in carmine on plain vellum, are decorated with crenellations, stylized foliate forms, palmettes, and cross motifs. Elaborate heart-shaped vegetal forms spring from the upper corners and large stylized finials are occasionally found stemming from the lower corners.

The Garrett miniatures (all obviously inserted) were probably once model drawings in an artist's sketchbook.[3] Such a hypothesis is supported by the strong emphasis on contour lines and by the absence of iconographic elements imperative to a finished work: halos, sandals,

and inscriptions (the present inscriptions were added by the scribe of the Gospel titles).[4] Finally, the unorthodox placement of the Virgin above the bust of Christ would not be found in a finished miniature.

A crease with four stitchmarks along the inner margin of folios 65 and 178 a few centimeters from the gutter, and a similar crease with four corresponding stitchmarks on the outer margin of folio 107, indicate that these three leaves were once part of another codex. Author portraits in Greek Gospel books are usually found on the verso of the folio facing the first page of the Gospel text. If the Luke miniature (fol. 107v) had been bound originally in a Gospel book, his portrait would have necessarily been on the recto of the folio.

A date in the second half of the twelfth century is suggested for the miniatures of the Garrett Gospels by the similarity of the pleated drapery fanning out from under the Evangelist's right thigh (fols. 65v, 107v) to that found in two dated manuscripts: Paris, Bibl. Nat. cod. suppl. gr. 612, dated 1164,[5] and Mount Athos, Koutloumousi cod. 60, dated shortly before 1171.[6]

Contrasting with the high quality of the washdrawings, the roughness of the headpieces suggests a provincial origin for the manuscript itself. A striking comparison may be made with Mount Athos, Panteleimon cod. 25, which also contains a set of inserted twelfth-century Evangelist portraits.[7]

B.A.V.

Lent by Firestone Library, Princeton University

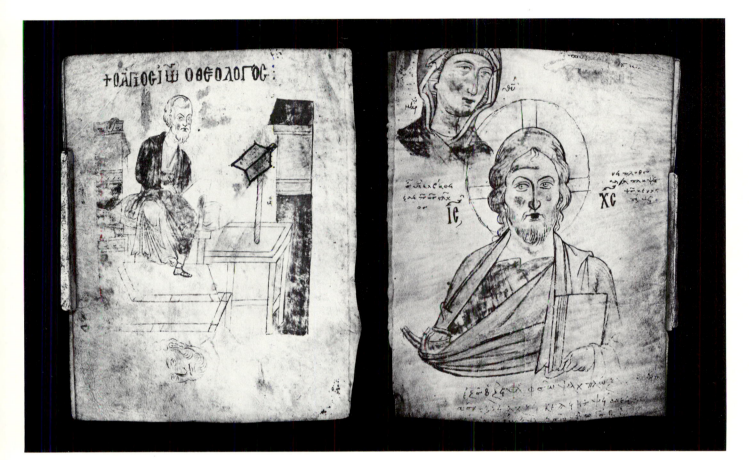

FIGURE 71. John
Princeton, Univ. Lib. cod. Garrett 7, fol. 178v

FIGURE 72. Christ Pantocrator and the Virgin
Princeton, Univ. Lib. cod. Garrett 7, fol. 178r

NOTES

1. The prayer and signature of a certain Michael on folio 240r are not integral to the manuscript. Folio 240 is the fifth leaf in a quire of five, sewn onto a stub appearing between folios 237 and 238. Its vellum is thinner and lighter in color than the rest of the manuscript. Its red ink is lighter and its simple interlace ornament has no parallels. Although it continues the liturgical tables of folio 239v, its script style is not the same.—Ed.

2. *Il Rotulo di Giosuè* (Codices e Vaticanis selecti, v), Milan, 1905. See cat. 52, 57.

3. Degenhart, "Zeichnungen," 102; Weitzmann, "Icon," 77.

4. See R. Scheller, *A Survey of Medieval Model Books*, Haarlem, 1963, introduction.

5. Lake, *Manuscripts*, v, pl. 320. Additional photographs in the Department of Art and Archaeology, Princeton University.

6. Huber, *Athos*, pls. 131–35.

7. Lambros (*Athos*, II, 284) dated Panteleimon cod. 25 to the thirteenth century. Its four Evangelist portraits, datable to the first half of the twelfth century by comparison with the Evangelist portraits in Vatican Lib. cod. Urb. gr. 2, dated around 1122, are probably inserted (see Dölger, *Mönchsland Athos*, Munich, 1943, fig. 124). See Huber, *Athos*, pls. 112–15. Additional photographs in the Department of Art and Archaeology, Princeton University.

42.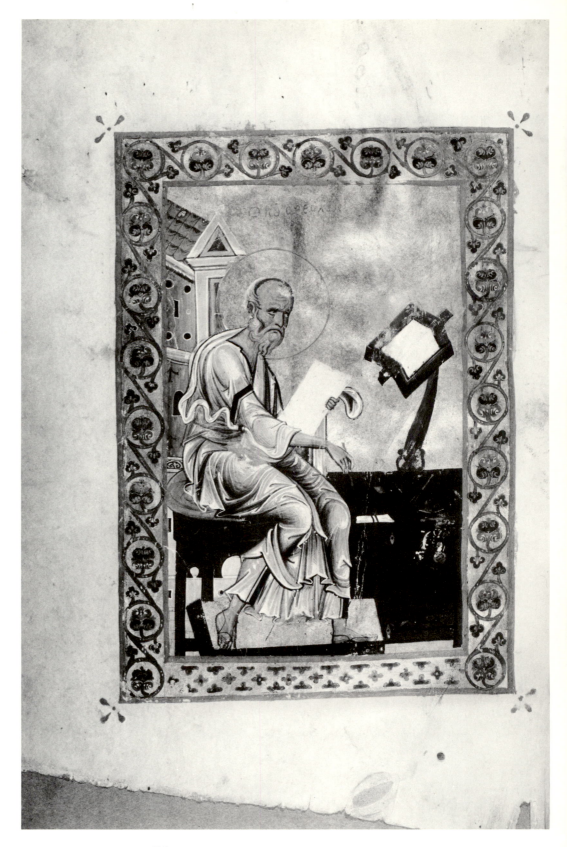

FIGURE 73. John
New York, Coll. H. P. Kraus, Gospels of Luke and John (olim Perrins coll.), fol. 150v

# The Four Gospels (fragment)

New York, Coll. H. P. Kraus (olim Perrins coll.). The Gospels of Luke and John. In Greek on vellum. 253 folios (23 x 17 cm.). Minuscule script. One column of 18 lines (16 x 10 cm.). Two full-page miniatures and two headpieces. Colophons: two on folio 253v, non-scribal. Binding: red velvet decorated with small "buttonhole" slits over old Greek wooden boards. Condition: includes Luke and John texts only; folios show occasional spotting or chipping; miniatures only slightly flaked and rubbed.

PROVENANCE: In 1521 in Gortyn, Crete (fol. 253v). Ex coll. B. Quaritch. Purchased from the collection of Lord Amherst through Sotheby on December 3, 1908, by D. Perrins. Acquired by H. P. Kraus in the sale of the Perrins collection through Sotheby on December 1, 1959.

EXHIBITED: Metropolitan Museum of Art, New York, 1970, *The Year 1200*, no. 292, ill.

BIBLIOGRAPHY: G. Warner, *Descriptive Catalogue of Illuminated Manuscripts in the Library of C. W. Dyson Perrins*, London, 1920, 309, no. 131, pl. CXIX; Sotheby and Co., London, December 1, 1959, *The Dyson Perrins Collection, Part II*, lot 56, pl. 5; H. P. Kraus and Co., *Mediaeval and Renaissance Manuscripts: Catalogue 117*, New York, 1968, 2f., no. 1, ill.

Portraits of Luke (fol. 4v) and John (fol. 150v, fig. 73), framed by broad decorative borders of simplified palmettes, precede each of the two preserved Gospel texts. Both are shown seated on red cushions before dark brown writing desks, against a background of gold occupied by a single pedimented structure with a blue facade and red tile roof. Although blue, red, and gold predominate, they are used almost as a foil for the richly highlighted drapery of lavender, blue, gray, and green.

The Kraus miniatures are among the clearest representatives in manuscript painting of that singular style that emerged in Byzantine art toward the end of the twelfth century.[1] Until now this "dynamic style" has been recognized primarily in monumental art (Kurbinovo, 1191; Lagoudera, 1192; Monreale, 1180s)[2] and, thanks to a discovery by K. Weitzmann, in an icon on Mount Sinai.[3] The multiple loops of drapery beneath John's outstretched right arm clearly indicate that the Kraus miniature belongs to the same stylistic sphere as these securely dated examples of late Comnenian art. The Kraus portraits appear less mannered than the Yugoslavian and Cypriote frescoes and relate more directly to the style of Monreale, especially in the use of deeply cut button-hook drapery folds. A date in the last quarter of the twelfth century seems secure for the Kraus Evangelists, whose high quality would indicate an origin in Constantinople.

The Luke and John portraits are particularly interesting since they are clearly derived from the same pen-dipping Evangelist type identified by A. Friend (see chapter 6). Their obvious differences in detail probably reflect the use of different models. The long, elegant curve of Luke's back is most closely paralleled in tenth-century Evangelist portraits such as

Mount Athos, Stavronikita cod. 43 (Luke)[4] or Paris, Bibl. Nat. cod. gr. 230 (Luke),[5] while John appears much closer to the traditions of earlier twelfth-century manuscripts (see cat. 36).

R.P.B.

Lent by Mr. H. P. Kraus

NOTES

1. See O. Demus, "Die Entstehung des Paläologenstils in der Malerei," *Berichte zum XI. Internationalen Byzantinisten-Kongress. München, 1958*, Munich, 1958, 24f., and Weitzmann, "Verkündigungsikone."
2. A. Nikolovski, *The Frescoes of Kurbinovo*, Belgrade, 1961; A. and J. Stylianou, *The Painted Churches of Cyprus*, Cyprus, 1964, 70f.; E. Kitzinger, *The Mosaics of Monreale*, Palermo, 1960.
3. Weitzmann, "Verkündigungsikone."
4. Weitzmann, *Buchmalerei*, pl. xxx, fig. 171.
5. Ibid., pl. xxxix, fig. 214.

# The Four Gospels  *Early Thirteenth Century*

Baltimore, Walters Art Gallery cod. W532. In Greek on vellum. 304 folios (35 x 26 cm.). Minuscule script. Two columns of 22 lines (24.0 x 7.0 x 16.7 cm.). Four full-page miniatures. Eight canon tables, four large headpieces, two full-page frames, and several small headpieces. Colophons: folios 4v, 5r, 304r; non-scribal. Binding: red velvet over wooden boards. Condition: miniatures excellent except Luke portrait, which is partially flaked; Luke and Mark miniatures are interchanged.

PROVENANCE: Given to the Church of the Holy Sepulchre in Jerusalem in 1542 by a certain Moses. By 1587 it belonged to the Church of the Anastasis in Jerusalem (later cod. 7). Around 1918 it was taken to Damascus as collateral for a loan. Acquired in Paris from Gruel by H. Walters.

EXHIBITED: Baltimore 1947, no. 733, pl. CIV; Washington Cathedral, Washington, D.C., 1965, *In the Beginning Was the Word*, no. 4; Brandeis 1968, no. 46, ill.

BIBLIOGRAPHY: DeRicci and Wilson, *Census*, 759; Clark, *N. T. Manuscripts*, 363f. (with further bibliography); C. Nordenfalk, "The Beginning of Book Decoration," *Essays in Honor of Georg Swarzenski*, Chicago, 1951, 17n.; Aland, *Liste*, 132; Lazarev, *Storia*, 422n.; Weitzmann, *Roll*, 108.

Full-page Evangelist portraits, framed by wide bands of floral ornament in blue, green, and rose over gold, precede each Gospel. Above each frame the name of the Evangelist is inscribed in red uncial letters. Matthew (fol. 16v), seated frontally on a cushioned bench, is about to write in a codex on his lap. He glances toward a scroll draped over a lectern at the left. At the right stands another lectern bearing an open codex. Luke (fol. 97v), whose portrait is inserted before the Gospel of Mark, is seated in profile at the left, holding a vellum leaf in his left hand and leaning forward to dip his pen into an inkwell on the desk at the right. Mark's portrait (fol. 150v, fig. 74) precedes Luke's Gospel. The Evangelist, seated in profile before a small building, rests his head contemplatively on his left hand. Behind a desk at the right is placed a lectern bearing an open codex. John (fol. 239v) is seated in a large wicker chair, holding an open book on his lap and touching his chin thoughtfully with his left hand.

The colors of these miniatures are generally rich and deep. Matthew and John are represented as old men with gray hair and beards, dressed soberly in robes of dark blue and gray. Mark and Luke are younger and wear brighter shades of rose, sky blue, and pale blue. All the backgrounds are gold.

Eight Eusebian canon tables are placed at the beginning of the manuscript (fols. 3v–10r, fig. 75), each framed by ornamentally conceived columns draped with curtains. These support triangular pediments or circular arches, set in large rectangular fields brilliantly illuminated with varied combinations of foliate, rainbow, diaper, and rosaceous patterns in blue, rose, and green on gold. Trees, birds, and candles ornament the margins.

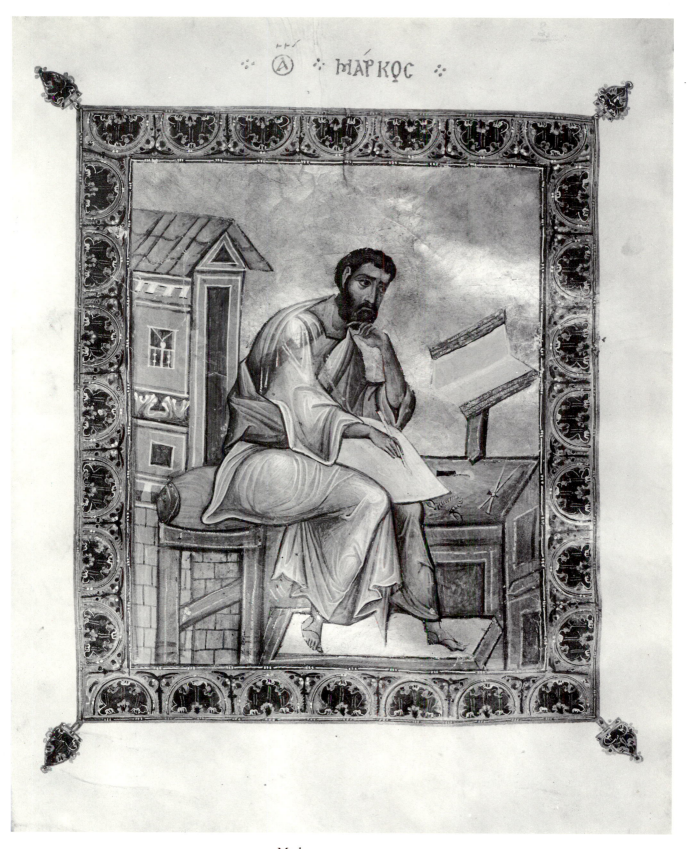

FIGURE 74. Mark
Baltimore, Walters Art Gallery cod. W532, fol. 150v

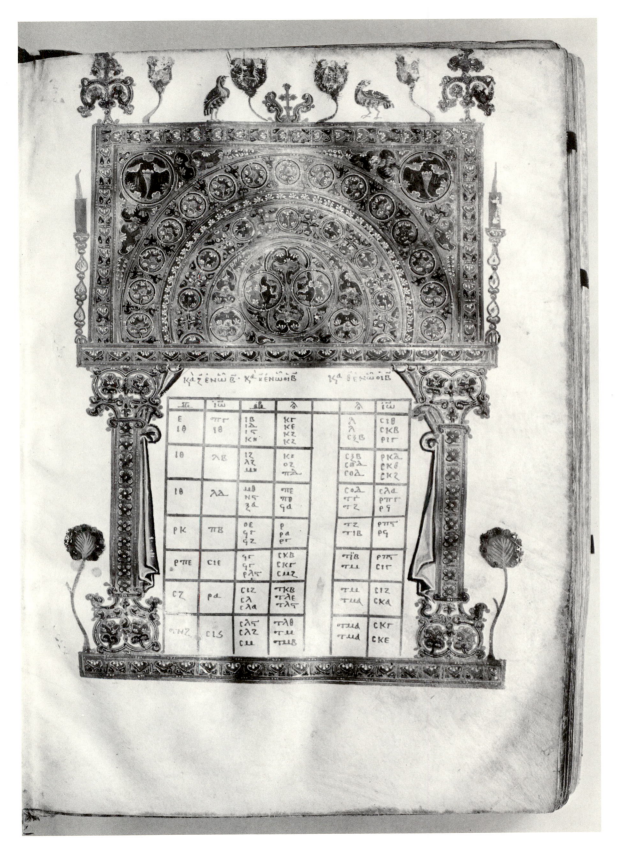

FIGURE 75. Canon Table
Baltimore, Walters Art Gallery cod. W532, fol. 8r

The letter of Eusebius to Carpianus (fols. 1v, 2r) is written in gold minuscule script on a quatrefoil field elaborately framed by a leafy blue molding and a foliate diaper design in green and blue on gold. The corners of the blue moldings are broken by tarnished silver birds on a red ground. At the top of each page is a pair of peacocks.

Although the Baltimore Gospel book has been variously dated between the twelfth and the fifteenth centuries, the monumental and imposing style of the Evangelist portraits relates most closely to manuscripts attributed to the first half of the thirteenth century.[1] The uneven success of the painter in his attempt to create a spatial environment, his fragmentation of the organic structure of the Evangelists's bodies and their irregular proportions are paralleled in a Constantinopolitan manuscript, Mount Athos, Philotheu cod. 5.[2] The smooth uncrowded forms of the drapery and the stiff fabric hanging rigidly about the arms and feet should also be compared. The drapery of the Baltimore Evangelists, however, is rendered in a system of decorative lines that flatten the body and deny a convincing impression of corporeality. Closely related to the Baltimore Evangelists are those in a Lectionary on Mount Athos, Koutloumousi cod. 61.[3]

The presence in the Baltimore canon tables of curtains drawn back and attached to column shafts indicates a familiarity with models from the Macedonian Renaissance.[4] Such features compare most closely with the late tenth-century canon tables in Vatican Lib. cod. gr. 364 and Florence, Laur. Lib. cod. conv. soppr. 159.[5] The Baltimore Evangelist portraits also appear to be derived from late tenth-century models. The portrait of Mark, for example, may be compared to that of Mark on a leaf in this exhibition from Baltimore (cat. 8).

T.J.-W.

Lent by the Walters Art Gallery

NOTES

1. Weitzmann, "Latin Conquest."
2. Ibid., fig. 9. Additional photographs in the Department of Art and Archaeology, Princeton University.
3. Huber, *Athos*, 212, pls. 129, 136. The dimensions of the Athos codex are strikingly close to those of the Baltimore manuscript: 278 folios (34.5 x 26.8 cm.); two columns of 20 lines.

   The correspondence includes composition, head type, geometricized drapery, and several distinctive features of the background architecture. The Athos Lectionary is in turn related to the frescoes of the Church of the Panagia Phorbiotissa at Asinou on Cyprus, dated 1105–6 (A. Papageorghiou, *Masterpieces of the Byzantine Art of Cyprus*, Nicosia, 1965, 15, pl. x) through a characteristic notch between the brows and the broad, geometricized drapery. Both manuscripts show close similarities to a Lectionary on Mount Sinai (cod. 208; M. Beza, *Byzantine Art in Roumania*, London, 1940, no. 35, pl. page 62) attributed to a Cypriote illuminator and associated with the style of Asinou in a forthcoming article by K. Weitzmann ("A Group of Early 12th-Century Sinai Icons Attributed to Cyprus"). The Evangelists of codex W532, however, show a breakdown of body structure and a flattening patternization of drapery beyond either the Sinai or Athos manuscripts, and, more significantly, their garments reveal an independent animation through occasional extended loops and folds of cloth. These characteristics would seem to indicate a later date for the Baltimore manuscript. —Ed.
4. Weitzmann, *Roll*, 108.
5. Weitzmann, *Buchmalerei*, pl. xxxiv, figs. 194–95.

Baltimore, Walters Art Gallery cod. W531. In Greek on vellum. 233 folios (32.4 x 24.0 cm.). Minuscule script. Two columns of 23 lines (22.8 x 7.0 x 15.8 cm.). Five full-page miniatures, one three-quarter page miniature, and two headpieces. Colophon: folio 174v, non-scribal. Binding: rebound in 1972 with previous white leather covers tooled in blind and gilt over new wooden boards. Condition: lacks canon tables and two miniatures before Matthew; text begins with Matthew 5:12 and ends with John 21:17; Luke miniature flaked in upper corners; Baptism miniature smeared in lower right corner.

PROVENANCE: Once belonged to Anna, daughter of Zanoula (fol. 174v). Formerly in a Trebizond monastery (according to tradition a Comnenian gift). Ex coll. Pelekides, Trebizond. Purchased from Gruel by H. Walters.

EXHIBITED: Boston 1940, no. 11, pl. vi; Baltimore 1947, no. 732, pl. cv; Oberlin 1957, no. 11, fig. 14; Athens 1964, no. 319.

BIBLIOGRAPHY: DeRicci and Wilson, *Census*, 758; Clark, *N. T. Manuscripts*, 361f.; A. Alpatoff, "Eine Reise nach Konstantinopel, Nicäa und Trapezunt," *Repertorium für Kunstwissenschaft*, XLIX, 1928, 75; G. Downey, "The Art of the New Rome in Baltimore," *Archaeology*, I, 1948, 24; W. Felicetti-Liebenfels, *Geschichte der Byzantinischen Ikonenmalerei*, Olten/Lausanne, 1956, pl. 16; H. Buchthal, *Miniature Painting in the Latin Kingdom of Jerusalem*, Oxford, 1957, 84n.; H. Buchthal, "A Byzantine Miniature of the Fourth Evangelist and Its Relatives," *Dumbarton Oaks Papers*, xv, 1961, 131f., fig. 6; Aland, *Liste*, 185; Diringer, *Book*, II-20c; Lazarev, *Storia*, 335n.; D. T. Rice, "The Paintings of Hagia Sophia, Trebizond," *L'Art byzantin du XIIIᵉ siècle* (Symposium de Sopoćani, 1965), Belgrade, 1967, 89; Rice, *Last Phase*, 40, pl. 127; Belting, *Buch*, 55.

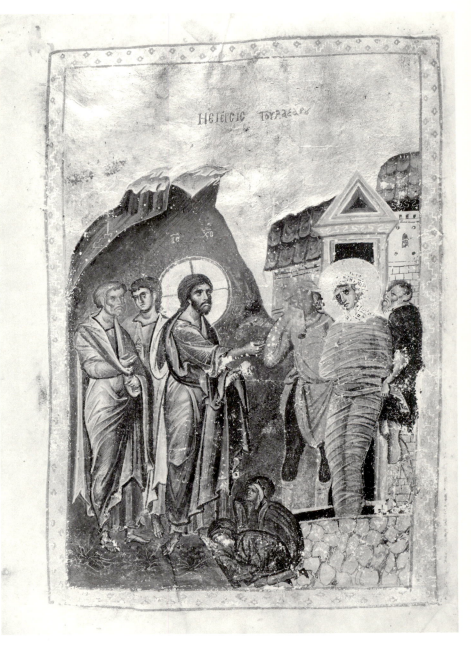

FIGURE 76.   Raising of Lazarus
Baltimore, Walters Art Gallery cod. W531, fol. 173v

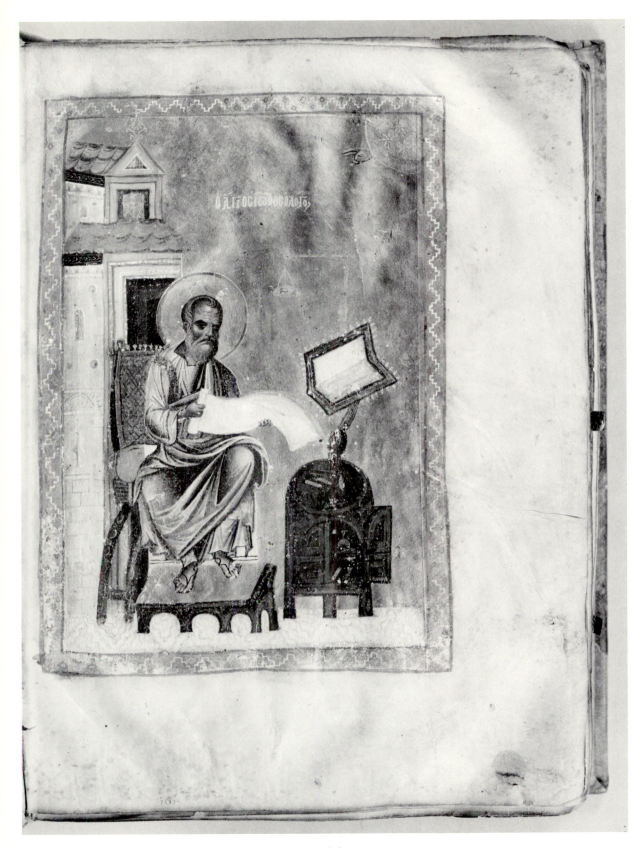

FIGURE 77. John
Baltimore, Walters Art Gallery cod. W531, fol. 174r

The illustration of this Gospel book consists of an Evangelist portrait paired with a full-page feast picture before each Gospel (those preceding Matthew are lost): Baptism-Mark (fols. 59v–6or); Annunciation-Luke (fols. 102v–103r); Raising of Lazarus-John (fols. 173v–174r, figs. 76, 77). The palette of all the miniatures is dominated by earth tones combined with blue and an occasional red accent, against a gold ground. Flesh tones are dark and modeled in olive green. In the Raising of Lazarus (fig. 76) the mountain, Christ's robe, and parts of the clothing of four other figures are brown; the garment of one of the crouching women, the ground, the mountain peak, the tomb facade, and Peter's mantle are in shades of green. Christ's mantle and Lazarus's bandages are blue, as is the clothing of two other figures, and the tomb roof. The sarcophagus from which Lazarus rises and a second roof are mixed pink and red, while Lazarus's headcloth is patterned white. The John portrait facing this miniature contains shades of brown in the furniture, the architecture, and the Evangelist's mantle (which is touched by bluish white highlights). His robe and the architectural details are rendered in shades of blue, while the seat cushion and roof are red and the footstool and flooring are marble, veined in white and gold.

The serene figures, with their full jaws and deep-set eyes marked by painterly shadows and their solid bodies accentuated by tightly wrapped, chevron-hemmed garments, are enveloped by windswept hills or set on a shallow stage before building facades turned parallel to the picture plane. These are thirteenth-century characteristics, though the style is softer, with less cubist architecture, than the frescoes at Sopoćani in Yugoslavia, of circa 1265.[1] Closer parallels are to be found in the frescoes at Žiča (1219–35) and Mileševa (1235–37), also in Yugoslavia.[2]

Certain codicological peculiarities as well as details of the frame decoration[3] and the painting technique show that the miniatures were executed by two artists. The Annunciation and the Luke portrait are in a more linear style, revealing the structure of the body under the drapery and including certain mannerisms of the late twelfth century, such as the snakelike roll of cloth edging the Virgin's mantle.[4] The other four miniatures are more painterly, with broad white highlights creating shimmering drapery surfaces, and with less clearly articulated bodies. This second style resembles that of a remarkably painterly iconostasis beam on Mount Sinai, considered by K. Weitzmann to date from shortly after 1200, and it is particularly close to a Sinai icon with precisely the same Annunciation iconography as in the present manuscript.[5]

Some such icons, repeating older classical iconographic types,[6] may have provided the models for the remarkably monumental miniatures, each of which contains only the essential figures, drawn massively and on a large scale.[7] The right-angled crenellated zigzag frames around the miniatures are like those in Constantinopolitan manuscripts of the eleventh and twelfth centuries, though their proportions are wider.[8] The iconographic program, a feast scene paired with the Evangelist's portrait before the text of each Gospel, was also popular in the twelfth century, though it is known in both earlier and later manuscripts (see cat. 5, 37).[9] Indeed, the types of the present Mark and Luke are precisely those found in a group of twelfth-century Gospel books, of which Vatican Lib. cod. Urb. gr. 2, datable 1122, is the most important.[10] The

Baptism and Annunciation scenes accompanying them are iconographically identical to those of another member of the group: Venice, Marciana cod. gr. I. 8 (in which the Matthew and the Nativity probably resemble the two miniatures lost from the present manuscript).[11] A frontal figure is rarely used for John, however, and this is the only known Gospel book with Evangelist-feast scene pairs to contain the Resurrection of Lazarus instead of the Anastasis.

Certain factors, in addition to its provenance, suggest that the Walters Gospels may actually have been made in Trebizond. The lozenge grid of one of its headpieces is like the decoration on a canon arch of a thirteenth-century manuscript that was found in Karahissar, near Trebizond (Leningrad, Public Lib. cod. gr. 101).[12] Wide frames with right-angled crenellated decoration are common in manuscripts from nearby Armenia, such as a tenth-century Gospel book, that came to its present home in Venice from Trebizond (San Lazzaro, cod. 1400/108),[13] and they were revived in the thirteenth century by T'oros Roslin and his school.[14] The frontal figure of John may be significant too: its upper half is similar to the corresponding part of the John in a tenth-century Lectionary given to Tsar Alexander II by the metropolitan of Trebizond (Leningrad, Public Lib., cod. gr. 21).[15] Perhaps the secondary decoration is the work of Trebizond craftsmen, while the miniatures are by Constantinopolitan artists (using older, presumably Constantinopolitan models), who came there with the Comnenian court after the fall of the capital in 1204.

A. VAN B.

Lent by the Walters Art Gallery

NOTES

1. A. Frolow, *La Peinture du moyen âge en Yougoslavie*, II, Paris, 1957, pls. 5, 19.

2. Ibid., I, pl. 51, figs. 2–3; pl. 54, figs. 1, 3; pl. 55, fig. 1; pl. 59, fig. 2. At Mileševa the space, architecture, and rendering of the human figure, but not the drapery, are similar to cod. W531; see pl. 70, fig. 3; pl. 72, fig. 1.

3. The Annunciation is on a single inserted leaf with its Evangelist portrait painted on the same page as the beginning of the text. The other two pairs, with full-page Evangelist portraits, are on bifolios inserted before the text of the accompanying Gospels. The frame decoration in the latter miniatures includes a repeated small lozenge that is absent from the former pair.

4. Weitzmann, "Verkündigungsikone."

5. G. and M. Sotiriou, *Icones du Mont Sinaï*, I, Athens, 1956, figs. 8, 113–16. For the dating see K. Weitzmann, "Byzantium and the West Around the Year 1200" (will soon appear in the third volume of *The Year 1200*).

6. The Baptism of Christ, with only two angels, is like the one in the eleventh-century Paris Gregory (Bibl. Nat. cod. gr. 533; see Galavaris, *Gregory*, fig. 247). The Virgin Annunciate seated in contrapposto, turning her back toward the angel, occurs repeatedly in the two illustrated copies of the homilies of the monk John, from the first half of the twelfth century (Paris, Bibl. Nat. cod. gr. 1208 and Vatican Lib. cod. gr. 1162; see Stornajolo, *Giacomo*, pls. 51, 53–57). Lazarus standing in his sarcophagus also repeats an early type (see Millet, *Recherches*, 252f.).

7. D. T. Rice (see bibliography) connects them unconvincingly with the frescoes of Hagia Sophia in Trebizond (ca. 1260), though they clearly belong to an earlier style than the expressive figures and cubist architecture of the frescoes. The manuscript and the frescoes share no particular iconographic or decorative features that could be seen as peculiar to Trebizond.

8. A. Frantz, "Byzantine Illuminated Ornament," *Art Bulletin*, XVI, 1934, 49. See the eleventh-century Vatican Lib. cod. gr. 756, fol. 11v–12r (Friend, "Evangelists," I, figs. 84–85).

9. Meredith, "Ebnerianus."

10. Stornajolo, *Giacomo*, pls. 83–93; Bonicatti, "Urb. gr. 2."

11. Photographs in the Department of Art and Archaeology, Princeton University. Meredith's fourteenth-century date for these miniatures is too late; see Lazarev, *Storia*, 119n., 254n.

12. Colwell and Willoughby, *Karahissar*, pl. VI.

13. M. Janashian, *Armenian Miniature Painting of the Monastic Library at San Lazzaro*, Venice, n.d., 23f., pl. XXII.

14. See Jerusalem, Armenian Patriarchate cod. 2660 and cod. 2563; A. Mekhitarian, *Treasures of the Armenian Patriarchate in Jerusalem*, Jerusalem, 1969, no. 11. Photographs in the Department of Art and Archaeology, Princeton University. A wide variety of crenellated decoration is used in canon arches and headpieces of this school, as well as in the earlier Trebizond, Mougna, and Sebastia Gospels; Janashian, *Armenian Miniature*, pl. XXX; L. Dournovo, *Miniatures Arméniennes*, Paris, 1960, pls. 51, 65.

15. Friend, "Evangelists," I, 136f.; fig. 110. The frontal pose is usually assigned to Matthew or Mark.

Chicago, Univ. Lib. cod. 965. In Greek on vellum. 207 folios (20.2–20.8 x 15.5 cm.). Minuscule script. One column of 41–43 lines in the Gospels, 34–37 lines elsewhere (15.0 x 9.6 cm.). Three full-page and 87 one-quarter to two-thirds page miniatures. Eight canon tables and four headpieces. Colophons: folios 7v, 207v, non-scribal. Binding: purple velvet over wooden boards with silver-gilt plaques representing the Crucifixion on the front and the Resurrection on the back. Condition: about 20 folios and 25 miniatures missing; remaining miniatures very flaked; probably originally included also a Psalter.

PROVENANCE: In the sixteenth century (?) belonged to a Voivode Alexander who presented it to the monastery "of the Saviour" (fol. 207r). In 1891 belonged to "B. K." (fol. 7v), perhaps in Zilch in Anatolia where it was procured twenty years later. Acquired in 1910 by M. Stora of Paris. Purchased by Mrs. E. Rockefeller McCormick of Chicago in 1928. From 1932–43 in the latter's estate. Presented by the McCormick family to the University of Chicago in 1943.

EXHIBITED: Baltimore 1947, no. 722, pl. CII; Athens 1964, no. 300; University of Chicago Library, Chicago, 1970, *Catalogue to the Exhibition of Notable Books and Manuscripts* . . . , no. 3, ill.; University of Chicago Library, Chicago, 1973, *New Testament Manuscript Traditions*, no. 54, ill.

FIGURE 78. Moses Receiving the Law
Chicago, Univ. Lib. cod. 965, fol. 6v

BIBLIOGRAPHY: DeRicci and Wilson, *Census*, 616; Bond and Faye, *Supplement*, 163; Clark, *N. T. Manuscripts*, 187f., pl. xxxv; Goodspeed, Riddle, and Willoughby, *Rockefeller McCormick*; H. Willoughby, "Codex 2400 and Its Miniatures," *Art Bulletin*, xv, 1933, 3f.; idem, *The Rockefeller McCormick New Testament and What Became of It*, Chicago, 1943 (with further bibliography); Aland, *Liste*, 187; Buchthal, "Manuscript," 217f.; Der Nersessian, "Dumbarton Oaks," 175, 177n.; H. Buchthal, "Some Representations from the Life of St. Paul in Byzantine and Carolingian Art," *Tortulae: Studien zu altchristlichen und byzantinischen Monumenten*, Rome, 1966, 44; A. Bank, "Les Monuments de la peinture byzantine du xiiie s. dans les collections de l'URSS," *L'Art byzantin du XIIIe siècle* (Symposium de Sopoćani, 1965), Belgrade, 1967, 92f.; Hamann-MacLean, "Quarto 66," 227, 238; Lazarev, *Storia*, 278n., 333n.; Rice, *Last Phase*, 40; Belting, *Buch*, 54; K. Weitzmann, "The Selection of Texts for Cyclic Illustration in Byzantine Manuscripts" (in press).

The Rockefeller McCormick New Testament contains about ninety framed miniatures, although H. Willoughby estimates that perhaps twenty-five more are now lost.[1] Those remaining include two full-page frontispieces, one on a purple vellum folio at the beginning of the New Testament text representing Moses Receiving the Law (fol. 6v, fig. 78), and another at the end of the codex showing David the Psalmist (fol. 206v) which must originally have preceded a Psalter text, now missing.[2] Six of the ten original author portraits are preserved: Mark (fol. 36r), Luke (fol. 56r), and John (fol. 85r) are depicted as full-length figures seated in profile within broad, ornamental, square frames, and the Epistle writers James (fol. 138r), Peter (fol. 141r), and Jude (fol. 150r) are shown as frontally standing half-figures. The eighty-two extant narrative miniatures (sixty-nine in the Gospels and thirteen in the Acts) immediately precede the texts they illustrate. Most depict single scenes of several figures and are bounded by simple frames. There are a few instances of continuous narrative treatment whereby separate scenes are incorporated into a single composition (e.g., fol. 10v, John Preaching and John Recognizing Christ; fol. 61r, John in Prison and John before Herod). The text illustrations vary in size, with only one full-page picture remaining: the Release of Peter from Prison (fol. 119v, fig. 79).

The dominant colors include red, blue, and some green with patches of brown and yellow accentuated by stiff black lines. The backgrounds are gold. Extensive flaking has revealed much of the red underdrawing.

A complete set of canon tables is found at the beginning of the Gospels on a gathering of four folios (2r–5v). The tables are placed between tall, thin arcades that support rich, ornamental decorations surmounted by birds. Colors include deep red, blue, and gold.

The miniatures feature awkward figures with large heads, thin legs, and dangling feet. Dressed in stiff, flat drapery, they reveal a distinctive facial type with heavily lined brows, and cheeks highlighted by spots of red.

A group of manuscripts in a nearly identical style and of comparable artistic quality has been assembled over the last thirty-five years around the Rockefeller McCormick New Testament (see cat. 46, 47, 51).[3] Early scholarship considered these manuscripts to be the first products of the Imperial scriptorium after the return to Constantinople of Michael VIII Palaeologos in 1261. More recently, however, the basis for this dating and localization has been seriously questioned.[4] The current theory dates the majority of these manuscripts in the first half and even the first quarter of the thirteenth century and places their production in Nicaea, host city to the exiled Imperial Court (1204–61).[5] It is also possible that they were made in Trebizond or some other artistic center that was active during the period of exile. The dearth of works firmly attributed to any of these cities makes an exact localization of the group impossible at the present time.

The fact remains that the Chicago manuscript bears far closer stylistic analogies to manuscripts of the late Comnenian period than to Palaeologan products. It is astonishingly similar in Evangelist portrait types, drapery style, ornamental frames, and technical quality to a Gospel book in the Vatican (cod. Barb. gr. 449), dated 1153.[6] These connections may well indicate a date as early as the late twelfth century for codex 965 and its related manuscripts. Further study, however, will be

necessary before this possibility can be seriously considered.

Besides being the central monument in the largest surviving group of Byzantine manuscripts illuminated in an identical style, the Rockefeller McCormick New Testament is significant in two further respects: although much less fully illustrated than the two eleventh-century Gospel books, Bibl. Paris, Nat. cod. gr. 74, and Florence, Laur. Lib. cod. Plut. VI, 23, it is a primary source of information on Mid-Byzantine Gospel illustration; and, more significantly, the Chicago manuscript contains the only known Byzantine cycle of text illustrations to the Acts.[7]

T.J.-W./S.G.

Lent by the Joseph Regenstein Library, University of Chicago

FIGURE 79. Peter's Release from Prison
Chicago, Univ. Lib. cod. 965, fol. 119v

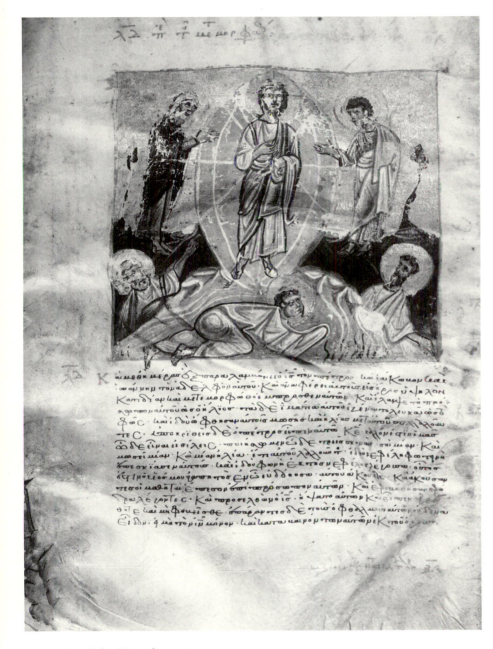

FIGURE 80. The Transfiguration
Chicago, Univ. Lib. cod. 965, fol. 24v

NOTES

1. Willoughby, "2400," 64.
2. Ibid., 4.
3. The essential members of this group are listed in Colwell and Willoughby, *Karahissar*, 11, 4n.
4. The history of scholarship is succinctly reviewed in Buchthal, "Manuscript," 217f. The dating of the Rockefeller McCormick New Testament to the years immediately after 1261 depends on its close similarities to Paris, Bibl. Nat. cod. Coislin 200, bearing a Latin colophon dated 1269 and a Greek colophon considered to be the autograph of Michael VIII Palaeologos. The trustworthiness of these colophons was effectively challenged in the description of the Coislin manuscript in the catalogue of the 1958 Paris exhibition (Bibliothèque Nationale, Paris, 1958, *Byzance et la France médiévale*, no. 47).
5. First proposed by S. Der Nersessian in her introduction to Colwell and Willoughby, *Karahissar*.
6. Goodspeed, Riddle, and Willoughby, *Rockefeller McCormick*, III, pls. c–ci; Lake, *Manuscripts*, VIII, pl. 583; additional photographs in the Department of Art and Archaeology, Princeton University.
7. K. Weitzmann, "The Selection of Texts for Cyclic Illustration in Byzantine Manuscripts" (in press).

FIGURE 81.  John
Philadelphia, Free Lib. cod. Lewis 353

Philadelphia, Free Lib. cod. Lewis 353. Two single vellum leaves (both 21.8 x 16.5 cm.). Two half-page miniatures. Text: folio 1, II Peter 3:15 through 1 John 2:9; folio 2, Exodus 15:1–19 and Deuteronomy 32:1–6 in Greek. Minuscule script. One column of 34 lines (15 x 10 cm.). Condition: miniatures show considerable flaking.

PARENT MANUSCRIPT: Palermo, Mus. Naz. cod. 4 (olim 1). New Testament-Psalter. 294 folios (21.8 x 16.5 cm.). Philadelphia folio 1 (John) was folio 161 and folio 2 (Moses) was folio 288.

PROVENANCE: Traditionally called the "Queen Costanza Codex," the manuscript has been associated with at least three queens who were in Sicily during the twelfth and thirteenth centuries. Kept in the Convento del Salvatore, Palermo, until the early nineteenth century. Philadelphia leaves excised before 1893, when their loss was first recorded by Martini (see bibliography). Ex colls. F. Richardson, Boston, and J. F. Lewis, Philadelphia. Presented to the Philadelphia Free Library in 1932 by Mrs. J. F. Lewis.

BIBLIOGRAPHY: DeRicci and Wilson, Census, 2079; E. Martini, Catologo di manoscritti greci esistenti nelle biblioteche italiane, Milan, 1893, 141f.; H. R. Willoughby, "Vagrant Folios from Family 2400 in the Free Library of Philadelphia," Byzantion, xv, 1940–41, 126f., pls. I-II; idem, "Stray New Testament-Psalter Leaves Identified," Journal of Biblical Literature, LXI, 1942, 57f., pl. I.

# John and Moses  *First Half of the Thirteenth Century(?)*

On the first leaf (fol. 1r, fig. 81) appears a bust portrait of John above the beginning of his First Epistle. Set within a patterned medallion of light blue and gray, the bearded Apostle is dressed in garments of green and blue, highlighted by black and white. He holds in his left hand a light orange scroll.

Moses is depicted on the second leaf (fol. 2v), preceding the Deuteronomy Ode. Dressed in light green and violet, he raises his left hand toward Heaven, while his right hand indicates the violet, pink, and red hills and foliage that surround him.

The two Philadelphia leaves have been identified as pages from a New Testament-Psalter manuscript in Palermo (Mus. Naz. cod. 4, olim cod. 1, fig. 82),[1] long recognized as a member of the group of thirteenth-century manuscripts stylistically related to the Rockefeller McCormick New Testament (cat. 45).[2] These miniatures, and those of the parent manuscript, bear a particular resemblance to a Psalter in Paris (Bibl. Nat. cod. suppl. gr. 1335),[3] which displays the same decorative treatment of architecture and drapery and a very similar figure style.

The portrait of John repeats the formula of the other three Epistle author portraits still bound in the Palermo manuscript (fig. 82), which show frontal figures blessing with their right hands and holding in their left either scrolls or codices. This portrait type is common among the Rockefeller McCormick group of manuscripts, although the medallion frame is rare.

The iconography of the Moses scene is also common among the manuscripts of this group, although it differs from the corresponding scenes in the Octateuchs.[4] It is related to the Deuteronomy Ode illustration in the marginal Psalters (for

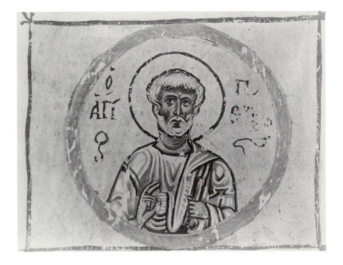

FIGURE 82. Peter
Palermo, Mus. Naz. cod. 4, fol. 155v

example, Vatican Lib. cod. Barb. gr. 372, fol. 245r),[5] where Moses stands on a hillock with both hands raised in prayer toward Heaven. The miniature on the Philadelphia leaf, however, is not so much a representation of Moses in prayer as a literal illustration of Deuteronomy 32:1: "Give ear, O ye heavens, and I will speak; and hear, O earth, the words of my mouth."

S.G.

Lent by the Free Library of Philadelphia

NOTES

1. Willoughby, "Vagrant."
2. For other members of this group and further discussion, see cat. 47 and 51.
3. Photographs in the Department of Art and Archaeology, Princeton University.
4. See Weitzmann, *Roll*, fig. 112.
5. Photographs in the Department of Art and Archaeology, Princeton University.

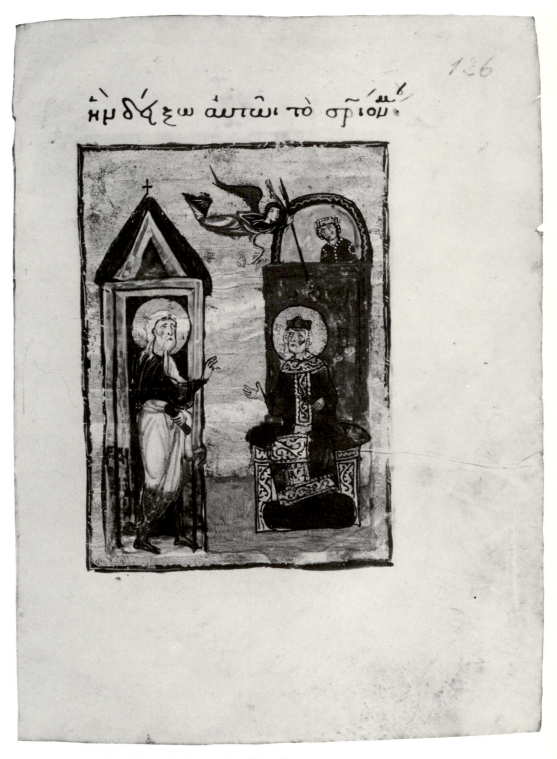

ἡμ δέ ξω αυτῶι τὸ σπίον

FIGURE 83.  Nathan's Reproach of David
New York, Public Lib. Spencer Coll. gr. cod. 1, fol. 126r

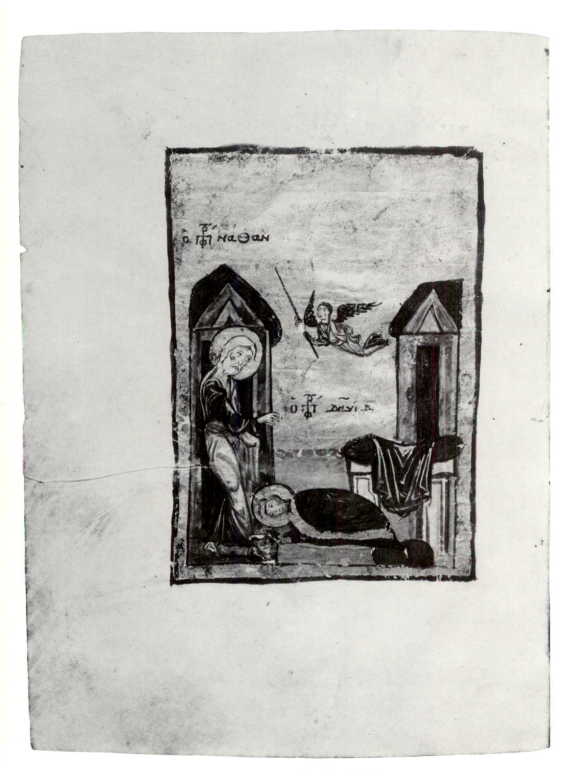

FIGURE 84.  David's Repentance
New York, Public Lib. Spencer Coll. gr. cod. 1, fol. 126v

New York, Public Lib. Spencer Coll. gr. cod. 1. In Greek on vellum. 408 folios (23.3 x 17.6 cm.). Minuscule script. One column of 15 lines (15.6 x 10.5 cm.). Seven full-page, fourteen marginal and half-page miniatures. Each Psalm begins with an ornamental initial. Binding: embossed leather over wooden boards. Condition: considerable flaking; some miniatures left incomplete.

PROVENANCE: Ex coll. B. Rosenthal. Purchased by the New York Public Library in Basel, 1955.

BIBLIOGRAPHY: L'Art ancien, Basel, May 26, 1955, *Catalogue* XXV, no. 528; K. Kup, "Front Matter," *Bulletin of the New York Public Library*, LXIII, 1959, 3, legend to frontispiece (fol. 395v).

The Spencer Psalter contains a total of twenty-one illustrations. Seven full-page miniatures (figs. 83, 84) are found before and within the text of the Psalms and immediately before the first Ode. The Odes are illustrated with eleven marginal miniatures of single figures or small groups, usually forming historiated initials. Half-page bust portraits of Basil and John Chrysostom are included after the Odes, and a headpiece, bearing Christ Logos within an aureole, precedes Psalm 1.

Red and blue predominate with occasional use of brown, yellow, and green. Highlights are executed in light blues and greens as well as in gold and white. The ornament of the decorated headpiece consists of heart-shaped flowers and leaves and rinceaux. Each Psalm begins with a simple flower-petal initial.

This Psalter is undoubtedly a member of the group of twenty or more manuscripts that have been assembled stylistically around the Rockefeller McCormick New Testament (see cat. 45).[1] It relates to the members of this group through its flat drapery style, its ill-proportioned figures, and its ornamental motifs. Its closest relative is a Catena in Job, Vatican Lib. cod. gr. 1231,[2] with which it further shares a distinctive facial type, with angular brows, a long J-shaped nose, and cheeks defined by an extended S-curve and highlighted with spots of red.

Significantly, this Psalter includes two antithetical pairs of full-page miniatures representative of a series of paired miniatures thought to have illustrated the lost archetype of the aristocratic Psalter recension. The more interesting pair occurs before Psalm 50 (51) and represents Nathan's reproach of David (fol. 126r, fig. 83) and David's repentance (fol. 126v, fig. 84).[3]

The ultimate iconographical source of these miniatures is an illustrated Book of Kings, such as Vatican Lib. cod. gr. 333 (fol. 50v),[4] where the two episodes occur in succession within a single frame. Significantly, the Psalter artist has shown David in *proskynesis* not before the Hand of God, as in the Vatican Kings, but before Nathan. The presence of Nathan in the second scene results from a conflation of the two original episodes. This had already taken place in earlier Psalter manuscripts, such as Vatican Lib. cod. gr. 752[5] (late eleventh century), where a kneeling David is inserted between Nathan and an enthroned David. That the two episodes were separated in the Psalter archetype is suggested by manuscripts that preserve full-page miniatures of only one of the two (e.g., Paris, Bibl. Nat. cod. suppl. gr. 1335, fol. 282v),[6] and by manuscripts that illustrate the two in separate registers of the same miniature (e.g., London, Brit. Mus. cod. add. 36928, fol. 46r).[7]

A second miniature deserving mention is that illustrating the Ode of Manasseh (fol. 395v, fig. 85). Instead of the standard representation of the impious king kneeling in repentance, he is shown here in *proskynesis* inside a large brazen bull standing amid red flames. This iconography is unique, although it is related to representations in two other manuscripts that depict Manasseh standing behind a live bull (Paris, Bibl. Nat. cod. gr. 510, fol. 435v, homilies of Gregory Nazianzenus;[8] and Athens, Nat. Lib. cod. 7, fol. 256v, Psalter[9]). The textual source for the scene is found in the Syriac *Apocalypse of Baruch*, which relates that Manasseh, captured by the Assyrians, was taken from his homeland inside a brazen bull (chapter 64). His subsequent repentance caused God to melt the bull, releasing him.[10]

S.G.

FIGURE 85. The Ode of Manasseh
New York, Public Lib. Spencer Coll. gr. cod. 1, fol. 395v

NOTES

1. The essential members of the group are listed in Colwell and Willoughby, *Karahissar*, II, 4n. See cat. 45, 46, 51.
2. Photographs in the Department of Art and Archaeology, Princeton University.
3. The second pair, before the Exodus Ode, represents Moses and the Israelites pursued by Pharaoh's army (fol. 365r), and Moses closing the Red Sea over Pharaoh's army (fol. 365v).
4. Lassus, "Rois," figs. 8–9.
5. E. T. DeWald, *Vaticanus graecus 752*, Princeton, 1942, pl. XXXI.
6. Photographs in the Department of Art and Archaeology, Princeton University.
7. Photographs in the Department of Art and Archaeology, Princeton University.
8. Omont, *Miniatures*, pl. LVII.
9. P. Buberl, *Die Miniaturenhandschriften der Nationalbibliothek in Athen*, Vienna, 1917, pl. XIX, fig. 48.
10. R. H. Charles, *The Apocrypha and Pseudepigrapha of the Old Testament*, 2 vols., Oxford, 1913, II, 515.

48.

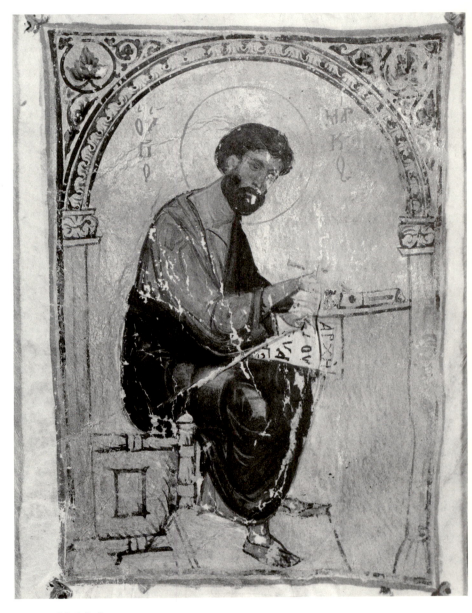

# Single Leaf: Mark

*Early Thirteenth Century*

Montreal, Museum of Fine Arts cod. acc. no. 33.1373. Single vellum leaf (21.2 x 14.0 cm.). One full-page miniature. Reverse blank. Condition: trimmed along right side; some flaking.

PROVENANCE: Part of a set of four Evangelist portraits with cat. 49. In the early twentieth century in the possession of the Paris dealer D'Aguerre. Brought to the United States with its three companion miniatures where all were purchased by the Bourgeois Galleries of New York around 1918. The Mark leaf later belonged to Durlacher. It was purchased in 1933 by F. C. Morgan for the Art Association of Montreal (now the Montreal Museum of Fine Arts). According to a letter of S. Bourgeois to F. C. Morgan (December 6, 1933), the portrait of Matthew (fig. 87) was sold to Thomas McCormick, Jr., of Princeton. The portrait of Luke was purchased by the Boston Museum of Fine Arts from S. Bourgeois in 1919. The present location of the John leaf is unknown (fig. 88).

EXHIBITED: University of Chicago Library, Chicago, 1931, "Byzantine Exhibition"; Royal Ontario Museum, Toronto, 1950, "Books of the Middle Ages"; Museum of Fine Arts, Montreal, 1965, *Images of Saints*, no. 2.

BIBLIOGRAPHY: Clark, *N. T. Manuscripts*, 8; Lazarev, *Storia*, 335n.

NOTES

1. Weitzmann, "Latin Conquest," figs. 3, 9. (Additional photographs in the Department of Art and Archaeology, Princeton University.)
2. Ibid., 205f.

The miniature depicts the Evangelist Mark (fig. 86)—his name inscribed on the partially flaked gold ground—sitting on a low seat under an arch, facing toward the right. In his left hand he holds a scroll displaying the opening words of his Gospel. With his right hand he dips his pen into an inkwell on the lectern before him, now badly flaked. He wears a purple tunic under a dark green mantle that seems to spread over his heavy body. His face is well modeled, with greenish touches on the nose, and is crowned by slightly agitated black hair in which are visible touches of purple. The arch is ornamented by a series of dark green stylized palmettes.

The figure style suggests a date in the thirteenth century. The drapery, which gives a certain heaviness to the figure, has a metallic quality and stands away from the body. The Evangelist's wide, columnlike neck is particularly striking, as is his hair painted with loose brushstrokes. All these characteristics point to the Palaeologan period. Specific stylistic parallels can be seen in Constantinopolitan manuscripts of the thirteenth century, such as Athens, Nat. Lib. cod. 118, and Mount Athos, Philotheu cod. 5.[1] The drapery in the Montreal miniature is not as metallic as that in the Evangelist portraits of the Athens Gospels. The folds are amply spaced, harsh breaks are avoided, and the highlights are not exaggerated. In general the treatment is softer and comes closer to the Evangelists in the Philotheu Gospels, which have been considered earlier than the Athens codex, being ascribed to the early thirteenth century.[2]

G.G.

Lent by the Montreal Museum of Fine Arts

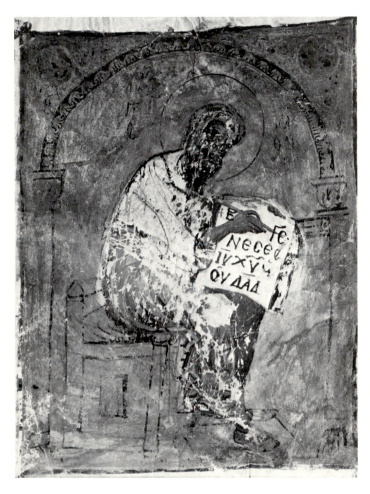

FIGURE 87. Matthew
Location unknown

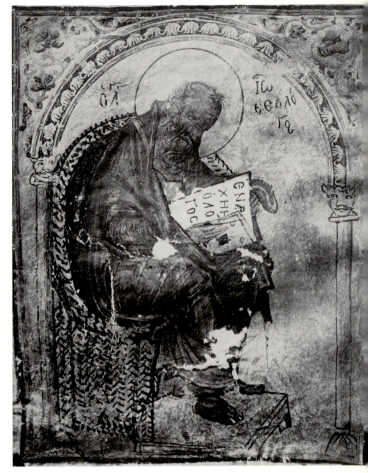

FIGURE 88. John
Location unknown

# Single Leaf: Luke    *Early Thirteenth Century*

Boston, Museum of Fine Arts cod. acc. no. 19.118. Single vellum leaf (21.4 x 15.6 cm.). One full-page miniature. Reverse blank. Condition: trimmed along right side; partially flaked.

PROVENANCE: Part of a set of four Evangelist portraits with cat. 48. Purchased in 1919 by the Boston Museum of Fine Arts from S. Bourgeois of New York.

EXHIBITED: Baltimore 1947, no. 719, pl. CXVIII.

BIBLIOGRAPHY: DeRicci and Wilson, *Census*, 947; Clark, *N. T. Manuscripts*, 140; Lazarev, *Storia*, 335n.

The Evangelist Luke (fig. 89)—his name inscribed on the gold ground—is represented seated on a low chair under an arch, facing toward the right. Dressed in a green tunic and a purple mantle, he writes the beginning of his Gospel in a codex held on his lap. His chair, footstool, and desk, as well as the columns that frame the composition, are rendered in reddish brown outline. Occasional touches of bright red accent the generally subdued color scheme.

G.G.

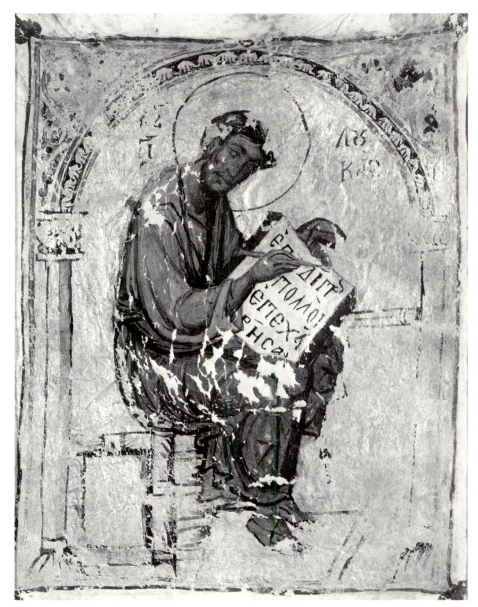

FIGURE 89. Luke
Boston, Museum of Fine Arts cod. acc. no. 19.118

Lent by the Museum of Fine Arts, Boston, Arthur Mason Knapp Fund

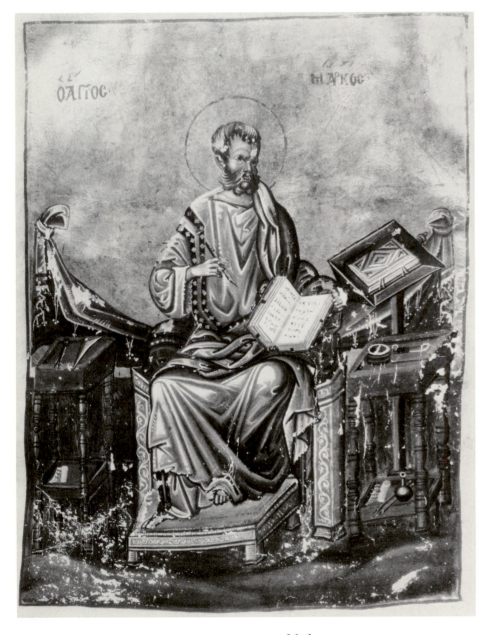

FIGURE 90.  Mark
Princeton, Univ. Lib. cod. Garrett 2 fol. 125v

Princeton, Univ. Lib. cod. Garrett 2. In Greek on vellum. 328 folios (25.6 x 20.2 cm.). Minuscule script. One column of 20 lines (16.8 x 11.3 cm.). Four full-page miniatures, three full-page text frames, ten canon tables, and nine headpieces. Colophons: folios Br, Cr, 327v, 328r, non-scribal. Binding: dark red leather over wooden boards; holes on front cover where a cross and metal bosses were attached. Condition: miniatures flaked in some areas; lacunae in text; first quire (14 leaves) a later insertion.

PROVENANCE: Belonged ca. 1300 to Callistratos, a priest-monk in Constantinople (fol. 327v). Repaired by Demetrios in 1563 (Br). In the monastery of Saint Andrew on Mount Athos (cod. 753). Brought to the United States by T. Whittemore. Purchased in 1925 by R. Garrett and given by him to the Princeton University Library in 1942.

EXHIBITED: Boston 1940, no. 6; Baltimore 1947, no. 725, pl. CIV.

BIBLIOGRAPHY: DeRicci and Wilson, *Census*, 865; Bond and Faye, *Supplement*, 311; Clark, *N. T. Manuscripts*, 63f. (with further bibliography); Friend, "Garrett," 131f.; Weitzmann, "Latin Conquest," 201f., figs. 4–5; I. Hänsel, "Die Miniaturmalerei einer Paduaner Schule im Ducento," *Jahrbuch der Österreichischen byzantinischen Gesellschaft*, II, 1952, 133; O. Demus, "Die Entstehung des Paläologenstils in der Malerei," *Berichte zum XI. Internationalen Byzantinisten-Kongress. München, 1958*, Munich, 1958, 19f., 54; Aland, *Liste*, 141; K. Weitzmann, "Icon Painting in the Crusader Kingdom," *Dumbarton Oaks Papers*, XX, 1966, 60f., fig. 20; Lazarev, *Storia*, 278, 332n., 336n.; Belting, *Buch*, 51, 61f; H. Belting, "Die Auftraggeber der spätbyzantinischen Bildhandschrift," *Art et société à Byzance sous les Paléologues* (Actes du colloque organisé par l'Association Internationale des Études Byzantines à Venise en Septembre 1968), Venice, 1971, 166f., pl. LXIX, fig. 7.

The four sumptuous, full-page miniatures serving as frontispieces to these Gospels depict nimbed, bearded Evangelists seated on cushioned benches against gold backgrounds. Their names are inscribed above in red uncial letters and the edges of their footstools and benches are decorated with various types of classicizing ornament and figures. Mark (fol. 125v, fig. 90) is shown in a strictly frontal position, while his three companions are represented in profile toward the right. Matthew (fol. 44v), holding an open codex close to his chest, sits on a large blue cushion before a lectern supporting a clasped book, in front of which stands a desk with various writing implements. Behind him is a taller desk upon which are visible pens, a compass, and an inscribed scroll; and in the left background is a tall, narrow building surmounted by a cross. The intensity of Matthew's concentration, conveyed by his knit brow, is echoed in the convoluted drapery folds on his lap. The volume of his gray mantle is rendered through a subtle combination of blue shadows and strong highlights.

Flanked left and right by desks, Mark (fol. 125v, fig. 90) supports an open codex with his left hand while holding a pen in his upraised right. A lectern with a clasped pink book stands behind the desk at the right and a dark blue curtain, knotted at the sides, is draped across the lower background. Two dark purple *clavi* with gold diamonds decorate the right sleeve of Mark's loose-fitting blue tunic. The drapery folds of his purple-gray mantle are modeled with prominent white highlights.

Luke (fol. 179v), whose face is unfortunately considerably flaked, sits in front of a low writing cabinet. With his left hand he touches the edge of a large blue lectern supporting an open codex; his

right rests on his left knee. Over his blue tunic, a rose mantle is wrapped high around his waist and slung over his left shoulder. In the left background a red cloth hangs over a tall blueish green building.

John (fol. 267v) is writing in an open codex propped upon his left knee. To the right stands an open writing cabinet in which may be seen a closed book, a bottle of ink, and a scroll. Seated on a red cushion, the Evangelist is clothed in a deep blue mantle.

The Garrett Gospels also include ten delicately executed canon tables (fols. 35v–40r, fig. 91) with double-arched rectangular frames surmounted by various species of juxtaposed birds. While the rich carpet pattern of each frame is different (consisting of vine scrolls, palmettes, and crenellated patterns), the lateral ornaments are generally repeated on facing pages. Although built from the same motifs, the nine headpieces of this codex are of generally lower technical quality than the canon tables; the palmettes and acanthus leaves are larger, flatter, and rougher (fig. 92). More splendid are the three full-page text frames (fols. 33v–34v) enclosing the letter of Eusebius to Carpianus. All types of ornament are rendered in blue, green, and rose against a shimmering gold background.

The production of the text of the Garrett Gospels is datable through its ornament to the first half of the twelfth century.[1] Liturgical tables (fols. 1r–11v) were added later by the same hand that entered an ownership colophon on folio 327v, including a reference to Patriarch Athanasios of Constantinople (1289–93 and 1303–9).[2]

The dating of the inserted Evangelist miniatures is more problematic. Iconographically they belong to a closely in-

terrelated group of portraits isolated by K. Weitzmann.[3] Athens, Nat. Lib. cod. 118, regarded as the nucleus of this group, is dated by Weitzmann circa 1230–40 on the basis of its close similarities to certain drawings in the Wolfenbüttel Sketchbook (Herzog August Bibliothek cod. 61/62 Aug. oct.).[4] In addition to the Athens and Princeton codices, the series includes Mount Athos, Philotheu cod. 5,[5] Iviron cod. 5,[6] and Paris, Bibl. Nat. cod. gr. 54.[7] The Paris codex is placed at the end of the stylistic development, yet still within the years of the Latin occupation of Constantinople (1204–61), on the evidence of its bilingual text.[8]

Advocating a greater time span between individual members of this series and suggesting their general stylistic development beyond manuscripts of the "Nicaea group" (see cat. 45–47, 51) and Paris, Bibl. Nat. cod. gr. 117 (dated 1262),[9] H. Belting prefers to date the group in the forty years after the recapture of Constantinople.[10] He assigns the Garrett miniatures to the end of the thirteenth century on the basis of stylistic comparisons with the frescoes of Saint Clement in Ochrid, dated 1295. He further suggests that their inclusion may coincide with the addition of the ownership colophon on folio 327v.[11]

Belting's comparison is not altogether convincing since the faces of the Ochrid figures are much more highly caricaturized and their garments more angular and agitated than those of the Princeton miniatures.[12] Furthermore, the architectural forms of the Ochrid frescoes are more stereometrically rendered and complex. These characteristics indicate a more advanced stage in the development of Palaeologan painting.

In both style and format the figure of John stands apart from the other three

FIGURE 91. Canon Table
Princeton, Univ. Lib. cod. Garrett 2, fol. 35v

Evangelists of codex Garrett 2.[13] He is more massively conceived, his garments consist of broader, more geometric folds, and they are modeled in gradual highlights and shadows as compared with the flickering, dramatic highlighting of the other portraits. Furthermore, the composition as a whole is simplified, more two-dimensional, and closer to the picture plane.

Stylistically, the miniature of John may be related to a series of wall paintings in the Church of the Ascension in Mileševa, dated circa 1235. In a scene of Christ Addressing the Apostles (narthex, west wall),[14] the drapery of the two figures seated in the foreground is very close to that of the Princeton Evangelist. In addition, John's expressive head type, with its high, bulging, furrowed forehead, finds close counterparts in frescoes of the nave and sanctuary.[15]

B.A.V./G.V.

Lent by Firestone Library, Princeton University

1. A striking similarity exists between the ornament of codex Garrett 2 and that of Mount Athos, Karakalou cod. 31 (photographs in the Department of Art and Archaeology, Princeton University), which in turn is closely related to Mount Athos, Vatopedi cod. 960, dated 1128 (Lake, *Manuscripts*, III, pl. 196; further photographs in the Department of Art and Archaeology, Princeton University). Both Clark and Belting had recognized the earlier date of the text: Clark, *N. T. Manuscripts*, 63; Belting, *Buch*, 61.

2. Belting, *Buch*, 61f. The colophon is transcribed in Clark, *N. T. Manuscripts*, 64.

3. Weitzmann, "Latin Conquest."

4. Ibid., 196f.

5. Ibid., fig. 9. Additional photographs in the Department of Art and Archaeology, Princeton University.

6. A. Xyngopoulos, Ἱστορημένα Εὐαγγέλια Μονῆς Ἰβήρων Ἁγ. Ὄρους, Athens, 1932, 7, pls. 12–57.

7. Omont, *Miniatures*, pls. xc–xcvi.

8. Weitzmann, "Latin Conquest," 204f.

9. Hamann-MacLean, "Quarto 66," pl. 13. Additional photographs in the Department of Art and Archaeology, Princeton University.

10. Belting, *Buch*, 61f. Demus ("Entstehung," 19f.) also suggests a greater time span between the manuscripts of Weitzmann's group. He does, however, consider the Garrett miniatures as among the oldest, suggesting a date in the second quarter of the century. See Lazarev, *Storia*, 278f.

11. Belting, *Buch*, 61f.

12. A. Frolow, *La Peinture du moyen âge en Yougoslavie*, III, Paris, 1962, pls. 1–19.

13. Although the John miniature is somewhat larger than its companions, its technique (painting over a dull red undercoat), its quality of vellum, its inscription, and several of its writing implements exactly match those of the other portraits.

14. A. Frolow, *La Peinture du moyen âge en Yougoslavie*, I, Paris, 1954, pl. 68, fig. 1.

15. Ibid., pl. 68, fig. 2; pl. 74, figs. 4–5.

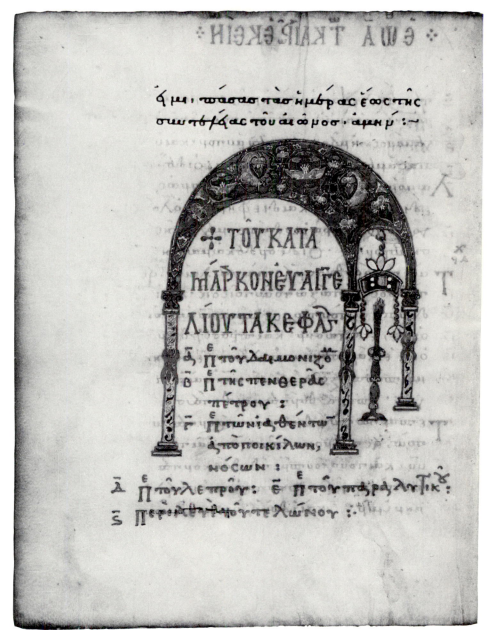

FIGURE 92. *Kephalaia* to the Gospel of Mark
Princeton, Univ. Lib. cod. Garrett 2, fol. 123v

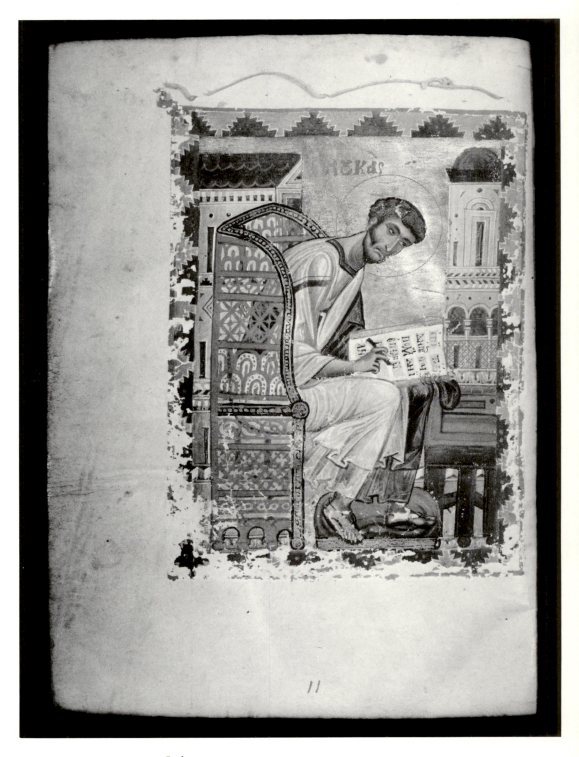

FIGURE 93.  Luke
New York, Coll. H. P. Kraus, (olim Phillipps coll. cod. 3887), fol. 121v

# The Four Gospels   *Early and Late Thirteenth Century*

New York, Coll. H. P. Kraus (olim Phillipps coll. cod. 3887). In Greek on vellum. 241 folios (20.5 x 15.0 cm.). Minuscule script. One column of 25 lines (14 x 9 cm.). Nineteen full-page miniatures, thirteen of which are later insertions. Eight canon tables and four headpieces. Zoomorphic initials. Binding: old velvet over canvas and wooden boards. Condition: some miniatures badly flaked; other leaves worn, stained, and discolored; other miniatures well preserved.

PROVENANCE: Bought by T. Phillipps in 1829 from the collection of F. North. Acquired by Kraus through Sotheby in November 1965 (Phillipps collection).

BIBLIOGRAPHY: Buchthal, "Manuscript"; Sotheby and Co., London, November 30, 1965, *Bibliotheca Phillippica, Catalogue of Thirty-Nine Manuscripts . . .* , lot 8, frontispiece, pl. b; Hamann-MacLean, "Quarto 66," 225; Lazarev, *Storia*, 333n., 335n.; D. T. Rice, "The Paintings of Hagia Sophia, Trebizond," *L'Art byzantin du XIII<sup>e</sup> siècle* (Symposium de Sopoćani, 1965), Belgrade, 1967, 89; Rice, *Last Phase*, 40, fig. 26; Belting, *Buch*, 4n.; M. Frazer, "Byzantine Art and the West," *The Year 1200: II, A Background Survey*, ed. F. Deuchler, New York, 1970, 229, no. 260, ill.

Of the nineteen full-page miniatures found throughout this manuscript, four are Evangelist portraits and fifteen are feast scenes. The Evangelists (fig. 93) and two of the feast scenes (the Incredulity of Thomas, fol. 76r, and the Death of the Virgin, fol. 190v) are contemporary with the manuscript's text, while the other thirteen feast miniatures (fig. 94) are later insertions. The manuscript must have originally contained a fuller cycle of feast pictures since stubs for eight of them are still to be seen. Most of these early miniatures probably deteriorated after a relatively short period of time and were replaced by the later leaves.

The predominant colors in both phases of the illumination are pinks, blues, and reds, the latter being used to create striking accents. A large amount of gold is also in evidence, particularly in the backgrounds and in the headpieces. There is a significant difference in the use of color between the original and the added parts of the decoration. In the earlier miniatures the overall tonality is lighter, while in the later leaves not only is the palette darker, but there are also stronger contrasts. Even the gold backgrounds vary from a dull finish in the original miniatures to a very shiny surface in the added leaves.

H. Buchthal has associated the original decoration of the Kraus Gospels with the growing number of manuscripts grouped around the Rockefeller McCormick New Testament (cat. 45).[1] This series of manuscripts has most recently been dated in the first half (perhaps even the first quarter) of the thirteenth century and assigned an origin in Nicaea, an important court center during the period of the Latin domination of Constantinople (1204–61).[2] The original parts of the decoration of the Kraus manuscript, however, differ in many ways from the generally

less accomplished miniatures of the Rockefeller McCormick group. In fact, the Kraus miniatures seem to be more closely associated with a smaller group of manuscripts centered around a Gospel book in Berlin, Staatsbibl. cod. gr. qu. 66, which, on the basis of an Arabic inscription describing the presentation of the codex as a gift, has been seen to date prior to 1219.[3] Comparisons with monumental painting from this period confirm a date at the end of the twelfth or the beginning of the thirteenth century for the Berlin manuscript. The original decoration of the Kraus codex (fig. 93) shares with this Gospel book similar architectural backgrounds with three-dimensional beam ends and diamond-shaped exterior paneling, as well as crenellated border ornament and simulated chrysography (see Christ in the Koimesis). The ornament of the headpieces in the two manuscripts, while not identical, is comprised of similar motifs—palmettes in conjunction with vine tendrils or more geometric elements disposed in symmetrical designs.

Headpieces even closer to those in the Kraus codex may be found in Florence, Laur. Lib. cod. Plut. VI, 36,[4] and Mount Athos, Dionysiou cod. 4.[5] Of the group of manuscripts related to Berlin cod. gr. qu. 66, however, the closest to the Kraus manuscript is a Gospel book on Mount Athos, Dionysiou cod. 23.[6] Three of the Evangelists in this codex are virtually identical to those in the Kraus Gospels, and even the unusual high-backed throne on which Luke sits (fig. 93) is common to both. The characteristic background architecture and crenellated border ornament are both found in Dionysiou cod. 23,[7] and many of the drapery motifs and facial characteristics are identical.

Although insufficient evidence can be brought to bear in order to fix the place of origin of this group of manuscripts, it is worthwhile to note that the city of Nicomedia in Bithynia (very near Nicaea) has featured in the provenance of at least one of its members (Kiev, Acad. Lib. cod. 19254).[8]

H. Buchthal was certainly correct in assigning the thirteen added miniatures, painted in a more energized and emotional manner than the earlier decoration, a date toward the very end of the thirteenth century. The Evangelists in London, Brit. Mus. cod. Burney 20, dated 1285, provide excellent comparisons for the strongly highlighted drapery and the intense facial features.[9] The low-browed, veiled female heads of the Kraus Gospels (fols. 74v, 237r), with their deep-set eyes, long noses, and pathetic expressions, find close comparisons in the frescoes of Saint Clement at Ochrid, dated 1295.[10] H. Buchthal's suggestion that these miniatures may have been added to the manuscript in Thessaloniki remains purely hypothetical.

The iconography of certain of the individual miniatures shows interesting deviations from general practice. As Buchthal pointed out, the Apostles in the Transfiguration (fol. 45v, fig. 94) are abbreviated from their usual full-figure form to mere busts, and the Christ Child in the Nativity (fol. 15r) is shown in exceptionally small scale. The Presentation (fol. 129v), almost always cast in a symmetrical composition, is here represented with Simeon on one side and the remaining three figures on the other.

Taken as a whole, the iconographic program of the Kraus Gospels clearly reflects the impact of the Liturgy. Instead of narrative Gospel illustrations in the text columns, the manuscript contains a large number of full-page miniatures commemorating the most important feast days of the liturgical year. Such a cycle had been developed for the Gospel Lectionary, and we may therefore assume the influence of this most important type of manuscript on the Kraus codex. In fact, it is only through the influence of the Lectionary's festival cycle that one can explain the appearance in our manuscript of scenes such as the Anastasis and Koimesis, events never even mentioned in the text of the Gospels.

<div align="right">R.P.B.</div>

Lent by Mr. H. P. Kraus

NOTES

1. Buchthal, "Manuscript." See cat. 46, 47.
2. The attribution to Nicaea was first proposed by S. Der Nersessian in her introduction to Colwell and Willoughby, *Karahissar.* See Belting, *Buch,* 54f.
3. Hamann-MacLean, "Quarto 66," 225f.
4. Photographs in the Department of Art and Archaeology, Princeton University.
5. Hamann-MacLean, "Quarto 66," fig. 23. Other photographs in the Department of Art and Archaeology, Princeton University.
6. Photographs in the Department of Art and Archaeology, Princeton University.
7. Even the three dots that appear in the crenellations of the Kraus manuscript are included.
8. A. Bank, "Les Monuments de la peinture byzantine du XIIIe s. dans les collections de l'URSS," *L'Art byzantin du XIIIe siècle* (Symposium de Sopoćani, 1965), Belgrade, 1967, 94f.
9. Buchthal, "Manuscript," 222; Lazarev, *Storia,* figs. 395–96.
10. A. Frolow, *La Peinture du moyen âge en Yougoslavie,* III, Paris, 1962, pl. 10, fig. 2.

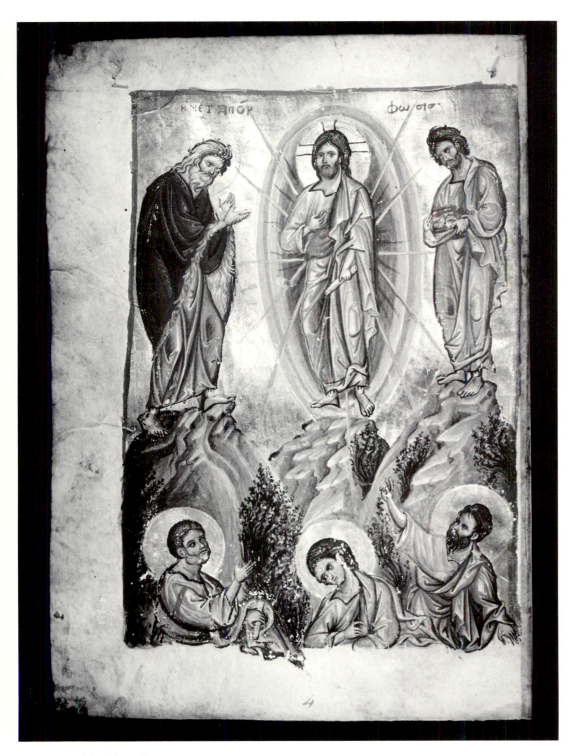

FIGURE 94. The Transfiguration
New York, Coll. H. P. Kraus, Gospels (olim Phillipps coll. cod. 3887), fol. 45v.

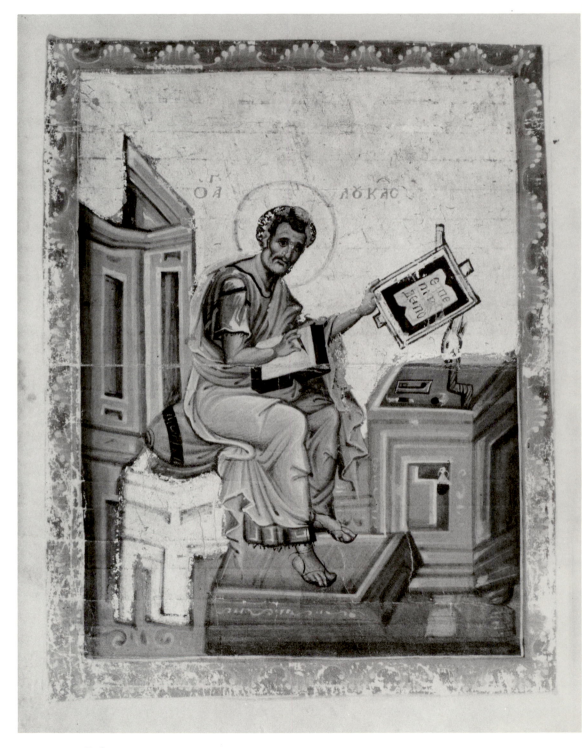

FIGURE 95.   Luke
Baltimore, Walters Art Gallery cod. W53of

# and Christ Appearing to His Disciples Through Closed Doors

*Late Thirteenth Century*

Baltimore, Walters Art Gallery cod. W530f, g. Two single vellum leaves (25.0 x 15.4 cm.). Three full-page miniatures. Luke reverse blank. Condition: horizontal crease across center of both leaves; portrait frames partially flaked.

PARENT MANUSCRIPT: Mount Athos, Lavra cod. A76. Gospel book. 217 folios (25.0 x 17.1 cm.). Baltimore leaves preceded Luke and John Gospels. Identification: K. Weitzmann.

PROVENANCE: Purchased from Gruel by H. Walters.

EXHIBITED: Baltimore 1947, no. 735, pl. CIII.

BIBLIOGRAPHY: DeRicci and Wilson, *Census*, 826; Clark, *N. T. Manuscripts*, 361f. (372 for further bibliography); Aland, *Liste*, 139; Weitzmann, "Washdrawings"; Lazarev, *Storia*, 422n.; Belting, *Buch*, 11.

Luke (fig. 95) is depicted writing in a codex on his lap and, at the same time, touching a lectern on which a second book is placed. John is seated on a bench about to read from a codex held unusually close to his eyes; a scroll draped over a lectern to the right is inscribed with the opening words of his Gospel. Conventional architectural motifs fill the left background. Above John's head hangs a curtain draped over a hook. The reverse of this leaf (fig. 96) bears an unframed washdrawing of Christ Appearing to His Disciples Through Closed Doors (John 20:19–23). The figures are organized hieratically before a decoratively conceived architectural background. The central Christ displays the stigmata on his extended hands to the disciples who are grouped at either side. Blue and olive tones are used for the robes and hair of the foreground figures, and lighter reddish brown for those behind and for the architecture. The thickset Evangelist figures are painted in gouache; heavy colors such as deep rose, sea green, and purple-blue predominate. Details of the architecture and furniture are rendered in red. Highlights are added by sharp strokes of white. The names of the Evangelists are inscribed in red uncial letters on the gold backgrounds.

The Evangelists are conventional in type and setting. Their Palaeologan date is revealed by the nervous, interrupted flow of the draperies and by the decoratively conceived background architecture, lacking spatial clarity. These leaves have been compared stylistically to Evangelists in a Gospel book in London, Brit. Mus. cod. Burney 20, dated 1285.[1] Both feature stocky figures, heavy furniture, ornamental architectural elements, and picture frames in which heavy dots are intended to suggest the curling edges of a leafy

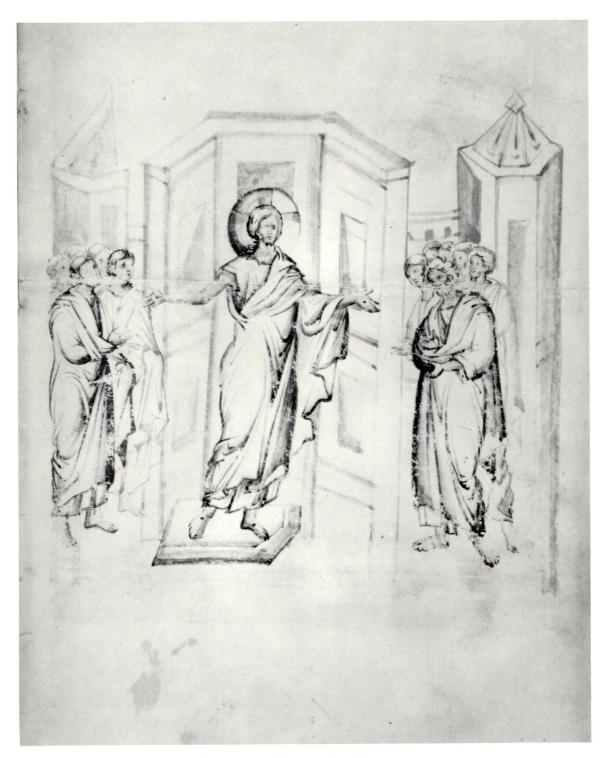

FIGURE 96. Christ Appearing to His Disciples Through Closed Doors
Baltimore, Walters Art Gallery cod. W530g

waveband. These similarities justify a late thirteenth-century date for the Baltimore leaves. Both the script and ornament of Mount Athos, Lavra cod. A76 (fig. 97), from which these leaves were cut, support this dating.[2]

The figures in the washdrawing are elongated and swaying, and the overlapping planes of the architecture create decorative effects without spatial depth, both characteristically Palaeologan features. The washdrawing has been dated both contemporary with[3] and slightly later than the Evangelist portraits.[4] The two types of representation can probably be assigned to the same workshop though to different hands. The stockier proportions of the Evangelists compared with the washdrawing figures may be attributed to the use of diverse models.[5]

Two other leaves with washdrawings, one in the Willoughby collection and one in Paris, École Nationale des Beaux-Arts, collection Masson, are closely related to codex 530f, g. All four leaves were cut from a Gospel book on Mount Athos, Lavra cod. A76, which still contains a portrait of Matthew and several washdrawings.[6] In the Lavra manuscript the washdrawings were originally grouped before the Evangelists's portraits on many, but not all, of the spaces left free before and after the texts of the *kephalaia* and *hypotheses*. The unusual choice and placement of these scenes may be explained by their presence and position in a Lectionary. The lack of a clearly formulated narrative or liturgical program as well as the use of washdrawings alongside traditional gouache miniatures are typical of the Palaeologan period when the iconographic and stylistic unity of the book began to disintegrate.[7]

The hieratic composition of the Baltimore washdrawing is conspicuous. All the

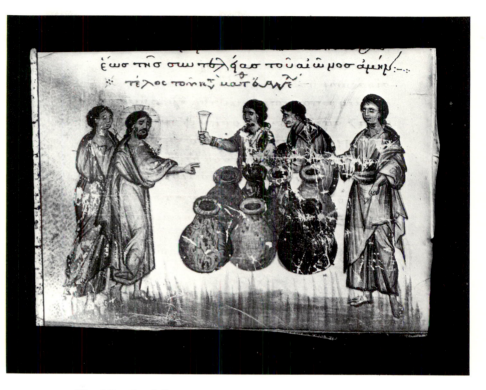

FIGURE 97.   The Miracle of Cana
Mount Athos, Lavra cod. A76, fol. 69v

other washdrawings associated with Lavra cod. A76 are more narrative in character.[8] The monumentality of this scene must result from its origins in a Lectionary where it could stand within the group of twelve great feast pictures.[9] K. Weitzmann has indicated likely precedents for this scene, such as Mount Athos, Dionysiou cod. 587, fol. 14v.[10]

T.J.-W.

Lent by the Walters Art Gallery

NOTES

1. Weitzmann, "Washdrawings," 97.
2. Ibid., 103.
3. Belting, *Buch*, 11n.
4. Weitzmann, "Washdrawings," 98.
5. Ibid., 97.
6. Ibid., 98–104.
7. Belting, *Buch*, esp. 10f.
8. Nevertheless, to explain its many-figured, large-scale presentation one does not have to describe it as a copy based on the model book of a fresco painter. For this opinion see Belting, *Buch*, 11.
9. Weitzmann, "Washdrawings," 96.
10. For the monumental sources of such scenes see Weitzmann, "Gospel Illustrations," 165f.

# 53. The Four Gospels

Cambridge, Harvard College Lib. cod. gr. 1. In Greek on vellum and paper. 296 folios (22 x 15 cm.). (37 folios are paper.) Minuscule script. One column of 23–24 lines (14.2 x 9.0 cm.). Four full-page miniatures and four headpieces. Binding: red stamped leather over wooden boards. Condition: margins of many pages damaged and repaired; extensively damaged after folio 244 and completed on paper; miniatures show considerable flaking.

PROVENANCE: Bought in Leipzig in 1888 by C. R. Gregory, who sold it to Harvard in 1889. According to Gregory the manuscript was formerly in Albania.

BIBLIOGRAPHY: DeRicci and Wilson, *Census*, 971; Clark, *N. T. Manuscripts*, 107f. (with further bibliography); Aland, *Liste*, 96.

This Gospel book contains full-page portraits of the four Evangelists, each at the head of his Gospel (fols. Ev, 94v, fig. 98; 147v, 237v). All are depicted seated before writing desks under ornamented arches or pediments carried on two columns.[1] Each miniature is painted over a continuous gold ground, which has undoubtedly contributed to the severe flaking. Figures and ornament are rendered in pinkish rose and light green; blue is entirely absent. The four headpieces, painted on the plain vellum and consequently better preserved, are decorated with ornament quite different in style and color from the miniatures. It consists primarily of large stylized palmettes within circular tendrils rendered in darker tones of red and green, as well as blue.

The text of the Harvard manuscript was written by the same scribe as that of Vatican Lib. cod. gr. 1158 and cod. gr. 1523, and Mount Sinai, cod. gr. 228.[2] Although none of these manuscripts is dated, they must all be roughly contemporary with a Gospel book in Florence, Laur. Lib. cod. Plut. vi, 28, dated 1285.[3] As is the case with many Palaeologan manuscripts, however, the Harvard miniatures are all on inserted single leaves and need not be contemporary with the text.

The miniatures themselves are clearly related to the Evangelist portraits in three other manuscripts: Leningrad, Public Lib. cod. gr. 223; Oxford, Bodl. Lib. cod. E. D. Clarke 6; and Rome, Vallicelliana Lib. cod. F. 17,[4] all of which have the same four Evangelist types under similar frames. The Leningrad manuscript has similar ornament as well and its Evangelist portraits even share the unusual technical feature of being painted directly upon the gold ground. Its figure style, however, shows a more rigidly geometrical patterning of the drapery, with deeply grooved folds and larger unarticulated areas less clearly related to the body.

The only dated member of the group, Vallicelliana Lib. cod. F. 17, from the year 1330, is certainly the latest in style. Closer to the Harvard manuscript in its finely shaded and loosely painted heads is a Gospel book in London, Brit. Mus. cod. add. 22506, dated 1305.[5] The very fluid brushwork and soft, clinging drapery, as well as the rather agitated hair seen in the Harvard manuscript, may indicate a date as early as the end of the thirteenth century, and certainly not later than the beginning of the fourteenth. This date agrees sufficiently with that indicated by the script to suggest that the miniatures were not later insertions but contemporary with the text.

L.N.

Lent by the Houghton Library, Harvard University

NOTES

1. Matthew, Mark, and John correspond to Luke, Mark, and Matthew of Paris, Bibl. Nat. cod. Coislin 195, while Luke corresponds to Luke in Mount Athos, Stavronikita cod. 43 (Friend, "Evangelists," I, figs. 97, 99–101).
2. I owe this knowledge to Professor H. Buchthal.
3. Belting, *Buch*, 62f.
4. Photographs in the Department of Art and Archaeology, Princeton University. For Vallicelliana Lib. cod. F. 17, see A. Muñoz, *I Codici greci miniati delle minori biblioteche di Roma*, Florence, 1905, 74f., pl. 16.
5. Friend, "Evangelists," II, figs. 14, 19.

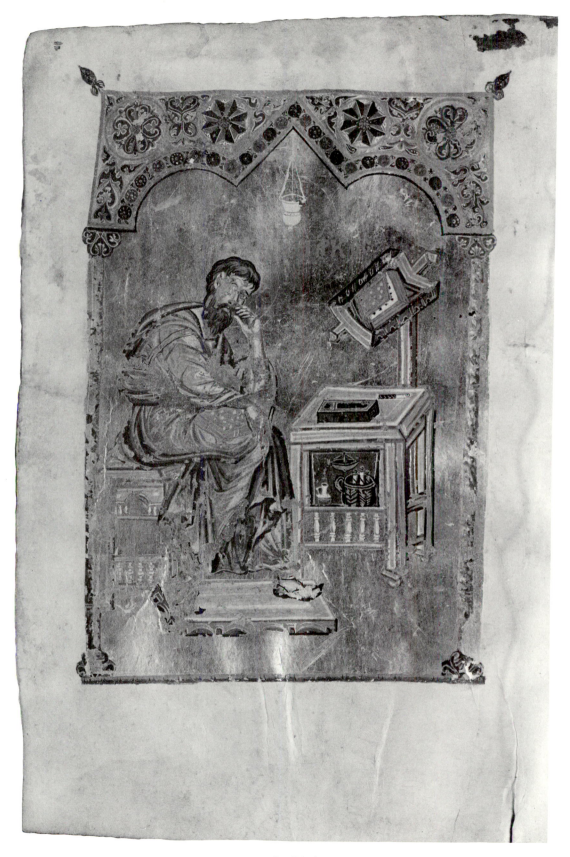

FIGURE 98. Mark
Cambridge, Harvard College Lib. cod. gr. 1, fol. 94v

# Works and Days of Hesiod

New Haven, Yale Univ. Lib. cod. 254. *Works and Days* of Hesiod with commentary of Johannes Tzetzes. In Greek on paper. 103 folios (19.8 x 14.5 cm.). Minuscule script. One column of 27–34 lines (13.5 x 9.2 cm.). Five marginal drawings and seven ornamental initials. Colophons: folios 102v, 103v, scribal dated 1312(?). Folio 103r, several non-scribal. Binding: nineteenth-century brown leather over heavy cardboard. Condition: heavily worm-eaten and water-stained; many leaves repaired; ink faded.

PROVENANCE: Ex colls. Speyer of Basel, T. Phillipps (cod. 3875), and L. Witten. Acquired in 1957 from Witten by the Yale University Library.

BIBLIOGRAPHY: Bond and Faye, *Supplement*, 46; B. Knox, "The Ziskind Collection of Greek Manuscripts," *Yale University Library Gazette*, XXXII, 1957.

FIGURE 99.   Mortar and Pestle, and Cart
New Haven, Yale Univ. Lib. cod. 254, fol. 67v

Lent by Beinecke Rare Book and Manuscript Library, Yale University

The codex, written in 1312(?)[1] on coarse light brown paper, contains Hesiod's *Works and Days*, along with a commentary by the twelfth-century grammarian Johannes Tzetzes. Its decoration is limited to seven uncolored ornamental initials and five crude marginal drawings in ink.[2] These simple diagrams belong to one of the oldest traditions of manuscript illustration, being characteristic of scientific and didactic treatises wherein they are used to render intelligible complex mechanisms.[3] Specifically, the Yale drawings may be placed within a tradition of illustration to *Works and Days*, recently established by G. Derenzini and C. Maccagni, with fifteen illustrated codices of the eleventh to the sixteenth century.[4] Parallels for each of the Yale diagrams may be found in these manuscripts.[5]

In the left margin of folio 67v (fig. 99), bearing lines 423–31, is a drawing illustrating lines 423–24: "Cut a mortar (ὅλμον) three feet wide and a pestle (ὕπερον) three cubits long, and an axle (ἄξονα) of seven feet, for it will do very well so . . . ." In the diagram the pestle appears as a short, thin rod placed horizontally over a chalicelike mortar.

The Yale drawing is less explicit relative to the functioning of a mortar and pestle than are the comparable diagrams in other manuscripts of its recension. In Florence, Laur. Lib. cod. conv. soppr. 158,[6] for example, the mortar is shown in cross-section and the pestle is fitted with a mallet head on one end and a pivot on the other. In Cambridge, Trinity College cod. Gal. O. IX. 27,[7] the two instruments are illustrated in the relative proportions indicated in the Hesiod text, and the mortar is in cross-section, this time revealing the grain being pounded inside. The pestle, again with a mallet head, is

given a tripod upon which to pivot. While the horizontal position of the pestle over the mortar in the Yale diagram reflects their functional relationship, the absence of the mallet and tripod as well as the incorrect proportions indicate a lack of interest in didactic representation and presumably a more remote position relative to the recension's archetype.

In the lower margin of the same folio is a crude drawing of a two-wheeled wooden cart with driver, being pulled by two oxen. It relates to line 426: "Cut a felloe three spans across for a waggon of ten palm's width." Obviously the driver and oxen are not called for by the text. Instead, they should be recognized as genre additions. As such they are paralleled in two other Hesiod manuscripts of the Palaeologan period: Cambridge, Trinity College cod. Gal. O. IX. 27, which includes two horses and a driver; and Vatican Lib. cod. gr. 2383, dated 1287, which includes a driver but no draft animals.[8] In showing the cart in natural perspective the Yale manuscript has gone further in compromising its didactic value than did the Cambridge manuscript, which gives a composite view from the top.

At the bottom of folio 69v is a diagram of a plow, relating to lines 432 to 438, transcribed in the column above, wherein Hesiod instructs the farmer to build two plows in case one breaks.[9] The type of plow represented does not correspond to the description of Hesiod nor to that in use in his day.[10] The convergence of pole and tail in the stock are characteristic of a type of plow that can be traced back no further than the first century B.C. The textual source of this illustration as well as of the sophisticated mortar and pestle combinations in other of the illustrated Hesiods may well be traceable to scolia.[11]

Proclus, in his fifth-century commentary to *Works and Days*, interpolated a contemporary plow in an effort to explain the by then little understood terms of Hesiod.[12] In light of the later dates of the manuscripts cited by G. Derenzini and C. Maccagni, it might be suggested that they depend on the twelfth-century commentary of Tzetzes, who in turn relied heavily on Proclus.[13] This question, however, must be left for further investigation.

J.C.A.

NOTES

1. Folio 103v: ἐτελειώθ[η] τὸ παρὸν βιβλίον τοῦ Ἡσιόδου χωριον . . . . [ἐν] μ[ηνὶ] ὀκτωβρίῳ κ̄ᾱ ἡμ[έρα] σ[αββ]άτω . . . ἔτει ͵ϛω[κ]?

2. Fol. 54v, schematic drawing of a face; fol. 60r, sickle; fol. 67v, mortar and pestle, and cart; fol. 69r, plow.

3. K. Weitzmann, *Ancient Book Illumination*, Cambridge, Mass., 1959, 5f.

4. G. Derenzini and C. Maccagni, "Per la storia degli attrezzi agricoli. Una tradizione iconografica nei codici esiodei?" *Le Machine* (Bollettino dell'Istituto italiano per la storia della tecnica), VI–VII, 1970.

5. Excluding the drawing of the face (fol. 54v), which may be a later addition.

6. Derenzini and Maccagni, "Esiodei," fig. 6.

7. Ibid., fig. 13.

8. Ibid., 28, fig. 13.

9. A number of manuscripts depict both plows.

10. A. Gow, "The Ancient Plow," *Journal of Hellenic Studies*, XXXIV, 1914, 256f., fig. 15.

11. H. Schultz, "Die handschriftliche Überlieferung der Hesiod-Scholien," *Abhandlungen der königlichen Gesellschaft der Wissenschaften zu Göttingen*, XII, 4, Berlin, 1910.

12. Gow, "Ancient Plow," 267.

13. C. Wandel, "Johannis Tzetzes," *Paulys Real-Encyclopädie der classischen Altertumswissenschaft*, 2d ser., VII, 2, Stuttgart, 1943, 1970.

# 55.

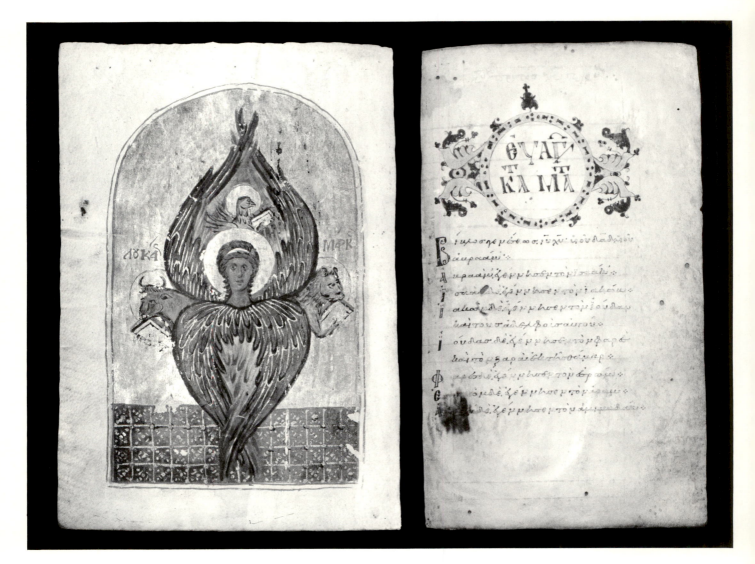

FIGURE 100.  Tetramorph
New York, General Theological Seminary Lib.
cod. DeRicci 3, fol. 114v

FIGURE 101.  Gospel of Matthew
New York, General Theological Seminary Lib.
cod. DeRicci 3, fol. 26r

# The Four Gospels

New York, General Theological Seminary Lib. cod. DeRicci 3. In Greek on vellum and paper. 315 folios (15.5 x 11.0 cm.). (Folios 17–24 are paper.) Minuscule script. One column of 18–19 lines (9.0 x 5.5 cm.). Six full-page miniatures (inserted). Four headpieces and three tailpieces. Binding: purple velvet over wooden boards with a late silver-gilt plate set with twelve stones depicting the Resurrection. Condition: canon tables, *kephalaia* for Matthew, and six miniatures are missing; several miniatures badly flaked.

PROVENANCE: Purchased in 1911 by S. V. Hoffman from J. Martini, a New York dealer. Presented by Hoffman to the General Theological Seminary in 1912.

BIBLIOGRAPHY: DeRicci and Wilson, *Census*, 1284f.; Clark, *N. T. Manuscripts*, 80f. (with further bibliography); Aland, *Liste*, 182.

The ornament and script of the General Seminary Gospels indicate a tenth-century date for the production of its text. Except for the headpiece to Matthew (fig. 101), all the decoration consists of precisely drawn pearl-dotted plaitwork motifs that emit tendrils ending in clusters of little balls, a decorative repertoire characteristic of Cappadocian manuscripts from the tenth century.[1] Stubs of excised leaves before the texts of the John and Matthew Gospels indicate that the original decorative program probably included Evangelist portraits.[2]

In the fourteenth century three miniatures were inserted before each Gospel: an Evangelist portrait on a single leaf, and the Evangelist's symbol and a tetramorph

on the two leaves of a bifolio (fig. 100). Although the four portraits and two of the tetramorphs have since been excised, their probable appearance may be reconstructed on the basis of a Gospel book on Mount Athos, Vatopedi cod. 937, whose style and decorative program corresponds closely to the extant miniatures in the General Seminary Gospels.[3]

Matthew's symbol (a man, fol. 25v) shows painterly white highlights on its solidly modeled face and full drapery, whose folds are rendered by long parallel dark and light strokes and interlocking curves to form superfluous bunches of cloth at the hem. These characteristics obtain throughout the fourteenth century, beginning with the frescoes of Kariye Djami in Constantinople in the second decade.[4] The drapery style in the Paris copy of the writings of John Cantacuzenos, Bibl. Nat. cod. gr. 1242, produced between 1371 and 1375,[5] is so close to that in the General Seminary Gospels as to suggest a comparable date for the inserted leaves of the latter. Mount Athos, Vatopedi cod. 937, reveals a slightly harder version of the same style.

Tetramorphs in a Gospel book derive from the vision of Ezekiel as interpreted by the church fathers, who considered these four-headed winged creatures as types of the unity of the four Gospels, with each of the four heads paired with a different Evangelist.[6] A few Gospel books from the second half of the eleventh century have prologues preceded by more or less complete illustrations of this patristic idea: the fullest is found in the Parma Gospels (Bibl. Palatina 5).[7] Although the appearance of individual Evangelist symbols in Byzantine Gospel books is not uncommon, at least from the twelfth century on (see cat. 38), their pairing with tetramorphs before each

Gospel is to our knowledge limited to the General Seminary and Vatopedi Gospel books. Here the iconographic program of the prologue headpiece in the Parma manuscript has in effect been broken up and distributed throughout the book.[8]

A.vanB.

Lent by Saint Mark's Library, General Theological Seminary

NOTES

1. See Jerusalem, Saba cod. 2. Weitzmann, *Buchmalerei*, 66, pl. LXXI, fig. 429.
2. The text of John is preceded by an inserted bifolio bearing a tetramorph miniature and an Evangelist symbol, and by two stubs, one inserted and one integral to the quire and attached to a leaf bearing tenth-century text. This latter stub testifies to the existence of a tenth-century Evangelist portrait.
3. This relationship was pointed out to me by K. Weitzmann. See Belting, *Buch*, 14, 40. Photographs in the Department of Art and Archaeology, Princeton University.
4. P. A. Underwood, *Kariye Djami,* 3 vols., New York, 1966.
5. Omont, *Miniatures*, pl. CXXVI.
6. W. Neuss, *Das Buch Ezekiel in Theologie und Kunst*, Münster in Westfalen, 1912, 26f.
7. Photograph in the Department of Art and Archaeology, Princeton University. See also Paris, Bibl. Nat. cod. gr. 74 (H. Omont, *Evangiles avec peintures byzantines du XIe siècle*, 2 vols., Paris, 1908, pl. 1); and Oxford, Bodl. Lib. cod. E. D. Clarke 10 (photographs in the Department of Art and Archaeology, Princeton University).
8. Matthew's half-length angel in the General Seminary Gospels is almost identical to the Parma angel. The symbols in the General Seminary Gospels correspond to the pairing of Jerome: Matthew = man, Mark = lion, Luke = calf, John = eagle. Vatopedi cod. 937 follows the order of Irenaeus, interchanging the symbols of Mark and John.

# 56. Amulet Roll (fragment)

*Second Half of the Fourteenth Century*

Chicago, Univ. Lib. cod. 125. Mark 1:1–8, Luke 1:1–7, John 1:1–17, Matthew 4:9–13, Nicene Creed, Psalm 68. In Greek on vellum. Roll (174.6 x 9.3 cm.). Minuscule script. One column of 114 lines (5.3 cm. wide). Seven framed miniatures. Colophon: verso, non-scribal (Arabic). Condition: miniatures badly flaked; overpainted.

PARENT MANUSCRIPT: New York, Pierpont Morgan Lib. cod. M499. Epistle of Abgarus, Psalms 35 and 91, and other texts. Roll (336.5 x 9.5 cm.). Chicago roll was attached at the head of the Morgan Library roll. Non-scribal (Arabic) colophon on verso with date 1374.

PROVENANCE: Belonged in the fourteenth century to Suleyman ibn Sara (Arabic colophon). Ex colls. B. d'Hendecourt of Paris and M. Stora. Purchased by the University of Chicago in 1930 from Stora.

EXHIBITED: University of Chicago Library, Chicago, 1973, *New Testament Manuscript Traditions*, no. 81, ill.

BIBLIOGRAPHY: DeRicci and Wilson, *Census*, 568; Clark, *N. T. Manuscripts*, 226f. (with further bibliography).

Even though badly flaked and almost totally repainted, this fragment (fig. 102) can be identified as a segment from the head of the Abgarus Rotulus in The Pierpont Morgan Library (cod. M499, fig. 103).[1] The Chicago manuscript is identical to the Morgan roll in its dimensions, palaeography, and border design, and it terminates in a badly mutilated miniature that may actually once have been a part of the fragmentary depiction found at the beginning of the New York manuscript.[2] Arabic translations of prayers and of the Abgarus legend in the same Coptic hand on the verso of both pieces seem to confirm the hypothesis that the two fragments were originally sections of a single roll.

The miniatures of the Chicago roll are directly related to the texts that follow them. Portraits of Mark and Luke accompany their Gospel passages, and a double miniature of the Ancient of Days and John and Prochoros illustrates the verses from the Gospel of John. Depictions of the Trinity, the Virgin and Child, and David precede, respectively, the Lord's Prayer, the Nicene Creed, and Psalm 68.

The extensive repainting of the Chicago manuscript accounts for its stylistic differences from the New York roll. The illustrations of the Abgarus legend on the Morgan Library roll are the product of a late fourteenth-century Constantinopolitan illuminator,[3] whereas the narrow almond-shaped eyes, greenish flesh tones, and schematic draperies of the Chicago figures indicate for them a later, Bohairic authorship.[4] Nevertheless, the Constantinopolitan style is still evident in the better preserved areas of the Chicago manuscript (e.g., the portrait of King David) and there is general agreement with the New York roll in the proportions of the figures and in details of furniture and drapery. This indicates that the Coptic artist followed the remains of earlier Byzantine painting when he restored this fragment, perhaps as early as the fifteenth or sixteenth century.

As in other Bohairic miniatures, vermilion, green, blue, and purple—against a gold background—are the dominant colors in the badly flaked Chicago segment.

H.L.K.

Lent by the Joseph Regenstein Library, University of Chicago

NOTES

1. This association was first suggested to me by Mr. Robert Allison of the University of Chicago. For Pierpont Morgan Lib. cod. M499, consult: S. Der Nersessian, "La Légende d'Abgar d'après un rouleau illustré de la bibliothèque Pierpont Morgan à New York," *Actes du IV^e congrès international des études byzantines*, Sofia, 1936, 98f.; K. Weitzmann, "The Mandylion and Constantine Porphyrogennetos," *Cahiers archéologiques*, XI, 1960, 172f. (*Studies*, 233f.); Athens 1964, no. 355; Belting, *Buch*, 37n.
2. The text ends with Psalm 68, while the Morgan Library roll begins with Psalm 91. The Chicago fragment, which includes the first verses of the Gospels of Mark, Luke, and John, may be lacking an initial section containing the opening passages of Matthew.
3. See note 1.
4. See M. Cramer, *Koptische Buchmalerei*, Recklinghausen, 1964.

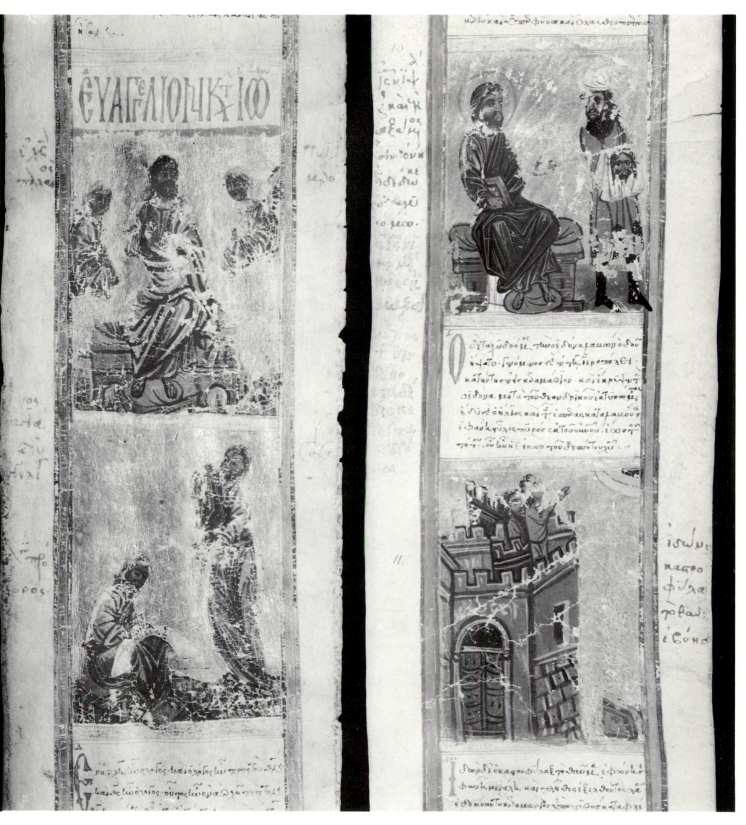

FIGURE 102. The Ancient of Days,
and John with Prochoros
Chicago, Univ. Lib. cod. 125, section 3

FIGURE 103. Christ delivers the Holy Image to the
messenger who (pict. 11) hides it at Hierapolis
New York, Pierpont Morgan Lib. cod. M499, picts. 10, 11

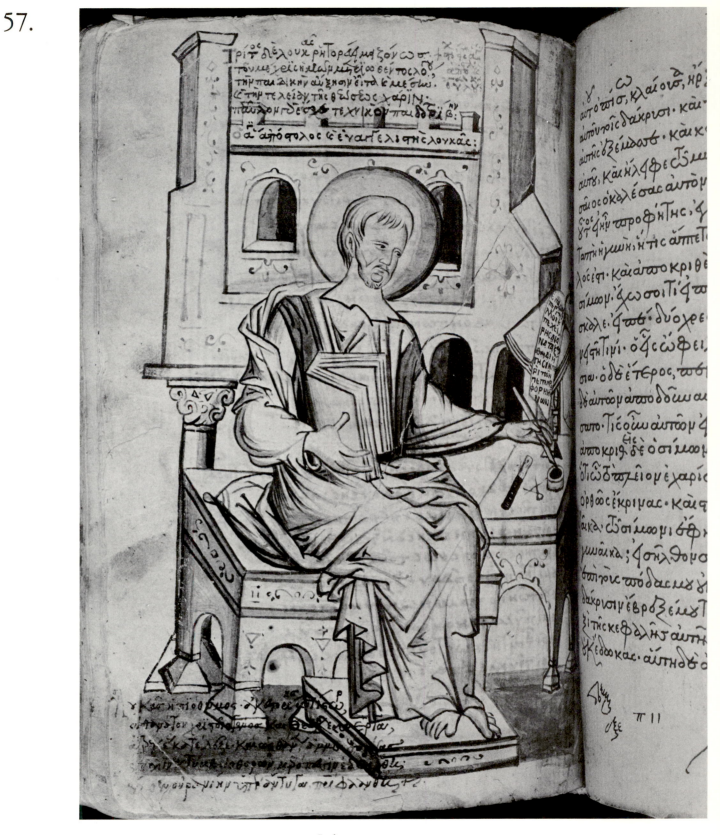

FIGURE 104. Luke
Princeton, Art Museum cod. acc. no. 57.19, fol. 81v

# The Four Gospels

1380 A.D.

Princeton, Art Museum cod. 57.19. In Greek on paper. 177 folios (28.8 x 20.0 cm.). Minuscule script. One column of 23 lines (20.4 x 13.3 cm.). One full-page miniature and two headpieces. Colophon: folio 170v, scribal, dated 1380. Binding: rebound in 1958 with red cloth and a leather spine. Condition: begins in the tenth chapter of Matthew; many lacunae including the beginning of Luke; three Evangelist portraits missing; Luke miniature shows a long diagonal tear.

PROVENANCE: Purchased in 1957 by The Art Museum, Princeton University, from H. Weissmann of Boston.

BIBLIOGRAPHY: "Recent Acquisitions," *Record of the Art Museum, Princeton University*, XVII, 1958, 42; Aland, *Liste*, 200; Weitzmann, "Washdrawings," 106f., fig. 14; Lazarev, *Storia*, 423n.

This Gospel book, written entirely on gray porous paper, retains only one of its original set of four Evangelist portraits. An unframed washdrawing portrait of Luke (fig. 104) fills folio 81v. The Evangelist sits semifrontally on a large bench, with his feet and knees together, head and shoulders inclined toward a writing table at the right in order to dip the pen held in his left hand into an inkpot. In his right hand he holds a partially opened codex against his chest. Behind him rises a fanciful architectural structure with multifaceted towers, windows, crenellations, and one large column.

The Evangelist's head, book, and mantle, as well as the furniture and the background towers, are rendered in reddish brown wash colors. His tunic and cushion, in addition to the ground strip, column, and the crenellated wall behind his head, are tinted in thin tones of steel blue. Luke's halo is yellow and his lips are accented with a touch of red.

A scribal colophon on folio 170v indicates that the Princeton manuscript was written by a certain Philotheos of Selymbria in 1380.[1] Luke's angular energetic drapery, characteristic of the Palaeologan period, may be seen in a less developed form in the mosaics of Kariye Djami, dating in the second decade of the fourteenth century.[2] There, white highlights strongly contrast with dark folds, and sharp angular breaks are at times illogically multiplied as they are in the area under the right knee of the Princeton Luke.

A Gospel book on Mount Athos, Lavra cod. A76,[3] datable to the late thirteenth or early fourteenth century, contains washdrawing miniatures in tones of blue and brown similar to the Princeton Luke (see cat. 52). The drapery in several miniatures, including the Calling of Philip and Nathaniel (fol. 71v),[4] is rendered in a comparatively angular manner but not as richly articulated as in the Kariye Djami or the Princeton codex.

The Princeton Luke derives ultimately from the Evangelist type exemplified by the portrait of John in Mount Athos, Stavronikita cod. 43[5] (see chapter 6). Luke, however, shows several mediaeval transformations of the classical tenth-century Stavronikita type: he holds in his right hand a codex instead of a rotulus; his left hand (not the customary right) is given a pen, instead of being raised to his chin in contemplation; and the fall of his mantle over his right shoulder and arm has been obviously misunderstood.[6]

J.C.A.

Lent by The Art Museum, Princeton University

NOTES

1. ἐγράφη τὸ παρ[ὸν] τετραενά[γγελ]ον παρ' ἐμοῦ τοῦ—φιλοθέου—σηλυβρίας ἐν τῷ ͵ϛωπη(ω) ἔτει ἰν[δικτιῶνος] τρίτις. The scribe's name was squeezed in above the line, apparently as an afterthought. Although written by Philotheos "of Selymbria," the codex itself need not have been produced there.
2. P. A. Underwood, *Kariye Djami*, 3 vols., New York, 1966.
3. For a discussion of the Athos manuscript and its relation to a group of Palaeologan washdrawing miniatures, including the Princeton Luke, see Weitzmann, "Washdrawings."
4. Ibid., fig. 10.
5. Friend, "Evangelists," I, fig. 98.
6. The portrait of Mark in a fourteenth-century Gospel book on Mount Athos, Vatopedi cod. 954, shows a very similar mediaeval transformation of the same Evangelist type (photographs in the Department of Art and Archaeology, Princeton University).

Princeton, Art Museum cod. 36.11. Single vellum leaf (15.7 x 10.3 cm.). One full-page miniature. Text: end of the *hypothesis* to John. Minuscule script. One column of 6 lines (incomplete). Column 7.2 cm. wide. Condition: flaked, especially along left side; face and hands redrawn in ink; right side and bottom only partially painted.

PARENT MANUSCRIPT: Mount Athos, Koutloumousi cod. 77. Gospel book. 350 folios (15.8 x 10.5 cm.). Princeton leaf was folio 269, preceding the Gospel of John. Identification: K. Weitzmann.

PROVENANCE: Still part of parent manuscript when studied by K. Weitzmann on Mount Athos in 1932. By 1935 in the possession of an Athens dealer; presented to The Art Museum, Princeton University, in June 1936.[1]

BIBLIOGRAPHY: Bond and Faye, *Supplement*, 304; Clark, *N. T. Manuscripts*, 181 (with further bibliography); Aland, *Liste*, 116.

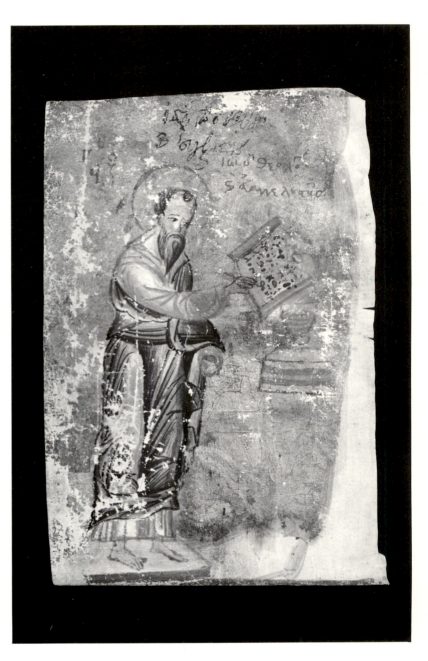

FIGURE 105. John
Princeton, Art Museum cod. acc. no. 36.11

This leaf (fig. 105), excised from a Gospel book on Mount Athos (Koutloumousi cod. 77) in the early 1930s, bears a portrait of the Evangelist John, whom the Greeks call "the theologian." He stands on a pedestal at the left turned almost in profile to the right in order to write in an open codex resting on a lectern suspended before him. The Evangelist's face is florid; he wears a gray-green mantle over an orange tunic. The gold of the background is applied unevenly and incompletely over an undercoat of yellow. The figure's right hand and facial features have since been redrawn. His name has been inscribed three times above his head; only the inscription in the upper left corner, however, appears to be contemporary with the illumination.

The Gospel book from which this leaf was excised may be dated to the eleventh or twelfth century on the basis of the clear upright minuscule in which the end of the *hypothesis* to John is transcribed on the reverse of the Princeton leaf. Later, apparently after the manuscript was bound,[2] John's portrait, and (presumably) those of the other Evangelists, were added.

Because of its crude quality, flaked condition, and redrawn facial features, it is difficult to date the Princeton miniature. Nevertheless, the Evangelist's thick waist and twisted, roll-hemmed mantle over a straight-hemmed tunic find counterparts in two fourteenth-century Mount Athos Gospel books: Pantocrator cod. 48, dated 1366,[3] and Dionysiou cod. 309, dated 1395.[4] Further, the figure's bulbous forehead, narrow face, and pointed beard are paralleled by the portraits in a manuscript of the Byzantine Liturgies on Mount Athos, Iviron cod. 835, dated 1426.[5]

This figure type, in three-quarter view with arm raised to write in a book on a lectern, is extremely rare among Byzantine Evangelist portraits (see chapter 6),[6] although close variations of it occur in other contexts.[7] The workshop pattern on which the Princeton John was based may have been derived from a Prophet portrait, such as those of Amos in Vatican Lib. cod. gr. 1153,[8] and Oxford, Bodl. Lib. cod. Laud. gr. 30A (which has drapery folds like those of the present figure).[9] John's unclear left hand seems to presuppose a scroll hanging from it, and his raised right could originally have been a speaking gesture.

A.vanB.

Lent by The Art Museum, Princeton University

NOTES

1. According to K. Weitzmann's notes, Koutloumousi codex 77 also contained portraits of Mark (fol. 102v) and Luke (fol. 166v). Clark's report (see bibliography) that these miniatures had been acquired by the Victoria and Albert Museum in London (nos. E. 912-1933, E. 913-1933) is incorrect. Their Mark leaf is too large (25.0 x 15.0 cm.) and their Luke portrait, although of the correct size, is quite different in style from the Princeton John and does not correspond to K. Weitzmann's notes, which describe the Evangelist as standing and reading a book before a lectern.

2. The unfinished background along the gutter side of the Princeton leaf testifies to the illuminator's difficulty in inserting his brush into the tight binding.

3. Now in the hands of a dealer. Photographs in the Department of Art and Archaeology, Princeton University.

4. Photographs in the Department of Art and Archaeology, Princeton University.

5. Photographs in the Department of Art and Archaeology, Princeton University.

6. H. Kessler has shown me a standing Luke before a lectern in the ninth-century Arnaldus Gospels in Nancy; W. Köhler, *Die karolingische Miniaturen, I. Die Schule von Tours*, Berlin, 1930, pl. 37. Touronian miniatures are sometimes dependent on Byzantine models.

7. As Christ Preaching in the Synagogue, in Paris, Bibl. Nat. cod. gr. 74, fol. 113v (H. Omont, *Évangiles avec peintures byzantines du XIe siècle*, 2 vols., Paris, 1908, pl. 101) and Florence Laur. Lib. cod. Med. Palat. 244, fol. 30v (V. Lazarev, *Istoriĩa vizantĩĩskoĩ zhivopisi*, II, Moscow, 1948, pl. 152); as Saint Saba in Paris, Bibl. Nat. cod. gr. 12, fol. 217v (J. Ebersolt, *La Miniature byzantine*, Paris, 1926, 55, pl. LVI, fig. 2); and as Luke the author of Acts (before a high table) in London, Brit. Mus. cod. add. 28815, fol. 162v, (Weitzmann, *Buchmalerei*, pl. xxv, fig. 136).

8. Fol. 20v (Friend, "Evangelists," I, fig. 81).

9. Fol. 241r (photograph in the Department of Art and Archaeology, Princeton University).

# Bifolio from a Gospel Book: Mark

Princeton, Art Museum cod. acc. no. 56.118. Single vellum bifolio (20.8 x 15.1 cm.). One full-page miniature (fol. 1v). Folios 1r and 2r, 2v are blank. Condition: some flaking, especially along left side.

PARENT MANUSCRIPT: Mount Athos, Pantocrator cod. 52. Gospel book. 284 folios (20.8 x 15.1 cm.). The Princeton miniature was folio 92v, preceding the Gospel of Mark. (Bifolio bears penciled folio numbers 92, 93.) Identification: K. Weitzmann.

PROVENANCE: Acquired by A. M. Friend, Jr., in Athens, June 1936. Given to The Art Museum, Princeton University, in 1956.

EXHIBITED: Baltimore 1947, no. 741, pl. XCVIII.

BIBLIOGRAPHY: Bond and Faye, *Supplement*, 306; Clark, *N. T. Manuscripts*, 60 (with further bibliography); Lazarev, *Storia*, 423n.

The portrait of Mark (fig. 106), painted predominantly in bright red and blue against uncolored vellum, was cut from a Gospel book on Mount Athos, Pantocrator cod. 52, which still contains its three companion Evangelist portraits (fig. 107). The style of the miniature is strikingly simplified, flat, and decorative with little feeling for weight. The folds and sharp pleats of the drapery are indicated with single brushstrokes, while the features of the almost unmodeled head are rendered in fine lines. The traditional bench and desk have merged into a single piece of furniture, and the lectern overlaps the arched frame. The whole composition works to create a harmonious balance and a decorative effect rather than a plausible spatial relationship.

A comparison with dated miniatures showing similar stylistic characteristics reveals the Princeton Mark to be a product of the late Palaeologan period. It postdates the portrait of Luke in the Princeton Art Museum (cod. acc. no. 57.19, cat. 57), dated 1380, which still displays the sharp, energetic drapery folds and complex background typical of the fourteenth century. Yet, the faces of both figures are somewhat flat and broad, and similar conventions can be seen, for instance, in the dark triangle of the cheek and the firmly drawn oval of the chin.

A portrait of the Evangelist John in a Lectionary in London, Brit. Mus. cod. add. 37008,[1] dated 1403, still shows sharp, strongly highlighted drapery. The composition as a whole, however, has begun to crystallize into a decorative system; as in the Princeton miniature, the

desk and bench have merged into a single, symmetrical piece of furniture. Closer comparisons for the broad, simplified treatment of Mark's head and draperies, on the other hand, are found in the standing author portraits of a manuscript of the Byzantine Liturgies on Mount Athos, Iviron cod. 835,[2] dated 1426.

On the basis of these comparisons a date before the first quarter of the fifteenth century seems unlikely for the Princeton Mark portrait.

C.L.B.

Lent by The Art Museum, Princeton University

NOTES

1. Photographs in the Department of Art and Archaeology, Princeton University.
2. Photographs in the Department of Art and Archaeology, Princeton University.

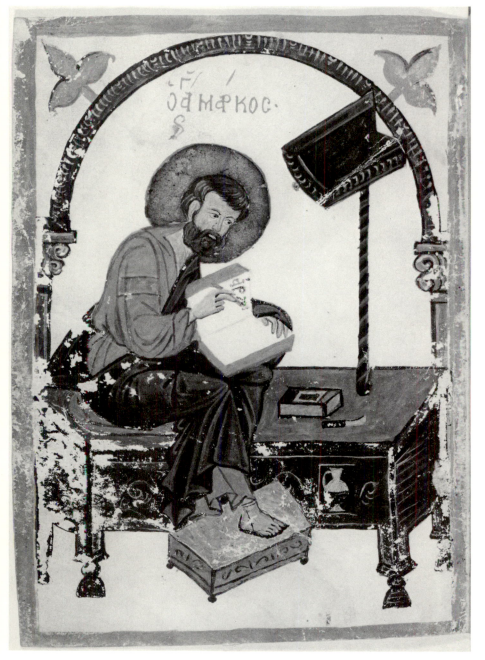

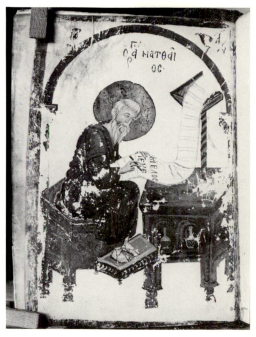

FIGURE 107.  Matthew
Mount Athos, Pantocrator cod. 52, fol. 11v

FIGURE 106.  Mark
Princeton, Art Museum cod. acc. no. 56.118

## 60.

New York, Public Lib. Spencer Coll. cod. 50. In Greek on vellum. 75 folios (20.1 x 12.0 cm.). Minuscule script. One column of 20 lines (12.0 x 5.7 cm.; 15 lines with miniature). 135 quarter-page miniatures. One three-quarter page text frame with figurative decoration. Each fable begins with an ornamental initial. Binding: tooled brown morocco. Condition: miniatures toward the bottom of the page injured by damp; fables 27, 28, 43, 44, 67, 68, 77, 78, and 144 are missing.

PROVENANCE: Ex colls. T. Williams and T. Phillipps (cod. 26309). Purchased by the New York Public Library through Sotheby (Phillipps coll.) in 1946.

EXHIBITED: Walters Art Gallery, Baltimore, 1949, *Illuminated Books of the Middle Ages and Renaissance*, no. 191, pl. LXXV.

BIBLIOGRAPHY: Bond and Faye, *Supplement*, 333 (with further bibliography); Sotheby and Co., London, July 1, 1946, *Bibliotheca Phillippica, Catalogue of a Further Portion of the Renowned Library . . .* , lot 26A, pls. XXXVIII–XXXIX.

FIGURE 108. The Dog Invited to Supper (fable 132) New York, Public Lib. Spencer Coll. cod. 50, fol. 68r

# Aesop's Fables

*Circa 1480 A.D.*

An ornamental initial on a square of gold flanked by delicate foliate border ornament marks the beginning of each of the 138 fables of Aesop bound in this manuscript.[1] A quarter-page rectangular miniature in gold and bright colors precedes each fable, interrupting the text column and often extending into the broad white margin of the leaf. The miniature on folio 68r (fig. 108) illustrates fable 132, "The Dog Invited to Supper," according to which a gentleman invited a friend to supper and the gentleman's dog, meeting the friend's dog, invited him as well. The dog was delighted and stood by watching the preparations for the feast. But when the cook saw him, he seized him by the legs and threw him out the window. Thus the friend's dog is depicted four times: standing at the door of the kitchen with his host, held by the cook in the window, falling from the window, and lying dejectedly outside.

The hands of two illuminators can be identified in this manuscript. The first, active in the first half of the codex, has a finer, more delicate technique, characterized by subtly modulated, mountainous landscapes in changing tones of blue, green, and brown. The second hand (fig. 108) is much less precise in details, broader in style, and looser in handling, but equally accomplished with interior perspective and in the modeling of light and shade.

The figure types, poses, and gestures used by both illuminators are reminiscent of Botticelli. Most characteristic is the relaxed contrapposto stance, with one hand resting on the hip. Their style also reflects something of the circle of Ghirlandajo. Folio 68r (fig. 108) of the Spencer codex may be favorably compared with the fresco lunettes of Davide (Benedetto?) Ghirlandajo in the Church of S.

Martino Buonomini in Florence, dated after 1479.[2] In the style of the Ghirlandajo family can also be seen landscape backgrounds like those of the first Spencer illuminator, with their sweeping vistas and spiky mountains reflecting Netherlandish influences.

Among other elements in these miniatures characteristic of Florentine painting of the second half of the fifteenth century is the repeated appearance of *mazzochi*, the typical Florentine male headdress of the period, and the particular rendering of Mercury on folios 47v and 48r, with loose tunic, soft boots, and pointed hat.[3] This type of Mercury was seen by Cyriacus of Ancona on a Hellenistic relief while on a voyage to Greece. His drawing of it was circulated in Florence and soon thereafter influenced works of art.

Further corroboration for the dating and localization indicated above is provided by the Medici coat of arms visible on the fireplace in folio 68r (fig. 108). A patron in the ruling Florentine family would certainly be plausible for such a luxurious and copiously illustrated manuscript.

Since Aesop's fables were never recorded by the author or transcribed early in their history, they have come down to us through several different recensions, in both Latin and Greek. B. E. Perry, the chief scholar of the text tradition of the Greek Aesop, distinguishes at least four recensions,[4] of which the Spencer collection manuscript appears to be the third, the Accursiana, named for its first modern editor, Bonus Accursius, who published the first Greek edition of Aesop in Milan about 1480.[5] A Byzantine, not an ancient recension, it is the work of a learned Byzantine scholar, who lived at about the time of Maximos Planudes (1260–1310).

Popular tradition attributes it to Planudes himself, and Perry agrees on the basis of language and style.

Thiele and Goldschmidt have deduced that all the Latin versions of the fables—Phaedrus, Babrius, Romulus, and Avianus—had complete cycles of illustrations in the late Roman period.[6] The oldest surviving representative of a Greek version (except for papyrus fragments) is an illustrated south Italian manuscript of the tenth century in The Pierpont Morgan Library (cod. M397).[7] Whether the Planudes text had a cycle of early illustrations cannot be determined without further study.

Although we cannot be sure whether or not the textual model of the Spencer codex contained a miniature cycle, it is clear that the iconography of codex 50 was not drawn from one of the Latin picture recensions, nor is it comparable to contemporary woodcut cycles.[8] What especially distinguishes the Spencer miniatures is the use of continuous narrative, i.e., the inclusion of several consecutive episodes within a single frame and setting. It is quite possible that its model contained more than three hundred illustrated episodes.[9]

This highly unusual manuscript is an eloquent witness to Renaissance humanism drawing from Greek tradition. In fifteenth-century Italy, humanists were avidly studying the classics, collecting manuscripts, and building libraries. Greek became more accessible to them through the influx of Byzantine scholars from the time of the Council of Florence in 1438, and especially after the fall of Constantinople in 1453. The Greeks who came to Italy brought manuscripts with them, and many who settled in Florence and elsewhere became university professors or were employed as copyists.[10]          C.L.B.

Lent by the New York Public Library, Spencer Collection, Astor, Lenox, and Tilden Foundations

NOTES

1. The fables are numbered 1 to 147. Nine fables are missing.
2. B. Berenson, *Florentine School*, II, London, 1963, pls. 987–88.
3. J. Seznec, *The Survival of the Pagan Gods*, New York, 1961, 200f.
4. B. E. Perry, *Studies in the Test History of the Life and Fables of Aesop*, Haverford, Pa., 1936, 73, 75.
5. The Spencer codex is comparable in number and sequence of fables to Florence, Laur. Lib. cod. Plut. LXXXIX, 79 (A. M. Bandinius, *Catalogus Codicum Graecorum Bibliothecae Laurentianae*, Florence, 1764–70, III, 415).
6. G. Thiele, *Der illustrierte Lateinische Aesop*, Leyden, 1905; A. Goldschmidt, *An Early Manuscript of the Aesop Fables of Avianus and Related Manuscripts*, Princeton, 1947.
7. M. Avery, "Miniatures of the Fables of Bid Pai and of the Life of Aesop in The Pierpont Morgan Library," *Art Bulletin*, XXIII, 1941, 103f.
8. *Aesop's Fables* was one of the first texts printed in Italy. It was immediately produced in various editions, and illustrated with woodcuts, the most famous of which is the Naples 1485 edition of Francisco del Tuppo.
9. Continuous narrative was not uncommon in Florentine art of the period, as for example in Botticelli's *Life of Moses* in the Sistine Chapel, dating 1481–82. Although this mode of painting was especially popular in *cassoni*, none with Aesop's fables are known.
10. J. A. Symonds, *The Renaissance in Italy*, II, London, 1877, passim.

Cambridge, Andover-Harvard Theological Lib. cod. Z243. In Greek on vellum and paper. 202 folios (20.5 x 15.5 cm.). (Folios 1–8, 167–86 are paper.) Minuscule script. One column of 23–24 lines (14.6 x 9.8 cm.). Five headpieces and a number of ornamental initials. Binding: thick red leather over wooden boards. Back: embossed with simple diamond pattern. Front: Crucifixion painted over gesso base. Condition: cover painting flaked and soiled; manuscript written on inferior vellum; ink and ornament faded; more than 80 palimpsest folios.

PROVENANCE: Brought by a native in 1834 to the home of W. G. Schauffer, a missionary in Pera. Sent a year later to the Andover Theological Seminary, then in Andover, Mass. Since 1908 in the Andover-Harvard Library in Cambridge, Mass.

BIBLIOGRAPHY: DeRicci and Wilson, *Census*, 1049; Clark, *N. T. Manuscripts*, 3f. (with further bibliography); Aland, *Liste*, 214.

# Lectionary with Painted Cover: The Crucifixion

The leather cover (fig. 109) of this provincial Mid-Byzantine Lectionary[1] bears a Post-Byzantine painting of the Crucifixion.[2] Christ, rendered in dark greenish brown flesh tones, is suspended with drooping head and closed eyes in a graceful sway before a dark brown cross. His torso is articulated in a schematic pattern of heavy white highlights; a greenish white loincloth with deeply channeled folds hangs loosely from His hips. Bright red blood spurts from the wounds in His hands, feet, and side. His yellow cross-nimbus bearing the inscription O ΩN, the Eternal One, stands out against the solid dark blue background of the painting.

Evangelist symbols in medallions flank the cross in the four corners of the cover. Replacing the customary attendant figures of John and the Virgin, they emphasize the unity of the four Gospels from whose texts the Lectionary is composed. Matthew's symbol, the winged man in the upper right, wears garments of greenish blue and brownish pink. His face is modeled from dark brown shadows to bright creamy highlights. The lion and calf in the lower corners, symbols of Mark and Luke, are rendered in light brown. John's eagle, in the upper left, is too extensively damaged to recognize. Each symbol has a yellow halo and carries a codex with bright red pages. The lion and calf are inscribed with the initials M and Λ. The cross carries two inscriptions: IC XC, Jesus Christ, along the horizontal bar and 'O B[A]C[I]Λ[EÙC] T[ĤC] Δ[Ó]Ξ[HC], the King of Glory, on the small plaque at the top.

The drapery style of the Cambridge painting, with its dark rectilinear folds outlined in white, is traceable in Byzantine illumination from the early fourteenth century well into the Post-Byzantine period.[3] The geometric treatment of Christ's torso, while not yet apparent in the beautiful Crucifixion icon in the Byzantine Museum in Athens datable to the mid-fourteenth century, is to be seen in a Baptism icon of the late fourteenth century in the possession of the Greek Patriarchate in Jerusalem.[4] The modeling of flesh in deep brown shadows and bright sketchy highlights, however, finds its closest comparisons in sixteenth-century icons, such as the Crucifixion and Entombment scenes on the frame of an icon of the Virgin Enthroned in the Benaki Museum, Athens;[5] a Crucifixion icon in the Byzantine Museum, Athens;[6] and a Crucifixion icon in Venice.[7] They share with the cover of the Cambridge codex a serene monumentality as well as a preference for large fleshy heads with receding chins drawn in to the neck.

G.V.

Lent by the Andover-Harvard Theological Library

## Eleventh to Twelfth Century and Sixteenth Century

NOTES

1. Codex Z243 is ornamented with carmine interlaces ending in serpent heads, "recessed tendril" headpieces colored in dirty washes of red and green, and large ornamental 'E's with hands for cross bars and 'T's with multiple shaft knots. These motifs are paralleled in manuscripts from Palestine and southern Italy of the eleventh and twelfth centuries. See Weitzmann, *Buchmalerei*, 72f., pl. LXXX, figs. 493–94, 497–98; 87, pl. XCIII, figs. 597–98.
2. The Crucifixion is often embossed or represented in metal relief on the covers of Byzantine manuscripts (see cat. 45, 64). Painted covers are, to my knowledge, rare. See the pre-iconoclastic painted wooden covers in the Freer Gallery, Washington, D.C. (Morey, *Freer*, 63f., pls. XI–XIII).
3. See Rome, Vallicelliana Lib. cod. G. 17 (A. Muñoz, *I Codici greci miniati delle minori biblioteche di Roma*, Florence, 1905, 74f., pl. 16), dated 1330, and Mount Sinai cod. 247, dated 1598 (M. Beza, *Byzantine Art in Roumania*, London, 1940, no. 36, pl. page 63).
4. K. Weitzmann, M. Chatzidakis, K. Miatev, and S. Radojčić, *Icons from South Eastern Europe and Sinai*, London, 1968, XXXIII, pl. 55; XXXV, pl. 81.
5. Ibid., XXXVI, pl. 91.
6. M. Chatzidakis, *Byzantine Museum, Athens: Icons*, Athens, n.d., 25, pl. 17.
7. M. Chatzidakis, *Icônes de Saint-George des Grecs et de la collection de l'Institut*, Venice, 1962, 31f., pl. 14. To this list should also be added a crucifixion icon in the National Gallery of Ireland (D. T. Rice and T. T. Rice, *Icons: The Natasha Allen Collection*, Dublin, 1968, 19f., pl. 3).

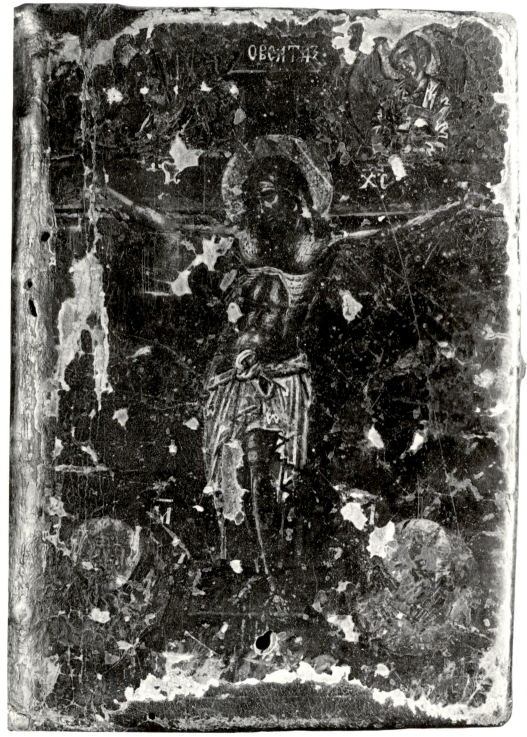

FIGURE 109. The Crucifixion
Cambridge, Andover-Harvard
Theological Lib. cod. Z243, cover

# 62. Two Leaves from a Lectionary

## HEADPIECES TO READINGS FROM JOHN AND MATTHEW

Princeton, Art Museum cod. acc. no. 54.67, 68. Two single paper leaves (67: 41.3 x 25.3 cm.; 68: 41.1 x 26.1 cm.). Two small framed miniatures and two headpieces with figural decoration. Text: 67: John 1:1–12; 68: Matthew 18:10–16, in Greek. Minuscule script. One column of 18 lines (24.2 x 13.5 cm.). Condition: miniatures only slightly rubbed; both leaves ripped along left side.

PARENT MANUSCRIPT: Jerusalem, Anastaseos cod. 5. Lectionary. 499 folios (40.2 x 26.5 cm.). Princeton cod. acc. no. 54.67 was folio 2; cod. acc. no. 54.68 was folio 66. Colophon: folio 516v, scribal dated 1596.

PROVENANCE: Written and illuminated in Moscow, 1596. For some time in the monastery of Saint Saba near Jerusalem. By the late nineteenth century in the Church of the Anastasis, Jerusalem (cod. 5). Excised from manuscript by 1950 when examined by Clark.[1] (They were probably removed with the Evangelist portraits, which were in the The Pierpont Morgan Library by the early 1930s; see note 8.) Purchased by The Art Museum, Princeton University, through Parke-Bernet in 1954.

BIBLIOGRAPHY: Bond and Faye, *Supplement*, 305; Papadopoulos-Kerameus, *Jerusalem*, III, 200f.; Gregory, *Textkritik*, 460, no. 1030; Parke-Bernet Galleries, New York, February 19, 1954, *Rare Near Eastern Pottery . . .* , lot 43.

Beneath a headpiece (fig. 111), bearing in nine medallions the Deesis flanked by four Evangelists and two saints, is the title and first three verses of the Lectionary reading for Easter Sunday (John 1:1–17). A small framed miniature occupies the left third of the text column, displacing the opening initial 'E.' Instead of the Anastasis, the scene most frequently used to illustrate the Easter Sunday pericope (see cat. 28), the painter of the Princeton leaf has chosen to illustrate John 1:6–8: "I have come to testify to the light."[2]

John the Baptist strides forward from the left before a landscape of orange and brown mountains, pointing up toward Christ, suspended in a mandorla beneath the outstretched arms of God the Father, who appears from behind swirling green clouds in a white robe. To the lower right a large crowd, dressed in red, green, maroon, and bluish gray garments, looks on in amazement. John wears a dark brown mantle over an orange tunic; Christ is dressed completely in orange. Flesh areas are modeled in dark brown with fine strokes of white and black to render features.

The second Princeton leaf is composed like the first: nine portrait medallions line the headpiece above the title, in gold Slavonic characters, and the first verse of the opening Matthew lection (Matthew 18:10–20, read on the second day of Pentecost). The central field of the headpiece bears an angel, Matthew's symbol,[3] in bright red robes against a dark green background. The area ordinarily occupied by a large ornamental 'E' is again filled by a rectangular miniature, this time illustrating Matthew 18:10: "Take heed that you despise not one of these little ones."[4] Christ strides forward from the left blessing two children kneeling at His feet. Before the walls of a city at the right

stands a crowd of men looking on. Above, God the Father sits enthroned, flanked by two angels, illustrating literally the second part of verse 10: ". . . in heaven their angels do always behold the face of my father." The mat, earth colors are generally the same as those of the first miniature, except for the substitution of a gold sky.

Both headpieces enclose stylized floral motifs in red, green, maroon, orange, and yellow. The margin of the John lection is filled with a long composite vegetal ornament punctuated with orange and bluish green brushes.

It has for some time been recognized that the Princeton leaves were cut from a Lectionary in Jerusalem (Anastaseos cod. 5, fig. 112).[5] A colophon on folio 515r of that manuscript identifies its scribe as Arsenios, Metropolitan of Ἐλασσῶνος. An inscription on folio 516v indicates that the manuscript was written in Moscow for Tsar Fedor (1584–98), son of Ivan the Terrible, in 1596 and dedicated to the monastery of Saint Saba near Jerusalem.[6] Exact correspondence of style and dimensions, as well as an offprint of border ornament on the Princeton leaves, allow the identification of four single Evangelist portrait leaves in The Pierpont Morgan Library (cod. M654, fig. 110) as originally part of Anastaseos codex 5.[7] The style of the Princeton miniatures— the puppetlike bodies with graceful, striding poses, clinging drapery, and round fleshy heads, as well as the preponderance of mat, earth tones and bright orange accents—is characteristic of the art of Moscow around 1600. Specifically, these qualities are to be found in a Transfiguration icon on Mount Sinai signed in Moscow and dated 1594.[8] The Morgan Library Evangelists repeat in a slightly rougher style the four Evangelists in a

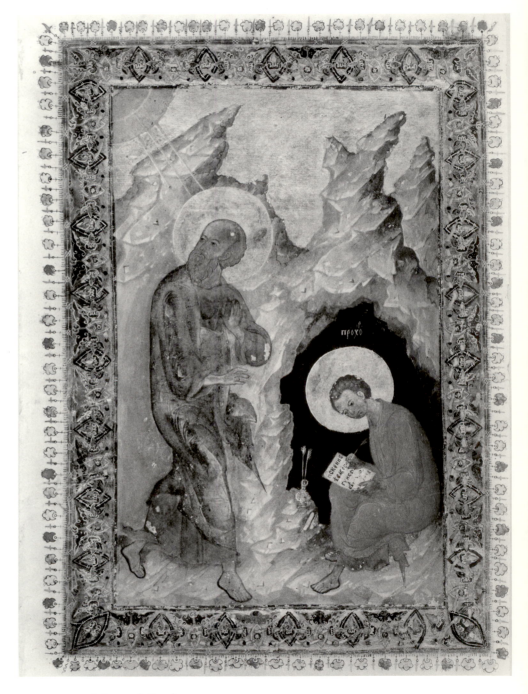

FIGURE 110. John and Prochoros
New York, Pierpont Morgan Lib. cod. M654

FIGURE III. The Testimony of John the Baptist
Princeton, Art Museum cod. acc. no. 54.67

Lectionary now in Jerusalem (Treasury cod. 1, olim Anastaseos cod. 18), produced in Moscow in 1596 for Boris Godunov.[9]

The large, ornamental script of the Princeton leaves is closely related to a school of calligraphy formed in the late sixteenth and early seventeenth centuries in Wallachia around Luke the Cypriot, Bishop of Buzǎo.[10] That such calligraphy was practiced in Moscow in 1596 is not surprising. Not only is Matthew, Metropolitan of Myra (see cat. 63) and one of Luke's earlier followers, known to have been a scribe in Moscow in 1596,[11] but Luke himself was sent there during this period as an emissary of the Wallachian Voevode, Michael the Brave.[12]

Other miniatures very close in style to those of the Princeton leaves are to be found in a Lectionary in the Walters Art Gallery (cod. W535), signed by Luke the Cypriot, Bishop of Buzǎo and dated 1594.[13] The stylistic and iconographic correspondence of the Evangelist portraits and the first nine framed miniatures,[14] as well as the close calligraphic similarities, would seem to suggest a direct relationship.[15]

The Princeton Lectionary leaves provide eloquent witness to the multiplicity of influences contributing to the efflorescence of Post-Byzantine art around 1600: Russian figure style, Roumanian calligraphy, and Slavonic titles and ornament.[16] At the same time, however, its format and iconography reveal obvious debts to the traditions of Mid-Byzantine illumination.

G.V.

Lent by The Art Museum, Princeton University

NOTES

1. K. Clark, *Checklist of Manuscripts in the Libraries of the Greek and Armenian Patriarchates in Jerusalem*, Washington, D.C., 1953, 30.
2. This scene is found in neither of the copiously illustrated eleventh-century Gospels: Paris, Bibl. Nat. cod. gr. 74; Florence, Laur. Lib. cod. Plut. VII, 23. See Leningrad, Public Lib. cod. gr. 305, fol. 1r (Millet, *Recherches*, fig. 156).
3. Evangelist symbols are not uncommon in Byzantine Gospel books, at least from the twelfth century (see cat. 38). For the symbol in the facing headpiece see Oxford, Bodl. Lib. cod. Seld. supra 6 (Athens 1964, no. 342, fig. 342).
4. For this scene in a Mid-Byzantine Lectionary, see Athens, Nat. Lib. cod. 68, fol. 43r. Photographs in the Department of Art and Archaeology, Princeton University.
5. Bond and Faye, *Supplement*, 305.
6. Papadopoulos-Kerameus, *Jerusalem*, III, 203.
7. Clark, *N. T. Manuscripts*, 161. Photographs in the Department of Art and Archaeology, Princeton University. Papadopoulos-Kerameus (*Jerusalem*, III, 200f.) describes these portraits. John and Matthew originally faced the Princeton headpieces.
8. Now kept in the old library of Saint Catherine's Monastery. Photographs in the Department of Art and Archaeology, Princeton University.
9. Papadopoulos-Kerameus, *Jerusalem*, III, 219, ill. Further photographs in the Department of Art and Archaeology, Princeton University.
10. L. Politis, "Eine Schreiberschule im Kloster τῶν Ὁδηγῶν," *Byzantinische Zeitschrift*, LI, 1958, 282f.
11. See London, Brit. Mus. cod. add. 19062 (Vogel and Gardthausen, *Schreiber*, 296).
12. N. Iorga, *Byzance après Byzance*, Bucharest, 1935, 159f.
13. Clark, *N. T. Manuscripts*, 367f. See Diringer, *Book*, pl. II-27e.
14. Anastaseos cod. 5: folios IV–11'; codex W535: folios 2r–13r.
15. The first iconographic divergence of Anastaseos cod. 5 (fol. 17v) and codex W535 (19r) coincides with the appearance of a different illuminator in the Baltimore codex.
16. Exact counterparts for the headpiece and marginal ornament may be found in a Slavonic manuscript in Moscow, Hist. Mus. cod. syn. gr. 524, dated 1587. See Sabas, *Specimina Palaeographica: Codicum Graecorum et Slavonicorum . . .*, Moscow, 1863, pl. μ̄γ̄.

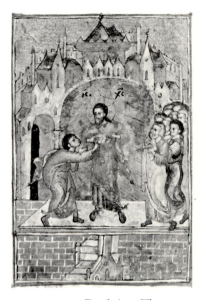

FIGURE 112. Doubting Thomas
Jerusalem, Anastaseos cod. 5, fol. 9v

Princeton, Univ. Lib. cod. Garrett 13. The twenty-four *oikoi* of the *Akathistos* preceded by the *prooemium* τῇ ὑπερμάχῳ στρατηγῷ τὰ νικητήρια (fols. 1r–25r); the twenty-four *oikoi* accompanied by the Salutations to the Virgin and a paraphrase of the hymn in popular Greek (fols. 27r–46v); the remainder of the Office of the *Akathistos* sung on Saturday of the fifth week in Lent (fols. 47r–65v); two invocatory canons in honor of the Virgin (fols. 66r–89v); the eleven *Eothina Evangelia* (90r–102v). In Greek on paper. 102 folios (27.8 x 21.0 cm.). Minuscule script. One column (fols. 28r–89v: 15 lines: 17 x 10 cm.; fols. 28r–46v bear a marginal text of about 25 lines; fols. 90r–102v: 24 lines: 19 x 12 cm.). Twenty-five full-page miniatures. One full-page text frame. Four headpieces and thirty-five large ornamental initials. Binding: gold embossed dark red leather. Condition: many miniatures show moderate flaking.

PROVENANCE: In the monastery of Saint Andrew on Mount Athos. Brought to the United States by T. Whittemore. Purchased by R. Garrett and given by him to the Princeton University Library in 1942.

EXHIBITED: Baltimore 1947, no. 744.

BIBLIOGRAPHY: DeRicci and Wilson, *Census*, 867; Bond and Faye, *Supplement*, 311; Friend, "Garrett," 135.

The decoration of codex Garrett 13 includes twenty-five full-page miniatures illustrating the *prooemium* (prelude) and the twenty-four *oikoi* (stanzas) of the *Akathistos Hymnos* (see chapter 2).[1] Those accompanying the twelve "historical" *oikoi* relate in a narrative fashion the story of Christ from the Annunciation to the Virgin to Simeon's recognition of God in the Child Jesus (fols. 2r–13r), while those illustrating the twelve "theological" stanzas are hieratic depictions of the adoration by various groups (bishops, angels, orators) of Christ or the Virgin and Child (fols. 14r–25r, fig. 113). A representation of the Tree of Jesse (fol. 1r) accompanies the *prooemium*.[2]

The ornament of the Princeton *Akathistos* consists of one full-page text frame and four smaller headpieces marking five major textual divisions, as well as thirty-five large, zoomorphic initials (fig. 114). The headpieces are decorated with stylized palmettes and peacocks enclosed by circles or geometricized tendrils. The initials combine smaller palmette motifs with hybrid, intertwining snakes and fowl, often devouring one another. Dark green and maroon as well as bright orange-red predominate in the miniatures. The manuscript shows a liberal use of gold throughout.

Although the Princeton *Akathistos* follows traditional iconography,[3] it has not been possible to find another cycle that closely resembles it, a fact that is partly the result of the highly diversified character of *Akathistos* scenes in Byzantine and Post-Byzantine art. Notwithstanding, individual scenes may be paralleled, especially among works of the Cretan school of illumination. The Annunciation (fol. 2r), for example, closely resembles the same scene in an icon in the Benaki Museum, Athens, signed by John Kyprios

and dated 1581.[4] Moreover, the Anastasis (fol. 19r), which includes a group of angels behind Christ, is closely related to the corresponding scene in the *Akathistos* fresco cycle in the *Trapeza* of the Great Lavra on Mount Athos, datable to the first part of the sixteenth century and assigned to Theophanus the Cretan, head of the Cretan school.[5]

The Princeton *Akathistos* also reveals close similarities to Cretan figure style.[6] Its interpretation, however, is marked by certain features that make the "Cretan" origin of these illustrations questionable. Most notably, the figures display a physical ugliness opposed to the classical ideal of beauty that constitutes a permanent feature of the Cretan school.[7] It thus appears more logical to argue in favor of the copying of a Cretan model by a non-Cretan artist.

Western stylistic influences are subordinate. They are mainly revealed in the rendering of landscape and in some perspective effects, as well as in the predilection for light colors. Only seldom do the garments reveal a Western treatment as, for example, in the figure of the Virgin in the scene of the Reproaches (fol. 7r). Western elements have been successfully integrated into traditional Cretan compositions, whose monumental nature would seem to indicate a source in monumental painting.

A study of the ornament provides insight into a third source of influence on the Princeton *Akathistos*. The intricate decorative motifs combined with various hybrid snakes and fowl reveal a markedly Slavonic flavor.[8] The ornamental initials, in particular, are strikingly similar to those in a Gospel book in Jerusalem (Anastaseos cod. 2), dated 1610 and copied by the calligrapher Matthew, Metropolitan of Myra.[9] Matthew, of Epirot origin, is one

of the best-known literati and scribes in the late sixteenth and early seventeenth centuries. It is known that he was for some time in the monastery of the Great Lavra on Mount Athos and that he established himself in Wallachia. The calligrapher Matthew can be related to a well-defined scriptorium characterized by its revival of the hieratic script of the twelfth century (see cat. 62). The Princeton *Akathistos* is an excellent specimen of this script.

The known data on Matthew's career might lead to the hypothesis that the Princeton manuscript was written and illustrated on Mount Athos. The close cultural relations between the Athos monasteries and Wallachia, whose Voevodes were among their great patrons, would explain the Slavonic ornament. From the contents of the manuscript it may be concluded that it had definitely a liturgical use and was destined for a priest.

D.M.

Lent by Firestone Library, Princeton University

NOTES

1.
*prooemium*: Tree of Jesse (fol. 1r)
*oikos* 1: the Annunciation (fol. 2r)
*oikos* 2: the Annunciation (fol. 3r)
*oikos* 3: the Annunciation (fol. 4r)
*oikos* 4: the Conception of the Virgin (fol. 5r)
*oikos* 5: the Visitation (fol. 6r)
*oikos* 6: Joseph Reproaching the Virgin (fol. 7r)
*oikos* 7: the Nativity (fol. 8r)
*oikos* 8: the Journey of the Magi (fol. 10r)
*oikos* 9: the Adoration of the Magi (fol. 10r)
*oikos* 10: the Return of the Magi (fol. 11r)
*oikos* 11: the Flight into Egypt (fol. 12r)
*oikos* 12: the Presentation in the Temple (fol. 13r)
*oikos* 13: the Virgin and Child worshipped by people (fol. 14r)
*oikos* 14: Christ worshipped by angels (fol. 15r)
*oikos* 15: Christ depicted twice: on earth among people, and in heaven, with his celestial escort (fol. 16r)
*oikos* 16: the Virgin and Child glorified by angels (fol. 17r)
*oikos* 17: the Virgin and Child among the orators (fol. 18r)
*oikos* 18: the Anastasis (fol. 19r)
*oikos* 19: the Virgin and Child as Protectress of the Virgins (fol. 20r)
*oikos* 20: Christ in Glory worshipped by holy bishops (fol. 21r)
*oikos* 21: the Virgin and Child as the Lamp of Living Light (fol. 22r)
*oikos* 22: Christ tearing the scroll of sins (fol. 23r)
*oikos* 23: the Virgin and Child glorified by people (fol. 24r)
*oikos* 24: the Virgin and Child glorified by angels (fol. 25r)
2. A representation of the Tree of Jesse is frequently combined with an *Akathistos* cycle, as, for example, in many Roumanian fresco cycles. See I. D. Ştefănescu, *L'Évolution de la peinture religieuse en Bucovine et en Moldavie*, Paris, 1928, esp. 106, 133.
3. Despite its generally close adherence to traditional *Akathistos* iconography, codex Garrett 13 shows several peculiarities: the presence of Joseph in the Annunciation (fol. 4r), perhaps under the influence of the corresponding Joseph figure in the Adoration of the Magi (fol. 10r); the seated positions of Joseph and the Virgin in the scene of the Reproaches (fol. 7r), perhaps a make-up from Joseph of the Nativity scene (fol. 8r) and the Virgin of the Annunciation (fol. 4r); and the Adoration of the Magi, which totally conforms to Western tradition.
4. A. Xyngopoulos, Μουσεῖον Μπενάκη. Κατάλογος τῶν Εἰκόνων, Athens, 1936, no. 7, pl. 9.
5. G. Millet, *Monuments de l'Athos*, I, Paris, 1927, pl. 146.
6. See the numerous studies by M. Chatzidakis, especially *Icônes de Saint-George des Grecs et de la collection de l'Institut*, Venice, 1962.
7. See M. Chatzidakis in *Actes du premier congrès international des études balkaniques et sud-est européennes*, II, Sofia, 1969, 801f.
8. S. Radojčić, *Stare Srpske Minjature*, Belgrade, 1950.
9. M. Beza, *Byzantine Art in Roumania*, New York, 1940, no. 39, pl. page 68.

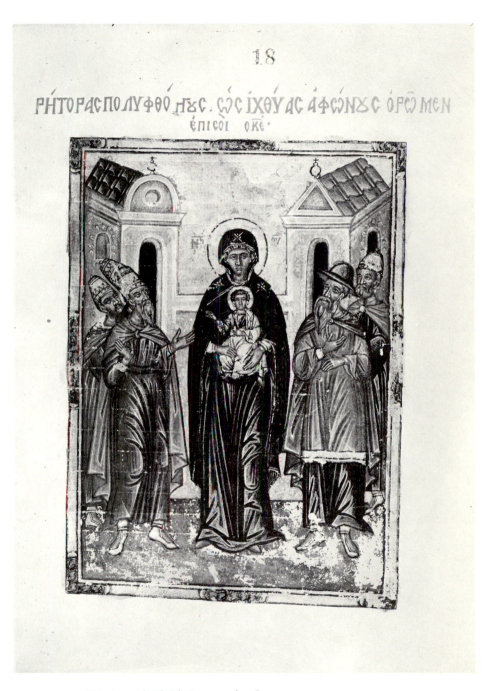

FIGURE 113. Virgin and Child Among the Orators
Princeton, Univ. Lib. cod. Garrett 13, fol. 18r

βορβορ ρ ωμέρμ ... χαιρ

χαιρε ...

περσκύμησιμ παύσασ

χαιρε φλογος παθρ σ

ψαμάμποισα · χαιε

τι τωρ ο ... σω φε —

ούμης · χαιρε πασω

πριωρ ο φοσύμη · χαιρ

ρύμφ κ ἁμύμφευ :—

καὶ ἑὐφροσύνη καὶ
χαρὰ ὅλων τῶν γενεῶν
τῶν ἀνθρώπου ::
χαῖρε νύμφη ἀνύμφευ
τε ::

... φόερι π
τομό πεοιμα
τοι , πι
ρε ψαμιις
βαβυλῶρα
ὁ προφητ ... ός χριςος τογ
φησαν ὡς φλύαρογ

οι μάγοι ἀφου
ἐκηρυξαν τὴν
θεοτητα σου ἐχωρισαν εἰς
τὴν βαβυλῶνα τελειωσαν
τες τὴν προφητείαν σου
καὶ κηρυξαν τες εἰς ὁ-
λους πως ἐσυ εἶσαι
δε ἡρωδην ἀ
καὶ ἀνόητον ὁπου δὲν

FIGURE 114. Ornamental initial
Princeton, Univ. Lib. cod. Garrett 13, fol. 35r

Chicago, Univ. Lib. cod. 931. A vernacular translation of the Revelation of John by Maximos the Peloponessian (including commentary of Andreas with elements of the commentary of Arethas). In Greek on paper (three watermarks, not in Briquet).[1] 194 folios (22.0 x 15.5 cm.). Minuscule script. One column of 23 lines (15.8 x 10.5 cm.). Sixty-nine half- to full-page miniatures and ca. thirty simple headpieces. Colophons: folio 1r and the last flyleaf, non-scribal. Folio 1r, scribal. Binding: stamped dark brown goatskin over wooden boards. Crucifixion on the front; four Evangelists front and back. Condition: some miniatures show minor flaking; only one leaf missing.

PROVENANCE: Belonged to Parthenios of Larissa (fol. 1r), late seventeenth or early eighteenth century. Acquired in Paris by Miss Elizabeth Day McCormick in 1932. Presented to the University of Chicago in 1937.

EXHIBITED: University of Chicago Library, Chicago, 1970, *Catalogue to the Exhibition of Notable Books and Manuscripts . . .* , no. 5, ill.; University of Chicago Library, Chicago, 1973, *New Testament Manuscript Traditions*, nos. 55–59, ill.

BIBLIOGRAPHY: Bond and Faye, *Supplement*, 163; H. R. Willoughby and E. C. Colwell, *The Elizabeth Day McCormick Apocalypse*, 2 vols., Chicago, 1940; J. Renaud, *Le Cycle de l'Apocalypse de Dionysiou*, Paris, 1943, vii, 4, 24n.; H. Aurenhammer, *Lexikon der Christlichen Ikonographie*, 1, Vienna, 1959–67, 205; R. Chadraba, "Apokalypse des Johannes," *Lexikon der Christlichen Ikonographie*, 1, Rome, 1968, 138.

This vernacular Greek Apocalypse (fig. 115) is illustrated with sixty-nine half- to full-page miniatures corresponding to its seventy-two chapters.[2] Most scenes, headed by titles in red, are followed by the text they illustrate,[3] which in turn precedes the Andreas commentary. The figures, architectural motifs and grotesque Apocalyptic beasts which inhabit these strange visual allegories, are drawn in coarse, heavy outline and are painted in bright red, dark blue, burgundy, yellow ochre, green, and gold. Heads are left unpainted, as are some backgrounds and many details; other backgrounds are painted dark blue and are dotted with yellow stars. The suspension of figures and buildings high above the groundline, as well as the illuminator's preference for decorative patterns, add to the overall two-dimensional effect of these miniatures. Wide variations in technical quality are immediately apparent, with illustrations before folio 114 being generally rougher and flatter and those after being more highly finished, uniform, and sophisticated.[4]

Typically, John is shown crouched in a lower corner observing a complex allegory unfolding above him. The sixty-nine miniatures may be reduced to eight subcycles based on the various repeated allegorical motifs of the Apocalypse text (the Seven Churches, the Seven Trumpets, the Seven Bowls of God's Wrath, etc.).[5] Compositions within the respective subcycles are often repeated; the Four Horsemen, for example, are depicted one each on four folios in almost identical compositions. At the same time certain complex figural motifs, such as God Enthroned and the Mystic Lamb, are found in similar form throughout the codex.

These miniatures reveal a keen interest in the accurate depiction of contemporary dress and national types; turbaned Moslems may be identified among the opponents of Christ in several scenes. Simple ornamental headpieces are prevalent, especially in the first half of the manuscript. They consist primarily of basic interlace patterns of ribbon and rope.

An ownership colophon at the top of folio 1r indicates that the Chicago codex once belonged to Parthenios of Larissa, a bibliophile of the late seventeenth and early eighteenth century.[6] A scribal colophon on the same folio attributes the vernacular translation of the Apocalypse to Maximos the Peloponessian, a well-known author and ecclesiastic of the late sixteenth and early seventeenth centuries.[7] Since the earliest of the three other known copies of this text is dated 1601, the production of the Chicago manuscript may safely be placed in the seventeenth century.

While the rough provincial style of these miniatures is quite extraordinary, certain parallels may be found in manuscripts from Mount Athos. A similar expressive linear drapery style, with button-hook folds and taut hems, is found in a Lectionary from the Koutloumousi monastery (cod. 289), dated 1562.[8] In addition, the headpieces of this manuscript, as well as those of Koutloumousi cod. 292, and cod. 447,[9] have patterns of interlacing ribbon and rope strikingly similar to those of the Chicago manuscript.

Chicago codex 931 is the only known Greek Apocalypse manuscript with extensive illustration. Beyond it, there are three Apocalypse codices of the fifteenth and sixteenth centuries that include a series of four marginal miniatures of grotesque beasts,[10] and occasional instances of an author portrait of John with Prochoros used as a frontispiece to the Revelation of John.[11]

The dearth of Byzantine Apocalypse illustration, especially striking in comparison with the continued popularity of these themes among artists in the mediaeval West, may be explained in part by the fact that only in the fourteenth century was the Apocalypse readily admitted to the canon in the Orthodox Church.[12]

It was only in the sixteenth century, and under direct influence from the West, that extensive illustration of the Apocalypse appeared in Greek art. A recurrent cycle of Revelation wall paintings may be traced in various monasteries of Mount Athos, beginning in the mid-sixteenth century with the nineteen-scene cycle in the vestibule of the Dionysiou *Trapeza*.[13] It has been clearly demonstrated that these cycles of the Apocalypse depend on the twenty-one scene cycle of woodcuts included in the Luther New Testaments printed in Wittenberg in 1522 (Lucas Cranach) and in Basel in 1523 (Hans Holbein the Younger).[14] These woodcuts in turn are derived from the fourteen-scene cycle published by Dürer in 1498.[15]

The Chicago manuscript's iconographic independence from those Athos cycles, as well as from all Eastern and Western Apocalypse cycles known to me, definitely makes it an extraordinary monument of Post-Byzantine illumination.[16]

G.V.

Lent by the Joseph Regenstein Library, University of Chicago

NOTES

1. The triple crescent watermark is also found in a manuscript on Mount Sinai (cod. 433), dated 1652. See Willoughby and Colwell, *Apocalypse*, I, 7.

2. The sixth-century commentator Andreas of Caesarea divided the Apocalypse into twenty-four sections of three chapters each.

3. Sixty-four miniatures precede the text they illustrate. Only the miniature on folio 15r of John Dictating to Prochoros is unrelated to its neighboring text (the Letter to Smyrna).

4. Willoughby and Colwell, *Apocalypse*, I, 120f.

5. Ibid., 108f.

6. Ibid., 27.

7. Ibid., II, 1f.

8. Photographs in the Department of Art and Archaeology, Princeton University.

9. Photographs in the Department of Art and Archaeology, Princeton University.

10. Leyden, Univ. Lib. cod. voss. gr. 48; Paris, Bibl. Nat. cod. gr. 239; and Vienna, Nat. Lib. cod. theol. gr. 69. See Willoughby and Colwell, *Apocalypse*, I, 5f.

11. E.g., Moscow, Univ. Lib. cod. 2 (2280). See Willoughby and Colwell, *Apocalypse*, I, 87.

12. Nicephoros Callistos, *Ecclesiastical History*, II, 45. Willoughby and Colwell, *Apocalypse*, I, 89f.

13. G. Millet, *Monuments de l'Athos*, I, pls. 207–9.

14. See L. H. Heydenreich, "Der Apokalypsen-Zyklus im Athosgebiet und seine Beziehungen zur deutschen Bibelillustration der Reformation," *Zeitschrift für Kunstgeschichte*, VIII, 1939, 1f.; Renaud, *l'Apocalypse*; and Huber, *Athos*, 365f. Heydenreich sees the Holbein cycle as the model, while Renaud envisions a model close to the Cranach cycle. Huber, who has discovered a total of ten Apocalypse cycles in nine Athos cloisters, shows evidence that both cycles were known.

15. Willoughby and Colwell, *Apocalypse*, I, 152f.

16. Ibid., xxvi, 85f.

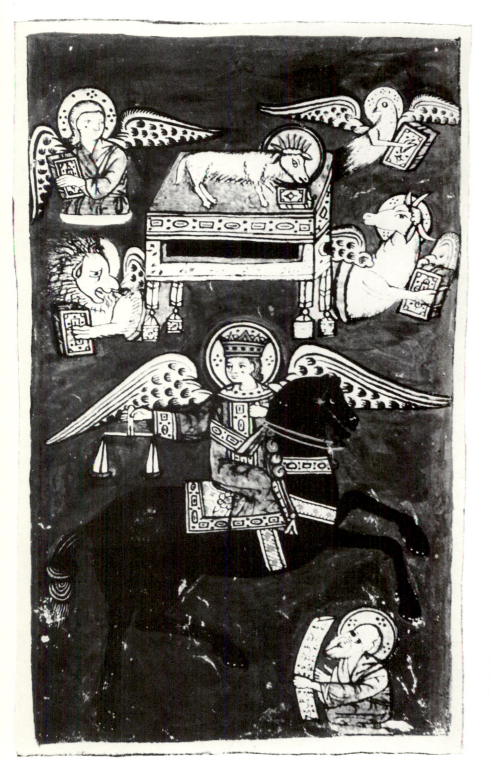

FIGURE 115. The Third Seal
(The Black Horse)
Chicago, Univ. Lib. cod. 931, fol. 52v

# 65.

Princeton, Univ. Lib. cod. Garrett 11. The
Liturgy of John Chrysostom (fol. 3r), of
Basil the Great (fol. 49r), and of the Pre-
sanctified (fol. 104r). In Greek on paper
(two watermarks, not in Briquet).[1] 146
folios (29.5 x 21.0 cm.). Minuscule script.
One column of 15 lines (20.0 x 11.8 cm.).
Three full-page ornamental text frames.
Eight headpieces and over eighty ornamental
initials; several anthropomorphic. Colo-
phons: folios 34v, 86v, 143r, scribal. Binding:
gold embossed black leather. Condition: ex-
cellent throughout; some silver-painted orna-
ment has tarnished.

PROVENANCE: Made for Constantios, Metro-
politan of Rhodes (fols. 34v, 86v, 143r).
Given by R. Garrett to the Princeton Uni-
versity Library in 1942.

BIBLIOGRAPHY: DeRicci and Wilson, *Census*,
867.

FIGURE 116. The Liturgy of Basil
Princeton, Univ. Lib. cod. Garrett 11, fol. 50r

# Greek Liturgy

*Circa 1700 A.D.*

This Post-Byzantine service book, written in a large hieratic minuscule script on glazed white paper, is decorated with more than eighty large ornamental initials (fig. 116). In addition it includes eight headpieces, marking major textual divisions, and two ornamental title pages —one preceding the Liturgy of Basil the Great (fol. 49r) and the other preceding the Liturgy of the Presanctified (fol. 104r). There is no evidence that the first Liturgy, that of John Chrysostom, ever bore a title page. At the end of the manuscript (fol. 143r), a simple arched frame encloses a single large column around which spirals a banderole bearing a dedicatory inscription.[2]

Initials and headpieces are composed of four-petal flowers with freely intertwining stems and buds, hanging draperies, acorns, lush leaves, strapwork, and grotesque human and animal heads. Occasionally a bell tower or a tree is enclosed in the initial. The Basil title page is decorated with heavy, inelegant strapwork; that preceding the Liturgy of the Presanctified includes an open rocky landscape framed by multiple superimposed columns and bell towers, and occupied by a single, polygonal domed structure.

The colors of codex Garrett 11, unusually lively for a Greek manuscript, include bright pink, light pea green, bright orange red, deep green, and gold and silver.

According to the dedicatory inscription on folio 143v, this service book was made for Constantios, Metropolitan of Rhodes (ca. 1700),[3] a member of the Palaeologan family from Lesbos. His name also appears on a banderole held by a double-headed Palaeologan eagle,[4] forming the initial 'T' within the Chrysostom Liturgy (fol. 34v) and on a banderole draped over a large ornamental 'T' in the Basil Liturgy (fol. 86v). In both cases the initial

marks the beginning of the Intercession, the prayer for the whole church. The inscription $\mu\nu[\dot{\eta}\sigma]\theta\eta\tau\iota$, Κύριε preceding Constantios's name on folio 86v shows clearly his desire to be included among those of the church whom the Lord should "call to remembrance."

Hundreds of illuminated Post-Byzantine Liturgies are to be found in large Eastern monastic libraries, such as those of Mount Athos, Jerusalem, and Mount Sinai. Typically they include foliated headpieces separating the three Liturgies, as well as numerous ornamental initials. Many contain standing author portraits of John Chrysostom, Basil the Great, and Gregory Dialogos.[5]

Codex Garrett 11 differs from most seventeenth-century Liturgies in its non-Byzantine ornamental motifs and coloring. Its strapwork and architectural title frames as well as its grotesque, ornamental heads are typically Western.[6] Also Western is the illuminator's preference for bright colors and open landscapes.[7] Comparable title pages may be found in Greek service books printed in Venice in the sixteenth and seventeenth centuries.[8] Thus, the Garrett codex clearly documents the increasing influence of Western art on Eastern illumination in the Post-Byzantine period.

G.V.

Lent by Firestone Library, Princeton University

NOTES

1. Its triple-crescent watermark is found in a Lectionary in Paris (Bibl. Nat. cod. suppl. gr. 242), dated 1650.
2. Συνδρομὴ, καὶ ἔξοδος, Κωνσταντίου, μ[ητ]ροπολίτου, 'Ροδου, Παλαιολόγου, τοῦ λεσβίου.
3. Papadopoulos-Kerameus, *Jerusalem*, I, 347 (Taphou cod. 276).
4. See B. Hemmerdinger, "Deux notes d'héraldiques," *Byzantinische Zeitschrift*, LXI, 1968, 305f.
5. See N. A. Bees, Τὰ Χειρόγραφα τῶν Μετεώρων, Athens, 1967, pls. XXXIV, LXXV, LXXVII.
6. See R. Berliner, *Ornamentale Vorlageblätter des 15. bis 18. Jahrhundert*s, 3 vols., Leipzig, 1925–26, pls. 108, 154, 172, 183, 184, 223, 225, 239, 268 (all dating from the second half of the sixteenth or the first quarter of the seventeenth century). Comparable Western architectural frames may be seen in a Greek liturgical manuscript on Mount Athos (Dochiariu cod. 248), dated 1688 (photographs in the Department of Art and Archaeology, Princeton University).
7. Comparable floral motifs, clearly differing from traditional Byzantine flower-petal ornament, are found in Mount Athos, Vatopedi cod. 1092, dated 1748 (photographs in the Department of Art and Archaeology, Princeton University).
8. See Bees, Χειρόγραφα, pl. XVI. Service books of the Orthodox use seem to have been printed exclusively in Venice before the nineteenth century (see F. E. Brightman, *Liturgies Eastern and Western*, I, Oxford, 1896, LXXXV).

# Forged Miniatures in a Gospel Book

Princeton, Art Museum cod. acc. no. 35.70. In Greek on vellum. 592 pages (17.8 x 13.4 cm.). Minuscule script. One column of 22 lines (13.5 x 8.5 cm.). Four full-page miniatures (forged). Four large and six small headpieces (redrawn). Colophon: pages 591–92, scribal, dated 1296. Binding: blind-stamped black leather over wooden boards. Crucifixion on the front; Resurrection on the back. Condition: first quire missing; carmine ornament, initials very faded; redrawn and recolored; miniatures rubbed.

PROVENANCE: Acquired in May 1935. (Formerly no. 308 in a sale catalogue.)

EXHIBITED: Baltimore 1947, no. 729.

BIBLIOGRAPHY: DeRicci and Wilson, *Census*, 1175; Bond and Faye, *Supplement*, 304; Clark, *N. T. Manuscripts*, 179f., pls. XXXIV, LXV; Aland, *Liste*, 188; Lazarev, *Storia*, 423n.

This Gospel book, written in 1296 by a certain Niketas,[1] contains a set of four Evangelist portraits: Matthew, pasted inside the front cover; Mark, page 166; Luke, page 276, fig. 117; John, page 458. Each is shown seated in profile, facing toward the right. All, except for John, are set before elaborate desks. Mark and Luke are placed in large curved thrones; Matthew and John on simple benches before sweeping rock formations. Their lively garments are rendered in dark mat tones of purple, blue, bluish pink, red, and green, and are liberally highlighted with creamy brown. The furniture is light reddish brown, backgrounds are dark blue, frames bright red, and halos and inscriptions dirty brownish yellow. The flesh of all figures is modeled in dark brown with strong white highlights.

These miniatures show none of the characteristics of late thirteenth-century figure style that one would expect in a manuscript dated 1296 (see cat. 51, 52, 53). Indeed, the linear perspective of Luke's footstool, as well as the modeling of flesh in dark brown with bright highlights (see cat. 61), and certain of the scribal instruments, such as the feather pen, do not appear until much later.

Unlike a number of manuscripts in this exhibition that show evidence of having undergone legitimate restorations long after they were written (see cat. 5, 38, 50, 51, 55, 56, 58), the Princeton codex appears to have been decorated by a modern forger. In addition to incorrectly substituting a young beardless Prochoros figure for John on page 458 and misspelling Mark's title (ἐγγελιστής) the forger betrays himself in meticulously redrawing and recoloring all the ornamental headpieces (fig. 118). He has even gone so far as to rub the miniatures in order to make them appear more antique,

being careful, however, not to damage the four faces, of which he must have been especially proud.[2] Finally, close examination of the Mark and Luke portraits shows that their borders are painted over parts of a late nineteenth-century inscription.[3]

More than a dozen manuscripts (including cat. 67) may be identified as containing miniatures by the forger[4] (or group of forgers) of this codex.[5] Especially close comparisons may be found in Montreal, McGill Univ. cod. 1;[6] in a Lectionary sold through Sotheby in 1928;[7] and in a set of four single portrait leaves once in the Paris collection of M. P. Filiba.[8] In almost every case miniatures were added on blank leaves or unused portions of the page of genuine Mid-Byzantine manuscripts (see cat. 67). Most of the manuscripts appeared and were sold in the 1920s and early 1930s.

Typically the forger copies a genuine work of art.[9] The Princeton miniatures were modeled on a set of early twelfth-century Evangelist portraits like those in Vatican Lib. cod. Urb. gr. 2[10] (see cat. 36). The forger's only error was to copy the young seated Prochoros, John's scribe, instead of the Evangelist himself.

G.V.

Lent by The Art Museum, Princeton University

FIGURE 117.  Luke
Princeton, Art Museum cod. acc. no. 35.70, p. 276

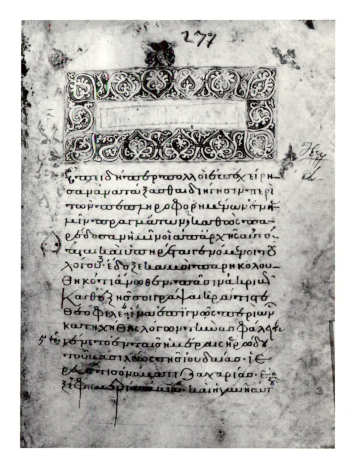

FIGURE 118.  Gospel of Luke
Princeton, Art Museum cod. acc. no. 35.70, p. 277

NOTES

1. ἐπληρώθη τὸ παρὸν τετραβάγγελον διὰ χειρὸς ἐμοῦ νικήτα τοῦ μ[α]βρώνι· δι' ἐνεργίας καὶ ἐξόδου κυρίου μιχαὴλ τοῦ ἐπονο[μα]ζουντ . . . . μηνὶ ιουν[ίω] ῑθ ινδ[ικτιῶνος] θ(?) ἐν ἔτει ῶδ̄ [ἡ]μέρα σα[ββάτω]· καὶ οἱ ἀναγινώσκοντες αὐτῷ εὔχεσθε ἡμῖν

   For other manuscripts, apparently by the same scribe, see Vogel and Gardthausen, *Schreiber*, 336.

2. The faces, painted with a thicker layer of paint, are usually flaked most severely.

3. This same hand has introduced page numerations, running title, and modern verse numbers. On a paper flyleaf at the end of the manuscript he transcribed the colophon, using the year 1876 to calculate its date.

4. M. Chatzidakis has identified the forger as a certain Demetrios Pelekasis born in Zakynthos in 1881 and still living today.

5. Princeton, Scheide Lib. cod. M142 (cat. 67); Montreal, McGill Univ. Lib. cod. 1; Oberlin, Coll. F. B. Artz, Mark leaf; two leaves sold through Sotheby and Co., London, May 21, 1928, *Catalogue of Superb Illuminations . . .* , lots 15, 16, ill.; four single leaves formerly in the collection of M. P. Filiba, Paris; Athens, Benaki Mus. Vitr. 34, cod. no. 1; cod. no. 3; cod. no. 4; cod. no. 7; cod. no. 8; cod. no. 9; cod. no. 11.

6. Baltimore 1947, no. 712. Photographs in the Department of Art and Archaeology, Princeton University.

7. See note 5.

8. Photographs in the Department of Art and Archaeology, Princeton University.

9. The forged miniatures in Athens, Benaki Mus. Vitr. 23, cod. 7, for example, are copied from a thirteenth-century Psalter in Istanbul (Seraglio cod. 13).

10. Stornajolo, *Giacomo*, pls. 83–93.

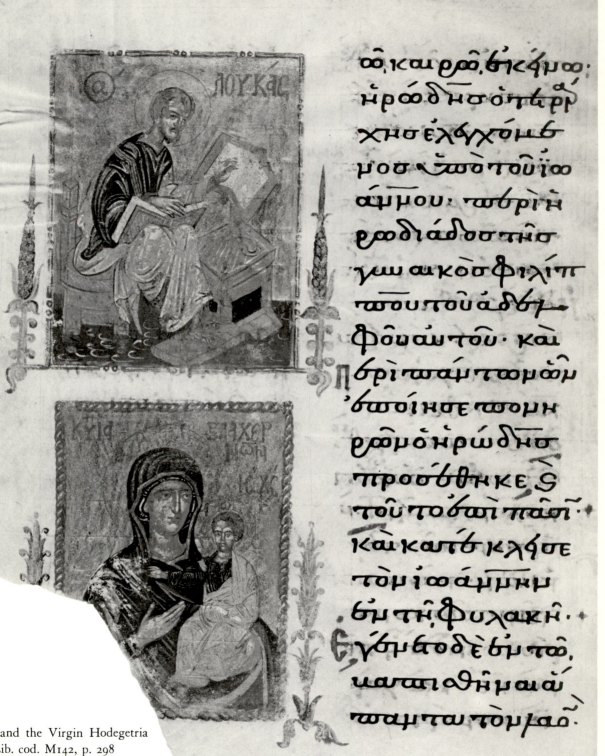

FIGURE 119. Luke, and the Virgin Hodegetria
Princeton, Scheide Lib. cod. M142, p. 298

# Forged Miniatures in a Lectionary

*Eleventh to Twelfth Century and Early Twentieth Century*

Princeton, Scheide Lib. cod. M142. In Greek on vellum. 738 pages (31.1 x 24.3 cm.). Minuscule script. Two columns of 20 lines (25.6 x 8.0 x 18.6 cm.). Nine one-column miniatures and one marginal figure (forged). Eight headpieces and many ornamental initials (forged). Colophon: page 615 (forged). Binding: blind-tooled dark red leather over wooden boards. Condition: text begins in the fourth John reading; some leaves ripped; all leaves extensively trimmed; many leaves repaired; miniatures rubbed.

PROVENANCE: Acquired in 1970 from H. P. Kraus, who purchased it from M. Bodmer, Geneva.

BIBLIOGRAPHY: Sotheby and Co., London, July 17, 1950 (sale catalogue), lot. 29, ill.

This Lectionary, written in a typical hieratic minuscule of the eleventh or twelfth century, is decorated with nine framed one-column miniatures and one marginal figure. Illustrations found in the synaxarion section include: seated portraits of the four Evangelists (Prochoros [!], p. 102; Matthew, p. 104; Mark, p. 206; Luke, p. 298, fig. 119); the Virgin Hodegetria (p. 298, fig. 119); Christ, the Man of Sorrows (p. 526); Christ Epitaphios (p. 576); and an unframed standing Virgin (p. 615, fig. 120). The figural decoration of the menologion section is limited to a double portrait of Cosmas and Damian (p. 658) and a carmine sketch of a monk passing a severed nimbed head to a priest (p. 728).

Colors include various shades of burgundy, dark green, dusty pink, light blue, and greenish white. Flesh areas are modeled in dark brown with bright, cool, greenish white highlights. Backgrounds are gold.

These miniatures betray the forger's hand more readily than do those of Princeton, Art Museum cod. acc. no. 35.70 (cat. 66). First, the dark flesh tones and strong highlights are incongruous with the Mid-Byzantine date indicated by the script. Second, each miniature has either been squeezed into an unused area of the text column or has been painted over an erased portion of text.[1] The leaf bearing the portrait of Mark was erased so completely that several holes were worn through the vellum. The Hodegetria on page 299 (fig. 119) covers the lection title for the first Luke reading, beginning at the top of the next column.

Third, although the forger was subtle enough to head the twelve lections of Holy Thursday with the Man of Sorrows and to place Christ Epitaphios over the first canonical hour of Good Friday,[2]

FIGURE 120. The Virgin
Princeton, Scheide Lib. cod. M142, p. 615

he erred in the placement of other miniatures: John (Prochoros!) precedes the *last* John pericope, Mark is found after the ninth Sunday in the Matthew readings, and the carmine drawing is placed over the first of the eleven morning lections (ἐωθινά), with which it has nothing to do.[3]

As in the Princeton Museum Gospels (cat. 66), the forger has mistakenly copied John's scribe; this time, however, the figure has actually been inscribed Prochoros. Further, he has incorrectly labeled the Virgin Hodegetria as "βλαχερνῶν,"[4] and has revealed his complete misunderstanding of Matthew's garments in extending the gold *clavus* of the tunic down over the mantle. Finally, he has carelessly left several headpieces unfinished revealing penciled underdrawings (p. 105), and has in one instance (p. 526) attempted to paint gold over waxed-stained vellum.

In addition to rubbing his miniatures in order to enhance the antiquity of the codex, this illuminator has added a colophon at the bottom of page 615[5] (fig. 120), in a script strikingly different from that of the text. It names the manuscript's donor as "Alexios of the Studion monastery," a famous eleventh-century patriarch of Constantinople (1025–43).

The miniatures of codex M142 belong to the same group of forgeries as the Evangelist portraits in the Princeton Museum Gospels (cat. 66), showing especially close similarities to Athens, Benaki Mus. Vitr. 34, cod. no. 8 and cod. 9;[6] and to the set of single leaves formerly in the Paris collection of M. P. Filiba.[7] The difference between the Luke portrait in the Scheide manuscript and that in the codex of the Princeton Museum is a function of the use of different models. While the miniatures of the Art Museum Gospel book are based on Comnenian models, those in the Scheide Lectionary are copied from paintings of a later period. Specifically, the Evangelist portraits appear to reflect fourteenth-century figure types (see cat. 57); while the Virgin Hodegetria, the Man of Sorrows, Christ Epitaphios, and the double portrait of Cosmas and Damian are surely copied directly from Post-Byzantine (Cretan) icons.[8]

G.V.

Lent by the Scheide Library, Princeton

NOTES

1. Offprints of initials now covered by the Prochoros portrait on page 102 are seen in the margin of page 103.
2. In addition, Matthew is correctly placed at the head of his readings; the portrait of the Virgin Hodegetria is next to Luke, who was claimed as its painter; and Cosmas and Damian head the lection for November 1, their feast day.
3. The drawing is probably a corruption of an illustration for the lection of August 29 marking the beheading of John the Baptist.
4. For the Virgin Blachernitissa, see G. and M. Sotiriou, *Icones du Mont Sinaï*, 1, Athens, 1956, pl. 147.
5. βοήθι τῷ δούλῳ σοῦ ἀλεξίῳ στουδίῳ ἡγουμένῳ κτησαμένῳ καὶ χρυσόσαντι.
6. Photographs in the Department of Art and Archaeology, Princeton University.
7. Photographs in the Department of Art and Archaeology, Princeton University. The Luke from this set is closely related to the style of cat. 66, while the Mark is very similar to the Scheide codex.
8. The Virgin flanking the colophon on page 615 is probably copied from a Deesis group (see cat. 32).

# List of Abbreviations

Aland, *Liste*: K. Aland, *Kurzegefasste Liste der griechischen Handschriften des Neuen Testaments*, I, Berlin, 1963.

Athens 1964: Zappeion Exhibition Hall, Athens, 1964, *Byzantine Art: An European Art*.

Baltimore 1947: Baltimore Museum of Art, Baltimore, 1947, *Early Christian and Byzantine Art*.

Belting, *Buch*: H. Belting, *Das illuminierte Buch in der spätbyzantinischen Gesellschaft* (Abhandlungen der Heidelberger Akademie der Wissenschaft: Philosophisch-historische Klasse, Jahrgang 1970, I. Abhandlung), Heidelberg, 1970.

Bond and Faye, *Supplement*: W. H. Bond and C. U. Faye, *Supplement to the Census of Medieval and Renaissance Manuscripts in the United States and Canada*, New York, 1962.

Bonicatti, "Urb. gr. 2": M. Bonicatti, "Per l'origine del salterio barberiniano greco 372 e la cronologia del tetraevangelo urbinate greco 2," *Rivista di cultura classica e medioevale*, II, 1960, 41f.

Boston 1940: Museum of Fine Arts, Boston, 1940, *Arts of the Middle Ages*.

Brandeis 1968: Brandeis University Library, Waltham, Mass., 1968, *In Remembrance of Creation*.

Buchthal, "Gospel Book": H. Buchthal, "An Illuminated Byzantine Gospel Book of About 1100 A.D.," *Special Bulletin of the National Gallery of Victoria*, Melbourne, 1961, 1f.

Buchthal, "Manuscript": H. Buchthal, "An Unknown Byzantine Manuscript of the Thirteenth Century," *Connoisseur*, CLV, 1964, 217f.

Chatzidakis and Grabar, *Painting*: M. Chatzidakis and A. Grabar, *Byzantine and Early Medieval Painting*, New York, 1965.

Clark, *Greek N. T.*: K. W. Clark, *A Descriptive Catalogue of Greek New Testament Manuscripts in America*, Chicago, 1937.

Colwell and Willoughby, *Karahissar*: E. C. Colwell and H. R. Willoughby, *The Four Gospels of Karahissar*, 2 vols., Chicago, 1936.

Der Nersessian, "Dumbarton Oaks": S. Der Nersessian, "A Psalter and New Testament Manuscript at Dumbarton Oaks," *Dumbarton Oaks Papers*, XIX, 1965, 153f.

Der Nersessian, *Psautiers*: S. Der Nersessian, *L'Illustration des psautiers grecs du moyen âge, II: Londres, Add. 19.352*, Paris, 1970.

DeRicci and Wilson, *Census*: S. DeRicci and W. J. Wilson, *Census of Medieval and Renaissance Manuscripts in the United States and Canada*, 3 vols., New York, 1935–40.

Diringer, *Book*: D. Diringer, *The Illuminated Book: Its History and Production*, New York, rev. ed. 1967.

Dufrenne, *Psautiers*: S. Dufrenne, *L'Illustration des psautiers grecs du moyen âge, 1: Pantocrator 61, Paris grec 20, British Museum 40731*, Paris, 1966.

Ehrhard, *Überlieferung*: A. Ehrhard, *Überlieferung und Bestand der hagiographischen und homiletischen Literatur der griechischen Kirche*, 3 vols. (*Texte und Untersuchungen zur Geschichte der altchristlichen Literatur*, L–LII), Leipzig, 1937–43.

Eustratiades and Arcadios, *Vatopedi*: S. Eustratiades and Arcadios, *Catalogue of the Greek Manuscripts in the Library of the Monastery of Vatopedi on Mt. Athos*, Cambridge, Mass., 1924.

Friend, "Evangelists," I: A. M. Friend, Jr., "The Portraits of the Evangelists in Greek and Latin Manuscripts," *Art Studies*, V, 1927, 113f.

Friend, "Evangelists," II: A. M. Friend, Jr., "The Portraits of the Evangelists in Greek and Latin Manuscripts," *Art Studies*, VII, 1929, 1f.

Friend, "Garrett": A. M. Friend, Jr., "The Garrett Collection of Manuscripts: III. The Greek Manuscripts," *Princeton University Library Chronicle*, III, 131f.

Galavaris, *Gregory*: G. Galavaris, *The Illustrations of the Homilies of Gregory Nazianzenus*, Princeton, 1969.

Goodspeed, Riddle, and Willoughby, *Rockefeller McCormick*: E. J. Goodspeed, D. W. Riddle, and H. R. Willoughby, *The Rockefeller McCormick New Testament*, 3 vols., Chicago, 1932.

Gregory, *Textkritik*: C. R. Gregory, *Textkritik des Neuen Testamentes*, Leipzig, 1909.

Hamann-MacLean, "Quarto 66": R. Hamann-MacLean, "Der Berliner codex graecus quarto 66 und seine nächsten Verwandten als Beispiele des Stilwandels im frühen 13. Jahrhundert," *Studien zur Buchmalerei und Goldschmiedekunst des Mittelalters, Festschrift für Karl Hermann Usener zum 60. Geburtstag*, Marburg an der Lahn, 1967, 225f.

Huber, *Athos*: P. Huber, *Athos: Leben, Glaube, Kunst*, Zurich, 1969.

Lake, *Manuscripts*: K. and S. Lake, *Dated Greek Minuscule Manuscripts to the Year 1200*, 10 vols., Boston, 1934–39.

Lambros, *Athos*: S. Lambros, *Catalogue of the Greek Manuscripts on Mount Athos*, 2 vols., Cambridge, Mass., 1895, 1900.

Lassus, "Rois": J. Lassus, "Les Miniatures byzantines du Livre des Rois," *Mélanges d'archéologie et d'histoire*, XLV, 1928, 38f.

Lazarev, *Storia*: V. Lazarev, *Storia della pittura bizantina*, Turin, rev. ed. 1967.

Martin, *Climacus*: J. R. Martin, *The Illustration of the Heavenly Ladder of John Climacus*, Princeton, 1954.

Meredith, "Ebnerianus": C. Meredith, "The Illustration of Codex Ebnerianus," *Journal of the Warburg and Courtauld Institutes*, XXIX, 1966, 219f.

Millet, *Recherches*: G. Millet, *Recherches sur l'iconographie de l'évangile*, Paris, 1916.

Miner, "Monastic": D. Miner, "The 'Monastic' Psalter of the Walters Art Gallery," *Late Classical and Mediaeval Studies in Honor of Albert Mathias Friend, Jr.*, ed. K. Weitzmann, Princeton, 1955, 232f.

Morey, *Freer*: C. R. Morey, *East Christian Paintings in the Freer Collection*, New York, 1914.

Muñoz, *Rossano*: A. Muñoz, *Il Codice purpureo di Rossano e il frammento Sinopense*, Rome, 1907.

New York 1933–34: New York Public Library, New York, 1933–34, *Exhibition of Illuminated Manuscripts.*

Oberlin 1957: Allen Memorial Art Museum, Oberlin, Ohio, 1957, *Byzantine Manuscript Illumination* (*Allen Memorial Art Museum Bulletin*, xv, 1957–58, 42f.).

Omont, *Miniatures*: H. Omont, *Miniatures des plus anciens manuscrits grecs de la Bibliothèque Nationale du VIᵉ au XIVᵉ siècle*, 2nd ed., Paris, 1929.

Papadopoulos-Kerameus, *Jerusalem*: A. Papadopoulos-Kerameus, Ἱεροσολυμιτικὴ Βιβλιοθήκη, 4 vols., St. Petersburg, 1891–99.

*PG*: J. P. Migne, *Patrologia cursus completus, series graeca*, 161 vols., Paris, 1857–66.

Putzko, "1061": V. G. Putzko, "K Voprosu o Proisxoždenij Četveroevangelija 1061 Goda," *Revue des études sud-est européennes*, x, 1972, 33f.

Rice, *Last Phase*: D. T. Rice, *Byzantine Painting: The Last Phase*, London, 1968.

Stornajolo, *Giacomo*: C. Stornajolo, *Miniature delle omilie di Giacomo Monaco e dell'evangeliario greco urbinate* (Codices e Vaticanis selecti, ser. minor, 1), Rome, 1910.

*Studies*: K. Weitzmann, *Studies in Classical and Byzantine Manuscript Illumination*, ed. H. L. Kessler, Chicago, 1971.

Tikkanen, "Psalterillustration": J. J. Tikkanen, "Die Psalterillustration im Mittelalter," *Acta Societatis Scientiarum Fennicae*, xxxi, no. 5, 1903.

Vogel and Gardthausen, *Schreiber*: M. Vogel and V. Gardthausen, *Die griechischen Schreiber des Mittelalters und der Renaissance*, Leipzig, 1909.

Weitzmann, *Buchmalerei*: K. Weitzmann, *Die byzantinische Buchmalerei des 9. und 10. Jahrhunderts*, Berlin, 1935.

Weitzmann, "Latin Conquest": K. Weitzmann, "Constantinopolitan Book Illumination of the Period of the Latin Conquest," *Gazette des beaux-arts*, xxv, 1944, 193f. (*Studies*, 314f.).

Weitzmann, "Vatopedi 761": K. Weitzmann, "The Psalter Vatopedi 761: Its Place in the Aristocratic Psalter Recension," *Journal of the Walters Art Gallery*, x, 1947, 20f.

Weitzmann, "Gospel Illustration": K. Weitzmann, "The Narrative and Liturgical Gospel Illustrations," *New Testament Manuscript Studies*, eds. M. M. Parvis and A. P. Wikgren, Chicago, 1950, 151f. (*Studies*, 247f.).

Weitzmann, *Mythology*: K. Weitzmann, *Greek Mythology in Byzantine Art*, Princeton, 1951.

Weitzmann, "Septuaginta": K. Weitzmann, "Die Illustration der Septuaginta," *Münchner Jahrbuch der bildenden Kunst*, iii–iv, 1952–53, 96f. (*Studies*, 45f.).

Weitzmann, "Morgan 639": K. Weitzmann, "The Constantinopolitan Lectionary, Morgan 639," *Studies in Art and Literature for Belle da Costa Greene*, ed. D. Miner, Princeton, 1954, 358f.

Weitzmann, *Grundlagen*: K. Weitzmann, *Geistige Grundlagen und Wesen der Makedonischen Renaissance* (Arbeitsgemeinschaft für Forschung des Landes Nordrhein-Westfalen, cvii), Cologne, 1963 (*Studies*, 176f.).

Weitzmann, "Washdrawings": K. Weitzmann, "A Fourteenth-Century Greek Gospel Book with Washdrawings," *Gazette des beaux-arts*, lxii, 1963, 91f.

Weitzmann, "Verkündigungsikone": K. Weitzmann, "Eine spätkomnenische Verkündigungsikone des Sinai und die zweite byzantinische Welle des 12. Jahrhunderts," *Festschrift für Herbert von Einem*, Berlin, 1965, 299f.

Weitzmann, "Eleventh Century": K. Weitzmann, "Byzantine Miniature and Icon Painting in the Eleventh Century," *Proceedings of the XIIIth International Congress of Byzantine Studies, Oxford, 5–10 September, 1966*, London, 1967, 205f. (*Studies*, 271f.).

Weitzmann, "Imperial Lectionary": K. Weitzmann, "An Imperial Lectionary in the Monastery of Dionysiu on Mount Athos: Its Origin and Its Wanderings," *Revue des études sud-est européennes*, vii, 1969, 339f.

Weitzmann, *Roll*: K. Weitzmann, *Illustrations in Roll and Codex: A Study of the Origin and Method of Text Illustration*, Princeton, 1947, rev. ed. 1970.

Weitzmann, "Greek N. T.": K. Weitzmann, "An Illustrated Greek New Testament of the 10th Century in the Walters Art Gallery" (forthcoming).

# Index of Exhibited Manuscripts

# Index of Cited Manuscripts

# Photography Credits